The Great Age of

British Watercolours

1750–1880

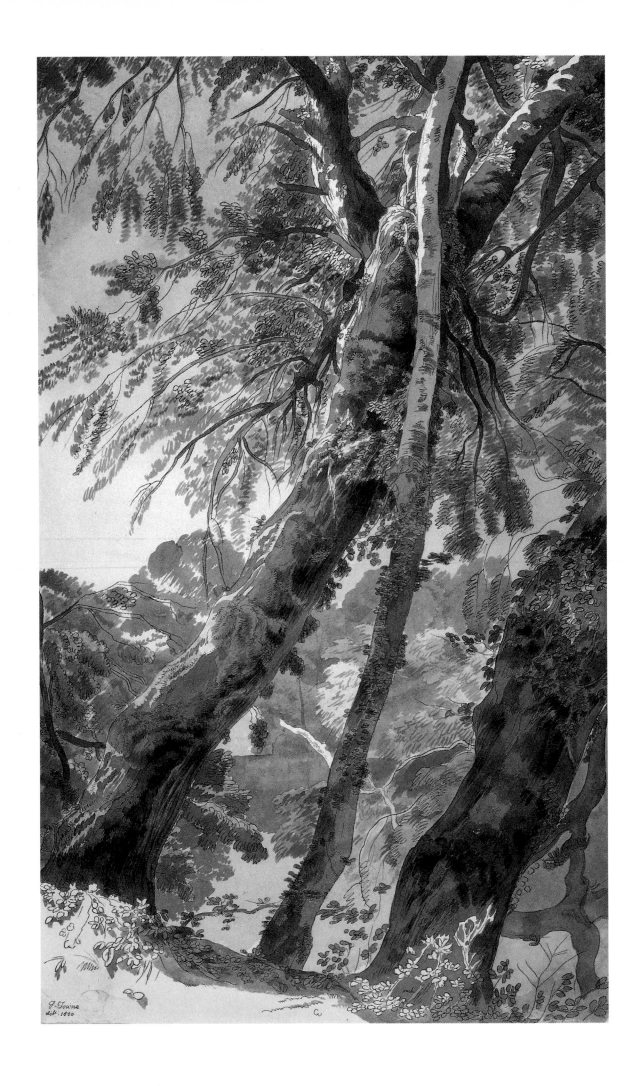

Andrew Wilton · Anne Lyles

The Great Age of
British Watercolours
1750–1880

Prestel

First published on the occasion of the exhibition 'The Great Age of British Watercolours, 1750–1880', held at the Royal Academy of Arts, London, 15 January–12 April 1993, and at the National Gallery of Art, Washington D.C., 9 May–25 July 1993

The exhibition was organised by the Royal Academy of Arts and the National Gallery of Art

In London the exhibition was made possible by Martini & Rossi Ltd

The Royal Academy of Arts is grateful to Her Majesty's Government for its help in agreeing to indemnify the exhibition under the National Heritage Act 1980, and to the Museums and Galleries Commission for their help in arranging indemnity

Exhibition selected by Andrew Wilton and Anne Lyles
Exhibition coordinator: Susan Thompson
Photographic coordinator: Miranda Bennion
Catalogue edited by Robert Williams
Catalogue coordinators: MaryAnne Stevens & Jane Martineau

Cover illustration: detail from John Sell Cotman, *Croyland Abbey, Lincolnshire, c.* 1804 (pl. 45)
Frontispiece: Francis Towne, *Trees Overhanging Water*, 1800 (pl. 134)
Page 10: detail from James Duffield Harding, *Modern Greece*, 1828 (pl. 293)

Prestel-Verlag, Mandlstrasse 26, D-8000 Munich 40, Germany
Tel. (89) 38 17 09 0; Fax (89) 38 17 09 35

Distributed in Continental Europe by Prestel-Verlag
Verlegerdienst München GmbH & Co. KG
Gutenbergstrasse 1, D-8031 Gilching, Germany
Tel. (8105) 38 81 17; Fax (8105) 38 81 00

Distributed in the USA and Canada on behalf of Prestel by te Neues Publishing Company,
15 East 76th Street, New York, NY 10021, USA
Tel. (2 12) 2 88 02 65; Fax (2 12) 5 70 23 73

Distributed in Japan on behalf of Prestel by YOHAN-Western
Publications Distribution Agency, 14–9 Okubo 3-chome, Shinjuku-ku, J-Tokyo 169
Tel. (3) 32 08 01 81; Fax (3) 32 09 02 88

Distributed in the United Kingdom, Ireland and all remaining countries on behalf of Prestel by
Thames & Hudson Ltd., 30–34 Bloomsbury Street, London WC1B 3QP, England
Tel. (71) 636 5488; Fax (71) 636 1659

Printed on Gardapat 13, acid and chlorine-free
matt coated, with 1.3 bulk factor, by Cartiere del Garda/Italy

Typeset by Max Vornehm, Munich
Colour Separations by Reproduktionsgesellschaft Karl Dörfel GmbH, Munich
Printed by Peradruck Matthias, Gräfelfing near Munich
Bound by R. Oldenbourg, Mohnheim

Printed in Germany
ISBN 3-7913-1254-5

Contents

Foreword

The history of British watercolour from the mid-eighteenth century to the end of the nineteenth century was intimately bound up with the evolution of man's response to the natural world. Neither drawing nor painting, the medium of watercolour presented the perfect vehicle by which so rich and varied a theme could be explored. Beyond its initial uses either to record the external world objectively or to expound more theoretical approaches to Nature, watercolour became the medium for the literal depiction of landscape, both in Britain and elsewhere, the transcription of the minutiae of the natural world, the analysis of natural phenomena, and the vehicle for the expression of man's emotional and intellectual response to the grandeur of Nature. This rich diversity of purpose demanded technical developments that allowed the medium to move away from precise outline and monochromatic washes to the heightened colour, varied brushwork and ambitious subject-matter that produced works which vied with oil paintings for supremacy on the walls of the Royal Academy of Arts. It engaged such major figures in the history of British art as John Robert Cozens, Thomas Girtin, John Sell Cotman, David Cox, James McNeill Whistler and J. M. W. Turner.

This exhibition and publication takes as its theme the development of attitudes to landscape and to the human figure in the landscape. It was conceived by Andrew Wilton, Keeper of the British Collection at the Tate Gallery in London. He has worked closely with Anne Lyles, Assistant Keeper of the British Collection at the Tate Gallery, in seeking out and selecting the works included in the show. Together they have also written the catalogue. Expertly edited by Robert Williams, the book will stand as a major contribution to our understanding of the subject. Andrew Robison, of the National Gallery of Art, and Norman Rosenthal, of the Royal Academy, have also helped to shape the exhibition, and, on the organisational side, Susan Thompson of the Royal Academy has handled the administration of the loans; at the National Gallery of Art, Dodge Thompson and Ann Robertson, assisted by Stephanie Fick, have coordinated the arrangements for the exhibition in Washington.

In London, the exhibition has received invaluable support from several sources: sponsorship of the show has been undertaken by Martini & Rossi Ltd; Paul Mellon KBE, an Honorary Corresponding Member of the Royal Academy, has most generously underwritten the cost of the educational programmes, and a grant from the Save & Prosper Foundation has financed the gallery guide. In the search for funding, the Royal Academy has been closely associated with the National Art Collections Fund, which was of course instrumental in acquiring for Britain an appreciable number of the works on display in the exhibition.

No exhibition can be realised without the wholehearted support of the owners, both public and private, who have agreed to lend works of art of capital importance. The quality of the exhibition will stand witness to their faith in its conception and their generosity in allowing their outstanding watercolours to be included.

This exhibition celebrates a collaborative relationship between the Royal Academy and the National Gallery of Art that spans nearly fifteen years. We hope that it will enlighten and bring pleasure to our respective publics.

Earl A. Powell III *Sir Roger de Grey*
Director, National Gallery of Art President, Royal Academy of Arts

Authors' Acknowledgements

The authors wish to acknowledge the many people who have helped in the preparation of this exhibition. The many owners, who have been extremely generous in lending much-prized works, are the first to be thanked, together with the staff of a number of public collections who have made the tasks of examination and selection both simple and enjoyable. Enthusiasts of watercolours of many kinds have volunteered advice and suggestions that have been gratefully received. Among these many benefactors they would especially like to thank the following: John Abbott, Philippa Alden, Nicholas Alfrey, Stephen Astley, Philip Athill, Caroline Bacon, Sir Nicholas and Lady Bacon, Chris Beetles, Peter Bicknell, Neil Bingham, Camilla Bois, David Blayney Brown, Mungo Campbell, Lindsey Candy, Janice Carpenter, Andrew Clary, Martin Clayton, Andrew Clayton-Payne, Helen Cocker, Malcolm Cole, Sean Cole, Patrick Conner, Katie Coombes, Trevor Coombs, Adrian Craft, Melva Croal, Jane Cunningham, Kevin Edge, Judy Egerton, Sir Brinsley Ford, Mr and Mrs Cyril Fry, John Gage, Catherine Gibson, Paul Goldman, Halina and James Graham, Richard Green, Francis Greenacre, Mr and Mrs Brian Greenwood, Martyn and Penelope Gregory, Antony Griffiths, Tessa Gudgeon, Charlotte Havilland, Luke Herrmann, Charles Hind, Ralph Hyde, Michael Jaye, Evelyn Joll, Margaret Kelly, Alex Kidson, Edward King, Lionel Lambourne, Jill Lever, Lowell Libson, Michael Liversidge, Briony Llewellyn, Catharine MacLeod, Christine Mackay, Sandra Martin, Sir Oliver and Lady Millar, Corinne Miller, James Miller, John Morton Morris, Jane Munro, Peter Nahum, Christopher and Jenny Newall, Sue Newall, Evelyn Newby, Charles Newton, Patrick Noon, Andrew Norris, Charles Nugent, Mr and Mrs Peter Nutting, Sheila O'Connell, Godfrey Omer-Parsons, Charlotte Oppé, Mr and Mrs Denis Oppé, Felicity Owen, Diane Perkins, Micki Rausa, Janice Reading, Michael Rich, Sarah Richardson, The Hon. Jane Roberts, Alexander Robertson, Anne Sandford, Gillian Saunders, Nicholas Savage, David Scrase, Joseph Sharpels, Kim Sloan, Vicki Slowe, Sue Smith, Michael Spender, Anthony Spink, Lindsay Stainton, Timothy Stevens, Sheena Stoddard, Robert Tear, Rosalind Thomas, Bill Thomson, Cornish Torbock, Helen Valentine, Neil Walker, Stanley Warburton, David Wardlaw, Ian Warrell, Henry Wemyss, Jon Whiteley, Stephen Whittle, Stephen Wildman, Hilary Williams, Timothy Wilson, Christina Wilton, Andrew Wyld, Richard Wood, Sir Marcus Worsley, Edward Yardley.

The preparation of an exhibition of this size would not have been possible without the dedicated support of the Royal Academy's Departments of Exhibitions and Education. Norman Rosenthal originally suggested the idea; MaryAnne Stevens has supervised its execution with energy and commitment. Sue Thompson has been the most equable and efficient of registrars. Robert Williams was an equally unflappable and punctilious editor, and has contributed the Biographical and Bibliographical sections of the catalogue, as well as the Chronology. Ivor Heal has supplied an appropriate and attractive setting for the exhibition's display. The rest of the R.A. team, including Jane Martineau, Annette Bradshaw, Charlotte Stirling, Emeline Max, Miranda Bennion and Sara Gordon, have provided very necessary help in all sorts of ways.

Work on the exhibition has taken the authors away from their desks at the Tate Gallery on many occasions, sometimes for protracted periods, and they are particularly grateful to their colleagues in the British Collection there, for much sympathetic toleration. Above all, it would not have been possible to proceed without the endorsement of the Director, Nicholas Serota, who has given his wholehearted support to the project from the beginning.

Andrew Wilton · Anne Lyles

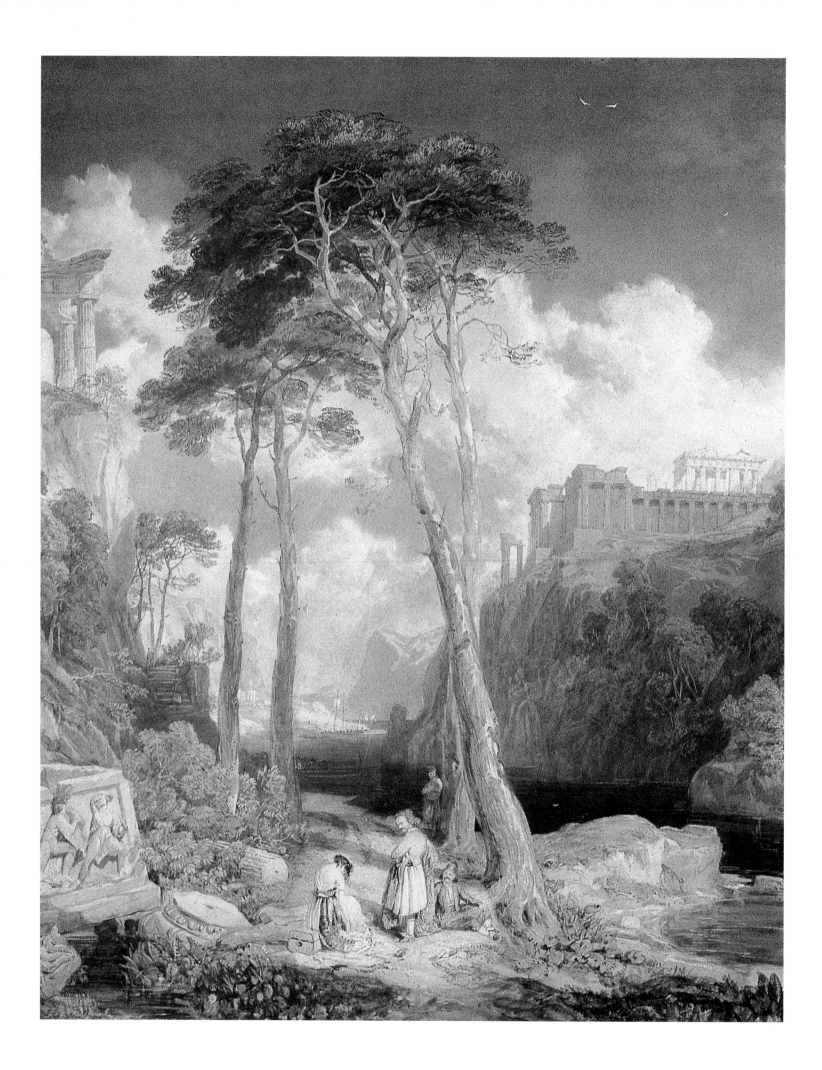

Ambition and Ambiguity:
Watercolour in Britain

Watercolour is well named: it embodies in its very nature an uncertainty, a fluidity and ambiguity that seems to symbolise its interest and aesthetic importance. Should we speak of a watercolour drawing, or a watercolour painting? Reporting on the opening of the Old Water-Colour Society's exhibition in 1824, William Henry Pyne recalled: 'Just twenty years ago, almost to the very day, … we met an old friend on entering the new rooms, one of the founders of the society … "Well," said we, almost simultaneously, "time was, in discussing the *title* for this society, whether the novel term *Painters in Water Colours* might not be considered by the world of taste to savor of assumption – who now, on looking round, will feel disposed to question the merits of that title?"[1] Thanks to the extraordinary developments of those decades, the terms 'drawing' and 'painting' are both correctly applied to watercolour, but in different contexts.

A drawing in pen or pencil may be amplified with washes, applied with a brush, that can be monochrome – grey, blue, or brown – or coloured. Such a drawing might be made out of doors, and in a short space of time, to record a particular idea, a particular set of observed facts or a response to them. It might be quite elaborate, yet still retain its identity as a drawing, perhaps even as a sketch. Completed, it would be mounted on a sheet of thin card decorated with a few parallel lines as a border, possibly tinted to harmonise with whatever colour is in the design (fig. 1). Rather than being framed, it would then, as like as not, be consigned to an album or portfolio, to be viewed in a collector's study or shown to friends in the course of discussion among antiquaries.

But watercolour can also be used in a quite different way, worked at laboriously in the studio as the medium of a large-scale picture with elaborate conceptual content, dense tones and complex imagery. In other words, a watercolour may be a finished painting in the same sense that a finished work in oils is a painting. Some oil paintings, of course, are themselves sketches or studies. There is a parallel between the two kinds of watercolour and these two uses of oil paint, for preliminary or exploratory studies and for evolved, finished works. There is also a striking historical difference: whereas watercolour evolved from the more tentative to the more complete form, the use of the oil sketch was a development from the process of making a finished oil painting. And while the oil sketch from Nature, which had been in use occasionally since the Renaissance, emerged as a distinct genre in many western European countries at roughly the same moment in the late eighteenth century, the watercolour painting, which developed contemporaneously, was an almost uniquely British phenomenon.

It presented the medium in a new dimension, that of the public statement. From being an essentially private channel of communication, small-scale, intimate and provisional, functioning according to the *ad hoc* requirements of individuals engaged in many aspects of recording the visual world, it became a fully fledged art form, with its own

intellectual programmes and purely aesthetic criteria of judgement. At the same time, watercolour retained its other, more practical, purpose, and so the two uses of the medium marched side by side through the nineteenth century, a uniquely flexible and varied means of expression.

In the second half of the eighteenth century, watercolour was developing somewhat similarly on the Continent. Although it had been in use in the Middle Ages for the illumination of manuscripts, its modern application as a medium for recording Nature was pioneered in a watery country, the Netherlands. It was reintroduced into Britain by artists from that part of the Continent in the early seventeenth century. There was no dearth of inventive skill in its use among the Dutch, the French and the Germans, who employed it for more or less elaborate landscape views (fig. 2). By the end of the eighteenth century artists all over Europe were using it as the medium for decorative landscapes, usually of a classicising kind, with subject-matter often drawn from the Grand Tour.

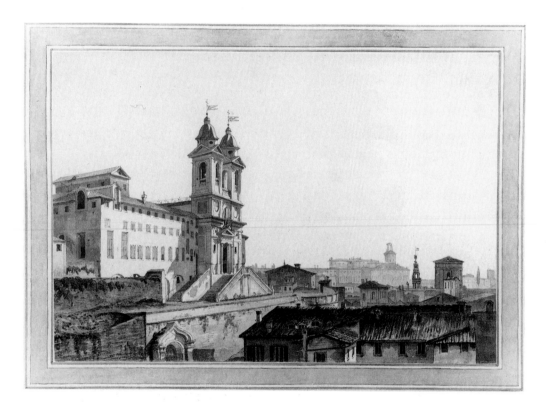

Fig. 1 John 'Warwick' Smith, *Church of SS Trinita dei Monti, Rome*, c. 1776, pencil and watercolour with pen and ink, 34.1 x 54.1. British Museum, London

For the British who made the journey through Europe to see the artistic wonders of ancient and modern Italy, and in due course came to appreciate the natural splendours of the Alps as well, the traditional interests of the antiquary were happily combined with the enthusiasms of the tourist, and watercolour was increasingly called upon to gratify both.[2] The need to record gave way to the need to recall, and recollection was as much a matter of atmosphere as of factual detail. Artists adapted themselves accordingly.

There was close contact between the British artists who travelled in Europe and their Continental *confrères*, and some stylistic interaction: the German Philipp Hackert (1737–1807), for instance, was much patronised by British travellers, and his drawings

were copied by English watercolourists: the connoisseur and collector Richard Payne Knight (1750–1824) took Hackert with him on a journey to Sicily in 1777, although Knight also travelled in the company of an accomplished English amateur draughtsman, Charles Gore (1729–1807), and later, in England, got another of his travelling companions, the professional Thomas Hearne (1744–1817), to make versions of Gore's drawings.[3]

Perhaps the most sophisticated of the Continental practitioners at this period was the Swiss painter Louis Ducros (1748–1810), whose often enormous scenes of Italy and Malta epitomise the technical virtuosity of the time (fig. 3).[4] They embody the dramatic vision of the moment when science and history gave way to the more subjective appreciation of early Romanticism, with its passion for Antique ruins, waterfalls and the scenery of the Roman Campagna. They demand to be treated as paintings, require no mount, and should be viewed in a heavy gilt frame like an oil painting. Ducros employs watercolour in a direct, brilliant way that takes maximum advantage of its inherent luminosity: he revels, for instance, in effects of sun shining through foliage, in which the idea of light transmitted through a membrane of colour is the essence of the

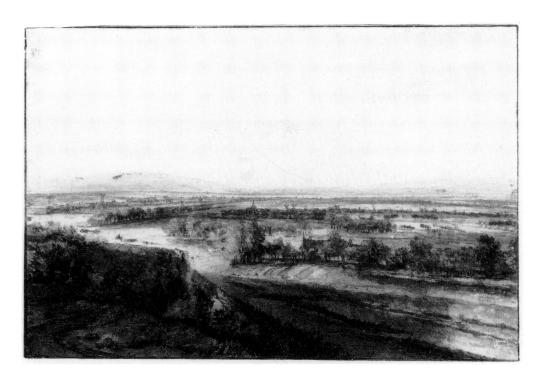

Fig. 2 Philips Koninck, *Landscape with a River and Distant Hills*, c. 1655, watercolour and bodycolour, 13.8 x 21.2. British Museum, London

image. It is an exact illustration of the principle of watercolour, where the transparent, water-based colour, applied directly to sheets of white paper, reveals the brightness of its ground in varying degrees according to the density of the pigment. The brilliance of sky or falling water is contrasted with the denser masses of rock or woodland, which are often strengthened with applications of gum arabic. Darker areas are often worked on first in a preliminary under-painting with a layer of grey or some other deeper tone. The human figure abounds, and Ducros's foregrounds are alive with the well-drawn and animated crowds that distinguish most good eighteenth-century topographical work. Outlines are lively and have a prominent role in the overall texture, but the linear rhythms of the whole design are generally subordinated to the visual wealth of detail.

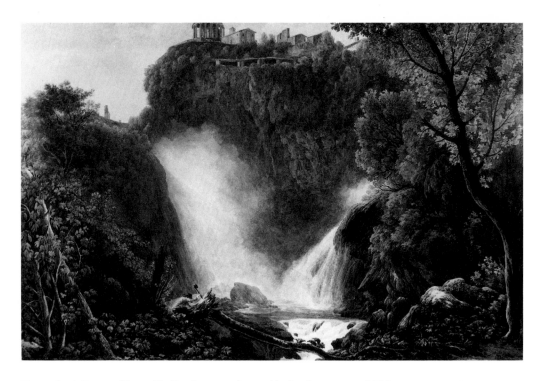

Fig. 3 Louis Ducros, *View at Tivoli*, 1787, watercolour and bodycolour on paper laid down on canvas, 66 x 101.5. The National Trust, Stourhead

Continental watercolours remained at this stage of development for the next half-century; indeed, on the whole they rarely again approached the complexity of Ducros's work. Hackert and his many followers, such as Franz Kaisermann (1765–1833), applied a decorative and effective formula to produce countless civilised views of an entirely predictable type. If the Continental artists developed technically it was towards a more adaptable sketching style, and hardly at all in the field of the finished watercolour. In Britain, by contrast, the eighteenth-century topographical view, however sophisticated, was soon left behind, and by the early years of the new century the expressive capacity of the medium had been stretched beyond recognition.

This rapid evolution is usually attributed to a special relationship between the British character and the medium of watercolour, to the unique beauty of the British landscape, or to the superabundance of bored young ladies requiring drawing-masters. These considerations all have some bearing on the quantities of topographical sketches produced in the eighteenth and nineteenth centuries, but they cannot adequately account for the profound conceptual seriousness with which watercolour was pursued by professional artists in these years.

The decisive factor in the evolution of the Romantic watercolour in Britain was precisely the same as the motive behind the development of the national school of oil painters. Since the early successes of William Hogarth (1687–1764) in the 1730s, there had been a heightened sense of national purpose in the visual arts, a chauvinism that impelled artists to incorporate themselves as a fully recognised establishment, setting standards at home and winning admiration abroad. The movement coincided with the first great expansion of Britain's imperial interests world-wide, with the Seven Years War and the confident heyday of the East India Company. The instinct for national advancement in the international context was becoming explicit, and when, in 1768, the Royal Academy of Arts was founded in London, supporters of the visual arts could argue for the first time that their activities, too, were taking a rightful place in the

expanding scheme of things.[5] The watercolourists were a part of this patriotic progress, caught up like everyone else in the pushy spirit of the times.

There were two strands to their ambition. On the one hand, they wanted to be part of the Academy; when they found that their work was rendered insignificant in the contest with oil paintings, they determined to make it more impressive; when that did not work, they formed an academy of their own, the Society of Painters in Water-Colours. This new institution was academic in the important sense that it incorporated the professional identity of the watercolourists, and provided them with a centre for exhibitions, their principal means of contact with the public. It did not, however, attempt to teach, as the Royal Academy did. Its 'schools' remained the studios of practitioners who trained their apprentices from the artisan class as engravers, scene-painters or topographers. On the other hand, the watercolourists believed in the intellectual importance of British painting, an idea that had received a substantial boost in the 1760s when William Woollett's engraving *Niobe*, after a historical landscape by the Welsh painter Richard Wilson (1713–82), was marketed all over Europe by Josiah Boydell (fig. 4).[6] Similar triumphs abroad were scored with the mezzotints produced by the reproductive printmakers that Joshua Reynolds (1723–92), the Academy's first President, was nurturing to disseminate his portraits.[7] There was no reason why watercolours should not reflect and embody this new international importance as much as oil.

This last assumption was, on the face of it, an illogical leap from the premisses. Until the 1780s there was little indication that watercolour might be a medium for the expression of the higher aspirations of art. Indeed, it was by definition a lowly and inferior branch, devoted chiefly to landscape (itself inferior to historical painting and

Fig. 4 William Woollett after Richard Wilson, *Niobe*, 1761, etching and engraving, 47.5 x 60. British Museum, London

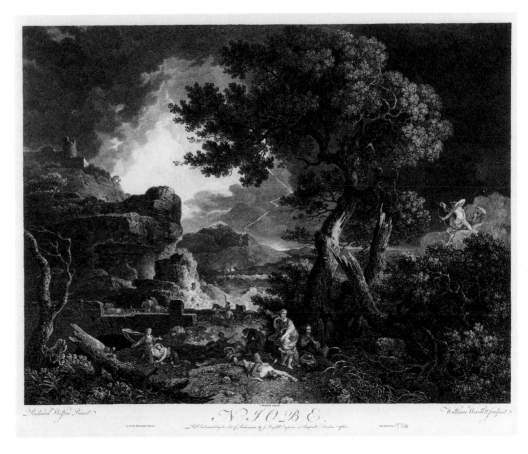

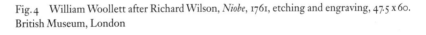

portraiture), and a lesser type of landscape at that – topographical view-making. Because the art establishment was locked into this system of hierarchies, there was plenty of scope for rivalry.

The very relegation of watercolour as a lesser art-form stimulated its practitioners to assert its potential. Those practitioners were a considerable body, with a well-established and much sought-after function in society. For the best part of a century they had supplied views of towns, of country seats, of antiquities to the nobility and gentry; they had accompanied the Grand Tourists on their journeys to Italy, and the archaeologists to Greece and Asia Minor and Sicily, with colours always ready on the spot to take an exact and scientific likeness of whatever objects of interest might appear. They had demonstrated the power of watercolour in worked-up views that might be hung like paintings on the wall. Ducros was by no means alone in doing so: Paul Sandby (1731–1809) had for much of his career specialised in large watercolours of just this type (pl. 24, 51), and had experimented with variations on the pure watercolour medium that gave his work a greater richness and intensity. While some artists, such as Ducros, preferred gum for this purpose, Sandby frequently adopted the thoroughly Continental medium of bodycolour – *gouache* as the French call it, from the Italian *aguazzo*, meaning mud. (In the early nineteenth century the word was sometimes expressively mistranscribed as 'gwash'). Instead of being mixed, as watercolour pigments are, with a transparent binding medium such as gum, and applied in thin washes that permit the tone of the support to contribute to their effect on the eye, the powdered pigments in bodycolour are combined with opaque matter, usually a fine clay or lead white, and applied thickly, so that the colour of the support cannot influence what the eye sees. When using pure watercolour the painter leaves the paper untouched (or 'reserved') as a way of introducing highlights, but bodycolour functions like oil paint: with it, the artist mixes increasing amounts of white into the pigment to achieve the lighter tones, with pure white for the highest lights.

Bodycolour pigments tend to be dense and saturated, more brilliant than watercolour. The medium had been used in Italy and France for two hundred years for painting fans and little fancy scenes, many of which were copied on a small scale from oil paintings. It had been put to serious purposes in the Renaissance when Albrecht Dürer (1471–1528) executed a series of exquisitely observed landscapes and Nature studies in bodycolour, but by the eighteenth century it was a largely decorative medium, associated particularly with the French. Its use in England was typified by the *capriccios* of the Italian viewmaker Marco Ricci (1676–1729; fig. 5) and the meticulous, brightly coloured copies after Old Masters of the Flemish draughtsman Bernard Lens III (1681–1740). Two Huguenots, Louis (1700–1747) and Joseph Goupy (c. 1680–c. 1768), used it in similar ways; Louis practised as a fan-painter and it was he who taught the young James 'Athenian' Stuart (1713–88), later famous as one of the earliest Greek Revival architects and co-author of *The Antiquities of Athens*. Stuart's bodycolour views in Greece (pl. 59, 60), drawn according to the most strict topographical principles, 'preferring', as he said, 'Truth to every other consideration',[8] are therefore executed in what was by tradition an essentially frivolous medium, and one which was, and remained for many decades, rather un-British.

If Stuart had direct influence on any of the topographers it was on William Pars (1742–82), who learnt much from his work but did not imitate his use of bodycolour (pl. 58). Paul Sandby, on the other hand, employed it frequently. The numerous *capriccios* that he painted in bodycolour, although often Italianate in general style, effectively

Anglicise the convention passed down by Ricci; and the decorative quality of body-colour perfectly suits his topography, imbuing his sunny mornings with a light-hearted, Haydnesque cheerfulness that has come to epitomise a certain aspect of eighteenth-century life. Sandby's fresh insouciance often disguises the richness of these works, but despite appearances, there is in the topographical discipline considerable complexity both aesthetic and intellectual, complexity of structure and, correspondingly, of the economic and social perceptions conveyed. When the watercolourists asked for academic recognition, they were protesting against a serious undervaluing of their art.

The late arrival of an academy in Britain was symptomatic of a typically British attitude to oil painting: a pragmatic readiness to experiment and evolve techniques according to need. No formal painting courses were instituted in the Academy's Schools; students were expected to work out their own technical salvation. The expressive vitality and variety of British Romantic painting, in which every artist devised his own means of expression, is due to this approach, although the frequent technical disasters of the school must also, no doubt, be ascribed to it. A precisely similar psychology governed the evolution of watercolour. Once the patriotic motivation and the profes-

Fig. 5 Marco Ricci, *Capriccio Landscape*, *c*. 1710, bodycolour on leather, 29.5 x 44.6. Private Collection

sional competition had been established by the successful inauguration of the Royal Academy, innate inventiveness took over. Between 1770 and 1800 a gamut of technical innovations had been tried, and the whole appearance of watercolours had been changed unrecognisably. This experimental drive had no parallel on the Continent, where watercolour was to change little until the 1820s or later.

Since the revolution in watercolour of the 1790s was so closely linked to contemporary oil practice, the connections between the two media need to be examined in more detail. The progenitor of the movement, if a single figure can be named, was John Robert Cozens (1752–97), who in the 1770s systematised a method of applying water-

colour pigment, without the admixture of bodycolour or any other substance, that for the first time comprehensively answered the requirement of landscape painting that it should represent vast expanses of land and sky. If earlier artists had failed to achieve this, it was because public sensibility had not required it: the appreciation of landscape scenery as a moving experience in its own right was only beginning at that time to make headway against the conventional perception of it as the setting for objects and actions of essentially extrinsic interest. The achievement of Richard Wilson was to reinterpret the seventeenth-century Ideal landscape of Claude Lorrain (1600–82), with its beautifully disposed and balanced elements and subtly diffused light, in terms appropriate to the eighteenth century (fig.6). In consequence, a poetic value had at last come to be placed on open space, distance and aerial perspective for their own sakes. Cozens found the visual equivalent of that value in the physical language of the watercolourist.

Fig.6 Claude Lorrain, *Landscape with Ascanius Shooting the Stag of Silvia*, 1682, oil on canvas, 120 x 150. Ashmolean Museum, Oxford

The main characteristic of John Robert's mature style largely derives from his training with his father, Alexander Cozens (*c.* 1717–86), which explains almost everything about him – his attitudes to composition, to texture and to colour are all present in some form in his father's work. It may be that his watercolour technique came to him by the same path, but that is less obvious, and there is something of mystery about the appearance of so masterly, powerful and poignant a means of expression at this moment in the history of landscape appreciation.

For John Robert was profoundly original. In his mature watercolours he propounded a view of Nature that was yet to be fully articulated in literature. The main direction of eighteenth-century writing on the natural world had been established as

early as 1730 by James Thomson in his great sequence of poems, *The Seasons*, where for the first time a detailed, almost scientific description of natural phenomena was married to a dramatic exposition of the place of humanity in the scheme of things. But the intimate personal engagement of the Romantic poets was not to be articulated clearly until the 1790s, when William Wordsworth invoked

> this majestic imagery, the clouds,
> The ocean, and the firmament of heaven

as representative of the grandeur of creation, echoing the main themes of John Robert's work. But Wordsworth went on to draw broader moral conclusions:

> All things shall live in us, and we shall live
> In all things that surround us. This I deem
> Our tendency, and thus shall every day
> Enlarge our sphere of pleasure and of pain.
> For thus the senses and the intellect
> Shall each to each supply a mutual aid...[9]

A passionate involvement in Nature as the embodiment, symbol and determinant of human experience was to form the kernel of Wordsworth's attitude to life and art alike. Many other Romantics voiced similar ideas. In 1798 Samuel Taylor Coleridge wrote to his brother: 'I love fields & woods & mountains with almost a visionary fondness'; like Wordsworth he saw this passion as central to his moral identity: 'because I have found benevolence & quietness growing within me as that fondness increased, therefore I should wish to be the means of implanting it in others – & to destroy the bad passions not by combating them, but by keeping them in inaction'.[10]

The close interconnection between the natural world and the moral well-being of the individual was a notion that had received its impetus from several sources. The Swiss philosopher Jean-Jacques Rousseau had identified the truly healthy human being as one free from the corruption of evolved modern civilisations, and set up as an ideal the 'natural' and 'innocent' state of primitive societies. In Britain, writers concerned with a range of different aspects of life and thought had defined increasingly precisely the conditions that determine aesthetic experience. In particular, they had related our perceptions of the external world to mental and emotional states: our appreciation of beauty can be traced to our reproductive urge, and hence 'beauty' is determined by those qualities that make a woman physically attractive to a man: softness, smoothness, gentleness, grace, delicacy, and so on. Our instinct for self-preservation, on the other hand, produces a *frisson* both disturbing and aesthetically exciting when we are confronted by danger. To contemplate the unknowably vast, the infinite, the empty, is to receive such a *frisson*, as is the experience of high waterfalls and cliffs, mountains, oceans and storms. These all threaten, or seem to threaten, our safety and can be classified as 'Sublime', either in themselves or in the effect they produce on our minds. Memory, likewise, gives a dimension to experience that renders particular places powerfully stimulating for their historical, literary or personal associations. In Germany, the most profound of the Romantic philosophers, Immanuel Kant, argued that in grasping such ideas as those presented by the Sublime, the human mind is capable of a transcendent effort 'which gives us courage to measure ourselves against the apparent almightiness of nature'.[11]

This sense of transcendental striving, of man in a vast and challenging universe, was fundamental to the thinking of the new age – the age that the French Revolution, beginning in 1789 and continuing into the wars of the 1790s and the conflict with Napoleon, was forcing into a new mould. The long ruminations of the Enlightenment were suddenly focused by that lens and burst into violent flame. Thomson's calm acceptance of a divine and immutable order was transmuted into a fierce sense of the value of the individual, however insignificant: landscape is the context of human life; its splendours are our splendours, our moral exemplars and encouragers. By the same token, it is the dwelling-place of humanity, and conditions our existence in all its aspects.

It so happened that the topographers had already given eloquent demonstration of at least some facets of this latter truth, although without any awareness of its Romantic implications. For them, Thomson's account of the place of man in his environment sufficed as a framework within which to describe the towns and countryside of Britain, a broad sunny realm in which everyone had his appointed place. Wordsworth restated that vision as a more thoughtful perception of 'The still, sad music of humanity',[12] – but, as Byron was to show in the succession of colourful and impassioned descriptions of Europe in his *Childe Harold's Pilgrimage* (1812–18), the survey of countries in terms of their civilizations and populations could still be a powerful vehicle of polemic and poetry alike.[13] Topography remained relevant, and its enduring strength as a basis for serious thought is one important reason why watercolour, the topographical medium *par excellence*, retained its value into the nineteenth century. As Samuel Palmer (1805–81) put it in 1856: 'Landscape is of little value, but as it hints or expresses the haunts and doings of man. However gorgeous, it can be but Paradise without an Adam'.[14]

Against this rapidly changing intellectual background, landscape began to undergo a succession of substantial investigations at the hands of a sequence of major artists. As its spiritual and emotional value was reappraised, so it was reformulated aesthetically, and in the process theories of aesthetics, too, were modified. By the 1830s, a potent new visual language had been created, ranging in its scope from the spontaneous atmospherics of David Cox (1783–1859) to the lean linearism of Edward Lear (1812–88) and the almost art-nouveau distortions of Samuel Palmer at Shoreham.

Revolutionary though these artists were, all of them belonged quite consciously to the watercolour tradition that stretched back to John Robert Cozens. It was a tradition as much cultivated and promoted as that of the 'national school' of oil painters at the Academy. If the Academy held Hogarth and Reynolds to be its founding fathers, so the watercolour societies revered, on the one hand, the topography of Paul Sandby and, on the other, the Sublime of John Robert and his great successor, Thomas Girtin (1775–1802). Girtin's early experience included copying the outlines of Cozens's sketches at the evening sessions of Dr Thomas Monro's famous 'academy' at the Doctor's home in Adelphi Terrace, by the Thames. It was Girtin's colleague J. M. W. Turner (1775–1851) who, according to Joseph Farington (1747–1821), 'washed in the effects',[15] but no doubt Girtin became well enough acquainted with Cozens's watercolour technique. His work evinces a thorough understanding of it. But temperamentally Girtin was not a fey, melancholic poet like Cozens. He was a modern, idealistic classicist, strongly sympathetic to the French Revolution and with a formalist streak that suggests that if he had ever found himself leading a revolutionary party he would have been the first to institute rigorous proceedings against faint-hearts and equivocators. There is no parallel to be drawn between a political and an aesthetic personality, of course; but Girtin's style of drawing and painting is a decidedly authoritarian neoclassicism. It

abolishes the tender, feathery touches of Cozens's style and proceeds by firm, vigorous definitions, bold generalisations and a ruthless suppression of detail. His natural sympathies were surely with the academic establishment. There is something Reynoldsian about his masterly abstraction from the particular to the general. He modelled his style quite specifically on that most Reynoldsian of landscape painters, Richard Wilson, although Wilson never used watercolour. Girtin's clear intention was to reproduce in watercolour the full, solid tonality of Wilson's paintings, and at the same time to attain something of Wilson's high seriousness in the depiction of natural scenery (fig. 7).[16]

Yet the wish to emulate oil painting in its appearance and content did not extend to compromise with the medium itself: there was no question of Girtin's enlisting bodycolour to strengthen the effect of his watercolour. The rule applied to everyone. This was partly a consequence of the chauvinistic pride of the watercolourists. To be sure, Sandby, their doyen, had used bodycolour – indeed he continued to do so until his long career ended in 1809; but he generally distinguished carefully between works in that medium and works in watercolour: the two were not to be mixed. And then, again, Sandby was not a Romantic poet, but a more earthy and practical artist, seeking effects that were not incompatible with the lighter mood of bodycolour.

Fig. 7 Richard Wilson, *The Valley of the Mawddach, with Cader Idris Beyond*, early 1770s, oil on canvas, 92 x 110. Walker Art Gallery, Liverpool

J. M. W. Turner, a Beethoven to Sandby's Haydn, was equally convinced of the rigid distinction to be made between watercolour and bodycolour, though unlike Girtin he used both throughout his life. He too imitated Wilson, and did so in both media: his finished watercolours of the late 1790s are highly Wilsonian, and so not far removed from Girtin's in mood and purpose. By that date he was also working regularly in oils,

with a similar debt to the Welsh master. At this stage, however, he confined his use of bodycolour to experimental sketches.[17]

William Blake (1757–1827), whose concerns lay in very different fields from those of Girtin and Turner, illustrates the ferment of the time in quite another way. His subjects were rarely landscape, though like Coleridge he approached all experience with an intensity that found its natural expression in terms of the 'visionary'. More literally than Coleridge, he claimed to depend on visions for the imagery of the intricate mythological dramas that he recorded in both his paintings and his poetry. Equally visionary were the means he adopted to transcribe them. His dead brother Robert revealed to him in a dream the system of stereotype printing by which Blake produced his Prophetic Books; and some of his most ambitious works, the great colour-printed drawings that he was making about the same moment as Girtin and Turner were experi-

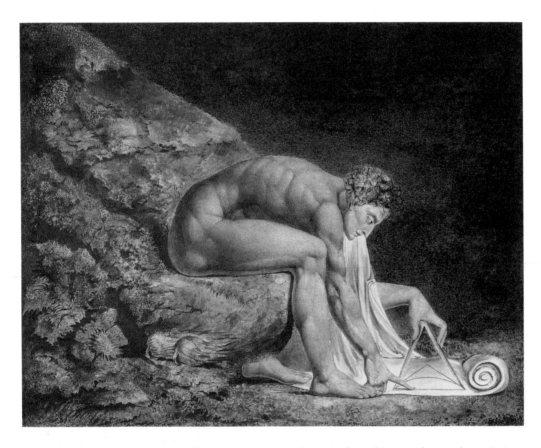

Fig. 8 William Blake, *Newton*, c. 1805 (first impression 1795), colour print finished in pen and watercolour, 46 x 60. Tate Gallery, London

menting so fruitfully, use a related technique of printing and hand colouring that creates a richness of effect and density of tone precisely parallel to the performances of the landscapists (fig. 8).[18]

Although his subject-matter was of the profoundest, and sometimes made use of fantastic and dreamlike landscapes, the bulk of Blake's later work, outside the Prophetic Books, is in pure watercolour – indeed, though entirely suited to his own needs, his methods were reactionary by 1810. Some other artists maintained the traditional techniques because their preoccupations did not require them to change. Thomas Rowlandson (1756–1827), who would never have claimed the highest intellectual status for his popular comic drawings, found the old washes, supported by energetic pen outlines, congenial to his purposes throughout his life (pl. 69).[19]

Girtin retained one thing in common with the old guard: his methods were essentially simple, in conformity with the view of watercolour as a 'pure' medium, best tackled directly and rapidly. He applied his washes boldly, sometimes over a simple underpainting of gamboge or earth colour, the intention of which was not so much to differentiate tones as to unify the whole design – a significant change of function – and used little or no scratching and scraping away of the pigment layers. What Girtin achieved he achieved by the dexterous laying on of the wash, and by the grandeur of his initial conception. The finer points of description he left to calligraphic touches of brown colour applied with a fine brush, which he used to define details. His system was an eminently reproducible one, and was widely copied, adapted and reduced to simple formulas by the writers of watercolour manuals, which became the handbooks of a

Fig. 9
Martino Rota (*fl.* 1558–86) after Titian, *The Death of St Peter Martyr*, engraving, 29.4 x 37.5. Titian's original altarpiece of 1528–30 for SS Giovanni e Paolo, Venice, was destroyed by fire in 1867

thousand amateurs. Turner, by contrast, evolved a technique unfathomable in its variety and complexity and subtle shades of expression; having been taught watercolour during the first decade of his career, he abandoned any attempt to do so, and moved further and further from the common practice, assuming more and more the role of miracle-worker, an inspiration rather than an example.[20]

Turner was not the only artist of the period to whom virtuoso powers were attributed. Indeed, sheer brilliance of execution became a characteristic of much Romantic art – the idea is summed up in the 'demonic' reputation of Paganini as a violinist. The greatness of Richard Parkes Bonington (1802–28) can be seen as resting primarily on his consummate manipulation of his materials – a pure technical control that leads on to Aestheticism. Even more notable is the magical draughtsmanship of

John Sell Cotman (1782–1842), whose abstract invention in pure line, supported by infinitely subtle arrangements of colour, sets him apart from all his contemporaries in his approach to the very nature of picture-making. Beside him, Turner's attitudes to composition were, quite deliberately, conventional. On the other hand, Turner in the end combined the virtuosities of all the virtuosos of his time in a single astonishing achievement.

If Turner was moved to imitate Wilson in his early years, he quickly found other models. As a painter in oils as well as watercolours, he was avidly concerned to bring into his stylistic net a range of masters whose work was worthy of emulation, even of straight imitation. Titian and Claude were among the earliest and most enduring of these influences, and when, after Girtin's untimely death in 1802, Turner became the prime inspiration of the Society of Painters in Water-Colours (OWCS) that was founded two years later, both Titian and Claude featured largely as stimuli to its members.[21] Claude's position as the inventor of Ideal landscape painting was well enough understood; the status accorded to Titian reveals more tellingly the role that the water-colourists had cast themselves in. He was, pre-eminently, the master who had demonstrated the symbiotic relationship of the genres of landscape and history – he had painted landscape which 'tho natural is heroick' as Turner put it, analysing Titian's *Death of St Peter Martyr* in Venice (fig. 9).[22] Turner spoke – or wrote – as an oil painter on this occasion; but his interest comprehended watercolour, and the early members of the OWCS devoted much energy to establishing the principle that a heroic landscape, that is, one containing large-scale and significant figures, might be expressed in their medium. Joshua Cristall (1768–1847) often made single figures or groups the whole subject of his pictures, and as often incorporated them in landscapes that are either arcadian or idyllic recastings of the contemporary countryside. A primary inspiration

Fig. 10 Nicolas Poussin, *Landscape with a Man Washing his Feet at a Fountain, c.* 1648, oil on canvas, 74.5 x 100. National Gallery, London

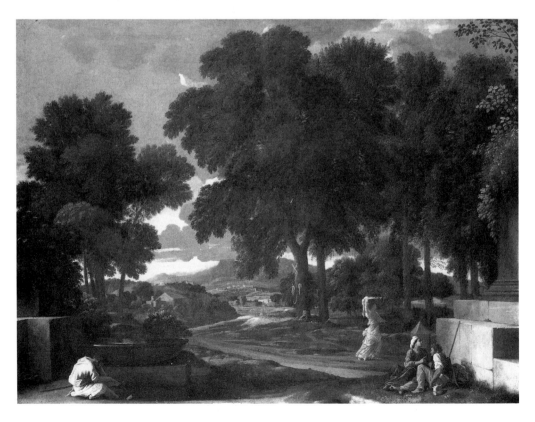

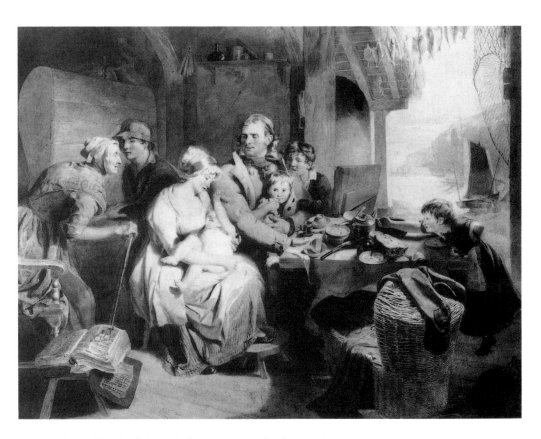

Fig. 11 Thomas Heaphy, *Fisherman's Cottage*, 1810, pencil and watercolour, 47 x 62.2.
Laing Art Gallery, Newcastle upon Tyne

was Nicolas Poussin (1593/4–1655; fig. 10), but it has been pointed out that in painting his idealising subjects Cristall was responding to an entirely modern fashion. His stalwart peasants resemble the figures in contemporary neo-Greek illustrations by artists such as Samuel Buck and Thomas Hope (pl. 289); and the arrival in London in 1808 of the Elgin Marbles, which so inspired painters like Benjamin Robert Haydon (1786–1846) and David Wilkie (1785–1841), must have had a profound influence on Cristall as well.[23] Thomas Heaphy (1775–1835), on the other hand, saw himself as continuing the Northern tradition, painting large-scale figures in cottage interiors that have nothing of the idyllic about them, but concentrate on vividly realistic still-life detail, and a dramatic, sometimes comic presentation of the psychology of his characters that depends heavily on the work in oils of Wilkie (fig. 12). Wilkie's reinterpretation of the Dutch genre tradition, from his first appearance, in 1805, at an Academy exhibition, put realistic rustic genre on a new footing (fig. 11), and began a movement that was to lead directly to the triumph of realist genre at the mid-century. So the Continental tradition of painting in oils became a crucial source for the new watercolour school, sometimes (as it was for Turner himself) through the medium of contemporary oil practice.

The development distinguished the new generation of watercolourists sharply from those of the recent past who had been content to paint landscape views but to adventure no further. Now, watercolour had to be seen to be infinitely versatile, susceptible of no limitation either technical or conceptual. To Girtin's bold washes was added Turner's arsenal of effects, assiduously gleaned or guessed at by careful analysis of his exhibited works, since he divulged few clues even to his closest associates, and had a habit, even when he did vouchsafe a hint, of letting it out in a sort of code that was deliberately intended to be difficult for any but the genuinely gifted to understand.[24]

Turner may have begun by subscribing to the generalised Sublime style perfected by Girtin, but his broad and inquisitive interest in everything natural and human rapidly forced him to diversify his methods and to invent ever more ingenious techniques. He took the manipulation of washes on wet paper to the point at which they became an incomprehensible jumble of marks, and used sponging, stopping-out, scratching-out and blotting-out with exquisite refinement and deftness. The hatching that he had adopted from John Robert Cozens, and which was a technique quite alien to Girtin's system, became a staple that enabled him to transfer the grandest ideas onto the smallest sheets of paper, a miniature technique that treated the details of Nature as if they were the details of an individual face, characterful, subtle, never to be fixed in permanence (pl. 89).

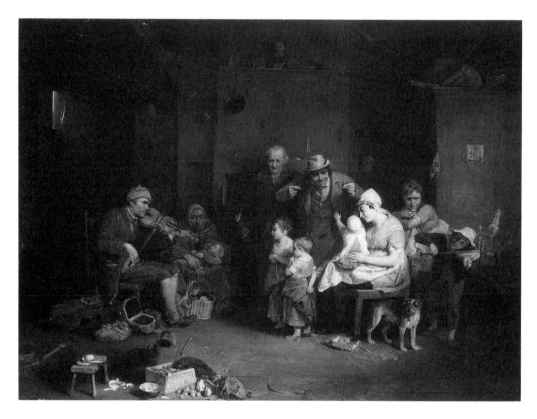

Fig. 12 David Wilkie, *The Blind Fiddler*, 1806, oil on canvas, 57.8 x 79.4. Tate Gallery, London

There was, then, a healthy opposition of approach and method between Turner and Girtin. Although so frequently thought of as 'twins' of the watercolour revolution, and although both were evangelists of the Sublime in landscape watercolour, they exemplified different principles, and exerted contrasting, and somewhat unexpected, influences. Through two of his most brilliantly inventive followers, David Cox and Peter De Wint (1784–1849), Girtin was the initiator of a development that led to a full-blown British impressionism in the 1840s and 1850s (pl. 234, 236). By contrast Turner, whose work as a watercolourist was known almost exclusively from his elaborate finished views – which contain important elements of the topographical tradition and, in particular, a strong emphasis on the role of the figure – became the progenitor (with John Ruskin as midwife) of High Victorian realist and Pre-Raphaelite landscape.

In practice, it is impossible to speak of either strand separately from the other. Much of what is thought of as a tight, hard Victorian realism is in fact often dedicated to the examination and reproduction of evanescent effects of atmosphere – of dappled

sunlight, mist, cloud or spray. One of the most technically and visually adventurous of these 'Pre-Raphaelite' artists, Alfred William Hunt (1830–96), took Turner as his supreme model and could quite easily devote a whole drawing to the study of a nebulous mist or a twilit shadow. An even younger artist, Albert Goodwin (1845–1932), often focused on the smooth surface of a stretch of weedy river or a band of morning haze along the sea-shore (pl. 320). What would for Turner have been only a part of a larger design can become for Hunt or Goodwin the self-sufficient subject of an elaborately finished work, heavy with moral overtones. Goodwin, in his self-dramatising diaries, wrote of 'a morbid liking for clouds' which are 'of the nature of *stain* on the clear heavens', with the rider, 'How impossible to see good without its shadow – evil'.[25] The Victorian landscape was a parable in which the patterns of Nature expressed the forces of human life. It could even take the form of a reflection of the artist's moral being.

Conversely, the breezy effects of light and air that foreshadow a much more apparently 'modern' approach to landscape in the work of Cox or Constable spring directly from the long-established impulse to observe and record precisely what nature presents to the eye. In the context of the ever-expanding scope of watercolour in the period, the two apparently contradictory streams, Pre-Raphaelitism and Impressionism, so clearly separate in the history of oil painting, can be seen as facets of the same development, a manifestation of the inherent ambiguity of the medium.

British watercolour, then, has stimulated a network of interacting experiments, trials and explorations that were made possible by the very nature and status of the medium. Empiricism was an integral part of the British temperament, and watercolour was the ideal vehicle for recording its progressing experience. In spite of its proud independence from oil painting, watercolour was from first to last a close sibling, appearing to follow but often leading in matters of expressive range and innovatory technique. The watercolourists' wish for an established position in the London art world was in no way at odds with their real independence of thought and originality of spirit. Their sheer virtuosity in expanding the technical capacity of the medium is alone a fact of primary significance. On this level, the innovatory brilliance of John Robert Cozens, Cotman or Cox must be seen in an international perspective if it is to be fully understood. But what gives that virtuosity its true importance is its close alliance with a wide-ranging content that draws its strength both from the intellect and from the emotions.

Much of the aesthetic evolution that worked itself out in Europe in the eighteenth and nineteenth centuries is adumbrated in the work of the watercolourists. The heightened value attached to form and colour in twentieth-century aesthetics can be traced to their innovations. Few artists in Europe were as sophisticated as Cotman in the handling of pure form, or as expressive as the young Palmer in its manipulation for emotional purposes. Constable and Cox explored the physical qualities of air and sky with unprecedented insight. Turner married the poetic grandeur he had imbibed in the eighteenth century from J. R. Cozens with the minutest observation of a range of natural phenomena never before discussed in art. The Victorians developed all these ideas in a perception of landscape that was a yet further development, a blend of poetry and pragmatism, of pure aesthetics and careful science. It arose out of, and responded to, the first period in history when technology threatened the natural world with extinction. Nature was injected with a new poignancy, and emerged as a fresh and urgent metaphor for the lot of humanity.

The institutionalisation of watercolour in nineteenth-century London was a measure of its status and of its estimated contribution to the national culture. If its blos-

som was splendid, its roots ran deep. Most of the members of the watercolour societies were teachers, and for every artist who exhibited professionally with the societies, there were dozens who pursued humble careers as drawing-masters to the gentry. The amateurs that this great force instructed, either directly or through the medium of published manuals, were legion. They were by no means confined to young ladies and maiden aunts; the activity was a highly respectable one for everybody, and was growing in popularity for much of the early nineteenth century, as the complaint of Thomas Uwins (1782–1857) from Rome in 1830 makes clear: 'What a shoal of amateur artists we have got here! I am old enough to remember when Mr Swinburne and Sir George Beaumont were the only gentlemen who condescended to take a brush in hand, but now gentlemen painters rise up at every step and go nigh to push us from our stools.'[26]

The amateur provides, as Vaughan Williams has said in another context, the loam from which great art can grow,[27] and this was never more true than in the case of watercolour. The machinery by which talent emerged from this social and economic structure can be seen in the operation of the regional schools of watercolour. In Exeter, for instance, a group of artists received their training and their inspiration from the teaching of Francis Towne (1740–1816), whose style they all imitated. One of them, John White Abbott (1763–1851), became a considerable figure on his own account while never shaking off the characteristic mannerisms of Towne (pl. 133). In Norwich, first John Crome (1768–1821) and then Cotman, with contrasting approaches and methods, disseminated a technical and aesthetic sense that has had an enduring influence on the way we perceive the landscape of East Anglia. Two great ports, Bristol and Newcastle upon Tyne (pl. 71, 282), stimulated significant local schools, and from both centres emerged major as well as highly talented secondary figures. These observations can be made despite the fact that, inevitably, London, with its academies and its wider market attracted many of the more accomplished artists.

If watercolour in Britain has been immeasurably enriched by the armies of amateurs who have practised it, it has been bedevilled as an art-historical subject by so amorphous and intractable a context. The traditional practice of oil painters throughout Europe, working professionally on technically complex projects with studio assistants who were themselves professionals either actually or potentially, has had the effect of limiting the field of research to a relatively compact and definable, albeit often large, body of practitioners. Watercolour, taught throughout Britain by itinerant or local masters as the accomplishment of almost every member of the upper social classes above the age of fifteen, comprehends a vast mass of work that ranges from the abysmal to the inspired. The penumbra of each professional may consist of drawings by others virtually indistinguishable from his own, of drawings executed partly by him and partly by a pupil, and of independent work more or less recognisable as having been derived from his. The pressure on artists even of high calibre to produce run-of-the-mill examples, for copying purposes, or to augment an exiguous wage, was often great. The very nature of watercolour practice encouraged repetition. Turner, as is well known, operated a kind of production line, having many sheets going simultaneously, washed with preliminary colour grounds and hung up on lines to dry or part-dry, like laundry.[28] The steady application of layers of colour to a sheet of paper brought to the requisite degree of moistness or dryness meant that the process required delays, and it was more efficient to work on a group of sheets together than to finish each one individually. The effects of this method are quite evident in Turner's output, although he was able to maintain an astonishing degree of freshness and originality from one composition to

the next. Other, lesser artists inevitably concealed the artifice with less skill, and even the best of them can be accused of over-production. The proliferation of minor examples, the application *ad nauseam* of compositional formulas, which were disseminated by means of potboiling manuals and eagerly adopted by the amateurs – all these factors have made it difficult for any but *aficionados* and specialist connoisseurs to find their way through the vast mass of material, to identify the significant threads and follow them through to some meaningful art-historical judgement. All this has only confirmed the view, assiduously propagated by the British themselves, that watercolour is of local and national interest only, hardly deserving of consideration in the wider international context. It may be added that the intrinsic charm of most watercolour, its cheerful palette and congenial subject-matter, while recommending it to collectors, has obscured the importance of its intellectual content and its aesthetic significance in the history of European art.

Perhaps the greatest obstacle to the understanding of watercolour is the problem of condition. Any painting is subject to change, to chemical alteration, to damage and to inappropriate cleaning or restoration. Watercolour is vulnerable to all these things, but most of all to the effects of light on its pigments, which far more than oil paints are liable to complete chemical modification under the influence of ultra-violet rays. The indigo blue that is so vital a component of many landscapes has been particularly fugitive, and its loss has reduced most greens, as well as blues, to a dull brown or pink. Where other pigments have survived unchanged, their relationship to the tonal and chromatic scheme of the work as a whole has been hopelessly distorted. Crisply defined forms have become vague; subtleties of lighting are annihilated, sunshine and shadow alike turned to a feverish, or pallid, twilight. The great developments in watercolour manufacture that accompanied the expansion of the art in the early nineteenth century only contributed to the problem, for many of the new, experimental pigments were even more unstable than the traditional ones.

The difficulty was unimportant as long as watercolour drawings were kept in portfolios or albums, as many were in the eighteenth century; but it was in the very nature of the reformed watercolour painting of the early nineteenth century that it should be given more prominence: that was, after all, what the watercolourists themselves wanted. Watercolour paintings were to be framed and hung in a good light. Many collectors at that time were perfectly well aware of the dangers. Smaller works were often equipped with fine gilt frames fitted with green silk blinds, which were religiously drawn down when the watercolour was not being examined. But the larger pictures rarely had this benefit and few artists seem to have taken precautions to ensure that their owners were properly advised. Throughout the second half of the nineteenth century John Ruskin, among others, was warning watercolour owners of the risks of exposure to light, and as late as the 1880s was having to argue his case against a determined opposition – there have always been those who refuse to believe, or to care, that watercolours can be destroyed by this form of neglect.[29] Yet it is almost impossible now to see the more important finished work of some leading figures of the school: for instance, the larger watercolours of John Glover (1767–1849), a prolific early member of the OWCS (pl. 211), hardly survive to be studied.

In Europe, British watercolour, like British painting in general, is known only by isolated examples, and those not necessarily of high quality or in good condition. In keeping with its popular character as an essentially intimate medium, watercolour still thrives in private collections, and that is a highly desirable state of affairs, though the

proviso must be added that private collections are the least susceptible of the kinds of control needed to ensure the conservation of works in the best condition. The more important the work, the more vulnerable it is: it is required for display and decoration, and needs a 'good light'; it is attractive to dealers and collectors alike. Watercolour, unlike oil painting, cannot be 'retouched' successfully. Like fading, overcleaning is permanent and disastrous.

These problems should not discourage collectors: it is possible to distinguish the fresh from the faded, and, with some practice, the pristine from the overcleaned. Watercolours can be kept in low light and still enjoyed. The old-fashioned system of blinds or easily removable covers is an excellent one; indeed it is ideal, for it combines the possibility of unlimited light on the work while it is being viewed, and total darkness at other times. But a due awareness of the dangers may help those who appreciate the watercolour as an art form to understand that, like all forms of art, it requires knowledgeable handling. It is as delicate, in its way, as porcelain; but its content is as robust as the greatest of Western painting. In this, as in so much else, it is characteristically ambiguous.

A. W.

1 W. H. Pyne [Ephraim Hardcastle], ed., *Somerset House Gazette, and Literary Museum*, 2 vols, London 1824, II, p.45.
2 A valuable study of the impact of the Grand Tour on British landscape artists in the later eighteenth century is *Travels in Italy, 1776–1783: Based on the 'Memoirs' of Thomas Jones*, exh. cat. by F. W. Hawcroft; Manchester, Whitworth Art Gallery, 1988. The evolution of artists' vision of the Alps is surveyed in D. Helsted, ed., *Maegtige Schweiz: Inspirationer fra Schweiz, 1750–1850*, Copenhagen 1973.
3 See *The Arrogant Connoisseur: Richard Payne Knight, 1751–1824*, exh. cat. by M. Clarke & N. Penny; Manchester, Whitworth Art Gallery, 1982, pp.20–31.
4 A recent study of Ducros is *Images of the Grand Tour: Louis Ducros, 1748–1810*, exh. cat. by P. Chessex *et al.*; London, The Iveagh Bequest, Kenwood; Manchester, Whitworth Art Gallery; Lausanne, Musée Cantonal des Beaux-Arts; 1985–6. See also D. Cutajar, ed., *Louis Ducros in Malta*, Valletta 1989.
5 A general survey of the fine arts in eighteenth-century Britain is W. T. Whitley, *Artists and their Friends in England, 1700–1799*, 2 vols, London 1928. The foundation of the Royal Academy is discussed in detail in S. C. Hutchison, *The History of the Royal Academy, 1768–1968*, London 1968, especially ch. IV.
6 See *Painters and Engraving: The Reproductive Print from Hogarth to Wilkie*, exh. cat. by D. Alexander & R. T. Godfrey; New Haven, Yale Center for British Art, 1980, especially pp.24–5.
7 See A. Griffiths, 'Prints after Reynolds and Gainsborough', *Gainsborough and Reynolds in the British Museum*, exh. cat. by T. Clifford, A. Griffiths & M. Royalton-Kisch; London, British Museum, 1978; and *Painters and Engraving*, pp.35–6.
8 James Stuart, *The Antiquities of Athens*, I, London 1762, p.viii.
9 From lines written in 1798 as a possible conclusion to *The Ruined Cottage*; quoted in S. Gill, *William Wordsworth: A Life*, Oxford 1989, p.496.
10 *The Collected Letters of Samuel Taylor Coleridge*, ed. E. L. Griggs, Oxford 1956–71, I, pp.397–8.
11 Immanuel Kant, *Kritik der Urteilskraft*, Berlin 1790, trans. J. H. Bernard as the *Critique of Judgement*, 1931, p.125.

12 'Lines Composed a Few Miles above Tintern Abbey' (*Lyrical Ballads*, 1798), *The Poems*, ed. J. O. Haydon, Harmondsworth 1977, I, p.360, l.91.
13 An assessment of the significance of Byron's *Childe Harold* for landscape painters, and especially Turner, has been made in *Turner and Byron*, exh. cat. by D. B. Brown; London, Tate Gallery, 1992.
14 *The Letters of Samuel Palmer*, ed. R. Lister, Oxford 1974, I, p.516.
15 J. Farington, *The Diary*, ed. K. Garlick, A. Macintyre & K. Cave, London 1978–84, III, p.1090. The relevant part of the entry for 12 November 1798 reads: 'Turner & Girtin told us they had been employed by Dr Monro 3 years to draw at his house in the evenings. Girtin drew in outlines and Turner washed in the effects. They were chiefly employed in copying the outlines or unfinished drawings of Cozens &c &c of which copies they made finished drawings. Dr Monro allowed Turner 3s. 6d. each night. – Girtin did not say what he had.' The complicated literature is summarised in A. Wilton, 'The "Monro School" Question: Some Answers', *Turner Studies*, IV/2, 1984, pp.8–23.
16 The most thorough attempt to define Girtin's achievement, stressing his 'high seriousness', is T. Girtin & D. Loshak, *The Art of Thomas Girtin*, London 1954.
17 Examples of Turner's early use of bodycolour are to be found in his *Wilson* sketchbook of *c.* 1797, TB XXXVI. See *J. M. W. Turner: The 'Wilson' Sketchbook*, with an Introduction by A. Wilton, 1988. A later insight into Turner's attitude to the 'permanent white' pigment that became an increasingly prominent feature of nineteenth-century watercolour is given in J. C. Horsley, *Recollections of a Royal Academician*, 1903, p.241, where the landscape painter is recorded as saying to J. D. Harding and David Roberts: 'If you fellows continue to use that beastly stuff you will destroy the art of water-colour painting in our country.'
18 Blake's intentions were characteristically complex. They cannot easily be explained by generalisations that apply to his contemporaries. The background to his technical experiments in the 1790s is discussed in D. Bindman, *Blake as an Artist*, Oxford 1977, pp.28–48.
19 A recent survey is J. Hayes, *Rowlandson: Watercolours and Drawings*, Oxford 1972.

20 The watercolour techniques adopted by Turner in different contexts were discussed and described by Ruskin on various occasions, primarily as guidance for other artists. His intention in making such careful descriptions was no doubt at least partly to dispel, but partly to enhance, the 'miraculous' aspect of Turner's art.

21 The foundation of the OWCS is recounted at length in J.L. Roget, *A History of the 'Old Water-Colour Society', now the Royal Society of Painters in Water-Colours*, London 1891, I, p. 125 ff. A more recent account is M. Spender, *The Glory of Watercolour*, London 1987.

22 In the *Studies in the Louvre* sketchbook, TB LXXII, p. 28a. See A.J. Finberg, *A Complete Inventory of the Drawings of the Turner Bequest*, London 1909, I, p. 184.

23 See *Joshua Cristall (1768–1847)*, exh. cat. by B. Taylor; London, Victoria & Albert Museum, 1975, pp. 26–7. The *Magazine of the Fine Arts* for 1821 said of Cristall's *Jupiter Nursed in the Isle of Crete by the Nymphs and Corybantes*: 'It is impossible not to compare it with some of the works of Poussin; but there is in the production of these two artists a difference in favour of Cristall … [;] Poussin … in too many instances painted *Sculpture*. Cristall learnt to see nature in the same point of view in which the ancients contemplated her …' (*Joshua Cristall*, p. 34).

24 'In teaching generally, he [Turner] would neither waste his time, nor spare it; he would look over a student's drawing, at the Academy, – point to a defective part, make a scratch on the paper at the side, saying nothing; if the student saw what was wanted, and did it, Turner was delighted, and would go on with him giving hint after hint; but if the student could not follow, Turner left him … Explanations are wasted time. A man who can see, understands a touch; a man who cannot, misunderstands an oration.' (John Ruskin, *The Works*, ed. E.T. Cook & A. Wedderburn, London 1903–12, VII, p. 441).

25 Albert Goodwin, *Diary* (12 October 1909), privately printed 1934.

26 *A Memoir of T. Uwins, R.A., by Mrs Uwins*, London 1858, II, p. 251.

27 Ralph Vaughan Williams, *Some Thoughts on Beethoven's Choral Symphony, with writings on other musical subjects*, Oxford 1953, p. 170.

28 *The Athenaeum*, 1894, p. 327.

29 A curious and detailed discussion of the problem (concluding that light does not usually damage watercolours) is to be found in B. Webber, *James Orrock: Painter, Connoisseur, Collector*, 1903, II, ch. XVIII–XX.

CATALOGUE

I

The Structure of Landscape:
Eighteenth-century Theory

The work of Sir Isaac Newton in natural science, and of John Locke in metaphysical philosophy, at the end of the seventeenth century led to a boom in theoretical speculation that lasted throughout the eighteenth century, affecting every aspect of life and experience. The subject of aesthetics was submitted to as much rigorous analysis and debate as any other, and numerous books were published in the attempt to define the nature of our responses to visual phenomena. Some linked those responses with moral judgements, like Francis Hutcheson in his *Enquiry into the Original of our Ideas of Beauty and Virtue* (1725), others with human physiology, as Edmund Burke did in his *Philosophical Enquiry into the Origin of our Ideas of the Sublime and Beautiful* (1757). Later in the century, the subject was brought into still sharper focus, its grander philosophical connotations taken for granted and other more purely aesthetic ideas marshalled into elaborate new structures of thought. Archibald Alison, for instance, in his *Essays on the Nature and Principles of Taste* (1790), laid emphasis on the power of images to move us by means of their associations with people and events of other ages and places. The Revd William Gilpin (1724–1804) evolved a regular code of practice for examining landscape scenery for 'that particular quality which makes objects chiefly pleasing in painting'.[1] This code he called the Picturesque, which became also a guide to the correct portrayal of Nature in pictures.

Fig. 13 William Gilpin, plate from *Observations on the River Wye*, 1782, aquatint, 10.2. x 17.2. British Museum, London

Gilpin, in his *Observations on the River Wye* (1782) and several subsequent publications, illustrated his theory with examples of his own compositional skill in the form of aquatints after designs in black or brown wash (fig. 13). He was in accord with the habits of his time in using wash drawings as demonstrations of aesthetic principles, or practical 'philosophical experiments', as it were. A dominant strain of contemporary philosophy was the cool and sceptical empiricism of men like David Hume (1711–76), who demanded direct logical and practical proof of any proposition; there was, then, a strong presumption in the very air of the period that received ideas were to be questioned, their validity established only by argument and demonstration. For artists as much as for philosophers the

inherited past was to be reassessed and reformulated, old models were to be subjected to analytical scrutiny and, if necessary, 'deconstructed' and reassembled in forms appropriate to modern use.

An archetypal figure of the mid-century is Alexander Cozens, a drawing-master at Eton College and Christ's Hospital with an extensive clientele among the sons and daughters of the nobility and gentry, for whom theorising and codifying were as natural as breathing. His philosophical schemes were as wide-ranging as any of the period. About 1772 he was planning a 'Great work, *Morality*', which was to encompass the illustration of 'the Vertues and Vices of Human Nature thru Epic poetry and historical painting';[2] and in 1778 he published *Principles of Beauty, Relative to the Human Head*, analysing proportion and expression in a rigorously categorised series of profiles. His theories were addressed to the broadest issues of life and art; he did not confine himself exclusively to landscape, though it was in that field he made his most important contribution. *The Shape, Skeleton and Foliage of Thirty-two Species of Trees* appeared in 1771, and a printed list of about the same date, *The Various Species of Landscape, &c. In Nature*, shows him thinking in a similarly orderly way about subjects for landscape compositions, their 'objects' and atmospheric effects or 'circumstances'. Many of Cozens's categories anticipate those of Gilpin. 'A single object, or cluster of objects, at a distance' or 'A track, road, path, river, or extended valley proceeding forward from the eye' might easily be ideas for a Picturesque view according to Gilpin; though Cozens goes further in breaking down his landscapes into their possible components: 'Wild. Barren. Rural, or rustic. Pastoral. Cultivated. Garden. Europe. Asia. Africa. America' and 'Dawn, or break of day. Before sun-rise. Rising-sun. Forenoon. Noon. Afternoon . . . Night. Spring. Summer. Autumn. Winter' etc.[3] Although a broadly philosophical intention remains, the didactic element is strong in these exercises. Already in 1759 he had written an *Essay to Facilitate the Inventing of Landskip Composition*, which foreshadows his famous *New Method of Assisting the Invention in Drawing Original Compositions of Landscape* (1785/6), which propounds the 'blot' system that has been so long and so widely misunderstood.[4]

Cozen's blots are not random in the modern way, linked to reality only as manifestations of the unconscious; they are simply the freest possible expressions of the artist's creative individuality. In advocating the liberation of the imagination Cozens invoked Leonardo da Vinci's famous observations on the suggestive properties of 'an old wall covered with dirt'; but Cozens proposed that his own scheme went further. 'An artificial blot', he claimed, 'is a production of chance, with a small degree of design';[5] too much attention to particular objects militated against the spirit of the true Blot. A random mark on a piece of crumpled paper, a few brushstrokes vaguely intended to evoke the contrast of land and sky: these are the ingredients of a Blot. Their effect will always depend on the inventive power of the artist.

By eliminating all considerations except the most basic compositional elements the Blot lays immense stress on the disposition of masses on the sheet, and on contrasts of light and dark tone (fig. 14). The primary expressive vehicle is the actual layout of the

landscape as a design. This is an emphasis that derives from the idealising landscapes produced by Claude Lorrain and Nicolas Poussin in seventeenth-century Rome. These two artists, and some of their contemporaries, had sought to present Nature in painting in such a way that a perfect harmony of elements was established within the rectangle of the picture-frame. The component parts, intended for the most part to suggest a Platonic version of the actual Roman Campagna, were of limited variety; temples (ruined or reconstructed), lakes, bridges, trees and sky were endlessly re-arranged to create dreamlike settings for biblical or mythical stories. The perfection of these artists' works held the eighteenth century in thrall; they were frequently imitated. But the temper of the age would not permit the mere copying of past methods. The work of Claude and Poussin contained the implication of a more far-reaching approach to the depiction of Nature, one that was fully in harmony with the scientific bent of the time. Cozens gave formal reality to that implication. In yet another series of examples he went so far as to categorise the possible permutations of land and sky, from a sheet almost entirely covered by foreground and trees or hills to one almost wholly occupied by sky, with every variant between. Similarly, a sky could be full of cloud, or almost empty of cloud, or somewhere in between. More important, Cozens equated types of landscape with different states of mind. Another of his lists details the possible permutations from tranquillity through 'attention, caution, awe, expectation, admiration from contemplating a great expanse of Sky', to 'fear, terror' and many other emotions.[6]

The philosophical need to redefine landscape in the eighteenth century did, then, penetrate to a fundamental level. The seventeenth-century Ideal landscape, whether that evolved in Bologna at the hands of Annibale Carracci (1560–1609) and Domenichino (1581–1641), or its Roman sequel developed by Claude and Poussin, or indeed the Italian-inspired Dutch landscapes of Jan Both (c. 1618–52) and Nicolaes Berghem (1620–83) and their school – all these inherited models were to be reconsidered in the light of an empirical, experimental practice. Alexander's influence on his own son was profound, and it was largely owing to his father's wide-ranging and open-minded experimentation that John Robert was able, in the 1770s and 1780s, to produce an entirely original topographical art in which broad compositional elements play a crucial part in establishing mood and atmosphere. The relationship between foreground, middle-ground and distance that had been an established principle, almost a cliché, for Claude and his imitators now became the vehicle for dramatic invention. Alexander's graded experiments showed John Robert the way to a vastly more liberated creativity, in which the structural patterns of landscape composition could take on fantastic forms while retaining the stamp of controlled design. The selfconsciousness of a highly intellectual art was integrated into the classic landscape tradition, a development that transformed the practice of landscape painting for subsequent generations in Britain.

Equally important in John Robert's work is a sophisticated and very subtle understanding of colour. Throughout his mature career he favoured a palette of muted greens and blues, with some

Fig. 14 Alexander Cozens, *Mountain Peaks ('Blot')*, from *A New Method of Assisting the Invention in Drawing Original Compositions of Landscape*, 1785–6, etching and aquatint, 23.8 x 32.5. British Museum, London

grey and black, which suffices to describe, and vividly evoke, great distances and broad sweeps of luminous sky. The explanation of this extraordinary expressive strength lies in his complete grasp of tonal relationships, and once again it is to Alexander's work that we must go for a model. Alexander practised almost exclusively in monochrome because his concerns were with the theory of landscape composition. Colour was a local matter, to be applied to describe particular objects to which particular colours belonged. A generalised or Ideal mountain, tree, rock or lake did not require to be allocated specific colour: its primary function was as form in the total design – form conveyed partly as a defined shape, certainly, but still more as a tonal value in relation to other tonal values. If John Robert employed colour, it was in this context of severe formal discipline.

His restricted palette was also, no doubt, a response to the larger question, equally momentous to Alexander, of sublimity in painting. The generalisation that Alexander thought appropriate to landscape was a characteristic of all serious art, which, as Sir Joshua Reynolds said, must seek to be universal rather than particular, and therefore must prefer the grand to the commonplace, the historical to the contemporary.[7] By these criteria, too, sombre and restricted colours were more appropriate than bright and too localised effects.

The topographical artists who, by the very nature of their work, needed to produce identifiable and specific views, inevitably made use of brighter colour. But the technical procedure of water-colour painting at the time involved a lay-in stage of pure monochrome, in which the tonal design of the view was laid out in grey washes, so that even the most unambitious local viewmaker would automatically go through the process of inventing his subject as a monochrome composition. This had important consequences in the work of an artist like Francis Towne, who took to making large numbers of studies in black or grey wash, without working them up subsequently in local colour (pl. 17, 19). As a result, even though he

approached landscape very differently from Cozens, Towne produced many views that exhibit the characteristic abstract preoccupations of the eighteenth century. They are given added interest in his case because he was temperamentally attuned to the contemporary instinct for simplification, and was adept at the reduction of images to generalised, elegantly balanced masses. His finished work marries a rigorous sense of abstract design, which, while not like that of Alexander Cozens, follows its own stringent rationale, with the luminous colour of the topographers: a uniquely attractive combination that has understandably appealed to the taste of our own century for flat, colourful pattern-making.

The habit of working out compositions in monochrome also has a parallel in the twentieth century. The work of the analytical Cubists – Picasso and Braque – is cast in a palette of sepia and grey for very similar reasons: it is concerned with formal questions rather than with specific description. It seems almost inevitable that colour will take a subordinate role in such circumstances. Cozens and Gilpin were not the only eighteenth-century landscape artists to work in monochrome. A much greater exponent of the Picturesque than Gilpin, Thomas Gainsborough (1727–88), used monochrome almost exclusively for his innumerable landscape compositions in chalks or ink and wash (pl. 11, 12); these include subjects derived from the Ideal landscapes of Poussin and Gaspard Dughet (1615–75), but they are more frequently derived from characteristic British scenery, making use of large trees, ponds and country lanes which, as is well known, Gainsborough simulated with broccoli and glass in a miniature theatre at home.[8] This was a means of arriving at abstract generalisation quite different from, but precisely parallel to, Alexander Cozens's system of blots. The important distinction is not between classical and British scenery, but between the imaginary and the real. The exercise of the imagination has the preference over 'mere' view-painting, or 'mapwork' as J. H. Fuseli (1741–1825) called it[9] – the exercise simply of technical control in the rendering of what is there.

The supremacy of the artist's imagination is one of the crucial concepts of the eighteenth century. It is the informing idea behind Reynolds's Royal Academy *Discourses*, and was to lead by logical steps to the integration of topography and 'serious' landscape by the end of the century. In this process a vital role was reserved for the work of an established landscape painter of the highest seriousness, that is to say a painter in oils. That painter was Richard Wilson, who was held to have reformulated the Ideal landscape of Claude in terms appropriate to the age and, if anything, even more serious in their intent.[10] Wilson's landscapes were sometimes topographical, but they often transcend any local reference in the interest of the Sublime or the classically grand. His historical landscapes could claim to operate on a still higher intellectual plane. Wilson made landscape drawings in monochrome – often black chalk and stump – and although these are not usually seen as belonging to the convention of the characteristic eighteenth-century 'scientific' landscape study it is reasonable to place them in that category. But Wilson did not have the pedagogic mind of an Alexander Cozens or a Gilpin. He evolved his Ideal landscape more pragmatically: by

means of a broad technique and bold conceptions he achieved a generalisation that eliminated all possible appeal to the obvious or immediate. By comparison with him, it was felt, Claude had loaded his pictures with too much detail.[11]

With such an example, the landscape artists of the later eighteenth century were under an obligation to press on towards the highest goals. If Wilson had shown what might be done in oils, the Cozenses, father and son, had already forged out of watercolour an expressive and flexible medium in which much could be said. John Robert's watercolours of scenes in Italy and the Alps – 'all poetry', as Constable described them[12] – were created with techniques that gave new conviction to the description of distances and vast spaces. The broken brushstroke, used as a kind of building-block for the construction of dense and solid masses, gradually dissolving into air and light as the eye travels back in space until the horizon and sky are washed in with broad delicate films of colour, was to become a necessary item of the Romantic watercolourist's stock-in-trade. Already, according to the formulations of the Picturesque, local variety and roughness of texture were essential to the effect of a landscape design,[13] and topographers like Michael 'Angelo' Rooker (1746–1801) and Thomas Hearne were employing short, interlocking strokes of the brush to create these effects (fig. 15). The thin, broad washes of colour so characteristic of eighteenth-century 'tinted drawing' were therefore being fragmented by a theory, and John Robert's inspired practice further demonstrated how the old techniques could be broken down in favour of the new sensibility.

The huge range of landscape types made available by the experimentation of the Cozenses had its inevitable effect on the vision of the topographers. They were able to respond to the burgeoning interest in Romantic scenery – mountains, waterfalls and lakes – with aesthetic and technical vocabularies immensely enlarged. There remained the difficulty of endowing watercolour with the full dignity of the oil medium that Wilson practised. This was accomplished within ten years at the very end of the century by a new generation of artists whose ambitions encompassed nothing

Fig. 15 Thomas Hearne, *The Gorge of the River Teme, Downton, Shropshire*, 1785, pencil and watercolour, 33.4 x 49.9. British Museum, London

less than the complete adaptation of watercolour to all the purposes hitherto reserved for oil. Those who wished, like Blake or Richard Westall (1765–1836), to paint historical subjects in watercolour continued to experiment with techniques that would increase the visual weight of their images: Westall employed washes of brown ink overlaid with gum arabic, while Blake developed his system of monotype printing. The landscape painters were able more straightforwardly to build on the technical and conceptual foundations that had been bequeathed to them.

There was still a strong prejudice in favour of monochrome. By the 1790s even Hearne and Rooker were frequently working in a restricted range of colour, dominated somewhat like John Robert's palette by blues and greys. Edward Dayes (1763–1804) likewise frequently produced views in which local colour was virtually eliminated in favour of an overall chromatic unity. The preponderant tonality of these views is, however, high. The profounder expressive aims of the Cozenses had always involved a more sombre key, more closely allied to the 'historical colour' favoured by academic painters, or to the 'sad and fuscous' colour identified by Burke as appropriate to Sublime ideas. The next step, then, for landscape painting in watercolour was to bring together the tone of Wilson and the mood of John Robert in order to produce subtle evocations of Romantic Nature with all the breadth of the most serious oil painting.

Thomas Girtin began his career as a pupil of Dayes, and moved purposefully towards this goal. During the 1790s his palette became steadily richer and darker, and his touch broader. In order to reproduce the quality and texture of Wilson's rough canvases he adopted a rough paper, and set himself to imitate in watercolour the depth of tone and breadth of handling that Wilson exemplified. This involved eliminating the preliminary monochrome 'lay-in' of the traditional eighteenth-century drawing, and instead building up the whole work in a series of warm layers of colour, as if the medium were oil. The expressive fragmentation of washes practised by John Robert was now reintegrated into denser washes manipulated with freedom and virtuoso precision. At the same time, structure was subjected to a similar control; Girtin was evidently impressed by Wilson's reputation for generalisation, and sought to impose a like discipline on his compositions. In the interests of this still wholly eighteenth-century pursuit, he sometimes constructed a complete subject in monochrome, deploying the elements with all the intellectual precision of Alexander Cozens, though with something of the aesthetic elegance of Towne.

Girtin's contemporary J.M.W. Turner moved along similar paths in the 1790s, though Turner never had the same rather puritanical attitude to design. His work is always more crowded with detail, and it is in the preliminary studies that he began to make in the late 1790s that his talents as a generaliser are most apparent (pl. 35). Even John Constable (1776–1837), a very different spirit, drew important lessons from both Alexander Cozens and Gilpin. His work as a young man, drawing dilapidated cottages with the topographer John Thomas Smith (1766–1833), brought him into direct contact with Picturesque theory, while some of the studies he made on his tour of the Lake District in 1806 are essays in a mono-

Fig. 16 John Sell Cotman, *A Cottage in Guildford Churchyard, Surrey*, 1800, pencil and watercolour, 35.6 x 53.2. Castle Museum, Nottingham

chrome Sublime that owes much to Girtin (pl. 47). But Girtin's true successor in these matters was John Sell Cotman, whose career began with an output almost exclusively couched in terms of a sombre monochrome, the Sublimity of which is sometimes out of keeping with the frankly Picturesque subject-matter of deformed cottages and moss-encrusted trees that he at first favoured (fig. 16). But he quickly progressed to more inspiring subjects, and it becomes clear from these that Cotman's interest in oddly shaped houses was by no means casual. His idiosyncratic sense of linear counterpoint was to become the staple of his vision, a development, as it were, of the decorative shapes beloved of Towne, and transformed into a more earnest and passionate medium by Cotman's brooding personality. It is in Cotman's great early watercolours (pl. 42, 46) that the compositional experiments of Alexander Cozens find their ultimate goal, a goal achieved by steady evolution through the stages of an inexorable eighteenth-century logic.

A.W.

1 William Gilpin, *Three Essays: On Picturesque Beauty; On Picturesque Travel; and On Sketching Landscape*, 2nd edn, 1794, p.6.
2 For a recent discussion see *Alexander and John Robert Cozens: The Poetry of Landscape*, exh. cat. by K. Sloan; London, Victoria & Albert Museum; Toronto, Art Gallery of Ontario; 1986, p.60 ff.
3 This list is reproduced in *Alexander and John Robert Cozens: The Poetry of Landscape*, p.54.
4 See *Alexander and John Robert Cozens: The Poetry of Landscape*, and J.-C. Lebensztejn, *L'Art de la tache: Introduction à la 'Nouvelle méthode' d'Alexander Cozens*, Paris 1990.
5 Alexander Cozens, *A New Method of Assisting the Invention in Drawing original Compositions of Landscape*, 1786, p.6.
6 *Alexander and John Robert Cozens: The Poetry of Landscape*, pp.55–6.
7 '... the whole beauty and grandeur of the art [of painting] consists, in my opinion, in being able to get above all singular forms, local customs, particularities, and details of every kind.' Sir Joshua Reynolds, *Discourses on Art*, ed. R.R. Wark, London 1975, p.44.

8 'I ... have ... seen him make models – or rather thoughts – for landscape scenery on a little old-fashioned folding oak table, which stood under his kitchen dresser ... This table, held sacred for the purpose, he would order to be brought to his parlour, and thereon compose his designs. He would place cork or coal for his foregrounds; make middle grounds of sand or clay, bushes of mosses or lichens, and set up distant woods of broccoli.' *Somerset House Gazette*, I, p.348.
9 J. Knowles, *The Life and Writings of Henry Fuseli*, London 1831, II p.217.
10 An example of this type of comment is in *The Works of the Late Edward Dayes*, London 1805, pp.357–8.
11 T. Wright, *Some Account of the Life of Richard Wilson, Esq., R.A.*, London 1824, p.62.
12 C.R. Leslie, *Memoirs of the Life of John Constable, Composed chiefly of his Letters*, 1843, ed. J. Mayne, London 1951, p.82. Constable also called J.R. Cozens 'the greatest genius that ever touched landscape' (*Memoirs*, p.241).
13 See Gilpin, loc. cit.

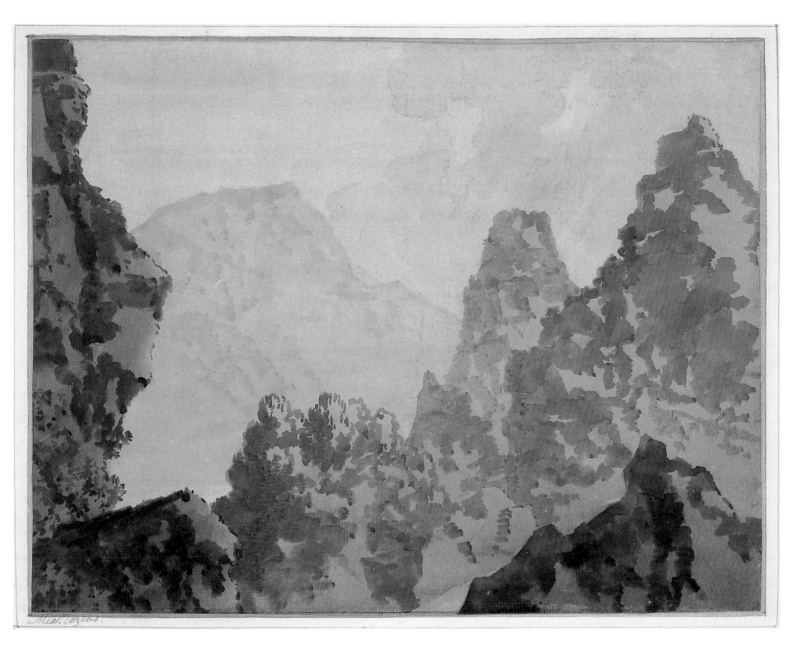

1 Alexander Cozens, *Mountain Peaks*, c. 1785 (cat. 82)

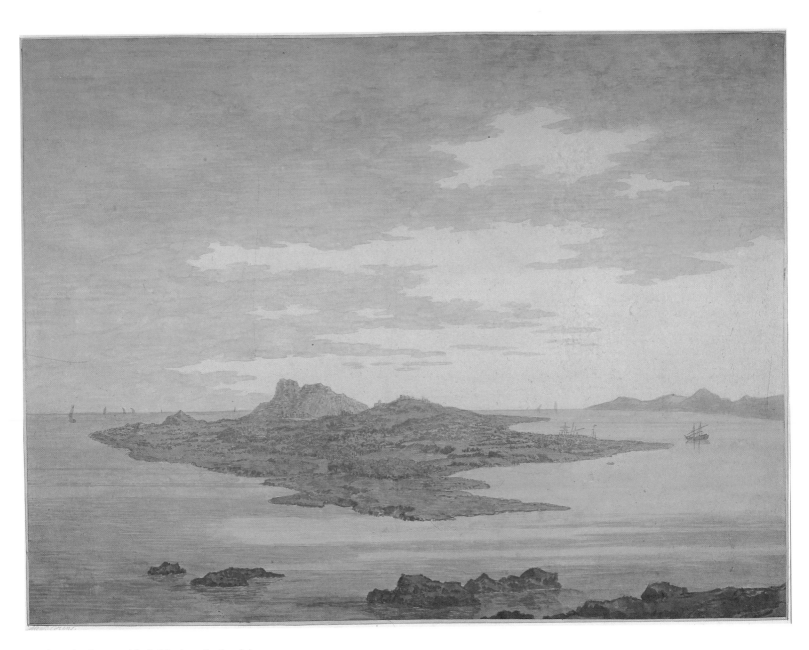

2 Alexander Cozens, *A Rocky Island*, *c.* 1785 (cat. 83)

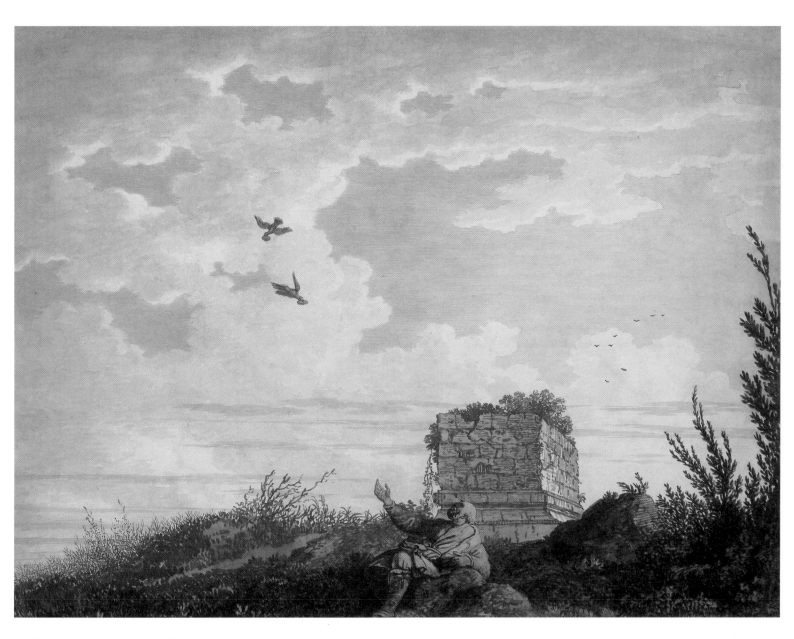

3 Alexander Cozens, *The Prophet Elijah Fed by Ravens, c.* 1765 (cat. 80)

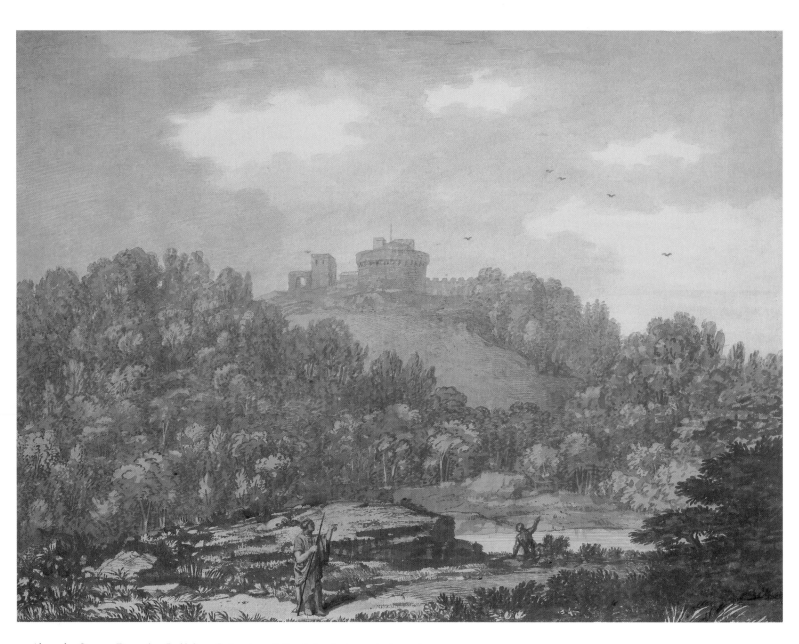

4 Alexander Cozens, *Figures by a Pool below a Fortress in an Italianate Landscape, c.*1765 (cat. 79)

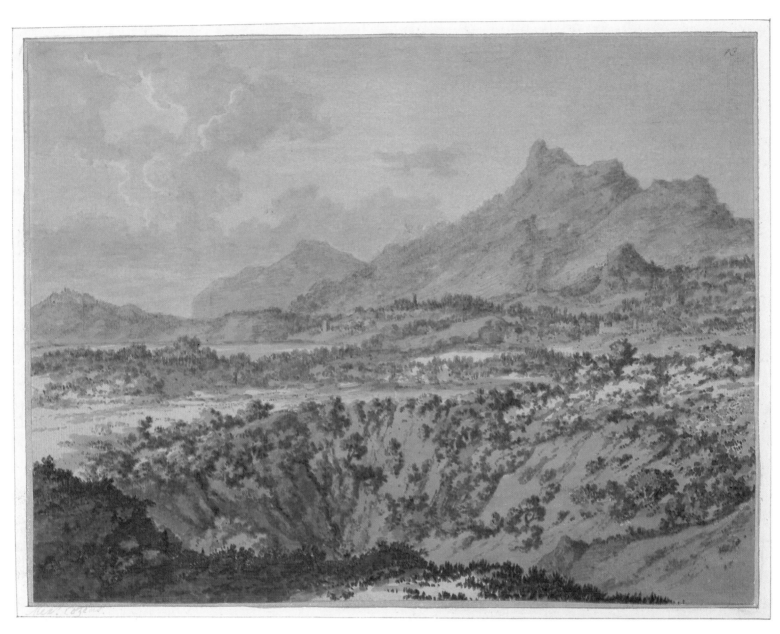

5 Alexander Cozens, *Mountain Landscape with a Hollow, c.* 1785 (cat. 84)

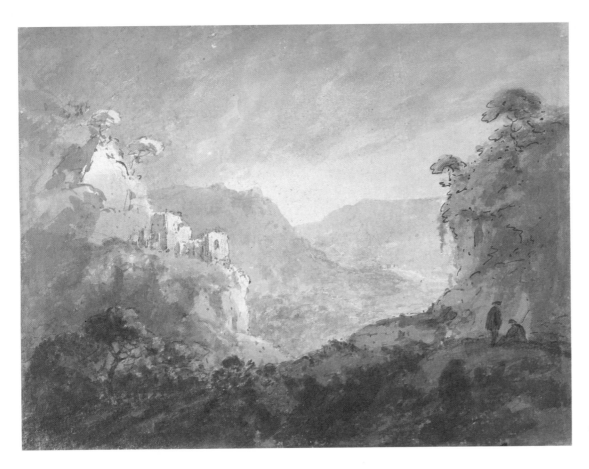

6 William Gilpin, *A View into a Winding Valley, c.* 1790 (cat. 137)

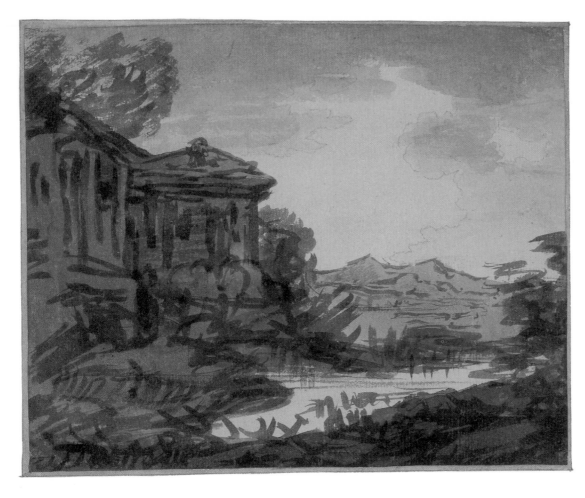

7 Alexander Cozens, *A Villa by a Lake,* (?) *c.* 1770 (cat. 81)

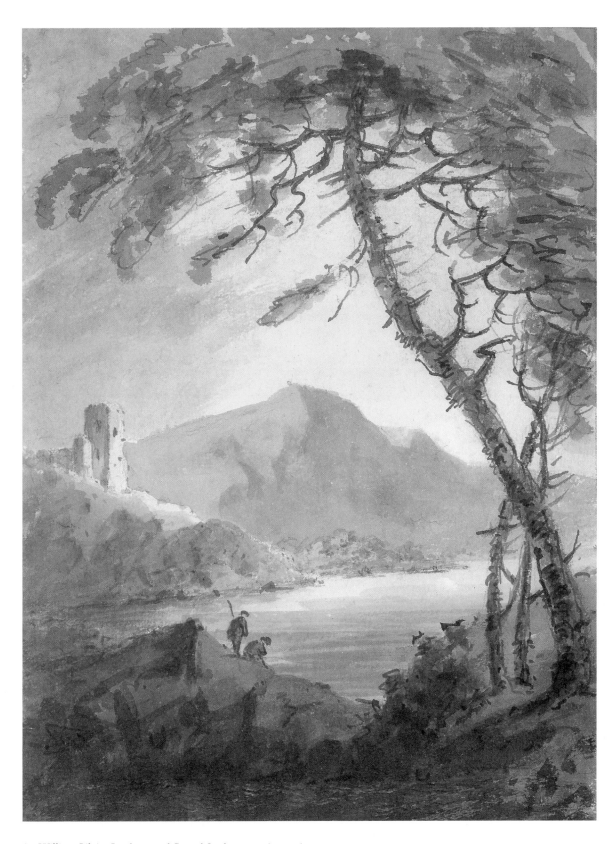

8 William Gilpin, *Landscape with Ruined Castle*, *c.* 1790 (cat. 136)

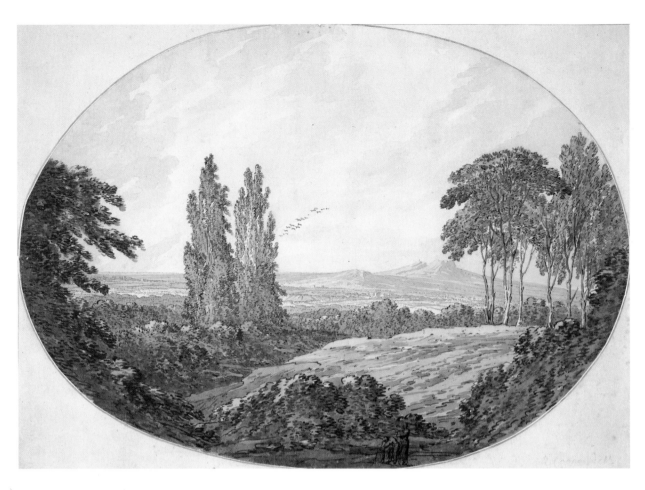

9 Richard Cooper Jnr, *Landscape: Trees and Rocky Hills*, *c.* 1780 (cat. 36)

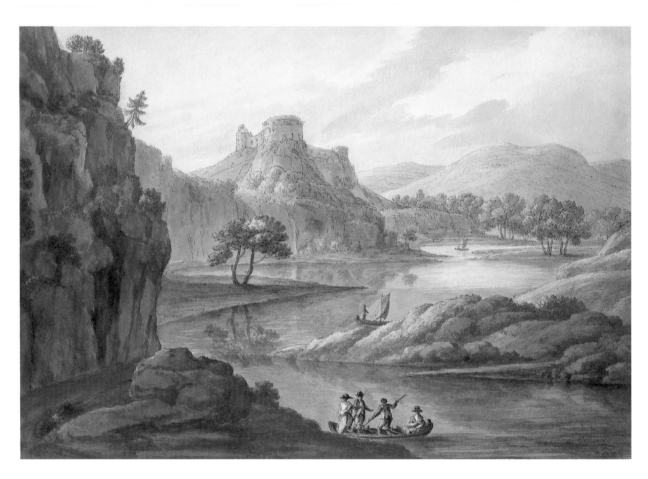

10 Robert Adam, *River Landscape with a Castle*, *c.* 1780 (cat. 2)

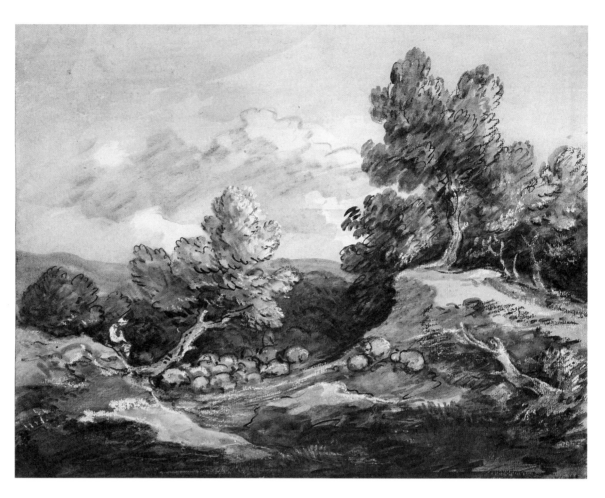

11 Thomas Gainsborough, *Wooded Landscape with Shepherd and Sheep*, *c.* 1780 (cat. 133)

12 Thomas Gainsborough, *Figures in a Wooded Landscape*, *c.* 1785 (cat. 134)

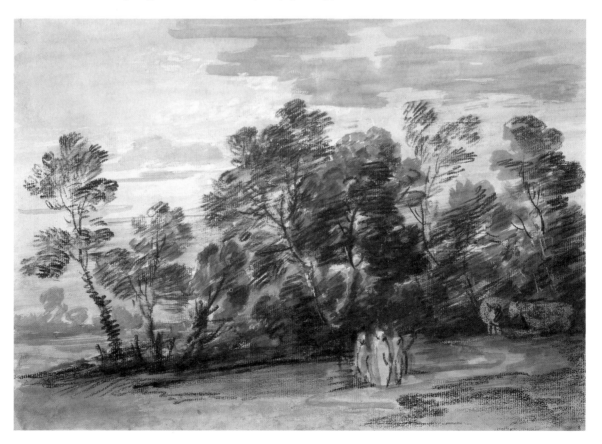

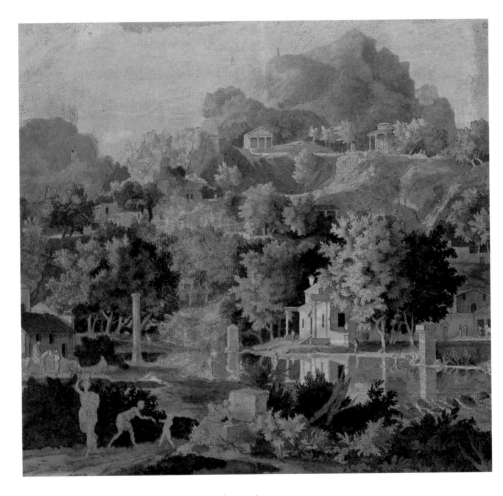

13 James Deacon, *Landscape Fantasy*, 1740–3 (cat. 107)

14 Jonathan Skelton, *In Greenwich Park*, 1757 (cat. 263)

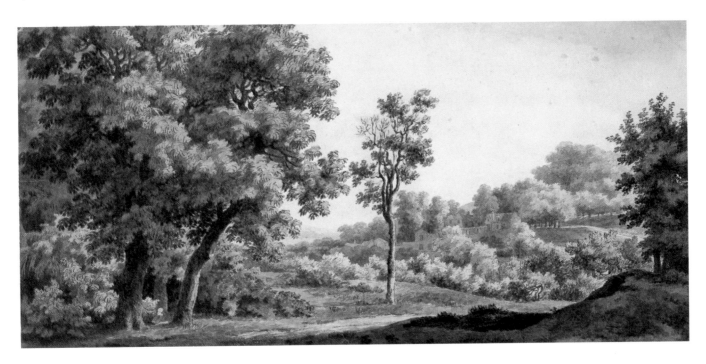

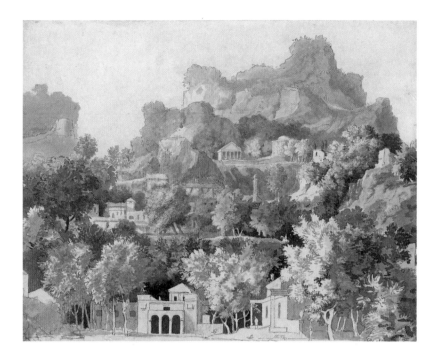

15 James Deacon, *Rocky Landscape with Classical Buildings*, 1745–50 (cat. 108)

16 Michael 'Angelo' Rooker, *Entrance to a Park*, (?)*c.* 1790 (cat. 240)

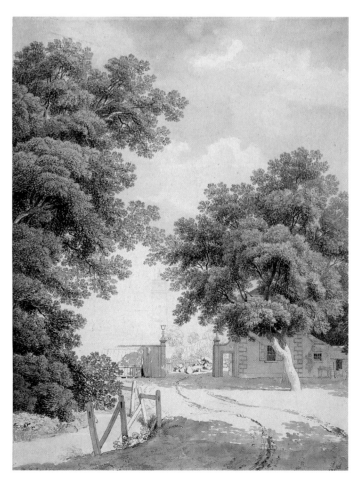

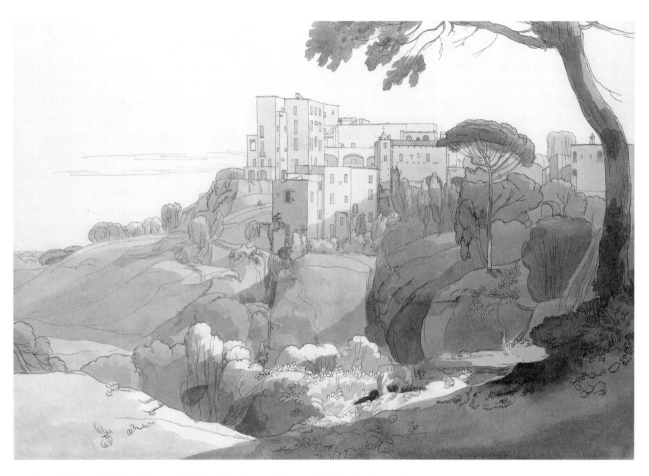

17 Francis Towne, *Naples: A Group of Buildings Seen from an Adjacent Hillside*, 1781 (cat. 270)

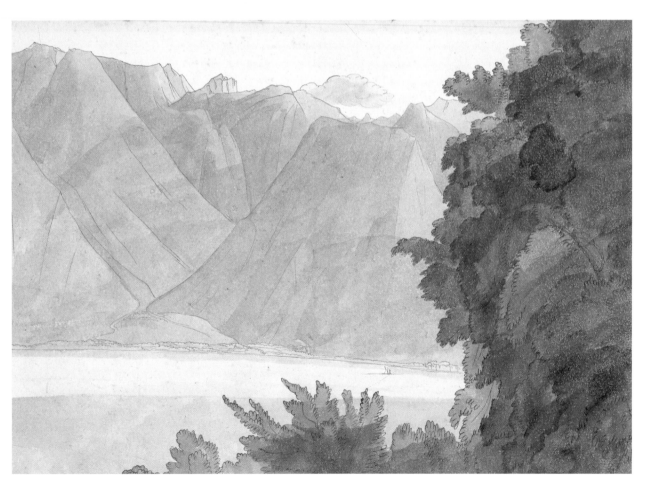

18 Francis Towne, *Head of Lake Geneva from Vevay*, 1781 (cat. 273)

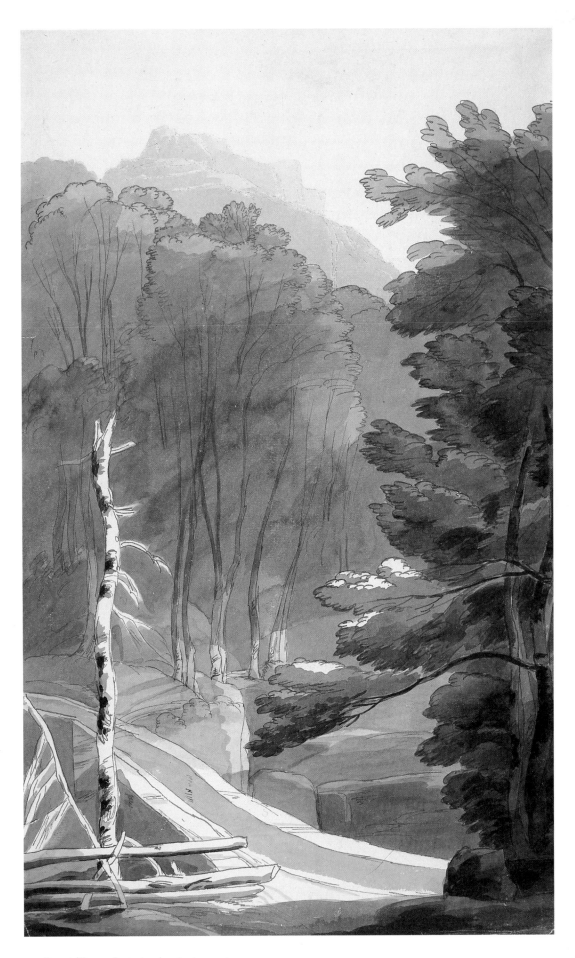

19 Francis Towne, *Pantenbruck*, 1781 (cat. 274)

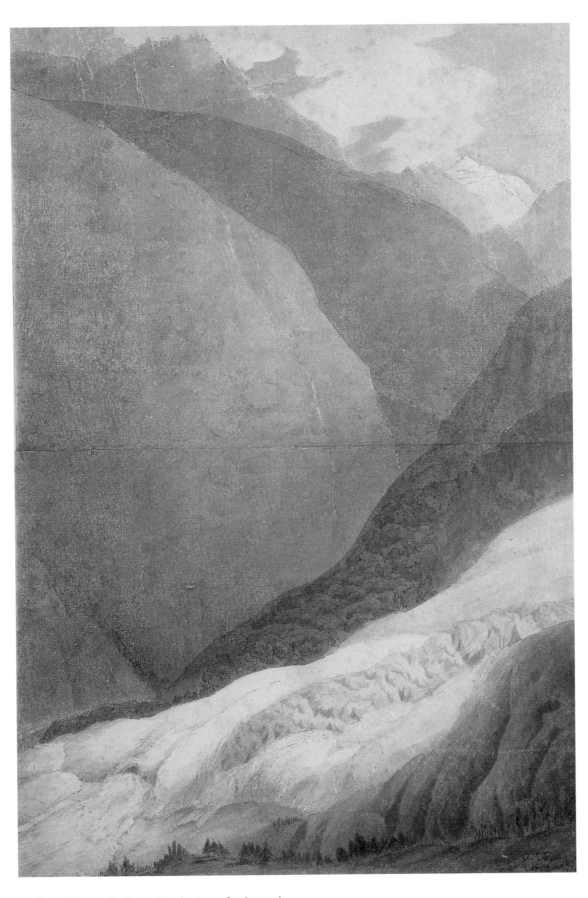

20 Francis Towne, *The Source of the Arveiron*, 1781 (cat. 272)

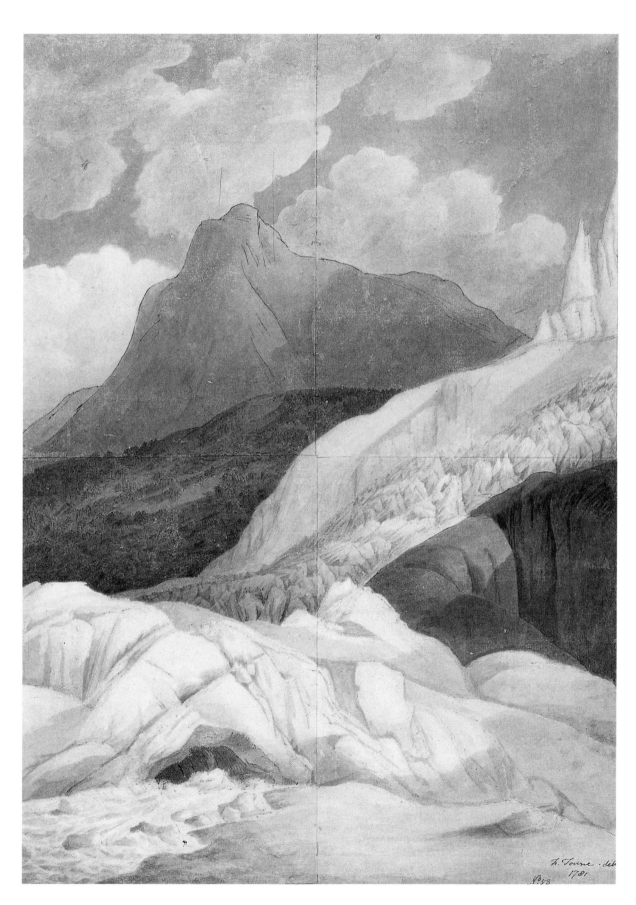

21 Francis Towne, *The Source of the Arveiron: Mont Blanc in the Background*, 1781 (cat. 271)

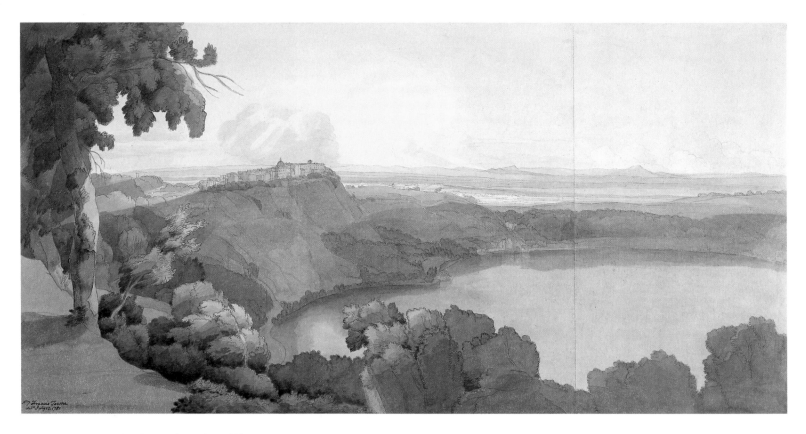

22 Francis Towne, *Lake Albano with Castel Gandolfo*, 1781 (cat. 269)

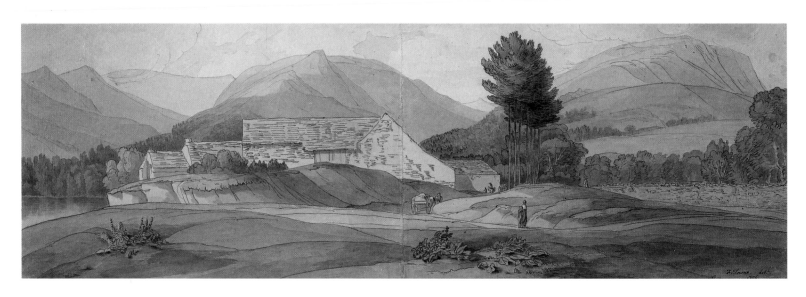

23 Francis Towne, *A View at the Head of Lake Windermere*, 1786 (cat. 275)

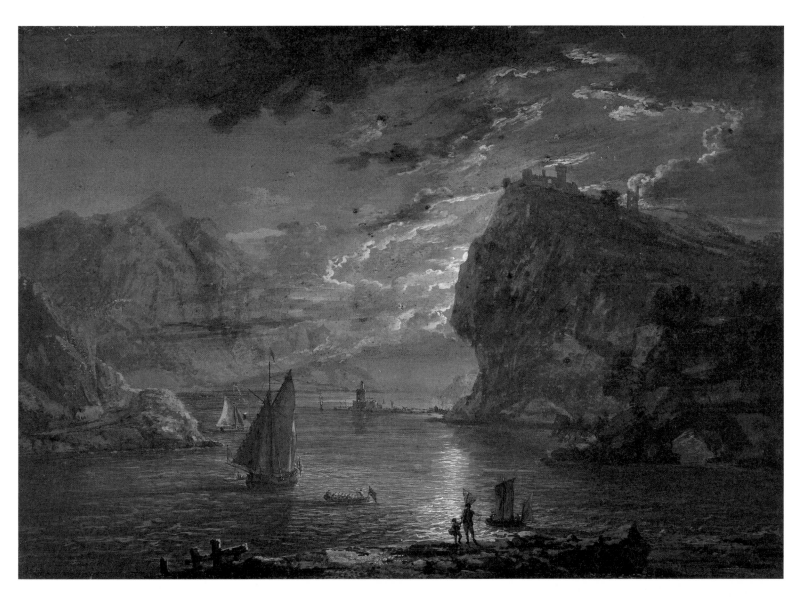

24 Paul Sandby, *A Rocky Coast by Moonlight*, (?)*c*. 1790 (cat. 255)

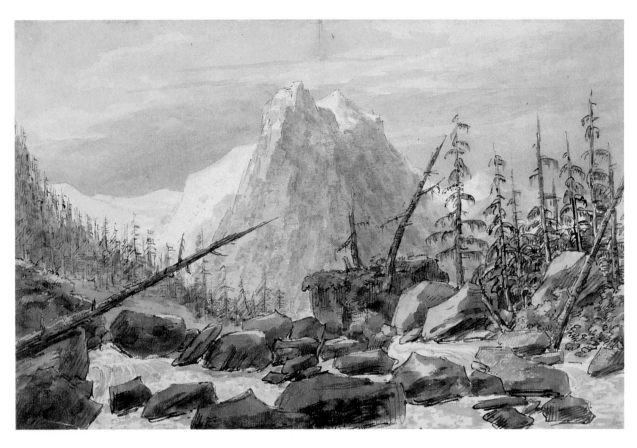

25 John Robert Cozens, *The Reichenbach between Grindelwald and Oberhaslital*, *c.* 1776 (cat. 85)

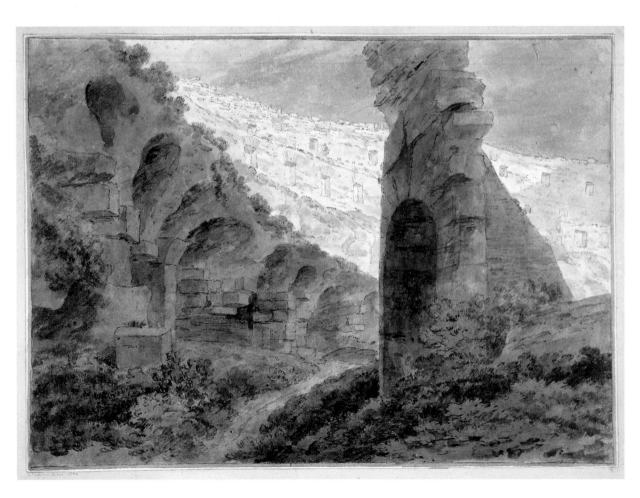

26 John Robert Cozens, *Interior of the Colosseum*, 1778 (cat. 87)

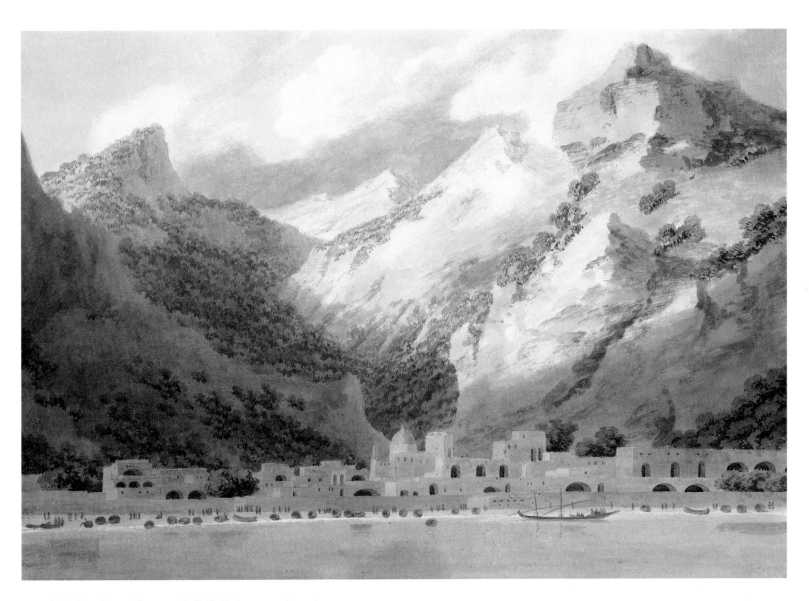

27 John Robert Cozens, *Cetara, on the Gulf of Salerno*, 1790 (cat. 94)

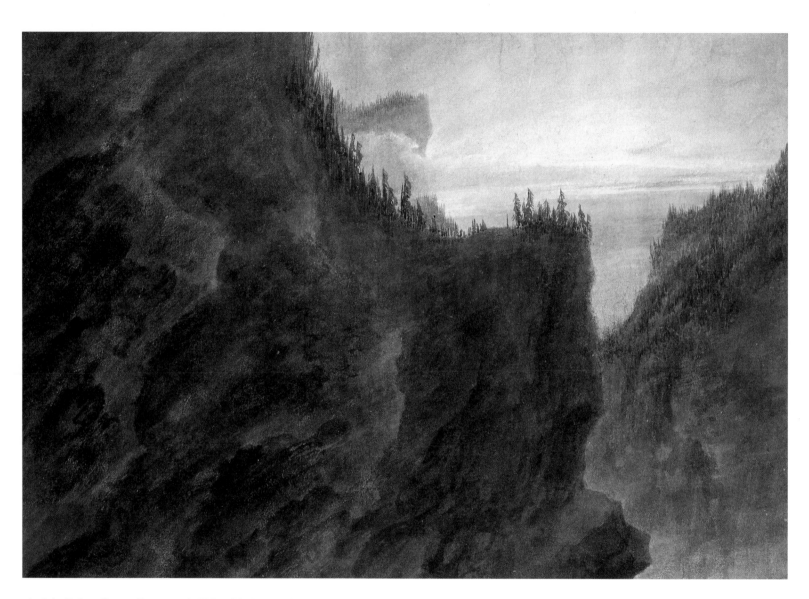

28 John Robert Cozens, *Entrance to the Valley of the Grande Chartreuse in the Dauphiné*, *c.* 1783 (cat. 90)

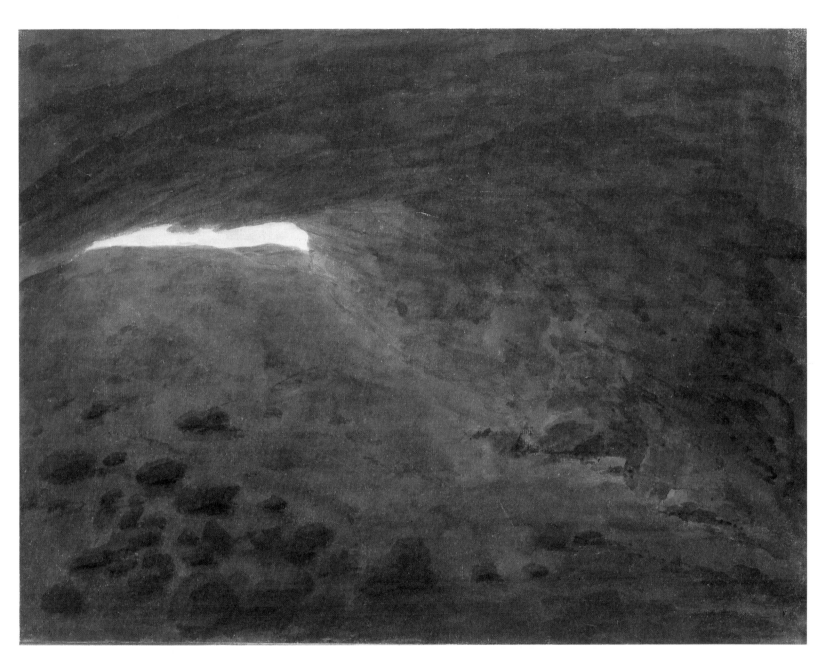

29 John Robert Cozens, *Cavern in the Campagna*, 1778 (cat. 86)

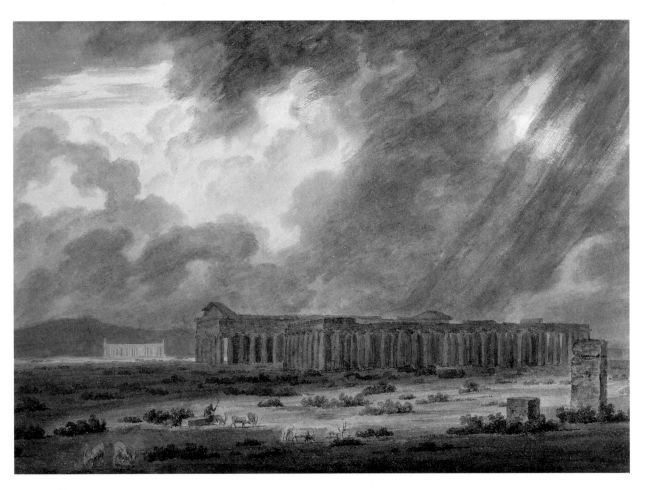

30 John Robert Cozens, *Ruins of Paestum, near Salerno: The Three Temples*, *c.* 1782 (cat. 88)

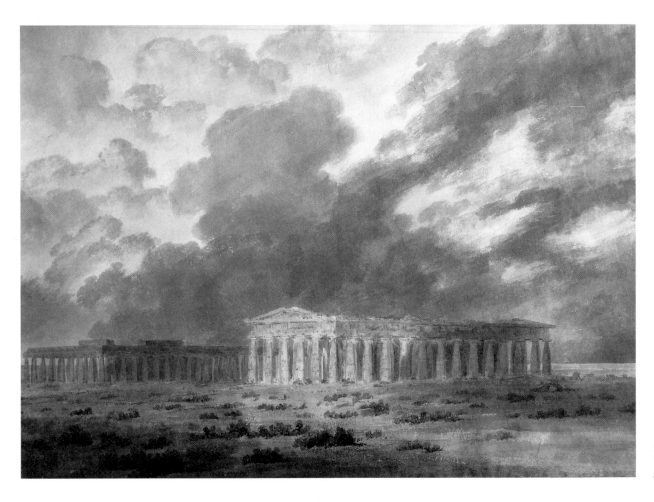

31 John Robert Cozens,
*The Two Great Temples
at Paestum*, *c.* 1782 (cat. 89)

32 John Robert Cozens,
*Florence from a Wood near
the Cascine, c.*1785 (cat.91)

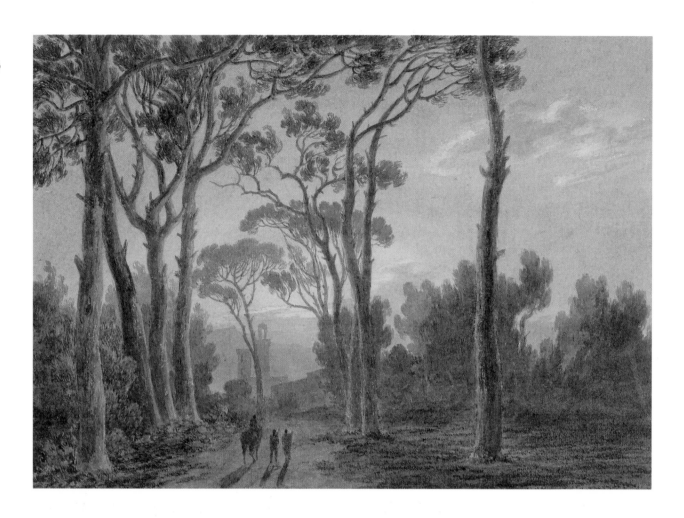

33 John Robert Cozens, *Lake Albano and Castel Gandolfo, c.* 1790 (cat.92)

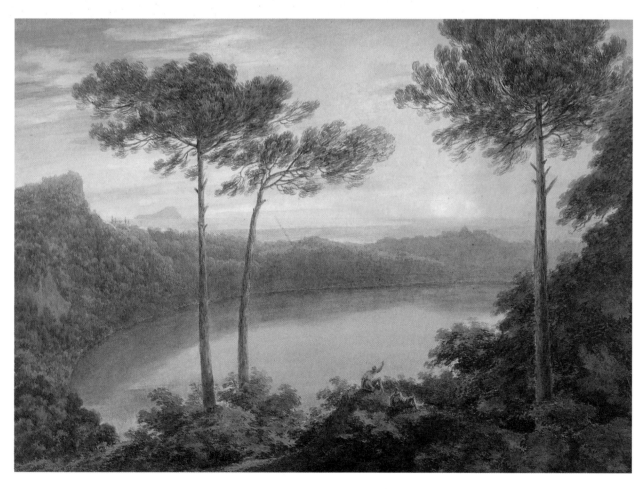

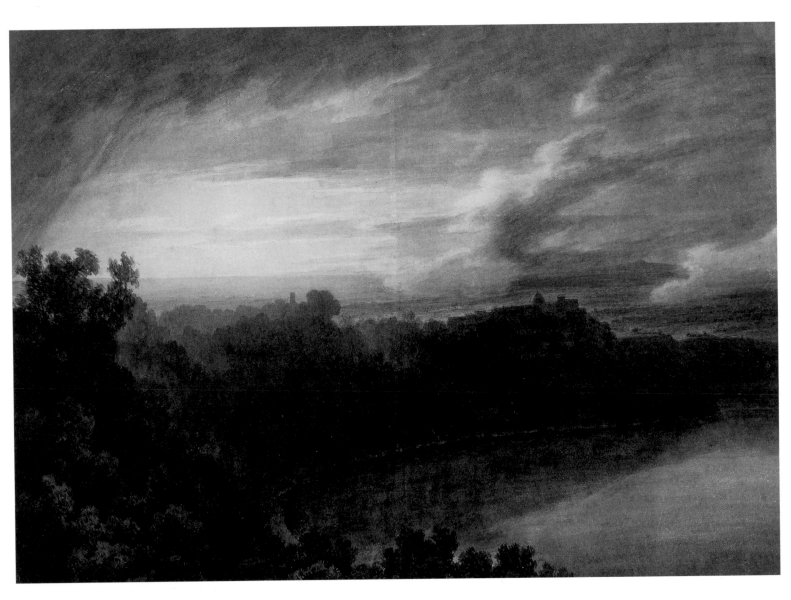

34 John Robert Cozens, *Lake Albano and Castel Gandolfo – Sunset*, *c.* 1790 (cat. 93)

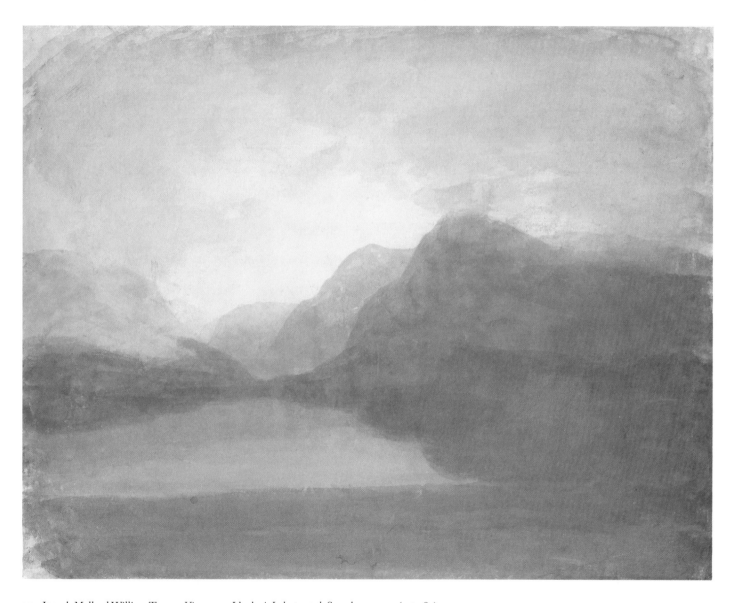

35　Joseph Mallord William Turner, *View across Llanberis Lake towards Snowdon*, *c.* 1799　(cat. 280)

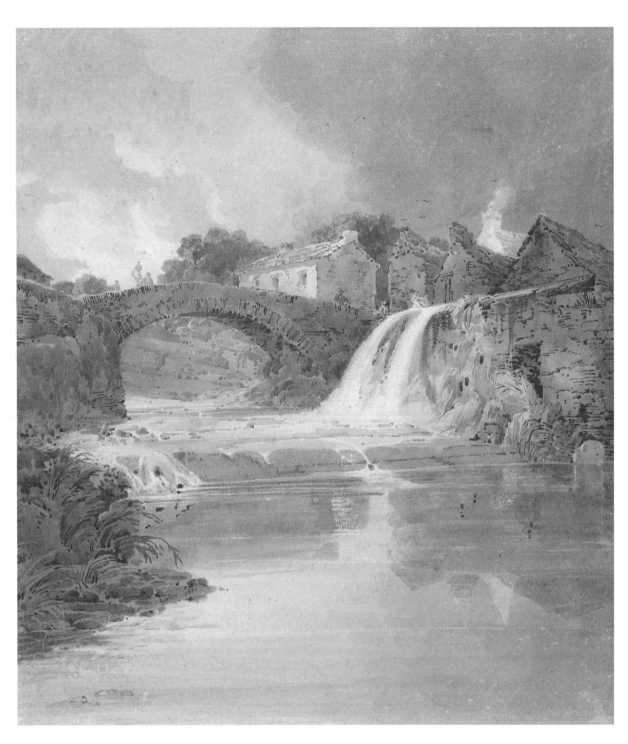

36 Thomas Girtin, *Hawes, Yorkshire*, 1800 (cat. 141)

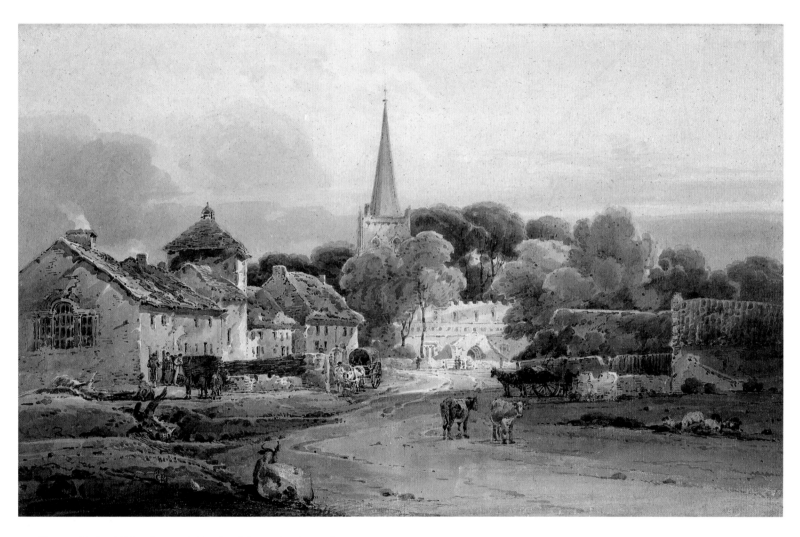

37 Thomas Girtin, *A Village Street and Church with Spire*, 1800 (cat. 144)

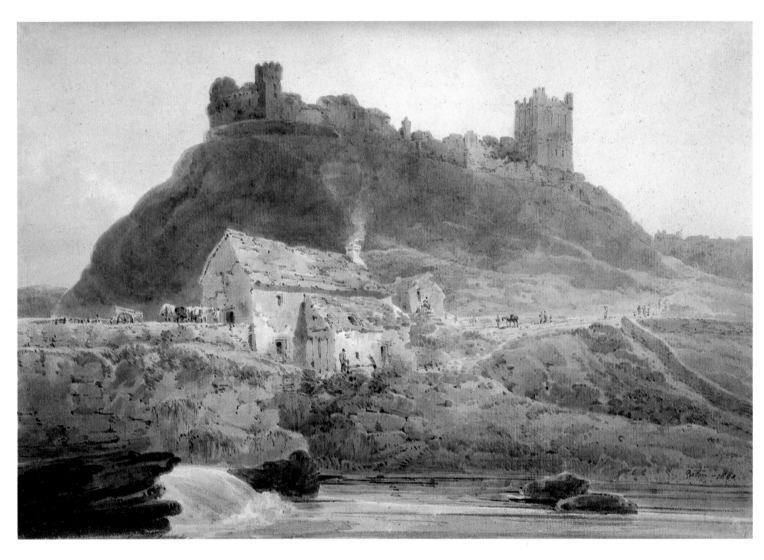

38 Thomas Girtin, *Richmond Castle, Yorkshire*, 1800 (cat. 145)

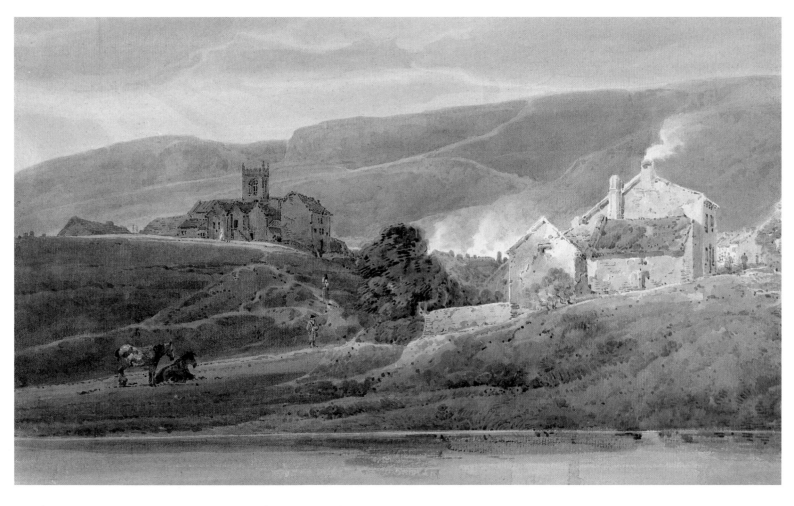

39 Thomas Girtin, *Ilkley, Yorkshire, from the River Wharfe, c.* 1801 (cat. 150)

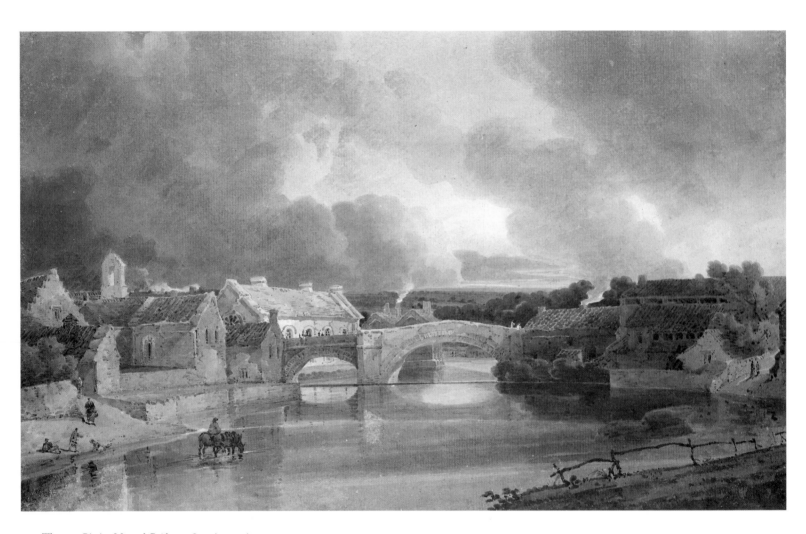

40 Thomas Girtin, *Morpeth Bridge*, *c.* 1802 (cat. 154)

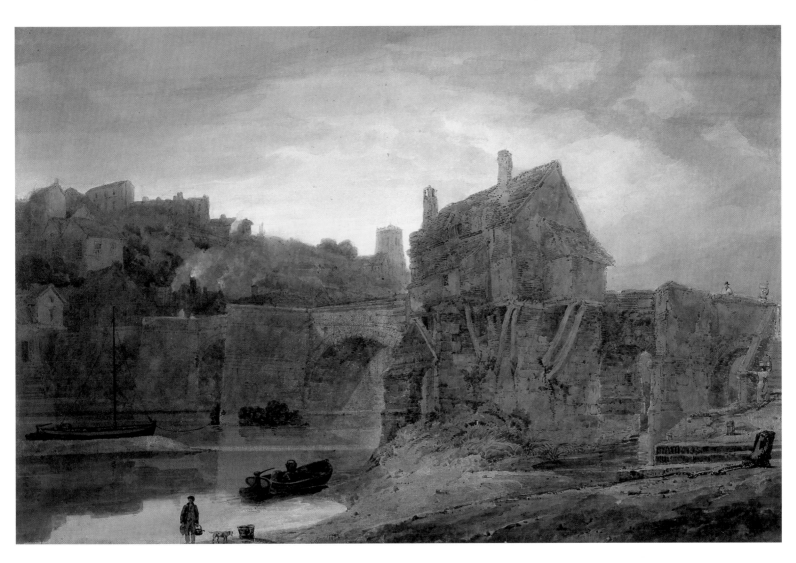

41 Thomas Girtin, *Bridgnorth, Shropshire*, 1802 (cat. 152)

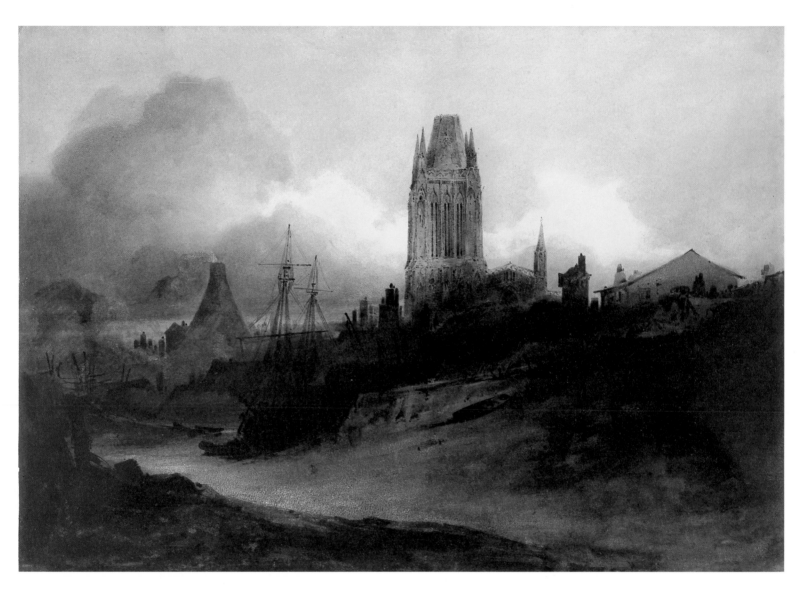

42 John Sell Cotman, *St Mary Redcliffe, Bristol: Dawn*, *c.* 1802 (cat. 38)

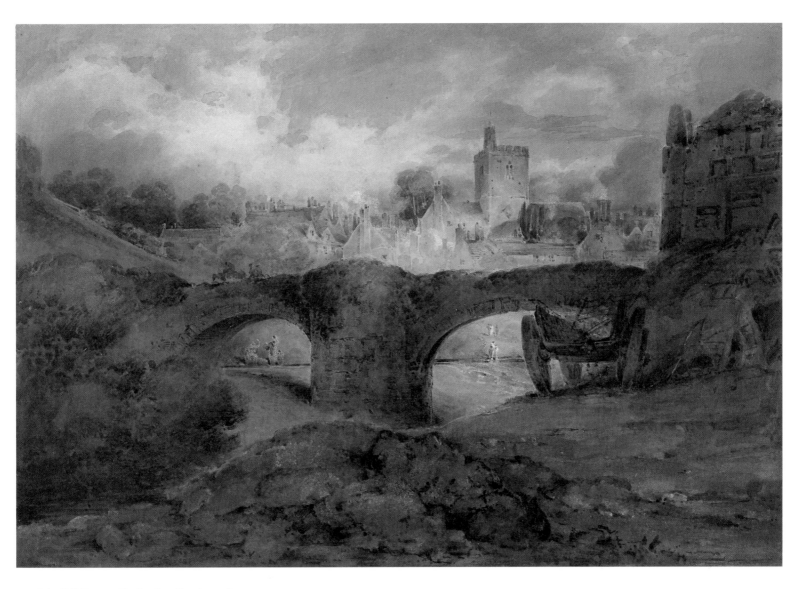

43 John Sell Cotman, *Brecknock, c.* 1801 (cat. 37)

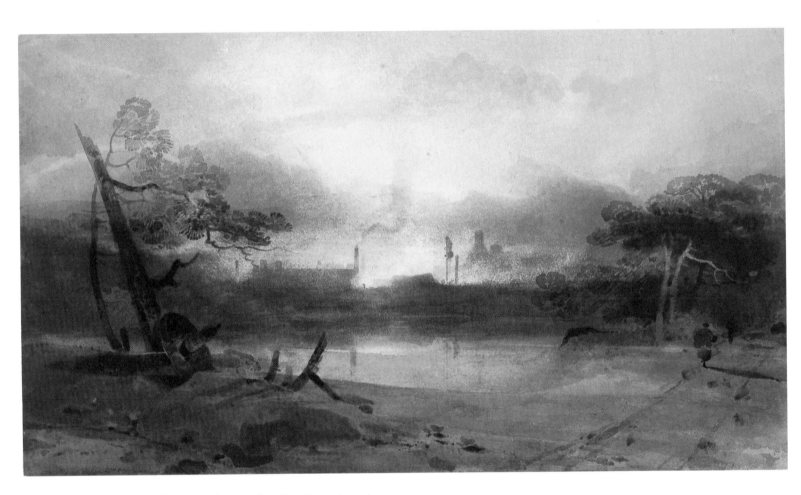

44 John Sell Cotman, *Bedlam Furnace, near Irongate, Shropshire*, 1802–3 (cat. 39)

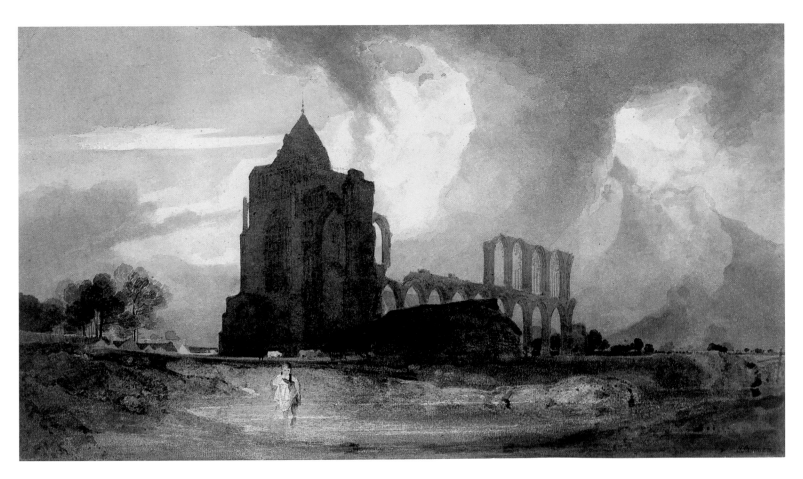

45 John Sell Cotman, *Croyland Abbey, Lincolnshire, c.* 1804 (cat. 40)

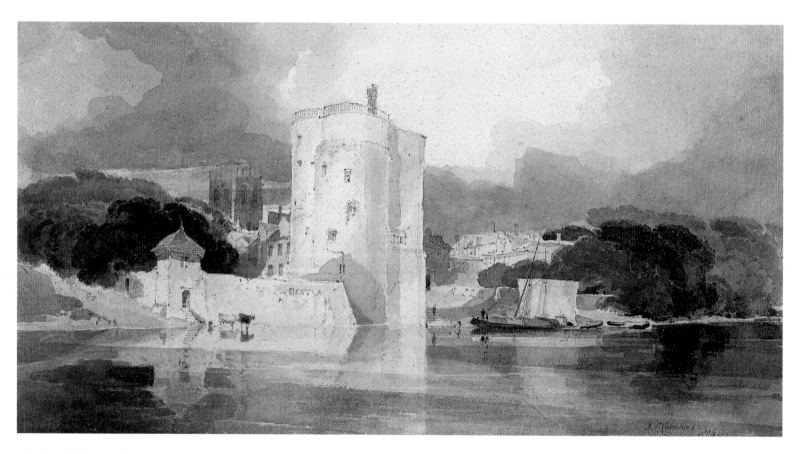

46 John Sell Cotman, *York: The Water Tower*, 1804 (cat. 41)

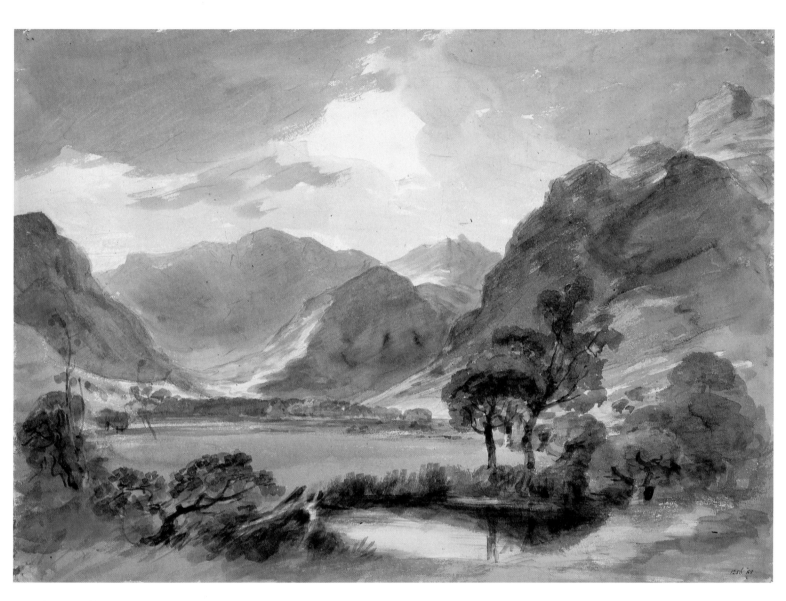

47 John Constable, *View in Langdale*, 1806 (cat. 26)

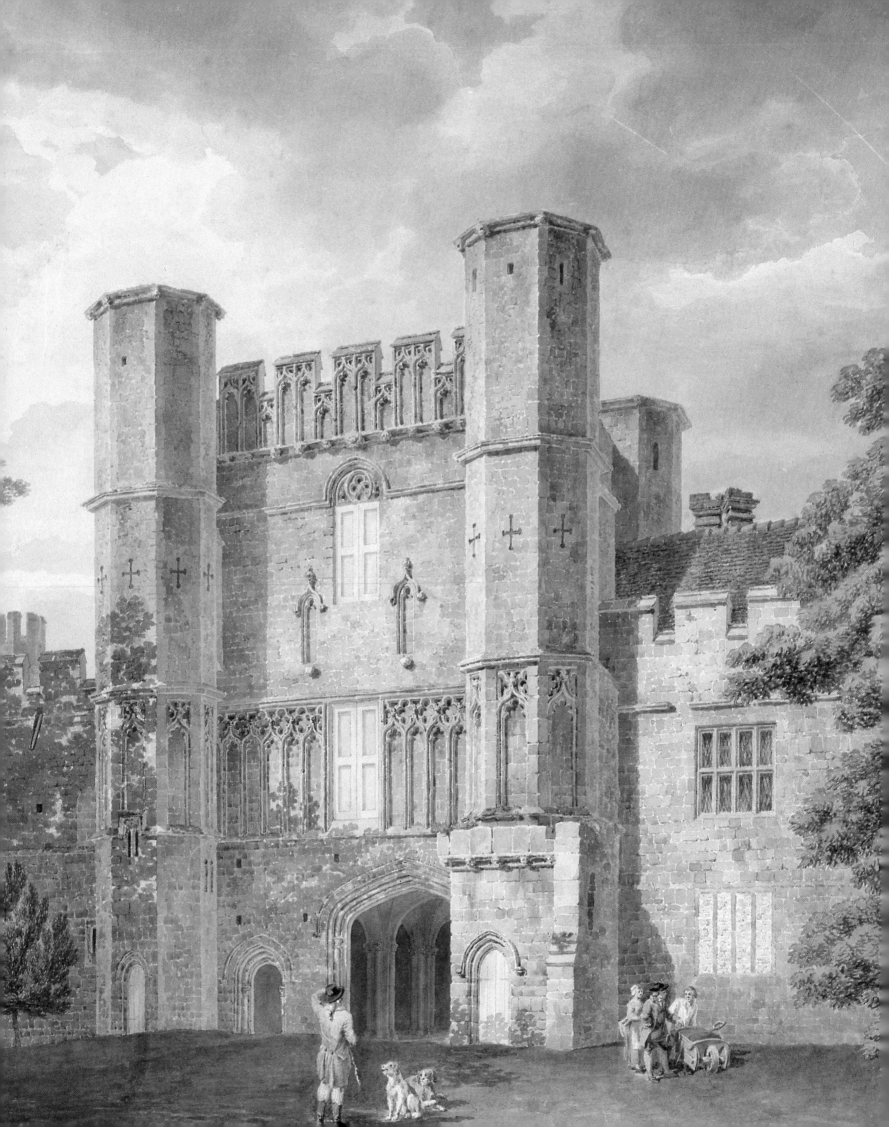

II

Man in the Landscape:
The Art of Topography

In 1801 J.H. Fuseli, lecturing in his capacity as Professor of Painting to students at the Royal Academy Schools, dismissed topography, or the 'real view' of Nature, as 'that kind of landscape which is entirely occupied with the tame delineation of a given spot'. Instead, he recommended to his students the Ideal landscape of 'Titian, Mola, Salvator, the Poussins, Claude, Rubens, Elzheimer, Rembrandt, and Wilson, [which] spurns all relation with this kind of mapwork'.[1] His remarks emphasise the gulf that, at the turn of the century, was still perceived by some artists to separate the work of the Ideal landscape painter from that of the topographer.

Topography can be defined as the practice of describing in detail a particular place, city or town, or the features of a locality. The topographical 'View' or 'Prospect', as it was often called, had a

other features, but serving essentially as decorative adjuncts or 'staffage'. The emphasis was on careful drawing and penwork, with colour kept to a minimum, and washes, mainly monochrome, applied in broad, clean, unmodulated layers (hence the expression 'tinted' or 'stained' drawing), which rendered it suitable for translation into an engraving (fig. 17, 18).

It was only from about the middle of the eighteenth century, with the advent of Paul Sandby and his brother, Thomas (1721–98), that the topographical watercolour first began to evolve into a more expressive and significant branch of landscape painting. The topographer now began increasingly to avail himself of the three features that could lift the real view above the ordinary, the 'tame' or the commonplace without at the same time rendering it unrecognis-

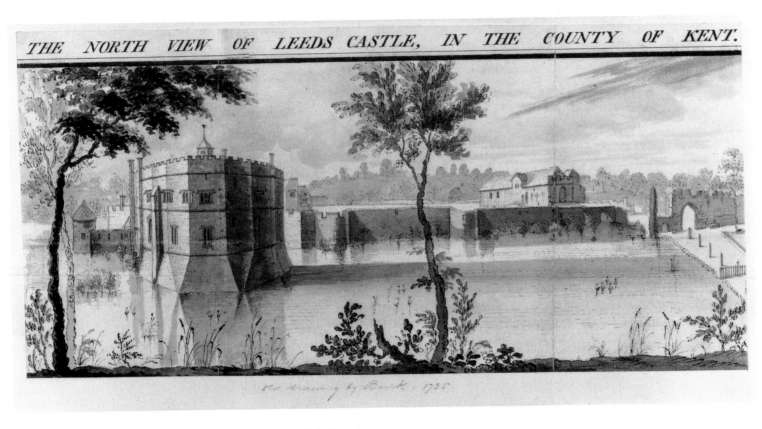

Fig. 17 Samuel and Nathaniel Buck, *Leeds Castle, Kent*, 1735, pen and ink with wash, 16.2 x 34.8. British Library, London

fairly continuous development in Britain in the seventeenth and early eighteenth centuries, influenced to a great extent by the work of foreign (particularly Dutch and Flemish) artists working in Britain. The topographer's brief was to record with clarity and accuracy the essential information about a place. Unlike the painter of Ideal landscape, who was free to manipulate his material for aesthetic ends, the topographer was required to transcribe the 'simple literal truth'.[2] Thus the typical early topographical watercolour tended either to be a panorama or a bird's-eye view, in which the maximum information could be conveyed; it was invariably presented in 'clear daylight unobstructed by clouds or shadows',[3] which were deemed to detract from the honest presentation of factual information; and it often included attendant figures, perhaps pointing at ruins or

able. First, he could select the viewpoint that, rather than convey the most information, would enable him to create the most interesting composition – although the degree to which he was free to innovate would be limited if, as was so often the case, he was employed in a formal capacity and his 'record' was destined to reach a wider audience in the form of a print. Second, as the potential of the watercolour medium for the depiction of atmosphere became increasingly evident, and the vagaries of climate more closely observed and better understood (see Section III), so the topographer could use the full range of naturalistic effects, even perhaps borrowing the soft and varied light of Ideal, especially Claudean, landscape painting. Above all, the topographer could choose to introduce well-observed and realistically rendered figures, which, rather than serving as mere

staffage, could be seen to interact with their environment and contribute to a sense of place. It is, indeed, the skilful and sensitive deployment of the human figure that is, arguably, the most important ingredient in the best topography. Nevertheless, the topographical watercolour reached its highest levels of expression in the hands of J. M. W. Turner, who fully exploited all three elements, creating a universal message through his use of the particular.

Paul Sandby was the first topographer in Britain to use the human figure with prominence and conviction. His earliest, most significant figure studies date from the five years he spent in Scotland acting as chief draughtsman on the Military Survey set up after the defeat of the Jacobite uprising of 1745–6 (fig. 19). Like his brother Thomas, he had been trained as a military draughtsman at the Board of Ordnance, then based at the Tower of London, and although few of the official military topographical drawings he made in Scotland survive, other related watercolours reveal the influence of his cartographic training.[4] Together with the watercolours made by Thomas for William Augustus, Duke of Cumberland, between the mid-1740s and mid-1750s, showing encampments at Fort Augustus in the Highlands, in Flanders and on Cox Heath (pl. 49),[5] they serve to remind us of the origins of the topographical drawing in military surveying and cartography. It was, nevertheless, during these years that Paul, as a diversion from his official tasks of working up detailed maps from drawings made in the field, pro-

duced a number of spirited and often humorous sketches of figures in the streets of Edinburgh (pl. 127) and the vicinity (pl. 48).

Sandby developed his skills in figure drawing on his return from Scotland. He spent much of his time sketching at Windsor, where Thomas's employer, the Duke of Cumberland, was Ranger of the Great Park from 1746. Particularly charming, and rather Dutch in flavour, are a group of studies he made in the mid-1750s at Sandpit Gate, a lodge on the Windsor estate, in which people are seen going about their everyday domestic tasks: women are making pies, or washing in the kitchen as light floods in through the window

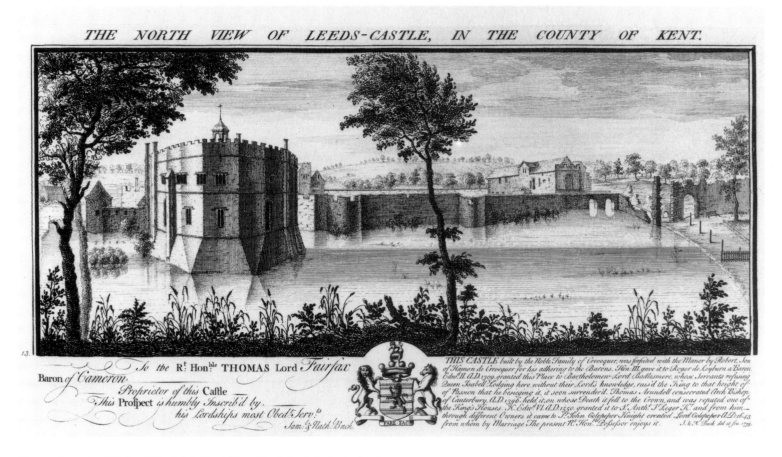

Fig. 18 Samuel and Nathaniel Buck, *The North View of Leeds Castle, in the County of Kent*, 1735, etching, 14.4 x 34.7 (image). British Library, London

(pl. 54).[6] Drawn, no doubt, for their own sake, studies such as these inform his finished watercolours: in plate 52, for example, a woman bending over her washing can be glimpsed beyond a doorway in the wall. Sandby's studies of children are particularly enchanting, and appear regularly in his finished watercolours as amusing vignettes: a young boy trundles a hoop, exciting the attention of a dog nearby (pl. 51) another chases a girl clutching a doll (pl. 55), the latter work almost certainly a study of Sandby's own grandchildren.[7] Nevertheless, Sandby sometimes recycled his figures in identical form in other watercolours, indeed they sometimes even appear in drawings by Thomas as well.[8]

In the same way that watercolour proved so useful for military surveying, so also, in the days before the invention of the photographic camera, was it particularly suitable for recording expedi-

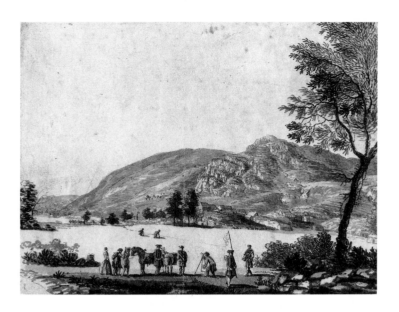

Fig. 19 Paul Sandby, *Survey Party near Loch Rannoch, Scotland*, 1749, pen and ink and watercolour, 17.2 x 23.2. British Library, London

tions made at home and abroad. Watercolour artists were generally favoured over oil painters in these circumstances since watercolour was a more portable medium than oil, and more suitable for sketching and making finished drawings on the spot (although some artist-travellers preferred to make detailed pencil drawings from which to elaborate finished watercolours on their return). When, in 1764, the young artist William Pars was selected by the Society of Dilettanti to serve as the official draughtsman on an expedition to Greece and Asia Minor with the antiquary Richard Chandler (1738–1810) and the architect Nicholas Revett (1720–1804), he was following hard on the heels of another draughtsman who had recently been making records of the archaeology in Greece, James 'Athenian' Stuart. In the 1770s two artists, William Hodges (1744–97) and John Webber (*c.* 1750–93), were commissioned to record, respectively, Captain James Cook's second and third voyages in the South Seas. And William Alexander (1767–1816) was asked to accompany George, 1st Earl Macartney's embassy to China of 1793–4 as official draughtsman, becoming the only artist of the period to penetrate the interior of China.[9]

Stuart's drawings (pl. 59, 60) are notable for the prominence given to the human figure. Indeed, in the preface to the first volume of his and Revett's *The Antiquities of Athens* (1762), in which engravings after some of his drawings were published, Stuart proudly stated that,

> preferring Truth to every other consideration, I have taken none of the Liberties with which Painters are apt to indulge themselves… Not an object is here embellished by strokes of Fancy… The Figures that are introduced in these views are from Nature, and represent the Dress and Appearance of the present Inhabitants of Athens.[10]

In an age of restricted travel, authentic and well-observed figures clearly had the advantage of novelty, as no doubt Alexander appreciated when he gave due emphasis in his watercolours to the

character and costume of the Chinese (pl. 57).[11] In Stuart's drawings, unlike those of Pars (fig. 20), even the members of the official archaeological party wear native Turkish dress. Most of all, however, unlike other archaeological topography of the period, the figures in both artists' drawings go about their activities with conviction, whether they are shown measuring the remains of buildings, taking tea or dozing in the sun (pl. 60, 58).[12] However, whereas Stuart's drawings are executed in pure bodycolour and have a decorative appearance, Pars preferred to use both watercolour and bodycolour (in parts varnished with gum), the better to enable him to express the rugged nature of the terrain, and he also exploited the atmospheric qualities of watercolour in order to capture the expansiveness of the landscape and evoke a heavily laden sky.

Other watercolour artists in this period were responding in similarly imaginative ways to the novelty and beauty of the scenery they saw abroad, in particular those visiting Italy on the Grand Tour. The Welsh painter Thomas Jones (1742–1803), whose *Memoirs* of 1776–83 recount the artistic and social life of a group of watercolourists based in Rome, which included Pars, Francis Towne and John 'Warwick' Smith (1749–1831), described Italy on his first impression as a 'Magick land'.[13] Indeed, the Italian subjects of Towne and Smith are among the finest topographical watercolours of the late eighteenth century, in part, perhaps, because both artists were freed from the obligation to produce work for an official publication (Towne didn't even have a patron) and were thus able to bypass – even to transcend – the usual requirements of the topographical view.[14] Neither artist, for example, pays more than passing heed to the human figure. In Towne's *Gateway of the Villa Ludovisi* (pl. 63), a characteristically unorthodox but carefully considered composition, so mesmerised is the viewer by the silhouette formed by a row of cypress trees against a large expanse of sky, that he or she barely notices that figures are included at all – nor for that matter that this is a record of a particular place. Smith sometimes eschews the use of the figure entirely, as, for example, in *Interior of the Colosseum* (pl. 62), where he achieves an extraordinary boldness of effect

Fig. 20 William Pars, *The Theatre at Miletus, c.* 1765, watercolour, pen and ink and gum, 29.6 x 47.1. British Museum, London

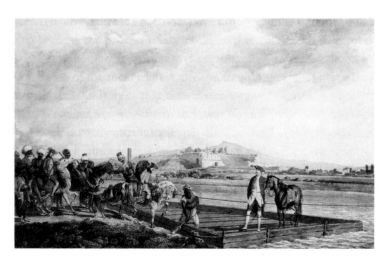

by presenting the arches of the Colosseum almost on the picture plane, completely filling the sheet; the more distant sketch of the Colosseum made some years earlier by the portrait painter Allan Ramsay has not been so carefully premeditated (pl. 61).

Towne's and Smith's Italian views, whether through inaccessibility or lack of appreciation,[15] failed to make an impression on the next generation of topographers, although it is just possible that J. M. W. Turner saw Towne's Italian views before he himself travelled to Italy in 1819 (pl. 90, and see fig. 21).[16] By comparison, the Italian views of John Robert Cozens, often repeated in several versions, and available for students to copy at Dr Monro's 'academy' in Adelphi Terrace, London, made a powerful impression on the generation who came to prominence in the 1790s, in particular on the young Turner and Girtin. Indeed, with the Continent more or less closed to British travellers from 1793 to 1815 because of the French Revolutionary and Napoleonic Wars, Cozens's watercolours were to provide for many of these youthful artists their only taste of the Italian landscape. Instead, topographical artists were forced to rely on the market for watercolours of British locations, for which a seemingly insatiable demand had developed.

In the last quarter of the eighteenth century the British had become tourists at home. If Paul Sandby had done much to open up Scotland and Wales,[17] publication of William Gilpin's Picturesque tours had helped promote the Wye Valley, the Lake District and elsewhere, and travel in general was much more comfortable thanks to improvements in road-building. A wealth of antiquarian publications now appeared on the market to satisfy the demand for visual souvenirs of well-known sites: *The Virtuosi's Museum* (1778), William Byrne and Thomas Hearne's *Antiquities of Great Britain* (1786–98), William Angus's *The Seats of the Nobility and Gentry* (1787–1815), John Britton and Brayley's *Beauties of England and Wales* (1801–14) and others were illustrated with copious prints after designs by watercolourists of castles, houses, priories, abbeys and cathedrals. As often as not these monuments were shown in a ruinous state and overgrown with weeds, the better to provide variety, roughness and irregularity for the benefit of an audience primed in the principles of the Picturesque. With the foundation of the Royal Academy in 1768, watercolourists had for the first time been provided with a public venue in which to exhibit and sell their work,[18] but in practice most of them continued to rely on the flourishing market for prints after their works.

It is in this context that much of the work of, for example, Michael 'Angelo' Rooker, Hearne, and the young Turner and Girtin belongs (pl. 65, 64, 279, 76). Rooker's meticulous brushstrokes were ideally suited to capturing the intricacies of crumbling masonry, and his well-observed figures always look appropriate to their context. In *Interior of the Abbot's Kitchen, Glastonbury* (pl. 74), where Rooker conceived the idea of taking the viewer inside the derelict monument, a farm-worker is seen dozing against a bale of hay next to a makeshift cattle-stall. In *Ewenny Priory* (pl. 75) Turner took up the idea of seeing the ruin as a place of human and animal habitation, but his use of a dramatic Rembrandtian lighting has transformed this veritable farm-in-the-making into a series of Piranesian vaults.

Running alongside that aspect of the 'real view' in Britain, which manifested itself in a love for all things antiquarian, rustic and Picturesque, was another branch that devoted itself to the symmetry of elegant façades and the 'smoothness of dressed stone'[19] – in short, the tradition of urban topography that had been pioneered in Britain by the Italian viewmaker Canaletto in the 1740s. Perhaps the most typical exponent of this branch of topography is the architectural draughtsman Thomas Malton Jnr (1748–1804), whose series of aquatints, *A Picturesque Tour through the Cities of London and Westminster* (1792–1801), based on watercolours he began making in the early 1780s, record various corners of Georgian London. The majority of them, such as *St Paul's, Covent Garden* (pl. 67), adopt a low, sharp, oblique viewpoint and deeply plunging perspective, and are usually peopled by a calculated cross-section of the metropolis's inhabitants: in this example the fashionably dressed and elegant figures to the left form a counterpoint to the market tradesmen opposite. Malton worked for a while as a stage-designer at Covent Garden and would have been able to observe such colourful characters at first hand, yet it is difficult to accept that these figures are anything more than staffage – types rather than individuals, there to animate the scene.

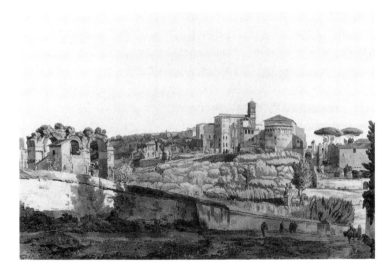

Fig. 21 Francis Towne, *SS Giovanni e Paolo, Rome*, 1780, pen and ink and watercolour, 31.7. x 47.1. British Museum, London

Turner received some of his early training from Malton, and was much influenced by the work of Edward Dayes, whose *Queen Square, London* (pl. 66) is very much in Malton's vein (although Dayes is better known as an antiquarian topographer). Turner's view of *The Pantheon* (pl. 68) owes much to their examples, but characteristically he goes one step beyond his mentors, for here the figures are not just decorative adjuncts but, rather, observers and participants in an actual event – the hubbub that followed the burning of the Pantheon, the pleasure palace built by James Wyatt in London's Oxford Street, on a freezing winter's morning in 1792.[20] Turner conveys the atmosphere of the scene as he himself experi-

enced it: a group of onlookers gather to watch as firemen hose down the burnt-out remains of the building, while icicles form on its façade. And yet the figures are contained within their context, a precondition for all topography. By comparison, the watercolours of Thomas Rowlandson barely operate within a topographical context at all. In *Skaters on the Serpentine* (pl. 69) we see a recognisable view, certainly – this is the Serpentine in Hyde Park with the Cheese-Cake House in the distance – but the setting merely functions as the framework for the human action in the foreground, an undulating line of comic figures brilliantly expressed through Rowlandson's infinitely varied and flexible pen-line.

However, both artists break away from the tradition of presenting the urban view under clear, sunny skies: Turner shows us the Pantheon roseate in the early morning, while Rowlandson's skaters cavort in the frosty, misty light of a winter's afternoon. Indeed, with Girtin a new understanding of light and atmosphere begins to enter the ultimate public expression of urban topography – the panorama. At a time when panoramas were enjoying a great vogue, and pur-

Fig. 22 J. M. W. Turner, *A Man Talking to an Oyster-seller*, c. 1832, pencil, 8.6 x 11.1. Tate Gallery, London

pose-built circular edifices were being constructed to display them, Girtin produced a panorama of London known as the 'Eidometropolis'. We know from contemporary accounts that it was painted in oil, and that it measured a staggering 108 feet long and 18 feet high.[21] The surviving preparatory watercolours indicate that his viewpoint was in Southwark, close to the burnt-out shell of the Albion Flour Mills (pl. 78) – not far, in fact, from the viewpoint that Robert Barker (1739–1806) had adopted for his London panorama a few years earlier.[22] But what distinguished Girtin's panorama from those of his predecessors was neatly summarised by the reviewer who commented that Girtin had paid

> particular attention to representing objects of the hues which they appear in nature, and by that means greatly

heightened the illusion. For example, the view towards the east appears through a misty medium arising from the fires of forges, manufacturers etc.[23]

And indeed one of the watercolour studies (pl. 77) shows an iron foundry belching out black smoke in the foreground.

These studies, concentrating as they do on the depiction of atmospheric effects, do not include figures, although the finished panorama itself would certainly have done so. A watercolour study of the Rue St Denis (pl. 79), made by Girtin on a trip to Paris in 1801–2 during a temporary lull in hostilities on the Continent (confirmed by the Treaty of Amiens), suggests that he may have intended to produce a panorama of Paris as well. By comparison with the Eidometropolis studies in which, thanks to the prominence of industry, the human presence is implied, the Rue St Denis is hauntingly empty, so much so that some suppose it to be a design for a stage-set.[24] It is a magnificent example of Girtin's skill as an architectural draughtsman, fully conveying the solidity, mass and majesty of the buildings.

By this time Girtin's art was already moving in a new direction, and it is interesting to speculate whether, had he not died in 1802, he might simply have left the topography of his youthful years behind him. His long-time friend and rival, Turner, by comparison, continued throughout his life not only to consolidate his early training, but greatly to extend the boundaries of the topographical watercolour, becoming its most sophisticated exponent. Turner's mature watercolours, particularly those produced for his famous topographical series, *Picturesque Views in England and Wales* of 1827–38 (pl. 86, 88, 89), blend topographical features with landscape and climate, but above all the landscape itself is conceived and presented in terms of its significance for human beings.

Like Paul Sandby, Turner was an inveterate observer of human life: his sketchbooks are full of notes and jottings showing people engaged in their everyday occupations (fig. 22), testimony to his all-embracing sympathy for humanity. However, unlike Sandby, Turner did not lift them for use in a specific watercolour, least of all was he tempted, as Sandby sometimes was, to use the same figure more than once. Furthermore, it would be inconceivable to find Turner ever having recourse to a published miscellany of figure types, such as W. H. Pyne's *Microcosm: or, a Picturesque Delineation of the Arts, Agriculture, Manufactures, &c. of Great Britain, in a series of above a thousand groups of small figures for the Embellishment of Landscape* (1803), but which his contemporaries were not so inclined to baulk at. The figures seen mending the road in *Bristol: St Augustine's Parade*, (pl. 71) by Samuel Jackson (1794–1869) were taken straight from Pyne's *Microcosm*, as were those in the foreground boat of his *View of the Hotwells and Part of Clifton* (pl. 191 and fig. 23).[25]

The main ingredients of Turner's mature watercolours are already present in a work such as *Wolverhampton* (pl. 398), where the bustle of a crowded market-day enhances our appreciation of the place; amid the tents, awnings, scaffolds and placards, 'stall-holders cry, buyers haggle, children and dogs play, actors leap, musicians perform' while others lean from windows to watch.[26] The extent to which people interact with their environment can be gauged by

Fig. 23
William Henry Pyne,
Boats, 1802, plate 2 from
Pyne's *Microcosm*, 1802,
etching and aquatint,
29 x 22.6 (image).
British Museum, London

comparing Cotman's watercolour of a market-day in Norwich (pl. 73), in which the more static figures are absorbed into the composition to serve the artist's pronounced interest in pattern-making. All that is missing from *Wolverhampton* is Turner's mature understanding of climate, which permeates the watercolours made for the *England and Wales* series, and which is sometimes an important contributory factor to their theme. In his view of *Stamford* (pl. 86) a sudden cloudburst has forced a group of passengers alighting from a stage-coach to open their umbrellas and rush for cover. In Turner's day Stamford was a busy coaching town on the Great North Road, one of the places to break the long journey between London and York.[27] It is absolutely characteristic of Turner's approach to topography that he should construct an episode of everyday life around a town's chief industry.

From a commercial point of view, Turner's *England and Wales* was a failure. The prints looked rather old-fashioned to a public increasingly accustomed to the illustrations of foreign places that had begun to flood the market after the reopening of the Continent following the end of the Napoleonic War. Now that artists and their audiences were free to travel to more exotic locations, novelty was becoming a force to be reckoned with. And the new middle-class tourist travelling for change and pleasure (unlike his eighteenth-century aristocratic predecessor in search of the classical past) wanted prints of the new countries he or she had seen or might be persuaded to visit. To satisfy this demand, artists found themselves travelling ever further afield. At first they quarried the picturesque corners of countries close to home – France, the Low Countries and the Rhineland, and then Spain and Portugal. But gradually even more distant destinations, such as Egypt, North Africa and the Holy Land, were added to the list.

At times artists travelled to new destinations in response to a specific commission from their entrepreneurial publishers, who were ever eager to exploit or plug a new gap in an increasingly competitive market. The publisher Charles Heath, for example, who

helped promote the new 'annuals' (a fashionable type of pocket literature increasingly devoted by the 1820s to the illustration of Continental views engraved on the recently introduced steel plates), was capitalising on the established popularity of France when, in the latter part of the decade, he commissioned from Turner a sequence of drawings of the rivers Loire and Seine (pl. 91). On the other hand, when, in 1837, the proprietor of the *Landscape Annual* commissioned James Holland (1799–1870) to make views in the little-visited country of Portugal (pl. 95), he was hoping to tap a new market.[28] Some artists, lured by the excitement of new destinations but nevertheless aware of the market potential of reproductive (especially, by this date, lithographic) illustrations, found themselves in friendly competition in the race to publish their drawings on their return: *Lewis's Sketches and Drawings of the Alhambra* (see pl. 103) by J. F. Lewis (1805–76) appeared on the market two years before *Picturesque Sketches in Spain* by David Roberts (1796–1864), although both artists had been in Spain at much the same time (see pl. 96).[29]

Whatever the circumstances of a commission, for the artist the task was much the same as it had always been – to record and present a truthful and recognisable view. What most of this later generation have in common is the high quality of their architectural draughtsmanship: Holland, Roberts, Lewis and Thomas Shotter Boys (1803–74) all drew buildings with confidence and precision (pl. 94). Even the stylised vocabulary for buildings adopted by Samuel Prout (1783–1852) – a system of curls, dots and dashes drawn with the reed pen to indicate the crumbling surfaces of Gothic architecture – is applied over firm and careful underdrawing (pl. 99). (Given that Prout's interest resided more in texture and

Fig. 24 Thomas Shotter Boys, *The Boulevard des Italiens, Paris*, 1833, watercolour heightened with bodycolour and gum, 37.2 x 59.7. British Museum, London

ornament than in structure and form, it is perhaps surprising that his work was greatly admired by his one-time pupil John Ruskin (1819–1900), whose own mature architectural drawings, for example plate 102, are considerably more searching than Prout's. Curiously, Ruskin chose to ignore Cotman's architectural drawings (pl. 84), which have an analytical quality much closer to his own.)

However, where these later topographers are less consistent is in their use of the human figure. For many of them the figure appears in a subordinate role. In David Roberts's watercolours, people are usually dwarfed by the scale of the architecture, particularly the sheer massiveness of Egyptian temples (fig. 24). For artists like Richard Parkes Bonington and W. J. Müller (1812–45), other factors, such as light, shadow and colour, are usually of equal if not greater importance (pl. 85, 98). In watercolours by Prout, figures may be more prominent, but they are hardly convincing: conspicuous in their colourful costumes, and massed together in calculated groups under Gothic portals or clustered in market squares (pl. 99), they are puppets that appear to have been lifted from the pages of one of his own drawing manuals (fig. 25) to evoke the flavour of the Continental picturesque. The one really accomplished figure draughtsman of the period is Thomas Shotter Boys, whose realistic and elegant characters enlivening the streets of Paris (pl. 94 and fig. 26) helped to breathe new life into the genre of urban topography, although they lack the sheer vitality and vibrancy of Turner's figures in his Parisian views (pl. 91).

Indeed, despite the number of artists who were still able to make a living from topography at this date, with the exception of Turner (and of Cotman, who returned to topography in the 1820s after a period in which he concentrated on etching; see Section IV), the truly innovative minds were devoting their energies to other branches of landscape painting. Edward Lear is, perhaps, the last of the great topographers (he often referred to his watercolours and oils as his 'Topographies'[30]). Covering an astonishing range of destinations, this prolific watercolourist produced compositions of striking simplicity and impressive originality – 'penning-out' in the studio and then adding broad colour washes to the pencil drawings he had made on the spot (pl. 104, 105), or making more elaborate finished watercolours many years later (pl. 106). Yet Lear's linear style of watercolour is sometimes seen as a reversion to the 'tinted drawing' manner of a hundred years earlier.[31]

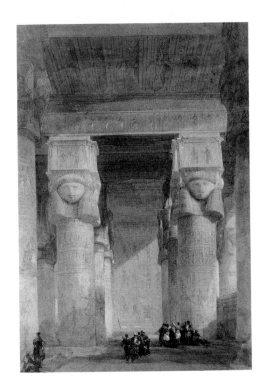

Fig. 26
David Roberts, *Ancient Tartyris, Upper Egypt*, 1848, watercolour, 48.2 x 34.
Aberdeen Art Gallery

In any case, the days of the topographer as artist-recorder were numbered. At the outbreak of the Crimean War in 1854, William Simpson (1823–99) was commissioned by Colnaghi & Son to make sketches of the campaign for a series of lithographs, the first British war artist to work in such a capacity. His *Valley of Vardan* (pl. 107) is from the six-week trip he made in Caucasia in the company of Henry Pelham, 5th Duke of Newcastle, following the fall of Sevastopol in 1855.[32] But Simpson was not the only sponsored recorder of this war, for the photographer Roger Fenton (1819–69) was backed by the Agnew brothers to make records of the campaign. And although at this date the camera was not sufficiently advanced to record scenes of action, its value as faithful witness was fully appreciated when Fenton's photographs were exhibited back in Britain: 'Whatever he represents from the field must be real' declared *The Times*.[33] The traditional role of the watercolourist as topographer was about to be usurped.

A. L.

Fig. 25 Samuel Prout, *A Group of Figure Studies*, plate 1 from *Prout's Microcosm*, 1841, lithograph, 24.1 x 33.6 (image). British Museum, London

1 J. Knowles, *The Life and Writings of Henry Fuseli*, London 1831, II, p. 217. Fuseli was referring to topography in oil painting, but he would no doubt have held exactly the same views about topography in watercolour.
2 R. & S. Redgrave, *A Century of Painters of the English School*, London 1866, I, p. 374.
3 Ibid.
4 J. Christian, 'Paul Sandby and the Military Survey of Scotland', *Mapping the Landscape*, exh. cat. ed. N. Alfrey & S. Daniels; Nottingham, University Art Gallery, 1990, pp. 21–2 and fig. 4.
5 A large encampment on Cox Heath took place in 1778, the date usually assigned to this drawing. However, it was suggested by A. P. Oppé (*The Drawings of Paul and Thomas Sandby in the Collection of H. M. the King*, Oxford & London 1947, pp. 47–8) that the

drawing may show an earlier encampment on the same Heath in 1754 – and certainly the style of the drawing would suggest a date in the mid-1750s.
6 For others in the group, see Oppé, *The Drawings of Paul and Thomas Sandby*, cat. 246 and 248–50. Sandpit Gate was the lodge in which Thomas Sandby lived in the early 1750s during the remodelling of Cumberland Lodge. The inscribed date, 1754, on *The Kitchen At Sandpit Gate* may well have been added in later years, and indeed 1751 seems more probable for the whole group. See *The Art of Paul Sandby*, exh. cat. by B. Robertson; New Haven, Yale Center for British Art, 1985, pp. 39–40.
7 Sandby's son, Thomas Paul Sandby, had settled at Englefield Green, near Windsor, in 1798. There are other watercolours of

Englefield Green in the collection of Nottingham Castle Museum, and one at Yale. See *The Art of Paul Sandby*, pp. 96–8 and fig. 129.

8 The Sandby brothers relied on a repertory of studies for the figures in their landscapes, many of which are now in the collections of the Royal Library at Windsor and in the British Museum; see *British Landscape Watercolours, 1600–1860*, exh. cat. by L. Stainton; London, British Museum, 1985, p. 25. Paul often supplied the figures in Thomas's drawings.

9 With the exception of the Irish portrait painter Thomas Hickey, who accompanied Alexander as official oil painter on the expedition, but who seems to have produced very little for his two years' travelling. See *William Alexander: An English Artist in Imperial China*, exh. cat. by P. Conner; Brighton, Royal Pavilion, Art Gallery & Museums, 1981, p. 9, and *The Fitch Collection*, exh. cat. London, The Leger Galleries, 1988, under cat. no. 26.

10 Quoted by A. Wilton, 'William Pars and his Work in Asia Minor', in Chandler's *Travels in Asia Minor, 1764–1765*, ed. E. Clay, London 1971, pp. xxiv–xxv.

11 Alexander also made many individual watercolour studies of Chinese figures, for example of soldiers, standard-bearers, actors and tradesmen; see *William Alexander: An English Artist in Imperial China*, cat. 5–6, 33–4, 37, 50 and 52–3.

12 Wilton, 'William Pars', pp. xxvii–xxviii, compares the figures by Giovanni Battista Borra in Robert Wood's publications on Palmyra and Balbec, which, when they appear at all, are generally inconspicuous, while Borra's Turks 'strike attitudes like actors in a Baroque stage setting'. Figures measuring ruins are found in Stuart's *View of Pola: Arch of the Sergii (Porta Aurata)*; see the *Catalogue of the Drawings Collection of the RIBA*, 20 vols, 1969–89, volume 'S', ed. M. Richardson, London 1976, no. 20.

13 See Jones's 'Memoirs', ed. A. P. Oppé, *The Walpole Society*, xxxii, 1951, p. 55, and

Travels in Italy, 1776–1783; Based on the 'Memoirs' of Thomas Jones, exh. cat. by F. W. Hawcroft; Manchester, Whitworth Art Gallery, 1988.

14 'Warwick' Smith's trip to Italy, which lasted from 1776 to 1781, was financed by George Greville, 2nd Earl of Warwick – hence Smith's nickname. This patronage appears to have been of the most liberal kind, and in no way imposed restrictions on Smith's style. On the contrary, Smith's Italian subjects are usually considered among his finest watercolours, while his work done after his return to England is much more conventional (*British Landscape Watercolours, 1600–1860*, p. 34).

15 The finest of Smith's Roman watercolours remained in the Warwick collection until 1936, when they were acquired by the British Museum. Towne's work was little appreciated during his lifetime because of his unorthodox style and unusual approach to composition.

16 On his death in 1816 Towne left his Italian watercolours to the British Museum, the first such bequest by an artist (*British Landscape Watercolours, 1600–1860*, p. 27). It is known that Turner was a visitor to the Print Room: there exists a watercolour portrait of him by J. T. Smith (the Print Room's Keeper 1816–33) dating from the 1820s, in which he is seen examining items there (reproduced in J. Russell & A. Wilton, *Turner in Switzerland*, Zurich 1976, p. 30; the portrait was subsequently lithographed by Smith as well). It seems more than likely that Turner would have heard about this unusual bequest, either from J. T. Smith or from William Alexander, the outgoing Keeper in 1816 (the year of the bequest itself) and an old friend of Turner's. Interestingly there is also in the British Museum a similar view of SS Giovanni e Paolo by 'Warwick' Smith (reproduced in *British Landscape Watercolours, 1600–1860*, plate 21) – probably made on the same occasion as that by Towne, since the two artists often went sketching together – although this did not enter the Museum's collection until 1936.

17 For Sandby's influence in opening up Scotland, see Christian, 'Paul Sandby and the Military Survey of Scotland', and *The Discovery of Scotland: The Appreciation of Scottish Scenery through Two Centuries of Painting*, exh. cat. by J. Holloway & L. Errington; Edinburgh, National Gallery of Scotland, 1978, chapter 4. Sandby's tour to North Wales with Sir Watkin Williams Wynn in 1771 was probably the first 'Picturesque tour' undertaken in that region for the purpose of admiring the wild scenery, and was particularly influential thanks to the three sets of aquatints of Welsh views he produced on his return, which were published in 1775–7 (*British Landscape Watercolours, 1600–1860*, p. 24).

18 Although, of course, Paul Sandby had exhibited watercolours at the Society of Artists in the 1760s before the Royal Academy was founded; see L. Herrmann, *British Landscape Painting of the Eighteenth Century*, London 1973, p. 40.

19 J. L. Roget, *A History of the 'Old Water-Colour Society'*, London 1891, i, p. 43.

20 It has recently been discovered that Turner worked as a scene-painter at the Pantheon in the summer of 1791, so he no doubt took a particular interest in the fate of the building; see C. Price, 'Turner at The Pantheon Opera House, 1791–2', *Turner Studies*, vii/2, 1987, pp. 2–8. Price argues that a powerful triumvirate on the Pantheon's committee, which included the Prince of Wales, conspired to have the theatre burned down so as to recoup via an insurance claim some of the losses the theatre was sustaining.

21 See *Panoramania*, exh. cat. by R. Hyde; London, Barbican Art Gallery, 1988–9, p. 87.

22 Girtin's viewpoint was stated to be the top of the British Plate Glass Manufactory on the west side of Albion Place, at the south end of Blackfriars Bridge, and thus only a few yards away from that adopted by Robert Barker – the roof of the Albion Mills – for his London panorama (see *Panoramania*, pp. 62 and 67).

23 Quoted in *British Landscape Watercolours, 1600–1860*, p. 44.

24 This idea, that the *Rue St Denis* study was for a pantomime by Thomas Dibdin, is questioned in *Thomas Girtin, 1775–1802*, exh. cat. by S. Morris; New Haven, Yale Center for British Art, 1986, p. 27, and by A. Wilton in *British Watercolours, 1750–1850*, Oxford 1977, p. 188.

25 The workman in *St Augustine's Parade* were taken from volume i, 'Gravel Diggers' (plate 1) and 'Paviours' (plate 1); see *The Bristol Landscape: The Watercolours of Samuel Jackson (1794–1869)*, exh. handlist, Bristol, City Art Gallery, 1986, cat. 2. The *View of the Hotwells*, and Jackson's use of Pyne's *Microcosm* in general, is discussed in the same exhibition's catalogue, by F. Greenacre & S. Stoddard, pp. 96–7.

26 See the introduction by A. Wilton to E. Shanes, *Turner's Picturesque Views in England and Wales, 1825–1838*, London 1979, p. 6.

27 E. Shanes, *Turner's England, 1810–38*, London 1990, p. 194.

28 M. Hardie, *Watercolour Painting in Britain*, iii, Woodbridge 1968, p. 32.

29 Although some of Roberts's Spanish views began to appear in the *Landscape Annual* from 1835 (see F. Irwin, 'The Scots Discover Spain', *Apollo*, xcix, 1974, p. 355). *Lewis's Sketches and Drawings* was followed by *Lewis's Sketches of Spain and Spanish Character* the next year.

30 Hardie, *Watercolour Painting in Britain*, iii, p. 65.

31 Ibid., and *British Landscape Watercolours, 1600–1860*, p. 75.

32 See *Mr William Simpson of 'The Illustrated London News': Pioneer War Artist 1823–1899*, exh. brochure; London, Fine Art Society, 1987.

33 B. Newhall, *The History of Photography*, 4th edn, New York 1981, p. 67.

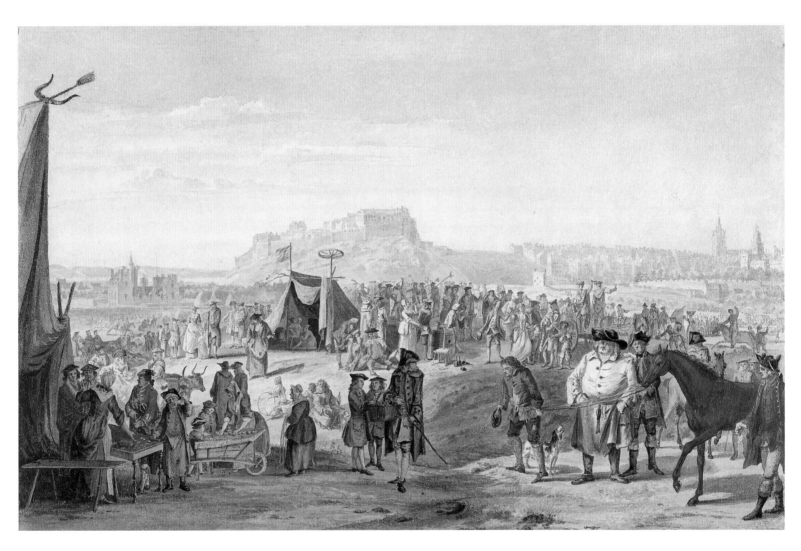

48 Paul Sandby, *Horsefair on Bruntsfield Links, Edinburgh in the Background*, 1750 (cat. 249)

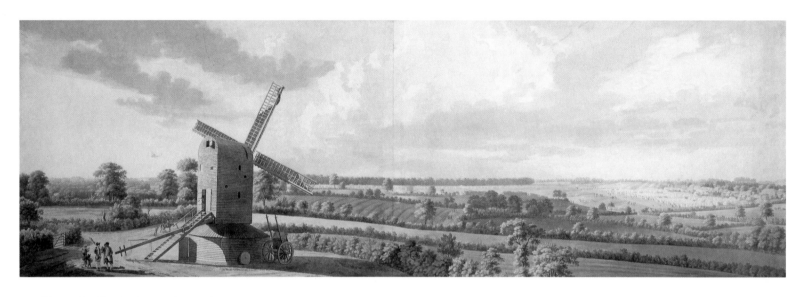

49 Thomas Sandby, *The Camp on Cox Heath*, (?) 1754 (cat. 260)

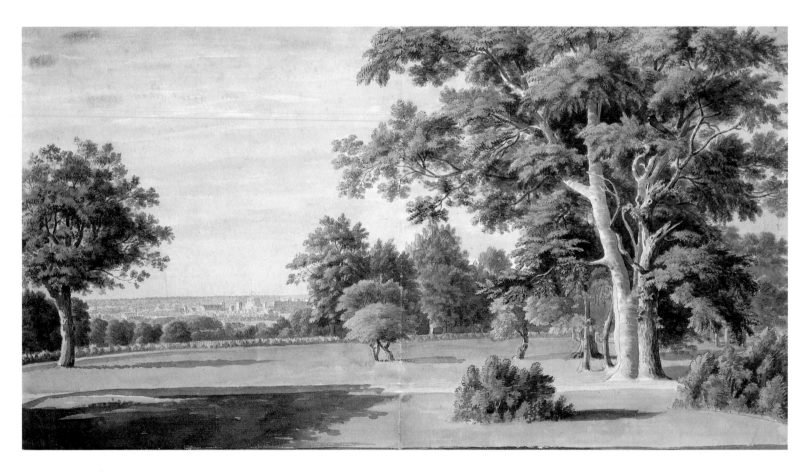

50 Thomas Sandby, *Windsor, from the Lodge Grounds in the Great Park*, early 1750s (cat. 259)

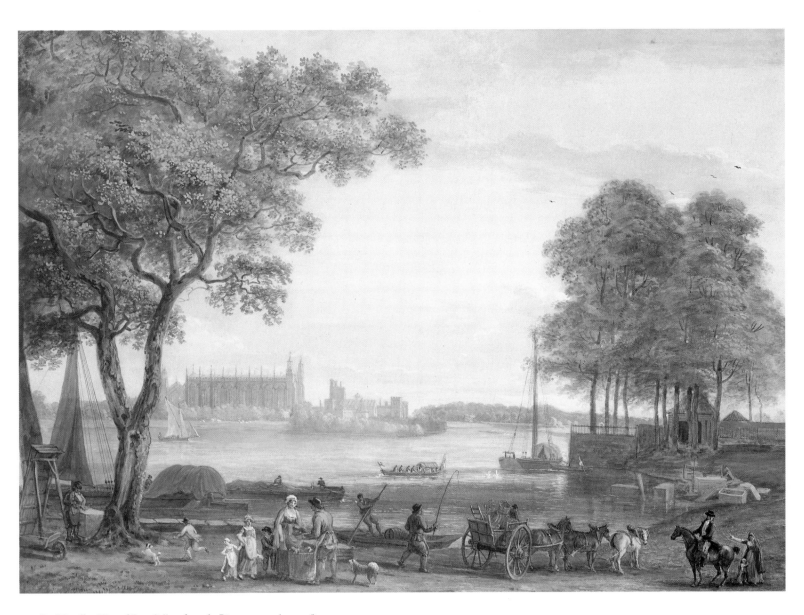

51 Paul Sandby, *View of Eton College from the River, c.* 1790 (cat. 256)

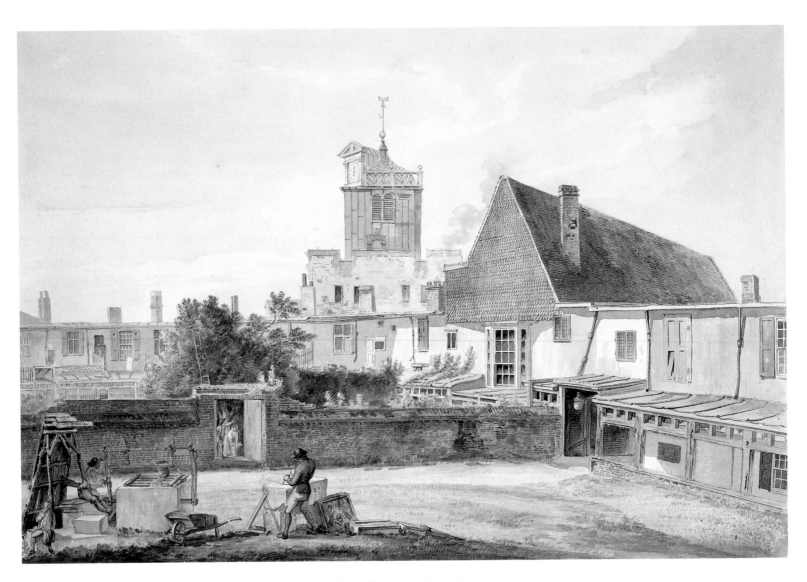

52 Paul Sandby, *Windsor: The Curfew Tower from the Horseshoe Cloister, Windsor Castle, c.* 1765 (cat. 252)

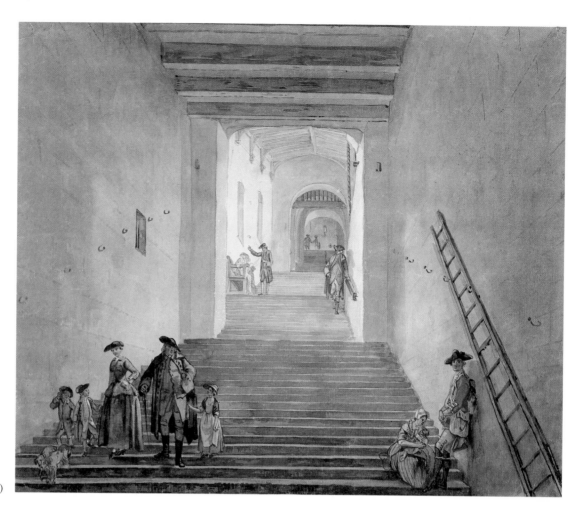

53 Paul Sandby, *Windsor: View of the Ascent to the Round Tower, Windsor Castle, c.* 1770 (cat. 253)

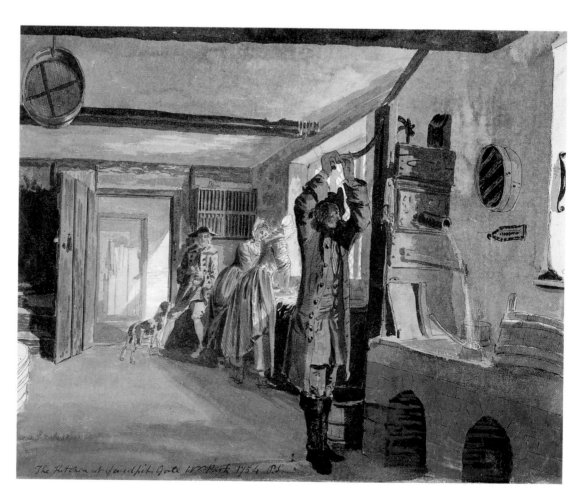

54 Paul Sandby, *Windsor: The Lodge Kitchen at Sandpit Gate, c.* 1751 (cat. 251)

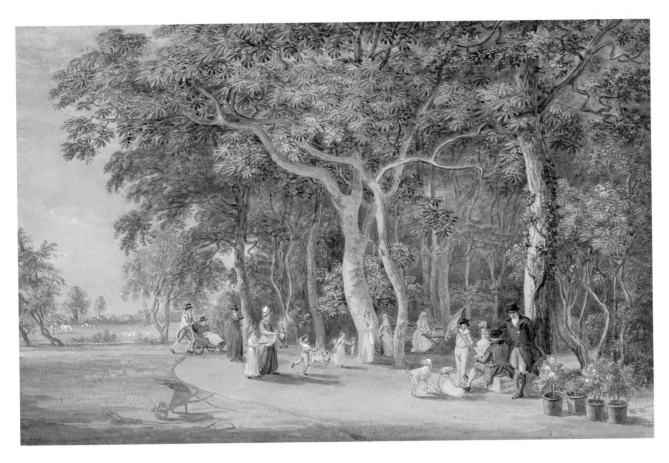

55 Paul Sandby, *Tea at Englefield Green, near Windsor, c.* 1800 (cat. 258)

56 William Pars, *A Picnic Party in Ireland,* 1771 (cat. 232)

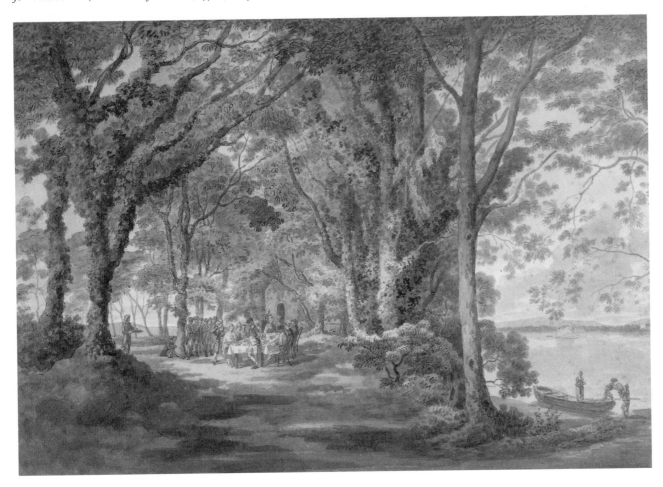

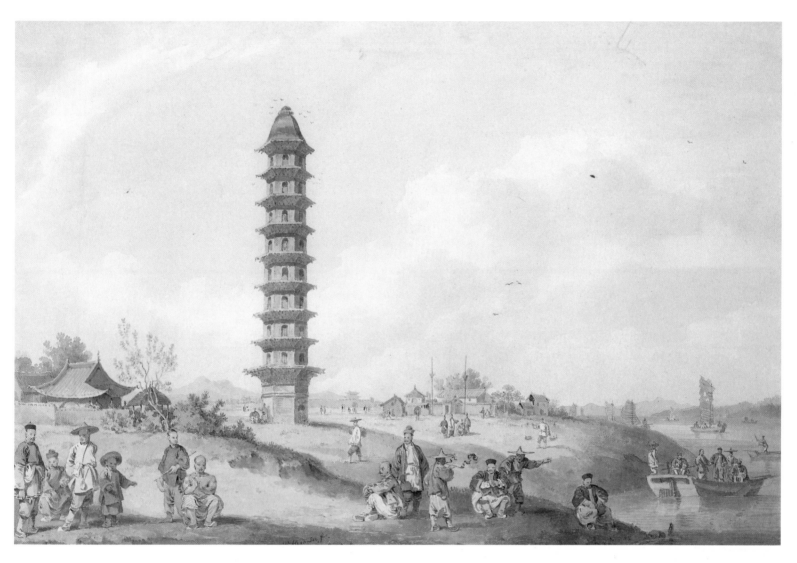

57 William Alexander, *The Pagoda of Lin-ching-shih, on the Grand Canal, Peking, c.* 1795 (cat. 3)

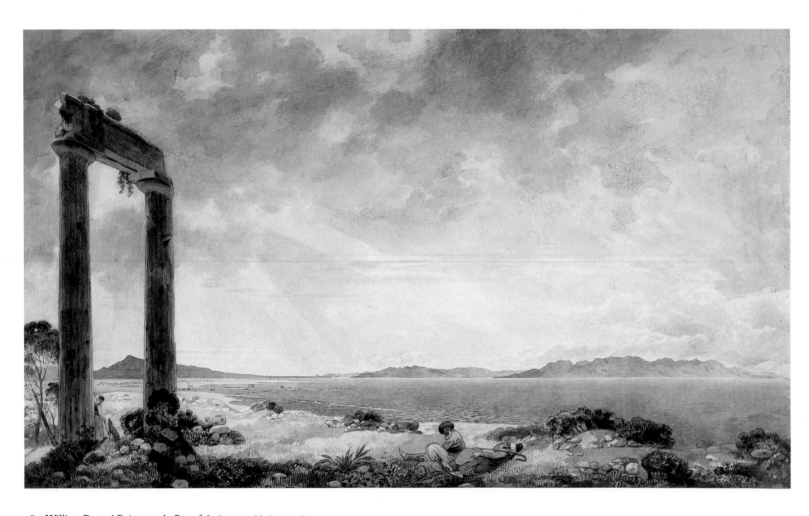

58 William Pars, *A Ruin near the Port of Aegina*, *c.* 1766 (cat. 231)

59 James 'Athenian' Stuart, *Athens: The Monument of Philopappos*, c. 1755 (cat. 266)

60 James 'Athenian' Stuart, *Salonica: The Incantada or Propylaea of the Hippodrome*, c. 1755 (cat. 267)

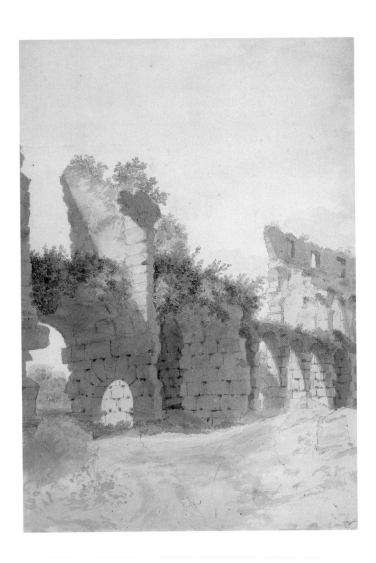

61 Allan Ramsay, *Study of Part of the Ruins of the Colosseum*, 1755 (cat. 235)

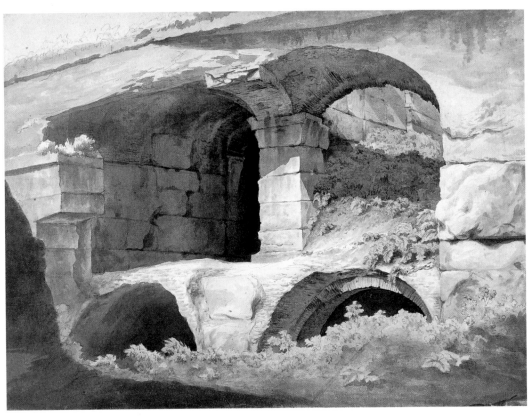

62 John 'Warwick' Smith, *Study of Part of the Interior of the Colosseum*, 1776 (cat. 265)

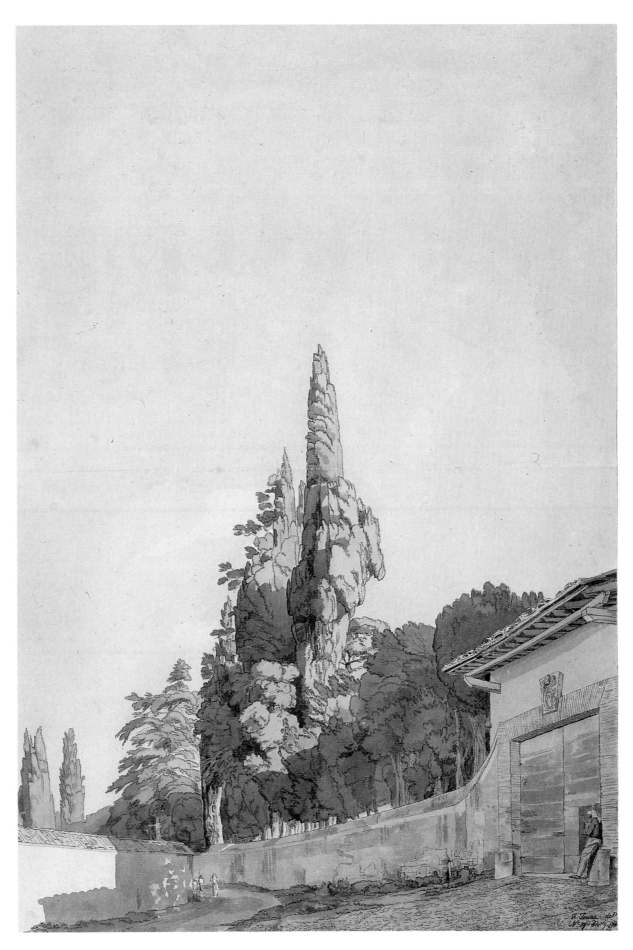

63 Francis Towne, *Rome: A Gateway of the Villa Ludovisi*, 1780 (cat. 268)

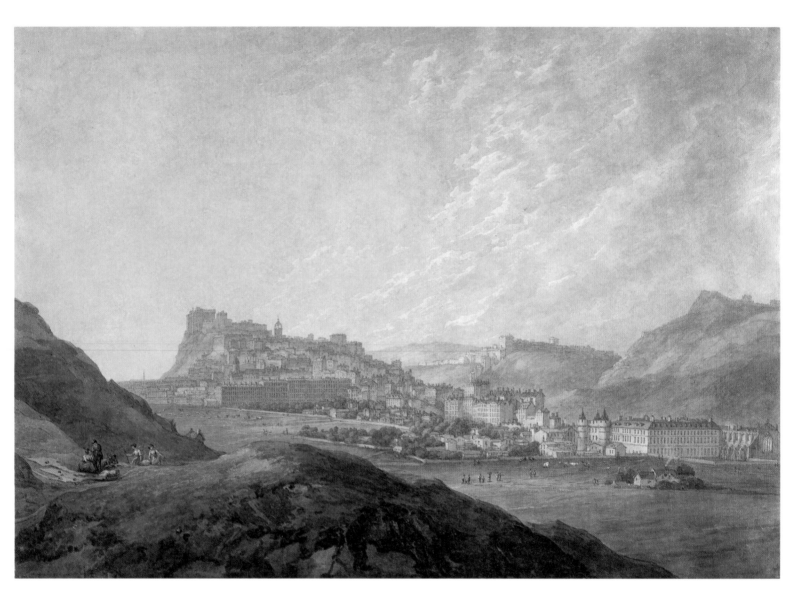

64 Thomas Hearne, *Edinburgh Castle from Arthur's Seat*, c. 1778 (cat. 163)

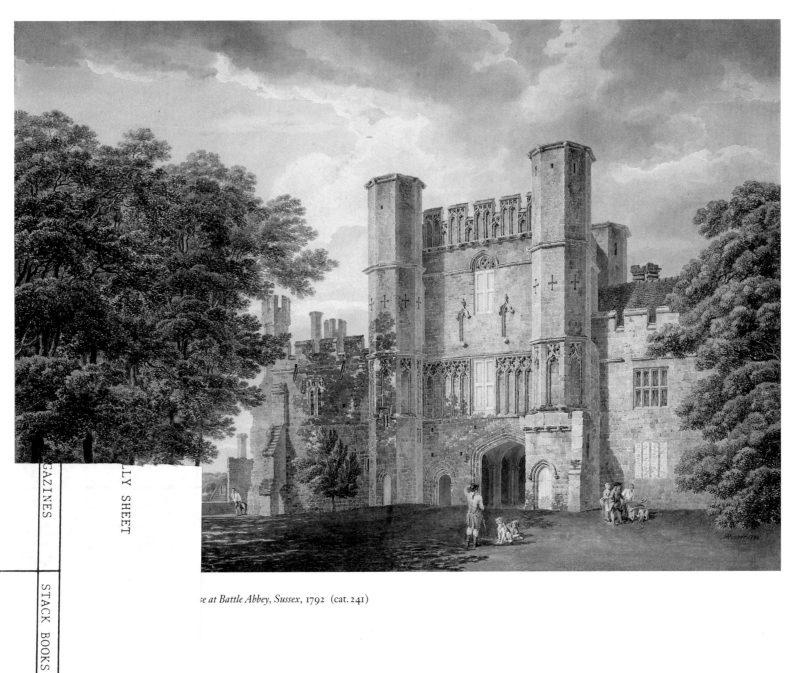

...se at Battle Abbey, Sussex, 1792 (cat. 241)

67 Thomas Malton Jnr, *St Paul's Church, Covent Garden, London, from the Piazza*, c. 1787 (cat. 209)

68 Joseph Mallord William Turner, *The Pantheon, Oxford Street, London*, 1792 (cat. 277)

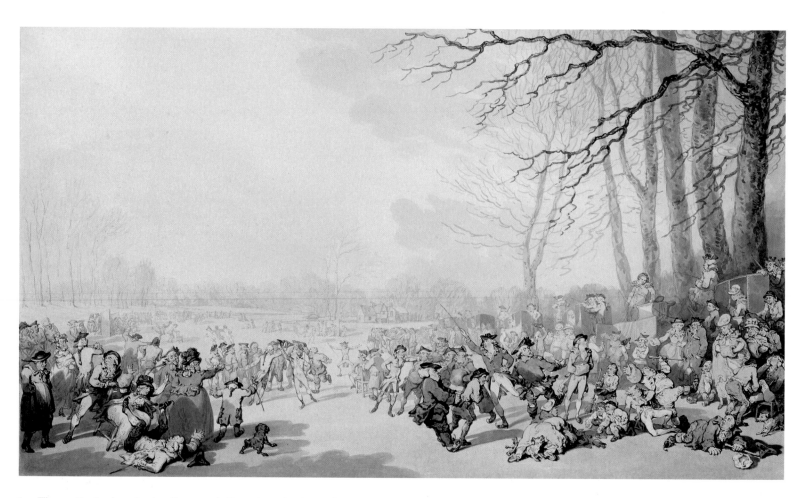

69　Thomas Rowlandson, *London: Skaters on the Serpentine*, 1784　(cat. 243)

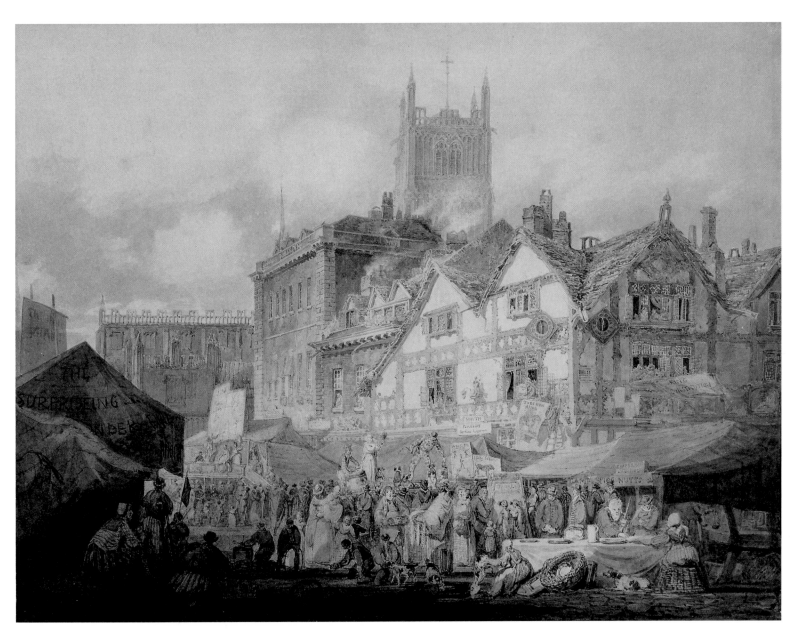

70 Joseph Mallord William Turner, *Wolverhampton, Staffordshire*, 1796 (cat. 278)

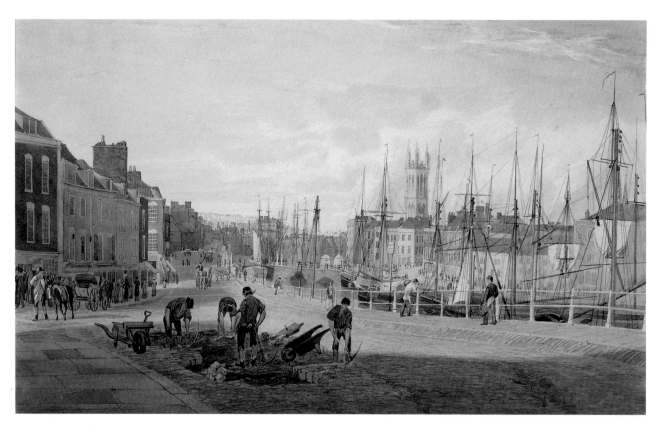

71 Samuel Jackson, *Bristol: St Augustine's Parade*, *c.* 1825 (cat. 188)

72 John Varley, *Market Place at Leominster, Hereford*, 1801 (cat. 316)

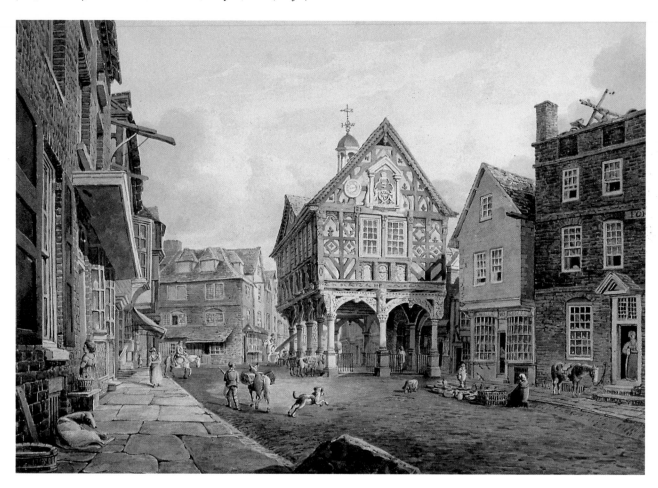

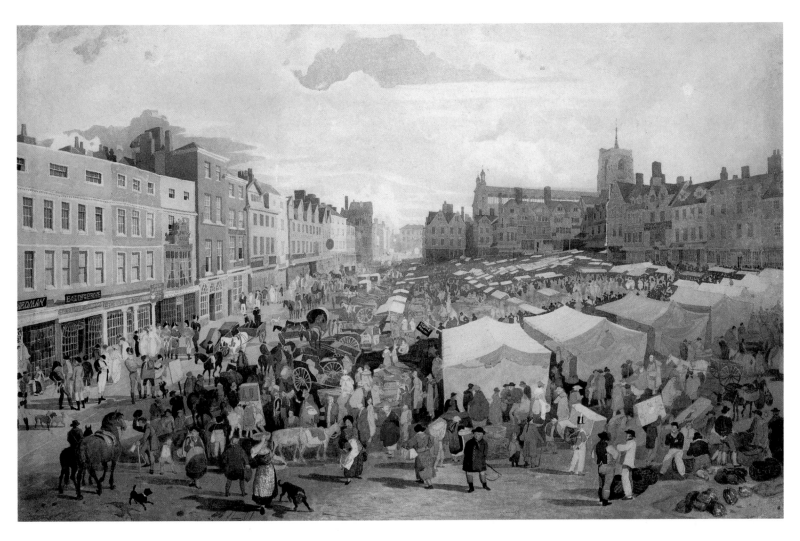

73 John Sell Cotman, *Norwich Market Place, c.* 1809 (cat. 52)

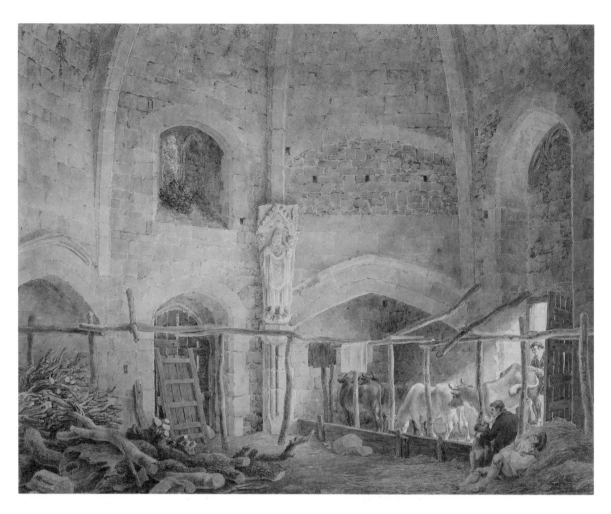

74 Michael 'Angelo' Rooker, *Interior of the Abbot's Kitchen, Glastonbury,* c. 1795 (cat. 242)

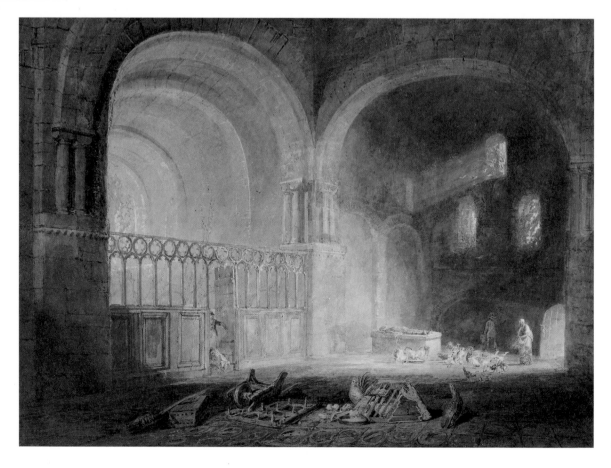

75 Joseph Mallord William Turner, *Transept of Ewenny Priory, Glamorganshire,* 1797 (cat. 279)

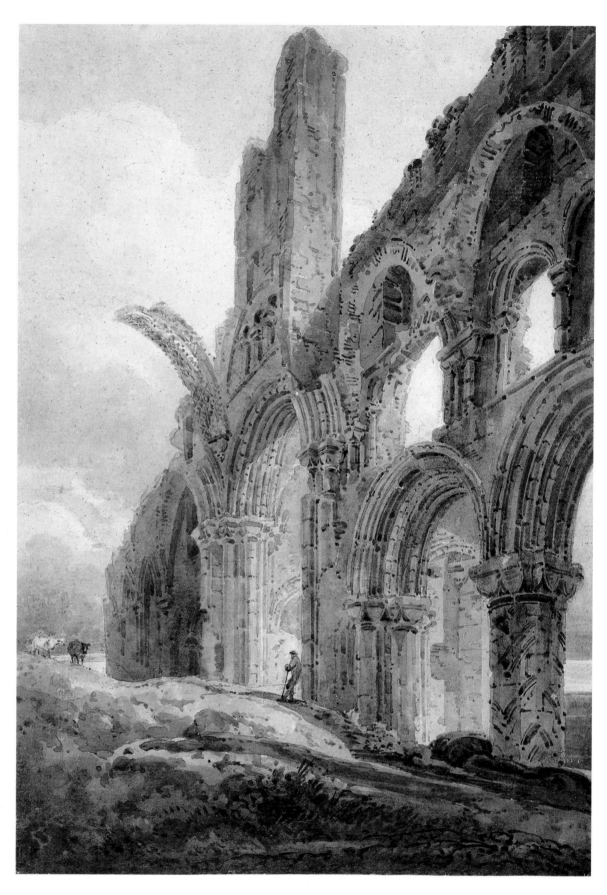

76 Thomas Girtin, *Lindisfarne*, *c.* 1798 (cat. 139)

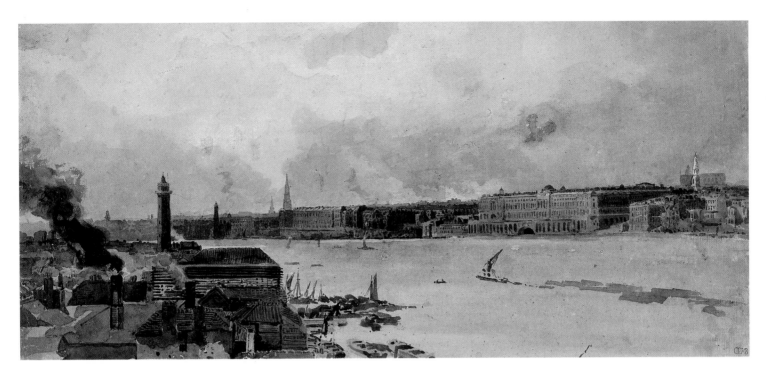

77 Thomas Girtin, *London: The Thames from Westminster to Somerset House, c.* 1801 (cat. 149)

78 Thomas Girtin, *London: The Albion Mills, c.* 1801 (cat. 148)

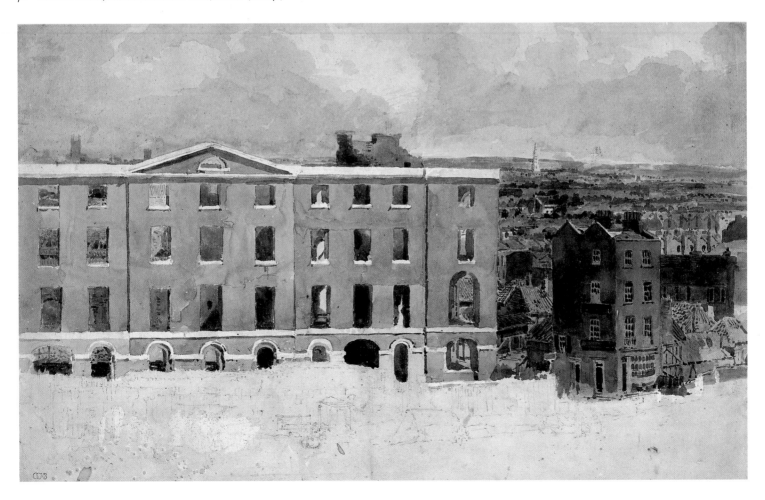

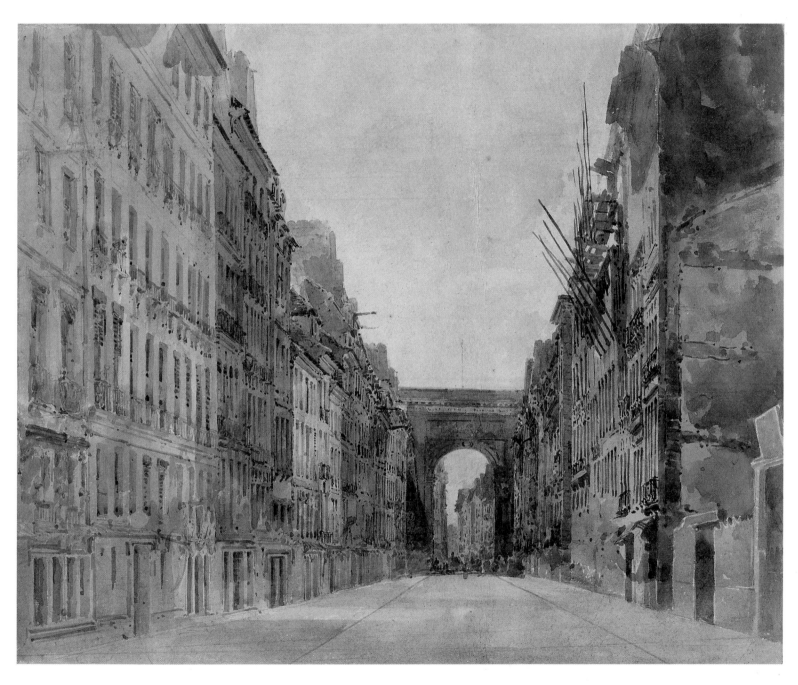

79 Thomas Girtin, *Paris: Rue St Denis*, 1801–2 (cat. 151)

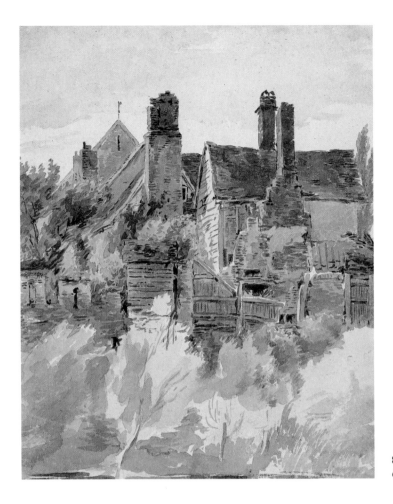

80 Henry Edridge,
Old Houses, with a Castellated Wall, c. 1810 (cat. 126)

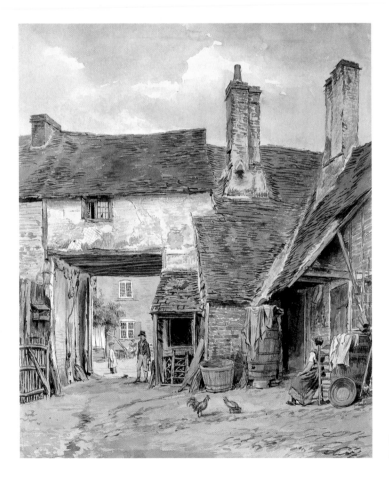

81 William Henry Hunt,
Old Bell Yard, Bushey, c. 1815 (cat. 178)

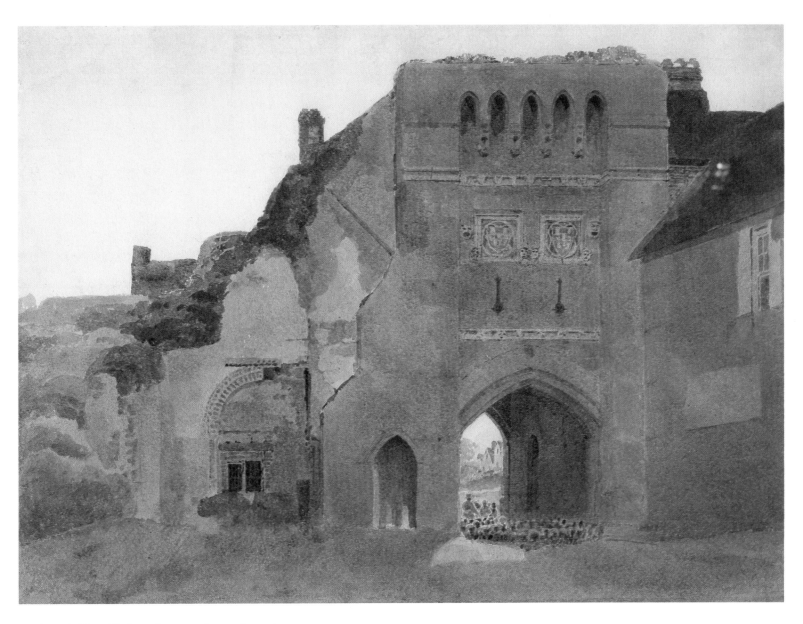

82 Peter de Wint, *Winchester Gateway*, c. 1810–15 (cat. 110)

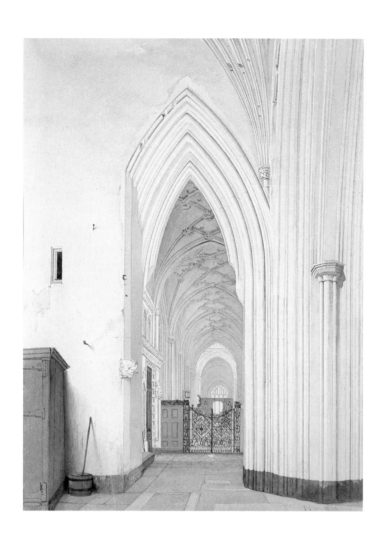

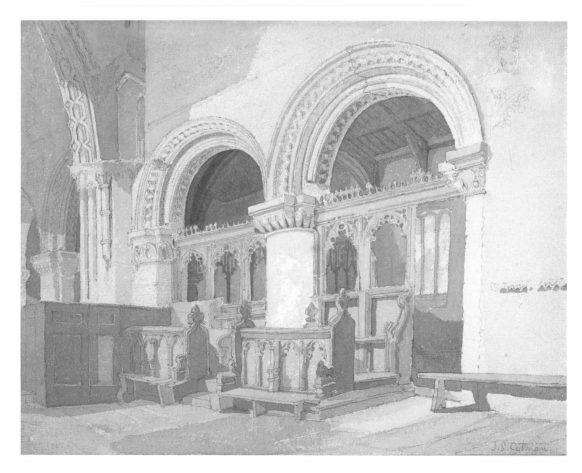

upper left
83 James Johnson, *Bristol: Interior of St Mary Redcliffe; the North Aisle looking East*, 1828 (cat. 191)

lower left
84 John Sell Cotman, *Interior of Walsoken Church, Norfolk: The Chancel, North Arcade*, c. 1811 (cat. 54)

85 Richard Parkes Bonington, *Verona: The Castelbarco Tomb*, 1827 (cat. 16)

86 Joseph Mallord William Turner, *Stamford, Lincolnshire, c.* 1828 (cat. 293)

87 Joseph Mallord
William Turner,
Caley Hall, Yorkshire,
c. 1818 (cat. 288)

88 Joseph Mallord William Turner, *Dartmouth Cove*, *c.* 1826 (cat. 292)

89 Joseph Mallord William Turner, *Kidwelly Castle, Carmarthenshire*, 1832–3 (cat. 295)

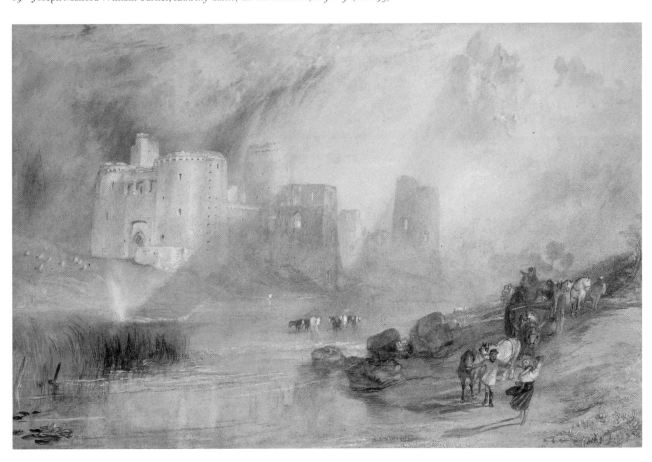

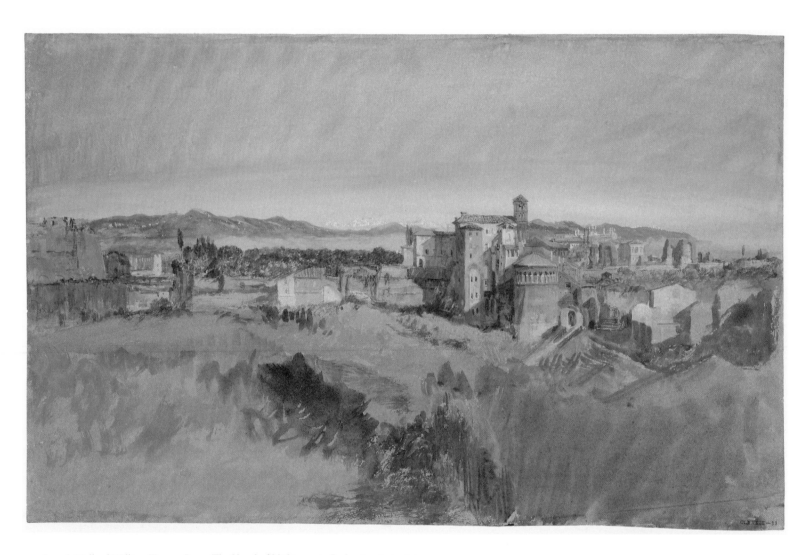

90 Joseph Mallord William Turner, *Rome: The Church of SS Giovanni e Paolo*, 1819 (cat. 289)

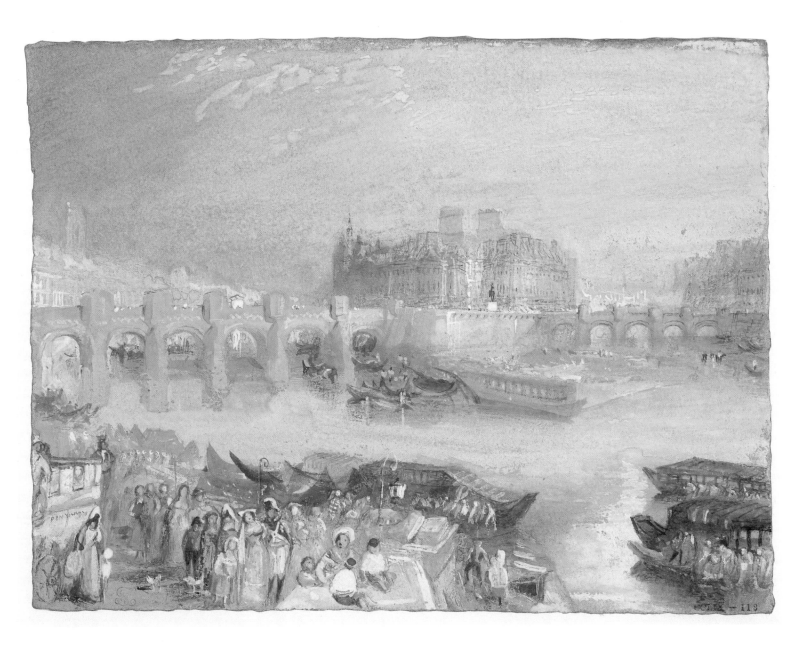

91 Joseph Mallord William Turner, *Paris: Pont Neuf and Ile de la Cité, c.* 1832 (cat. 294)

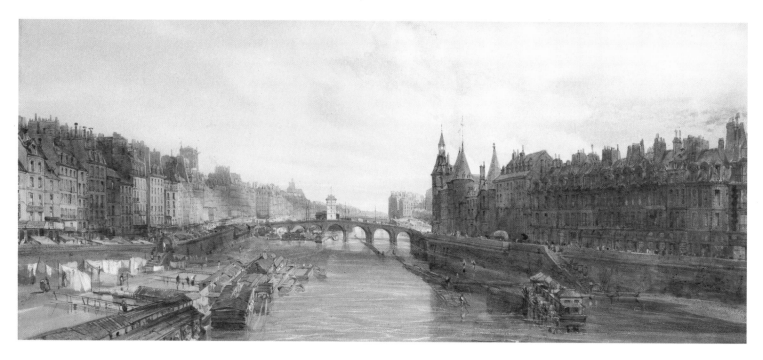

92 William Callow, *Paris: Quai de l'Horloge, c.* 1835 (cat. 21)

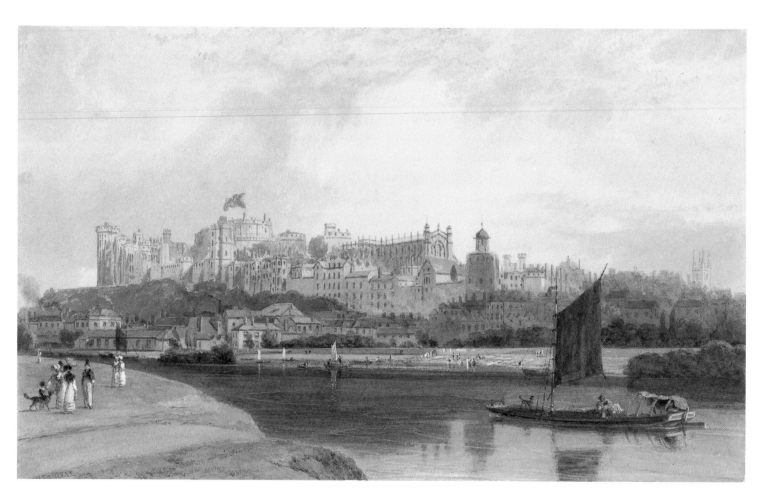

93 William Daniell, *Windsor*, 1827 (cat. 105)

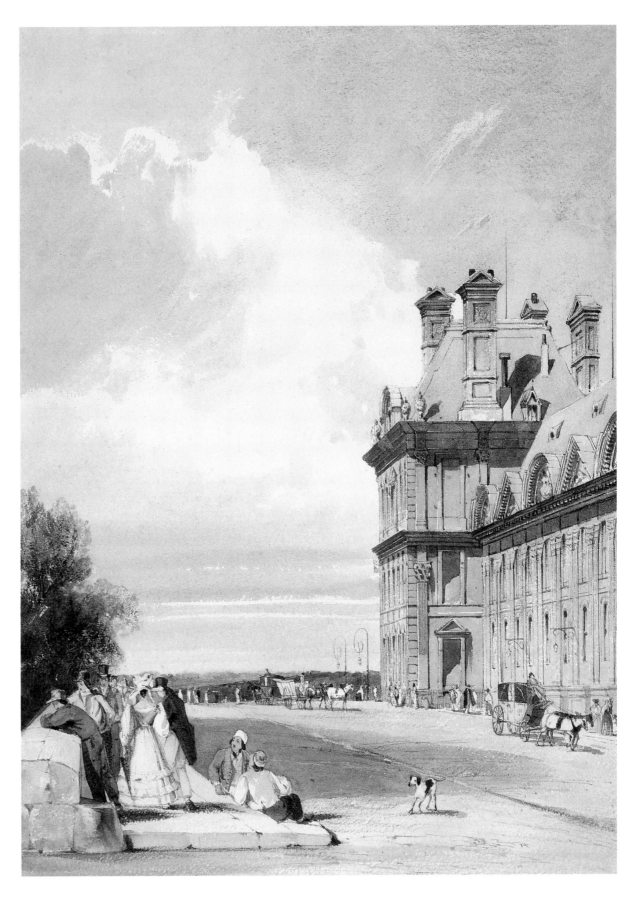

94 Thomas Shotter Boys, *Paris: Le Pavillon de Flore, Tuileries, c.* 1830 (cat. 20)

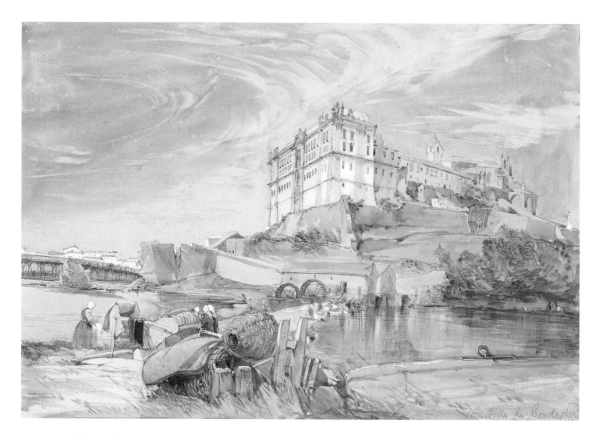

95 James Holland, *Villa do Conde near Oporto, Portugal*, 1837 (cat. 171)

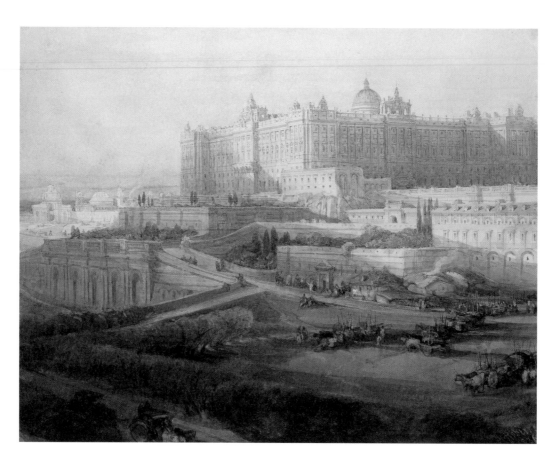

96 David Roberts, *Madrid: Palacio Real*, 1833–5 (cat. 237)

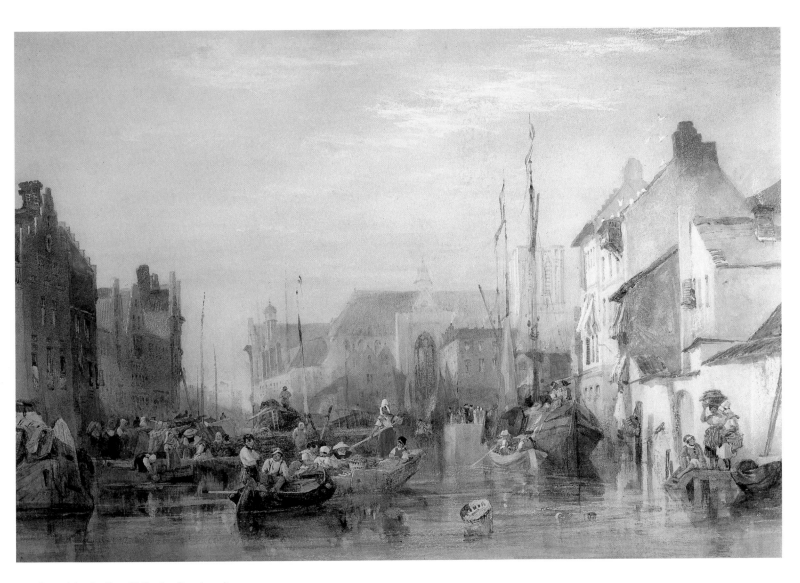

97 Samuel Austin, *Dort, Holland, c.* 1830 (cat. 4)

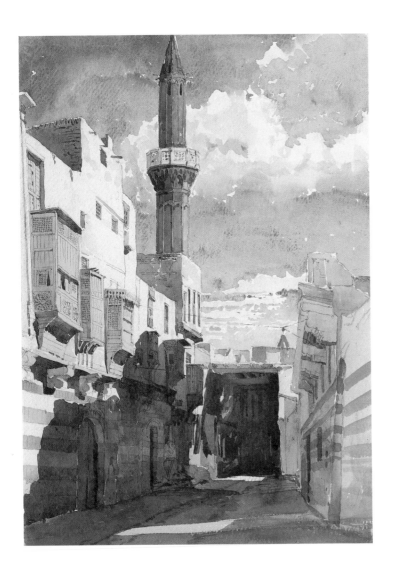

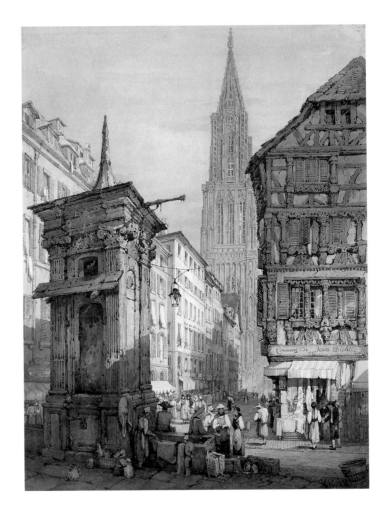

above
98 William James Müller, *Cairo: A Street with a Minaret, c.* 1838 (cat. 216)

right
99 Samuel Prout, *A View in Strasbourg,* (?) 1822 (cat. 233)

below

100 David Cox, *Paris: (?) A Street in the Marais, c.* 1829 (cat. 68)

right

101 David Cox, *Rouen: Tour d'Horloge*, 1829 (cat. 69)

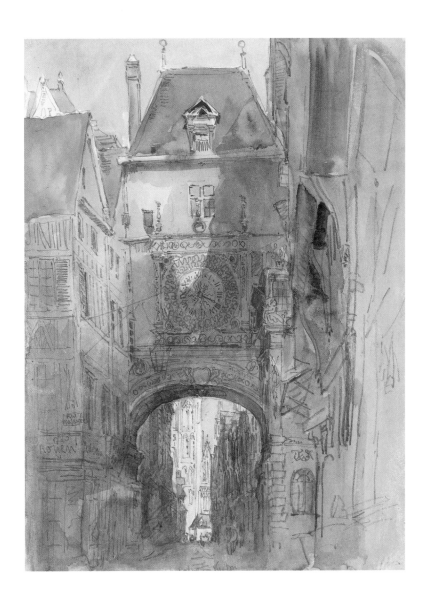

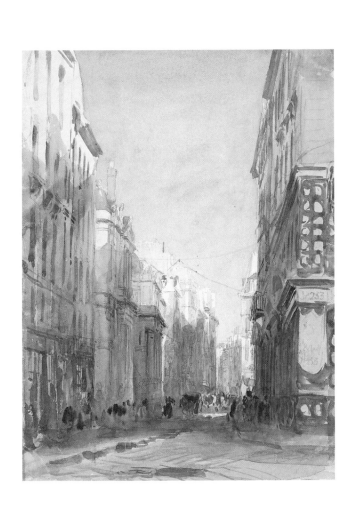

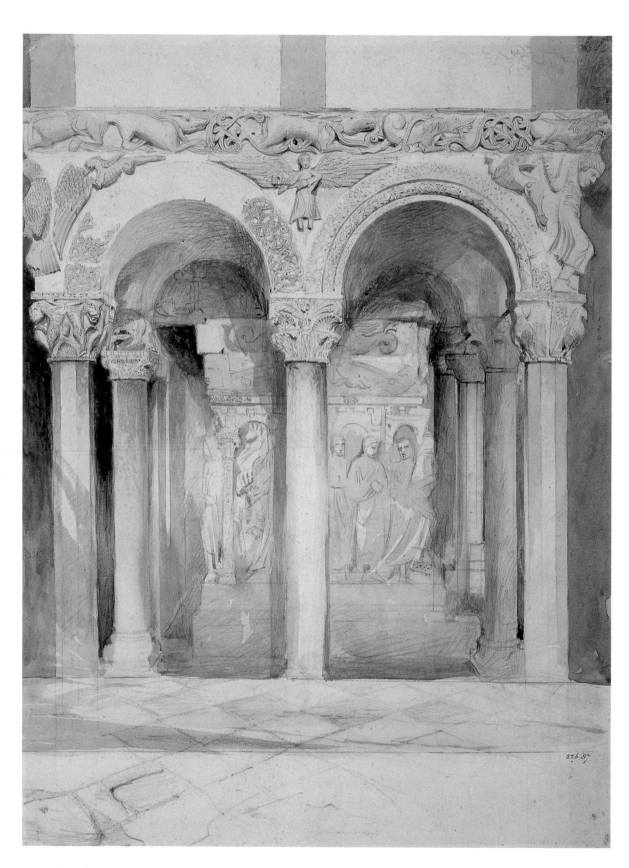

102 John Ruskin, *Milan: The Pulpit in the Church of S. Ambrogio,* (?) 1845 (cat. 244)

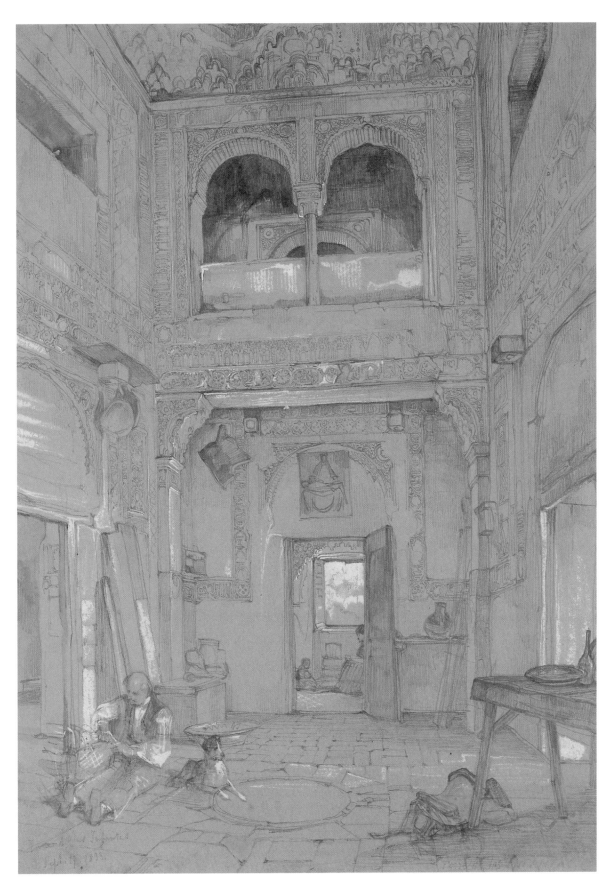

103 John Frederick Lewis, *Torre de las Infantas: One of the Towers in the Grounds of the Alhambra, Granada*, 1833 (cat. 197)

104 Edward Lear, *The Pyramids with Sphinx and Palms*, 1858 (cat. 193)

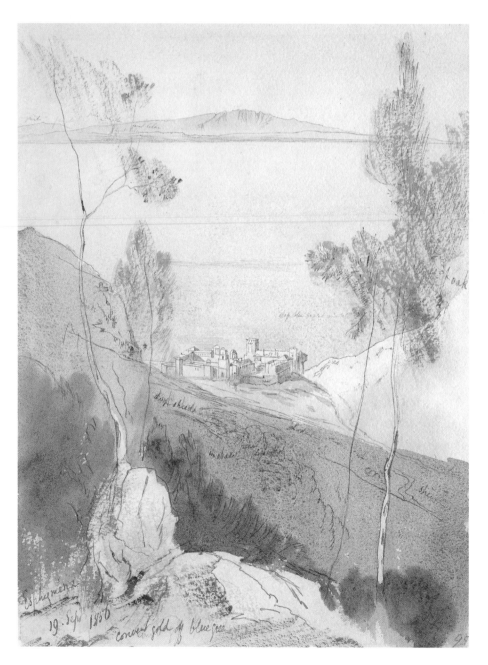

105 Edward Lear, *The Monastery of Esphigmenou, Mount Athos, Greece*, 1856 (cat. 192)

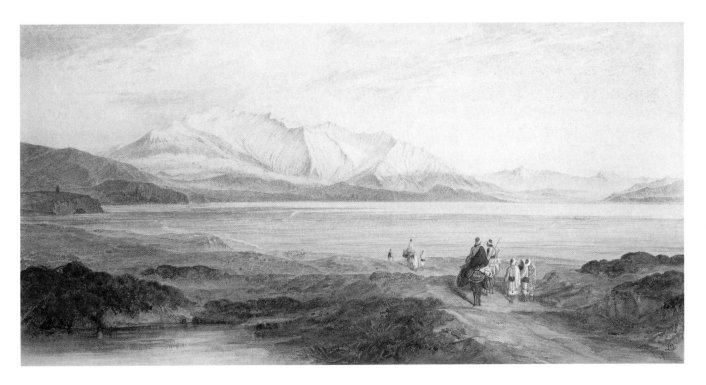

106 Edward Lear, *Mount Parnassus, with a Group of Travellers in the Foreground*, 1879 (cat. 194)

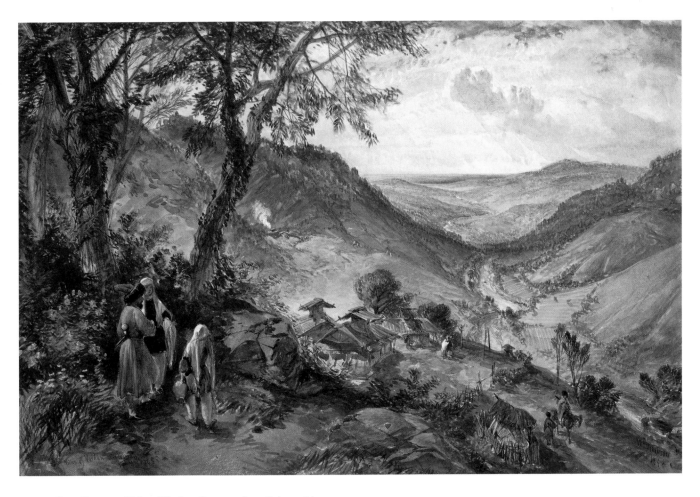

107 William Simpson, *Valley of Vardan, Caucasus*, 1855–8 (cat. 262)

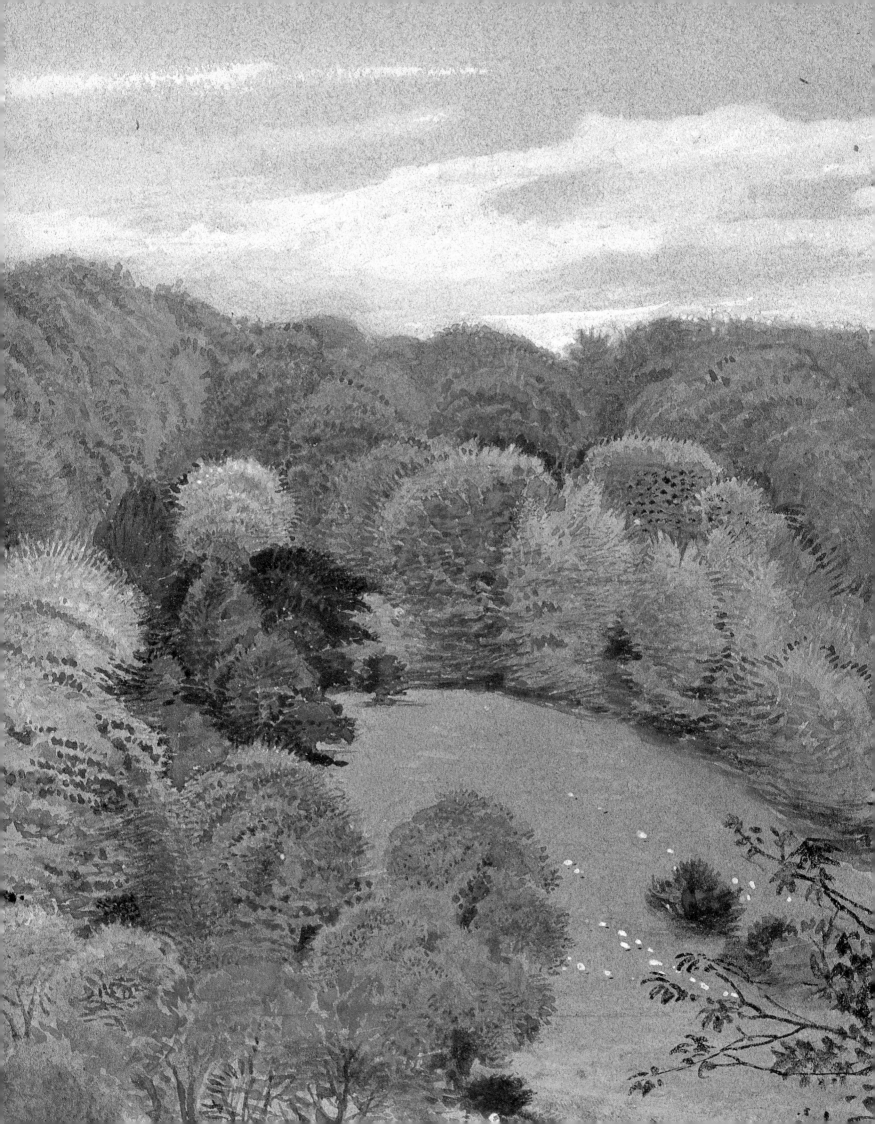

III

Naturalism

Around 1764 Thomas Gainsborough wrote an apologetic letter to Philip Yorke, 2nd Earl of Hardwicke, in which he declined to paint for Hardwicke '*real Views* from Nature in this Country'. Instead, Gainsborough recommended Paul Sandby as 'the only Man of Genius…who has employ'd his Pencil that way'.[1] By 'real views' Gainsborough was, of course, referring to topography (see Section II), but one can only speculate as to which aspects of Sandby's art he was thinking of when he praised him as a 'Man of Genius'. Being himself a painter of idyllic pastorals (pl. 11, 12), Gainsborough might have been thinking of the topographical views that Sandby cast in the language of Ideal landscape. He might, however, have been referring to the more informal and understated quality of Sandby's art and his sensitive and personal response to Nature, which, rightly, is said to have anticipated the thrust of naturalistic landscape art in the nineteenth century.[2]

Informal and atmospheric watercolours by Sandby exist from all stages of his career. A broadly handled, spontaneous study of Leith at sunset (fig. 27), made in 1747, proclaims his interest in the observation of naturalistic effects from an early date, and was to be followed by others of this sort. In 1773, for example, Sandby painted

On the Continent, however, there is evidence that British artists were making watercolour studies *en plein air* in the second half of the eighteenth century. Rome and its Campagna had for many years been the favoured location for artists sketching from Nature in oil, and many oil studies survive from this period by French painters, for whom the landscape *étude* had long been part of academic practice.[4] The British watercolourist Jonathan Skelton (*c.* 1735–59) was no doubt mindful of their example when he attempted a number of oil sketches outdoors in the vicinity of Rome in 1758, although he found himself defeated by the glare cast by the bright light on his paper.[5] Yet, we also know that during his time in Italy Skelton was 'taking all opportunities of making drawings from Nature, some in Indian ink, and some in Colours where I find the colouring very fine in Nature'.[6] *Study at Tivoli* (pl. 108), which concentrates on a small area of rocks and foliage along the river-bank, could easily have been made on such a sketching expedition. It is certainly more spontaneous in approach than Skelton's earlier British subjects, which, for all their apparent informality, reveal the desire to improve on Nature that is such an important characteristic of eighteenth-century landscape painting. The individual elements

Fig. 27
Paul Sandby, *Leith*, 1747,
pencil and watercolour,
16.2 x 45.3.
Ashmolean Museum, Oxford

a free and breezy watercolour showing a group of travellers narrowly escaping the tide rushing in at Briton Ferry, an episode he had witnessed that year during his journey in South Wales with Joseph Banks, Dr Daniel Solander and John Lightfoot, all of whom appear in the foreground (pl. 112). The studies Sandby made in Bayswater, London, where he lived from 1772, and still a suburban village at that date, are often remarkably direct in their observation, and like much of his other work seem to reflect his admiration for the unaffected qualities of Dutch landscape painting (pl. 111).[3] However realistically presented, all these watercolours are nevertheless scenic in the traditional manner, that is, they represent a slice of Nature confined into a limited space with an eye towards its pictorial suitability. Sandby rarely made studies of the individual components of Nature, although the trees (especially beech) he included in his finished watercolours are certainly convincing as individual species. And although clearly observed from Nature, watercolours such as *Briton Ferry* and *Bayswater* are unlikely to have been coloured on the spot.

making up Skelton's *In Greenwich Park* (pl. 14) have almost certainly been 'grouped at Fancy', as he put it when describing how he had painted another of his Greenwich views that same year.[7]

It is when working outdoors that artists have so often managed to transcend contemporary conventions,[8] partly because the sketch from Nature is a personal rather than a public statement, but also because the process of sketching itelf encourages a directness and spontaneity that working up compositions in the studio does not. Some of the most remarkable watercolour sketches made by a British artist in Italy at that time are those by the pastel portraitist John Downman (1750–1824), and their originality and freshness of approach is partly attributable, perhaps, to the fact that he was not principally a landscapist. Downman's *View over Nice* (pl. 110), which he made in 1773 en route to Italy with the painter Joseph Wright of Derby (1734–97), and taken, as the inscription indicates, 'out of my bedroom window … on a bad day', has an almost photographic instantaneity that invites comparison with similar studies of Neapolitan roof-tops made by Thomas Jones in oil almost ten years

Fig. 28 Thomas Jones, *Naples: The Capella Nuova outside the Porta di Chiaja*, 1782, oil on paper, 20 x 23.2 Tate Gallery, London

later (fig. 28). Downman's watercolour of a tree-trunk (pl. 130), sketched in the woods near Albano, is equally novel for its date in concentrating on a humble motif from Nature from such a close viewpoint, and anticipates many similar studies of trees, or details of trees, made by Romantic landscape artists in the first half of the following century.

In 1782 a young Cambridge graduate, J.H. Pott, published his *Essay on Landscape Painting* (described by one writer as 'in effect the first manifesto of the English landscape school'[9]), in which Pott argued that

> In this country, the merely copying from nature would of itself give a character to the landscape of our painters... and would sufficiently establish the taste of an English School... We have also a great advantage over Italy... in the great variety and beauty of our northern skies; the forms of which are often so lovely and magnificent, where so much action is seen in the rolling of the clouds.[10]

Deprived of the opportunity to travel to Italy during the Revolutionary and Napoleonic Wars, British landscape artists at the end of the century were to discover the truth of these words for themselves.

In the mountainous regions of North Wales in the late 1790s both Turner and Girtin used watercolour to depict storms breaking over mountain-tops (fig. 29) or to show heavily laden skies (pl. 114). Watercolour was the ideal medium for the spontaneous recording of transient atmospheric effects, given the speed with which it could be applied and its inherent luminosity. However, some of Turner's Welsh watercolour sketches are very large and more conceptual than those by Girtin, and are likely to have been evolved in the studio (see also pl. 35). Girtin's *Near Beddgelert*, on the other hand,

has every appearance of having been coloured on the spot. In fact, one of Girtin's early biographers recorded that 'when he had made a sketch of any place, he never wished to quit until he had given it all the proper tints'.[11]

It was Cornelius Varley (1781–1873) who reported that Girtin, when sketching from Nature, would 'expose himself to all weathers, sitting out for hours in the rain to observe the effect of storms and clouds upon the atmosphere'.[12] Perhaps it was with Girtin's example partly in mind that Varley himself turned to recording in watercolour the climatic effects he observed on sketching tours to Wales and Ireland in the early years of the nineteenth century (pl. 113, 115, 116).[13] In 1803 he had travelled to North Wales with Joshua Cristall and William Havell (1782–1857), but in 1805 he journeyed alone, recalling that 'the whole season was so rainy that in most places I was the only traveller. This apparent solitude mid clouds and mountains left me more at large "To hold converse with Natures charms and view her stores untold"'.[14] Compositionally, Varley's *Near Pont Aberglaslyn* (pl. 113) is not dissimilar to Girtin's *Near Beddgelert*, but whereas Girtin's study was used for a finished composition (fig. 30), as various others by him also were,[15] Varley's sketches were always done for their own sake. Clouds and atmosphere are depicted through a masterly handling of subtle but broad washes, sometimes applied on damp paper (pl. 115). And being working sketches, they were often left unfinished.

In his later years Varley became better known as a scientist than as an artist. Even if his empirical bent is revealed in his declared intention to 'observe and understand what [he] saw' on the trip to Wales in 1805,[16] to a modern audience in particular his mountain studies are highly evocative. This is not necessarily a contradiction, indeed the combination of careful observation and intensity of feeling is, perhaps, a precondition for what is usually understood by the term 'naturalism' in art. Certainly, key artists and critics of the period did not believe that the 'truth to Nature' they themselves espoused was synonymous with imitation, however much they

Fig. 29 J.M.W. Turner, *(?)Nant Peris, Looking towards Snowdon*, c. 1799, pencil and watercolour with stopping-out and scraping-out, 55.1 x 77. Tate Gallery, London

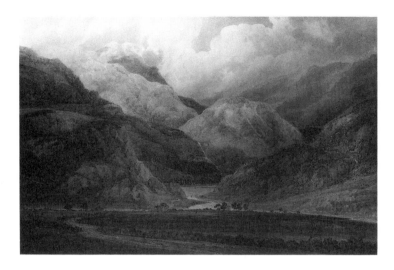

Fig. 30 Thomas Girtin, *Near Beddgelert, North Wales*, 1799, watercolour, 61 x 91.5. Private Collection

might recommend an empirical and objective manner of looking at Nature. In a letter of 1833 Constable mentioned that he had been to see the landscapes of the painter F. R. Lee (1794–1879), which 'pretend to nothing but an imitation of nature – but that is of the coldest and meanest kind'.[17] In similar vein Ruskin was later to write that 'the painter who really loves nature … will make you understand and feel that art *cannot* imitate nature; that where it appears to do so, it must malign her and mock her'.[18]

Indeed Constable, perhaps the greatest exponent and practitioner of naturalism, could claim on the one hand that 'painting should be *understood* … as a pursuit, *legitimate, scientific,* and *mechanical*', and on the other that 'Painting is but another word for feeling'.[19] His cloud studies are frequently cited to prove that these statements are not contradictory.[20] Painted from Hampstead in the early 1820s in oil, and in the early 1830s in watercolour, they either show the sky alone or – particularly in the case of the watercolours – in relation to the tops of trees (pl. 125, 224, 225). They are accurate representations of different types of clouds (Constable seems to have been familiar with the classification of clouds made by the meteorologist Luke Howard[21]), and are often annotated with the time of day and direction of the wind (see pl. 125). This very specific way of inscribing drawings was most likely learned from the talented amateur artist and member of the Oxford School, Dr William Crotch (1775–1847), who was in turn taught the habit by the Oxford drawing-master John Baptist Malchair (1731–1812). It is an interesting example of the amateur contribution to mainstream landscape painting in this period.[22] Yet Constable's cloud studies are also highly expressive works, and he himself emphasised the importance of the sky in providing the mood of a picture: 'It will be difficult to name a class of Landscape, in which the sky is not the "*key note*", the *standard of "Scale*", and the chief "*Organ of sentiment*"'.[23]

This same combination of directness of observation and intensity of vision characterises the watercolour sketches of the young John Linnell (1792–1882) from 1811 onwards. As a result of being introduced that year by Cornelius Varley to the pastor of a

Baptist Church in London, Linnell underwent a spiritual crisis that resulted in his becoming a Baptist early in 1812.[24] At about that time he began painting some of his most remarkable and unconventional landscapes, both in oils and in watercolours (fig. 31 and pl. 122, 126). And indeed a work like *Primrose Hill* (pl. 119) does seem to have an almost spiritual intensity most readily explained by Linnell's new understanding of landscape and its meticulous organisation as direct proof of God's existence – beliefs based on his reading of William Paley's *Natural Theology*.[25] The studies Linnell made in the vicinity of Bayswater (to where he had moved about this time) also show a new interest in unassuming and often featureless slices of Nature, a far cry from the distinctly 'Picturesque' motifs of broken fences and gnarled trees he had sketched from Nature in oil alongside fellow-artist William Henry Hunt (1790–1864) only five years earlier under the tutelage of John Varley (1778–1842), Cornelius's elder brother.[26]

It has, however, been suggested that some of the unusual angles and flattened shapes that characterise some of the most famous of Linnell's Bayswater studies, *Alpha Cottages* and a group of watercolours of brick-kilns (fig. 32), can be explained by their having been drawn with the aid of a *camera obscura*.[27] Certainly, it is known that Linnell purchased such an instrument from Cornelius Varley in 1811;[28] while he could easily have made use of the Patent Graphic Telescope that Varley had invented to facilitate *plein-air* sketching and had patented that very year. We can be sure that Varley himself often used the telescope for making landscape drawings and watercolours, a number of which are inscribed 'PGT'. The more distant views in particular (fig. 33)[29] share a number of features in common with Linnell's *Primrose Hill*, such as clear, bright daylight

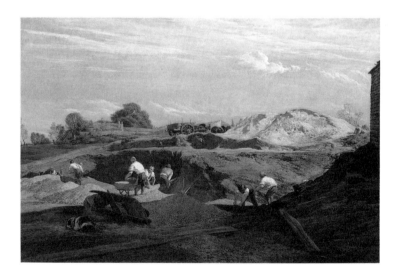

Fig. 31 John Linnell, *Kensington Gravel Pits*, c. 1811–12, oil on canvas, 71.1 x 106.7. Tate Gallery, London

and the general absence of shadows (noon was the recommended time for using a *camera obscura*), together with a tendency to show distant features in sharp focus in combination with a summary or bare foreground.

Of course it is possible that Linnell might have learned this approach to composition from Varley himself, for it can be found in a watercolour by the latter, *Lord Rous's Park* (pl. 121), which predates the invention of the Graphic Telescope (although this view could conceivably have been made with another drawing instrument[30]). Perhaps the use of a *camera obscura* or graphic telescope simply served to modify an existing mode of vision. Drawing instruments had long been used by topographical artists to achieve a more accurate and empirical rendering of their views: in Britain Thomas Sandby, for example, certainly made use of the *camera obscura*.[31] The fact that in the early nineteenth century these instruments were adopted for pure landscape (although just how widely is difficult to establish) should be seen as a symptom of the desire for a greater naturalism, even if in the long run they had little to offer the landscape sketcher, for whom, as it has been argued, spontaneity was as much a requisite as objectivity and precision.[32]

Fig. 32 John Linnell, *A Brick Kiln*, 1812, watercolour, 10.3 x 14.4. Private Collection

In 1814 Linnell toured Dovedale in Derbyshire in company with the publisher Samuel Bagster, who planned to bring out a new illustrated edition of Isaac Walton and Charles Cotton's *The Compleat Angler*. The very circumstances of the trip meant that Linnell, when making sketches, was likely to have possible finished compositions in mind, and *Dovedale* (pl. 117), for all its apparent immediacy, was later used for a finished oil painting (which was in turn engraved for the 1839 edition of *The Compleat Angler*[33]). An artist such as Turner would instinctively find himself selecting his *plein-air* material with a pictorial eye, as he did, for example, for *Benson* (pl. 118). Yet despite producing some important work when studying directly from Nature, particularly around the year 1805 when *Benson* was painted,[34] Turner was not a *plein-air* painter by disposition. A contemporary recorded him as saying that 'it would take up too much time to colour in the open air – he could make 15 or 16 pencil sketches to one coloured'.[35] John Varley, better known for the many classicising landscapes he exhibited at the Old Water-Colour Soci-

ety (fig. 44 and pl. 287), made 'sketches from Nature' most of his life, yet with the passing years they were increasingly subjected to the conventions of the picture-maker: after years of teaching pupils that 'Nature wants Cooking', he could not refrain from grilling even his own directly observed studies (fig. 34).[36]

The Romantic generation's heightened interest in landscape led them to scrutinise natural details not only for their own sake, but also the better to understand the component parts of a completed view. The genre painter William Mulready (1786–1863) who, like Linnell, had been closely associated with John Varley in earlier years, wrote that his life-long devotion to sketching from Nature was undertaken to 'strengthen our knowledge of the structure [of the natural world] to enable us to paint better views with increased truth and feeling'.[37] Joshua Cristall, Patrick Nasmyth (1787–1831) and a number of ex-pupils of John Varley – Linnell, Cox, De Wint and William Turner of Oxford (1789–1862) – are just some of the better-known artists who turned to making watercolour studies of natural details in this period, of trees, plants, animals, birds and fish as well as mountains and clouds. Their tree studies tend to be portraits of individual and identifiable species – Cristall paints a beech tree stem (pl. 131), Turner of Oxford a pollarded willow (pl. 140); in this sense they can be distinguished from earlier tree studies by, say, Francis Towne or his pupil John White Abbott (pl. 134, 133), which, compositions rather than sketches, are investigations into pattern, rhythm and light, even if, as the inscriptions on Towne's watercolours frequently indicate, they were observed on the spot.[38] The skate that appear in the foreground of Cristall's large watercolour of a *Fish-market on the Beach, Hastings* (fig. 35) are convincing because he had already made them separate objects of study (pl. 144), as had De Wint the various plants (pl. 137) that appear in the foregrounds of his landscapes, or Cox the seagulls (pl. 143) that hover over his views of the sands at Ulverston, Lancaster and Rhyl.

If Cox chose to use the rapidity and breadth of the watercolour medium to capture the flight pattern of a seagull, J.M.W. Turner rather explored its ability to express the detail of a bird's

Fig. 33 Cornelius Varley, *View from Ferry Bridge, Yorkshire*, c. 1815, pencil and watercolour, 35.3 x 52.1. British Museum, London

Fig. 34 John Varley, *Hackney Church ('A Study from Nature')*, 1830, pencil and water-colour, 27.4 x 38. British Museum, London

plumage or the 'subdued iridescences' of fish (pl. 145, 146).[39] The *Heron* was one of twenty bird studies Turner made for inclusion in a family scrapbook assembled by members of the Fawkes family at Farnley Hall in Yorkshire,[40] where he would sometimes participate in the shooting expeditions on which some of the specimens he painted were brought down (pl. 87). Ruskin was immensely im-

pressed by them – the *Heron* study was among those he told his father in 1852 he would give '*any* price for if I *had* it to give',[41] and they stimulated him to make equally detailed ones of his own (fig. 36). In later years Ruskin was equally struck by the detailed still-life water-colours of William Henry Hunt, admiring the artist's 'keen eye for truth'.[42] Hunt's *Oyster Shell and Onion* (pl. 150) is one of a group of watercolours Ruskin commissioned from the artist in the 1850s; despite the difficulties Hunt reputedly suffered when painting the shell,[43] he has beautifully rendered its silky sheen, carefully jux-taposing its reflective surface with the coarser texture of a peeling onion skin. This particular watercolour shares many of the under-stated qualities of Hunt's earlier work in this vein, for example soft light and gentle harmonies of colour. His later still-lifes (pl. 307), by comparison, painted with more intense colours in the minutest detail, and lit by a much harsher light to permit a greater accuracy of vision, anticipate many of the stylistic features that were to become so highly valued by the Pre-Raphaelite painters in their search for 'truth to Nature'.

Indeed, the famous technique of the 'wet white' ground used by the Pre-Raphaelites when painting in oil (whereby delicate touches of colour are applied over a brilliant white ground that is still wet) is not dissimilar to the technique used by Hunt for painting his still-lifes in watercolour. Yet, because the Pre-Raphaelites worked directly out of doors on the very pictures they intended to exhibit, unlike the Romantic generation they very rarely made sketches of pure landscape from Nature, coloured or otherwise. The

Fig. 35
Joshua Cristall, *Fish-market on the Beach, Hastings, c.* 1807, watercolour, 76.2 x 102.8. Victoria and Albert Museum, London

Fig. 36
John Ruskin, *Study of a Kingfisher*, c. 1870, watercolour and bodycolour, 26 x 22. Ashmolean Museum, Oxford

Fig. 37 William Holman Hunt, *Helston, Cornwall*, 1860, watercolour with scraping-out, 19.4 x 25.8. Whitworth Art Gallery, Manchester

study of Ben Nevis (pl. 162) by John Everett Millais (1829–96), and *Helston* (fig. 37) by William Holman Hunt (1827–1910) are among the exceptions.[44] The former may relate to a phenomenon Millais observed in the summer of 1853 when 'the sun, with British effulgence, burst out upon the rocky hills . . . and all the distant mountains changed suddenly from David Cox to the Pre-Raphaelites'.[45] It is particularly interesting in that it reveals him tackling the sort of atmospheric effects generally outlawed from Pre-Raphaelite oils: Millais's famous portrait of Ruskin at Glenfinlas (fig. 38), the entire landscape background of which was painted in oil from the motif that same summer, eschews space, sky and atmosphere. Perhaps Millais's sketching activities in watercolour that year can be interpreted as a welcome release from the painstaking and laborious discipline of painting into that picture every rock and fern. It was not the Pre-Raphaelites themselves, then, who made microscopically detailed and highly finished studies from Nature in watercolour, as one might have expected when thinking of their oils, but those who came under their spell: Albert Joseph Moore (1841–93), for example, exhibited a number of them at the Royal Academy in the early years of his career, one of which was the *Study of an Ash Trunk* in 1858 (pl. 141), although, surprisingly, these went unnoticed by Ruskin.[46]

Other artists associated with the Pre-Raphaelites chose to use watercolour to make sketches from Nature as the Romantics had done, often painting details that subsequently became the subject of oils. The Scottish artist and poet William Bell Scott (1811–90), unlike the Pre-Raphaelites themselves, believed the best education for an artist was daily sketching in a pocket-book.[47] No doubt he referred to his spontaneous study of *Penwhapple Stream* (pl. 161) when painting an oil version of the subject with his beloved Penkill Castle in the distance.[48] Similarly, William Dyce (1806–64) made watercolours of the mountains he had observed during holiday trips to Scotland and Wales in 1859 and 1860, and again these seem to have served as raw material for the small biblical and genre subjects he produced in oil soon afterwards: the sketch of *Tryfan* (pl. 163), for example, was used for his *Welsh Landscape with Figures*.[49]

Dyce regarded the Welsh mountains as more rugged, 'more awful and terrific looking than anything I know in Scotland', and his written analysis of the reasons for the differences between Welsh and Scottish scenery indicates that he had read Charles Lyell's *Principles of Geology* (1830–33).[50]

Fig. 38 John Everett Millais, *John Ruskin at Glenfinlas*, 1854, oil on canvas, 78.7 x 68. Private Collection

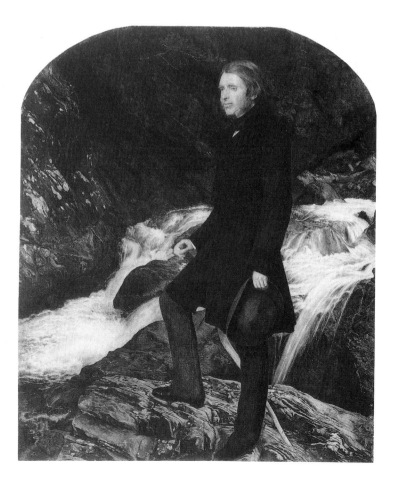

It was, of course, geology that of all the branches of natural history Ruskin pursued most assiduously, and indeed Ruskin's own studies of mountains (pl. 164) make an interesting comparison with those by Dyce. But Ruskin's drawings of mountains attempt something more than an intelligent grasp of geology. Like his other works from Nature (pl. 142, 149), they seek to show the inner construction, rhythms and tensions of form – to reveal, in fact, the underlying structural order of the natural world. Ruskin believed that artists should try to reveal historical 'truths', that is to say those 'which tell us most about the past and future states of the object to which they belong'.[51] If, when painting from Nature, the Romantics sought to seize and fix the moment, Ruskin wished to show that Nature was in constant evolution and flux. And while the Romantics may have sought to transcribe Nature with 'increased truth and feeling', Ruskin began to record the reactions of his own mind and emotions. His drawings increasingly seem to reflect his gradual loss of faith in the continuity of divine action in Nature.[52] When, back in 1795, during his enforced sojourn in Britain, the French writer Chateaubriand had declared that 'landscape should be *drawn* from the *nude* if one wants to give it resemblance, in order to reveal, so to speak, the muscles, bones and limbs',[53] he surely never imagined that naturalism might eventually lead to this.

A.L.

1 M. Woodall, ed., *The Letters of Thomas Gainsborough*, London 1963, pp. 87–91.
2 *The Art of Paul Sandby*, p. 12.
3 *British Landscape Watercolours, 1600–1860*, p. 25.
4 See *Painting from Nature*, exh. cat. by P. Conisbee & L. Gowing; Cambridge, Fitzwilliam Museum; London, Royal Academy; 1980–1, and *Oil Sketches from Nature: Turner and his Contemporaries*, exh. cat. by D.B. Brown; London, Tate Gallery, 1991, pp. 10–16.
5 In a letter of 20 July 1758 to his patron William Herring from Rome, Skelton wrote that in the open daylight the colours 'shine so much there is no such thing as seeing what one does' (B. Ford, ed., 'The Letters of Jonathan Skelton Written from Rome and Tivoli in 1758', *The Walpole Society*, XXXVI, 1960, p. 51).
6 Letter to William Herring from Tivoli, 25 Sept 1758; 'The Letters of Jonathan Skelton', p. 60.
7 See S.R. Pierce, 'Jonathan Skelton and his Watercolours – A Checklist', *The Walpole Society*, XXXVI, 1960, pp. 10–22, no. 13 (reproduced as plate XB), and inscribed on verso: 'The Parts of this Drawing are in Greenwich park But grouped at fancy, J. Skelton 1757.'
8 *Original Eyes: Progressive Vision in British Watercolour 1750–1850*, exh. cat. by D.B. Brown; Liverpool, Tate Gallery, 1991, p. 21.
9 *A Decade of English Naturalism, 1810–1820*, exh. cat. by J. Gage; Norwich, Castle Museum; London, Victoria & Albert Museum; 1969–70, p. 2.
10 *An Essay on Landscape Painting, With Remarks General and Critical on the Different Schools and Masters, Ancient or Modern*, 1782, pp. 5–6, published anonymously but identified as by Pott (1759–1847) in L. Herrmann, *British Landscape Painting of the Eighteenth Century*, London 1973, p. 61.
11 In *The Gentleman's Magazine*, and quoted in Roget, *A History of the 'Old Water-Colour Society'*, I, p. 95.
12 Quoted by Roget in *A History of the 'Old Water-Colour Society'*, and reported by Varley to J.J. Jenkins; see M. Pidgley, 'Cornelius Varley, Cotman and the Graphic Telescope', *The Burlington Magazine*, CXIV, 1972, p. 781.
13 Varley is reported to have sketched 'out of doors all day long, often amid frost and snow' in Suffolk in 1801, which M. Pidgley puts down to the influence of Girtin's sketching habits (Introduction to *Exhibition of Drawings and Watercolours by Cornelius Varley*, exh. cat. by S. Somerville; London, Colnaghi & Son, 1973, not paginated).

14 *Cornelius Varley's Narrative written by Himself*, quoted by Pidgley, *Exhibition of Drawings and Watercolours by Cornelius Varley*.
15 Three other watercolour sketches by Girtin in the British Museum from the Chambers Hall Bequest (*Cayne Waterfall*; *The Great Hall, Conway Castle*; and *Above Bolton*; see *British Landscape Watercolours, 1600–1860*, cat. 77–8 and 80b) were all later elaborated into finished watercolours; see Girtin & Loshak, *The Art of Thomas Girtin*, no. 322 (ii), 320 (ii) and 441 (ii).
16 In his *Narrative*, quoted by Pidgley, *Exhibition of Drawings and Watercolours by Cornelius Varley*.
17 Letter to C.R. Leslie, 20 Jan 1833; see *John Constable's Correspondence*, ed. R.B. Beckett, Ipswich 1962–8, III, p. 91.
18 *Modern Painters*, I (1843); see *The Works*, III, p. 289.
19 The first quotation is from a lecture of 1836; see *John Constable's Discourses*, ed. R.B. Beckett, Ipswich 1970, p. 69. For the second, see the letter to John Fisher, 23 Oct 1821, in the *Correspondence*, VI, p. 78.
20 For example by C.M. Kauffmann, from whom this argument is taken (*Sketches by John Constable in the Victoria and Albert Museum*, London 1981, p. 39).
21 Constable seems, however, not to have learned of Howard's cloud classification through the latter's standard work on the subject, *The Climate of London*, but rather through Thomas Forster's *Researches about Atmospheric Phaenomena* (Kauffmann, *Sketches*, p. 37), although he may not have come to own (and annotate) a copy of Forster's book until after 1821–2 (see *Constable*, exh. cat. by L. Parris & I. Fleming-Williams; London, Tate Gallery, 1991, p. 228).
22 Constable seems to have started inscribing his drawings in a similar fashion around 1806, the year he and Crotch were first acquainted; see I. Fleming-Williams, 'Dr William Crotch, 1775–1847: Member of the Oxford School', *The Connoisseur*, May 1965, pp. 28–31, and also appendix I on 'Drawing-Masters' (for Malchair) and II 'The Amateur' (for Crotch) revised by I. Fleming-Williams for Hardie, *Watercolour Painting in Britain*, III, pp. 233, 265–6.
23 Letter to John Fisher, 23 Oct 1821; see the *Correspondence*, VI, p. 77.
24 C. Payne, 'John Linnell and Samuel Palmer in the 1820s', *The Burlington Magazine*, CXXIV, 1982, p. 131.
25 *John Linnell: A Centennial Exhibition*, exh. cat. by K. Crouan; Cambridge, Fitzwilliam Museum; New Haven, Yale Center for British Art; 1982–3, p. xi.
26 See *Oil Sketches from Nature*, cat. 45–8,

and made at a time when Varley's motto was 'Go to Nature for everything' (A.T. Storey, *The Life of John Linnell*, London 1892, I, p. 25).
27 *John Linnell: A Centennial Exhibition*, pp. xii and 11; the brick-kilns are cat. 18–20 and *Alpha Cottages* cat. 29.
28 See K. Crouan (introduction to *John Linnell: Truth to Nature (A Centennial Exhibition)*, exh. cat.; London, Martyn Gregory Gallery; New York, Davis & Langdale; 1982–3, p. viii. Cornelius Varley also sold Linnell a *camera lucida* in 1820 and a Graphic Telescope in 1848.
29 See also cat. 8a, 32 and 98 in *Exhibition of Drawings and Watercolours by Cornelius Varley*.
30 A pencil drawing of Henham Hall (British Museum, 1981-11-7-2), the seat of the Lords Rous, made by Varley on the same visit to Suffolk, certainly looks as though it was drawn with the aid of a *camera obscura*. This raises the possibility that Varley was using drawing instruments from an early stage in his career, and that his invention of the Patent Graphic Telescope was chiefly motivated by the desire to have at his disposal a drawing instrument that was easier to use than the cumbersome *camera obscura*.
31 A drawing by Sandby of Windsor in the Royal Collection is inscribed 'drawn in a camera' (Oppé, *The Drawings of Paul and Thomas Sandby*, no. 78. Oppé also records that a large *camera obscura* formed the last lot on the first day of the Thomas Sandby sale of 18 July 1799).
32 *A Decade of English Naturalism*, p. 16.
33 *Presences of Nature: British Landscape 1780–1830*, exh. cat. by L. Hawes; New Haven, Yale Center for British Art, 1982–3, p. 169; the oil painting is reproduced on p. 69.
34 See *Oil Sketches from Nature*, cat. nos. 13–19, for examples; the watercolours, like *Benson*, are mainly pages from the 'Thames from Reading to Walton' sketchbook (TB XCV). Turner's *plein-air* sketches previously dated to c. 1806–7 have recently been reassigned to 1805 by David Hill, who is preparing a book on the subject.
35 Letter to John Soane from his son, 15 November 1819; see A. Bolton, ed., *The Portrait of Sir John Soane, R.A.*, London 1927, pp. 284–5.
36 A. Lyles, 'John Varley's Early Work, 1800–1804', *The Old Water-Colour Society's Club*, LIX, 1984, p. 9. Varley's well-known maxim 'Nature wants Cooking' was first recorded by the Redgraves in *A Century of Painters of the English School*, I, p. 492.
37 Notation on an undated drawing in the Whitworth Art Gallery, University of Manchester; see K.M. Heleniak, *William Mulready*, London 1980, p. 47 and n. 31;

Heleniak also reproduces a sample of Mulready's Nature studies, most of which are in pen and ink.
38 A watercolour by Towne of trees in Peamore Park, Exeter, in the Fitzwilliam Museum (reproduced in *Town, Country, Shore and Sea*, exh. cat. by D. Robinson; Cambridge, Fitzwilliam Museum, 1982–3, no. 21) is inscribed as 'drawn on the spot'; inscriptions on many other drawings by Towne also emphasise the site and time.
39 Ruskin's phrase: see *The Works*, XIII, p. 370.
40 The assembly of this scrapbook is examined in detail in *Turner and Natural History: the Farnley Project*, exh. cat. by A. Lyles; London, Tate Gallery, 1988. See also D. Hill, *Turner's Birds*, Oxford 1988.
41 *The Works*, XIII, pp. xlviii–xlix.
42 *Modern Painters*, I (1843); see *Ruskin and the English Watercolour from Turner to the Pre-Raphaelites*, exh. cat. by A. Sumner; Manchester, Whitworth Art Gallery, 1989, p. 57.
43 Roget, *A History of the 'Old Water-Colour Society'*, II, p. 196.
44 Of course Holman Hunt did make a number of elaborate finished watercolours of views in Egypt and the Holy Land, but these are not strictly Nature studies.
45 Quoted in *Ruskin and the English Watercolour*, n. 38, where it is pointed out by Sumner that the date (September 1853) and the place (Ben Nevis) inscribed on the drawing are inconsistent. During September 1853 Millais was in Glenfinlas; it was not until the following year that he made a more extensive tour of Scotland and visited Fort William, close to Ben Nevis. Either the location of the drawing is in fact Glenfinlas, or (and this, to Sumner, seems less likely) the monogram signature and date were added many years later, and should read 1854.
46 A. Staley, *The Pre-Raphaelite Landscape*, Oxford 1973, p. 175.
47 Ibid., p. 92.
48 *The Rustic Bridge*, reproduced in *The Discovery of Scotland*, exh. cat. by J. Holloway & L. Errington; Edinburgh, National Gallery of Scotland, 1978, fig. 122.
49 Reproduced as plate 95b in *The Pre-Raphaelite Landscape*; the other related oils are plates 94a–b, and 95a.
50 M. Pointon, *William Dyce, 1806–1864: A Critical Biography*, Oxford 1979, p. 174.
51 *Modern Painters*, I (1843), ch. VI, section I.
52 See P.H. Walton, *The Drawings of John Ruskin*, Oxford 1972, p. 98.
53 'Lettre sur l'art du dessin dans les paysages', first published in *Mélanges et Poésies*, Paris 1828, p. 5; quoted in H. Honour, *Romanticism*, Harmondsworth 1979, p. 63.

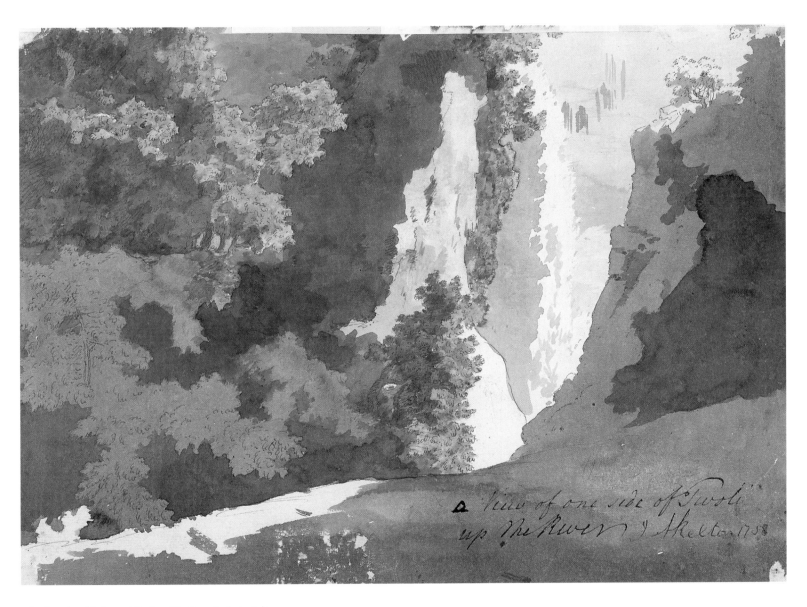

*a View of one side of Tivoli
up the River y Skelton 1758*

108 Jonathan Skelton, *A Study at Tivoli*, 1758 (cat. 264)

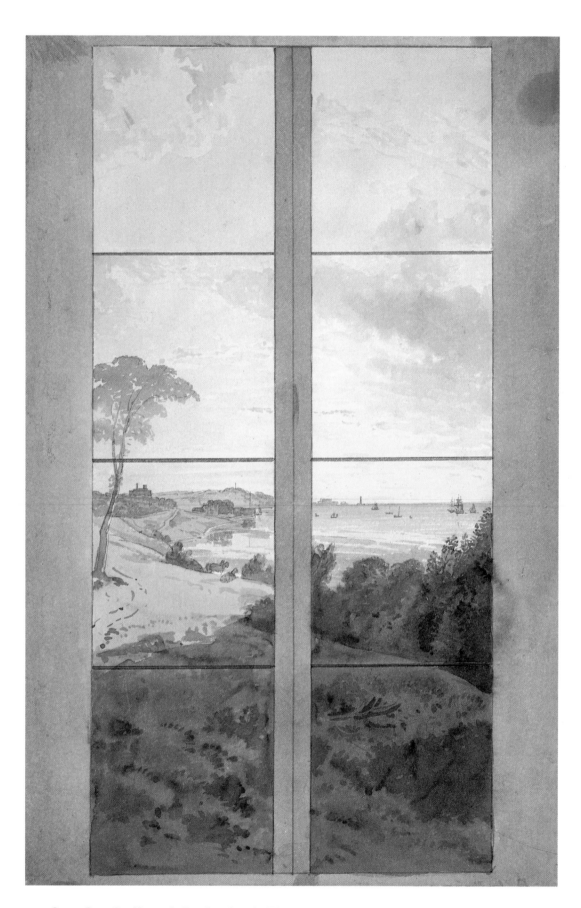

109 George Barret Jnr, *View on the Coast Seen through a Window, c.* 1815 (cat. 5)

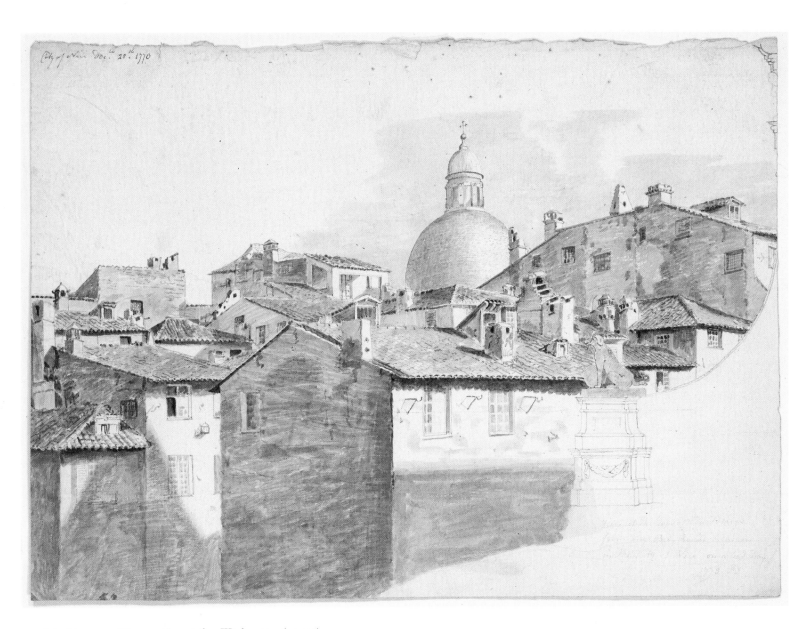

110 John Downman, *View over Nice out of my Window,* 1773 (cat. 123)

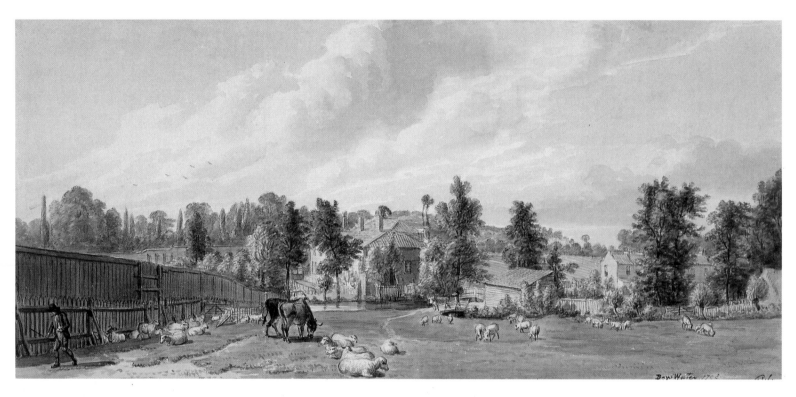

III Paul Sandby, *Bayswater*, 1793 (cat. 257)

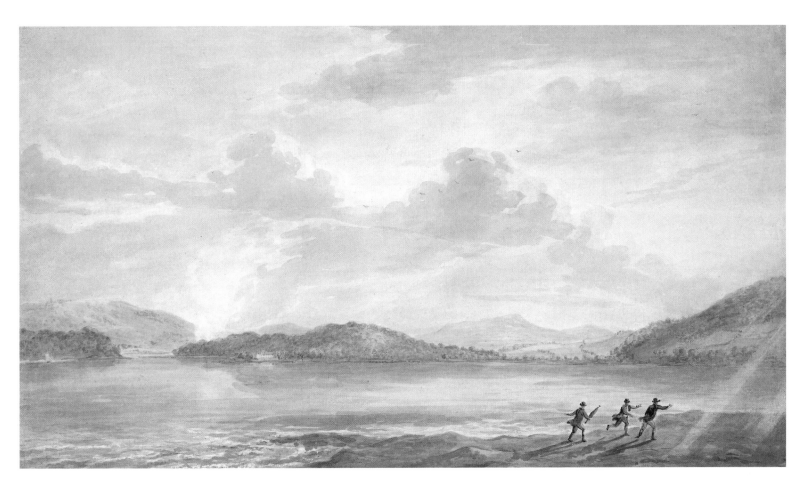

112 Paul Sandby, *The Tide Rising at Briton Ferry*, 1773 (cat. 254)

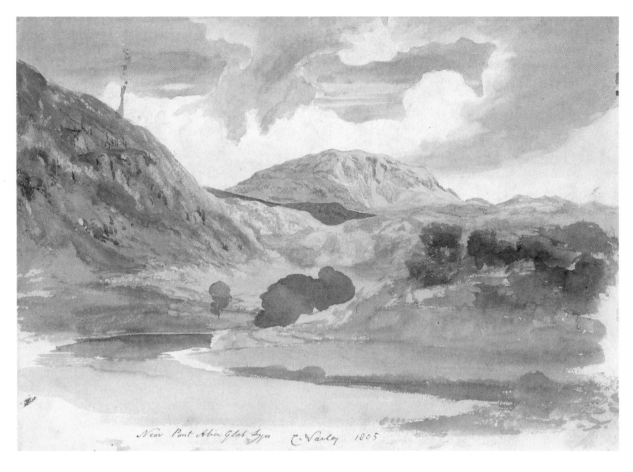

113 Cornelius Varley, *Near Pont Aberglaslyn, North Wales*, 1805 (cat. 312)

114 Thomas Girtin, *Near Beddgelert, North Wales*, c. 1798 (cat. 140)

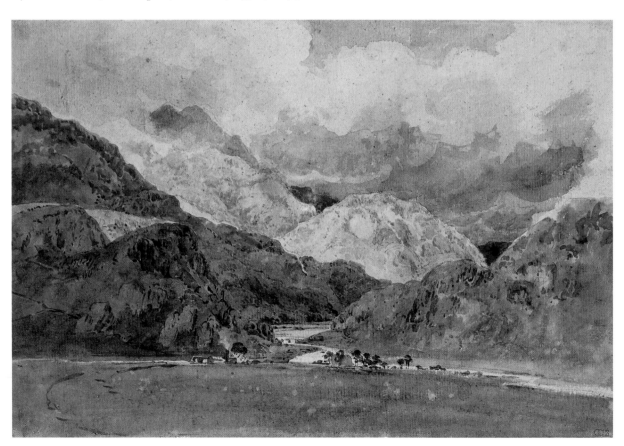

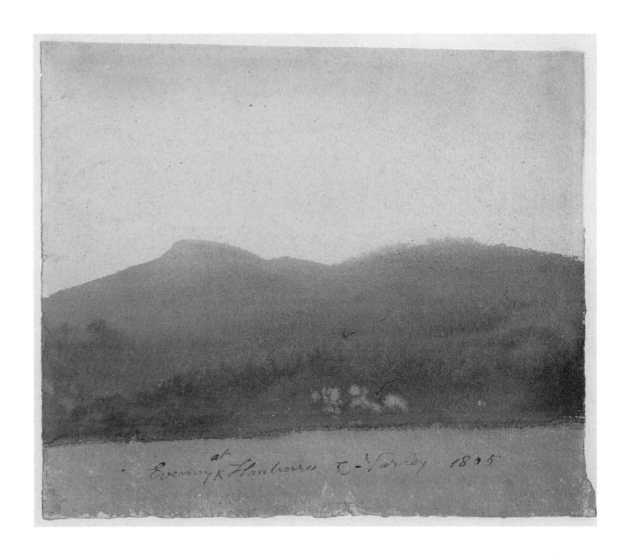

115 Cornelius Varley, *Evening at Llanberis, North Wales*, 1805 (cat. 313)

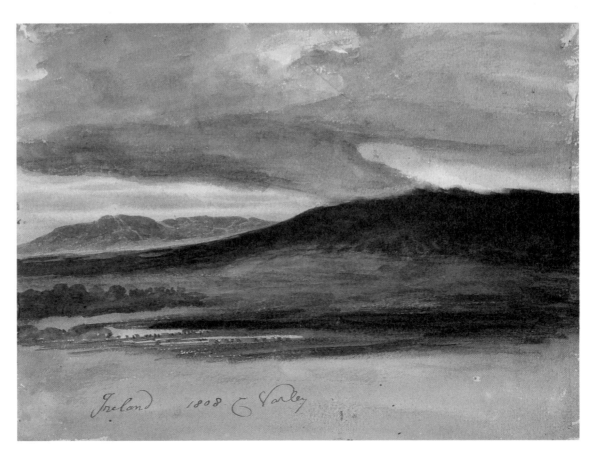

116 Cornelius Varley, *Mountainous Landscape, Ireland*, 1808 (cat. 314)

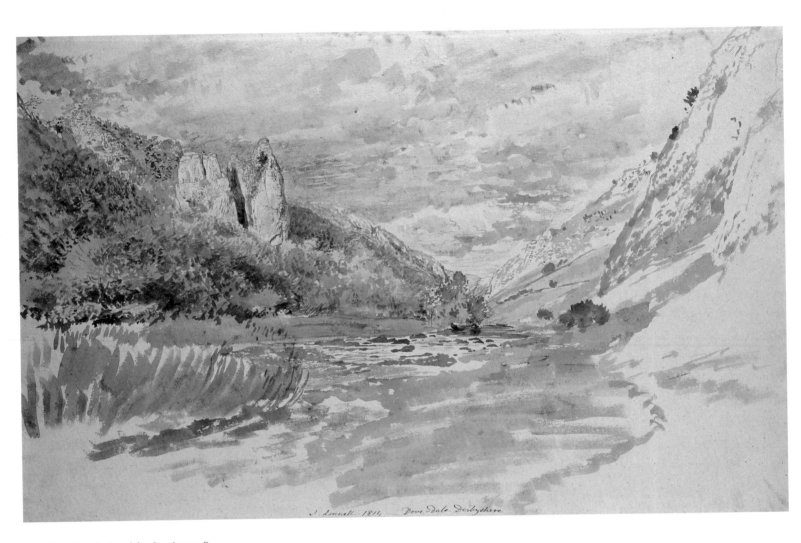

117 John Linnell, *Dovedale*, 1814 (cat. 206)

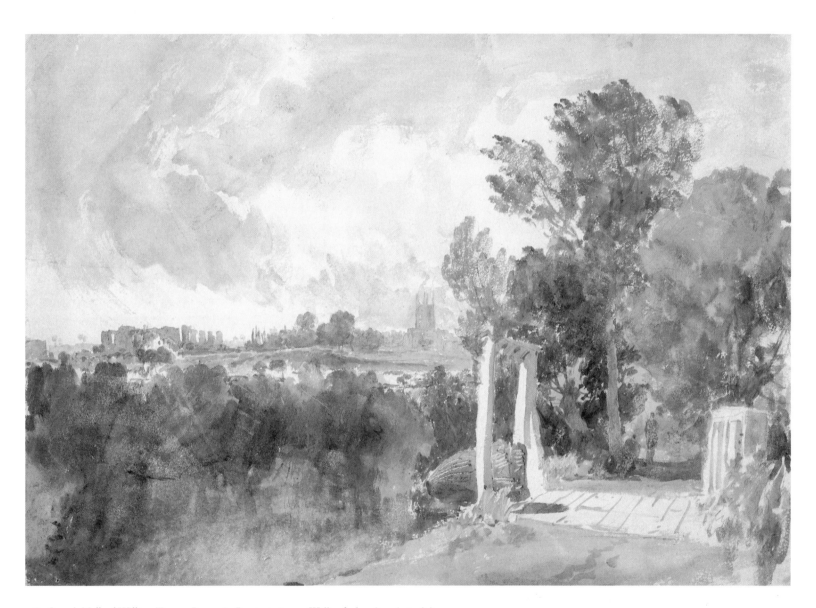

118 Joseph Mallord William Turner, *Benson (or Bensington), near Wallingford*, *c.* 1805 (cat. 285)

119 John Linnell, *Primrose Hill*, 1811 (cat. 203)

120 George Robert Lewis, *Clearing a Site in Paddington for Development*, c. 1820 (cat. 195)

121 Cornelius Varley, *Lord Rous's Park, Henham, Suffolk*, 1801 (cat. 311)

122 John Linnell, *Bayswater and Kensington Gardens*, 1811 (cat. 204)

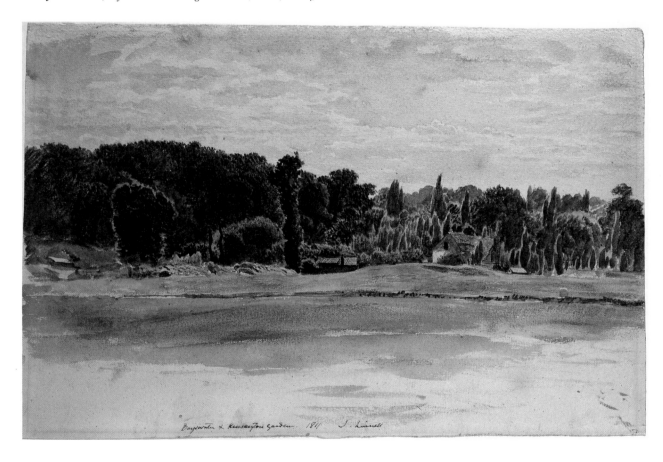

123 Robert Hills, *Two Studies of Skies, at Windsor, c.* 1810 (cat. 164)

below
124 David Cox, *Landscape with Sunset,* (?)*c.* 1835 (cat. 72)

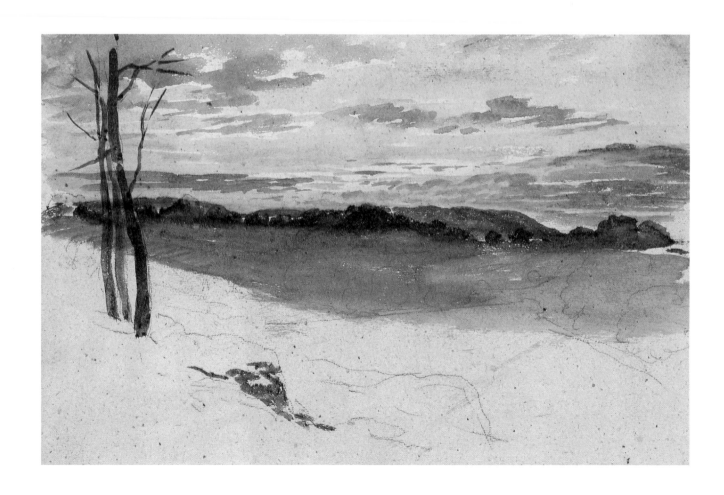

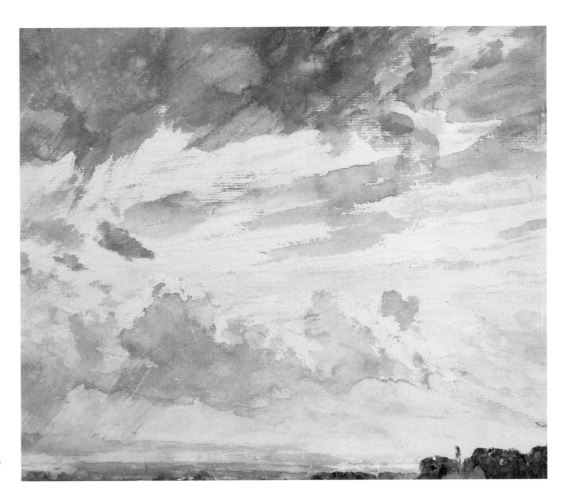

125 John Constable, *Study of Clouds at Hampstead*, 1830 (cat. 27)

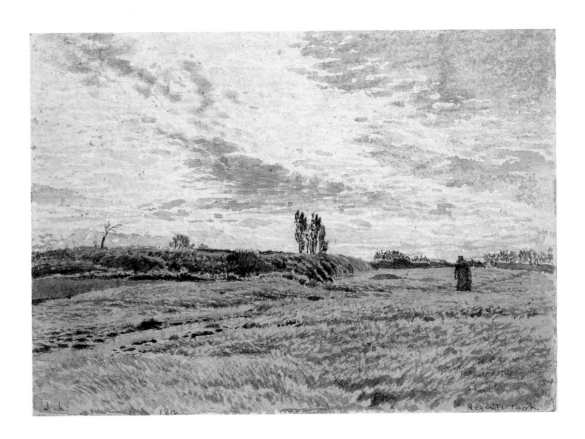

126 John Linnell, *Regent's Park*, 1812 (cat. 205)

above
127 Paul Sandby, *Figure Studies at
Edinburgh and in the Vicinity,* c. 1750 (cat. 250)

right
128 Robert Hills, *Sheet of Studies of
Country Children,* c. 1815 (cat. 165)

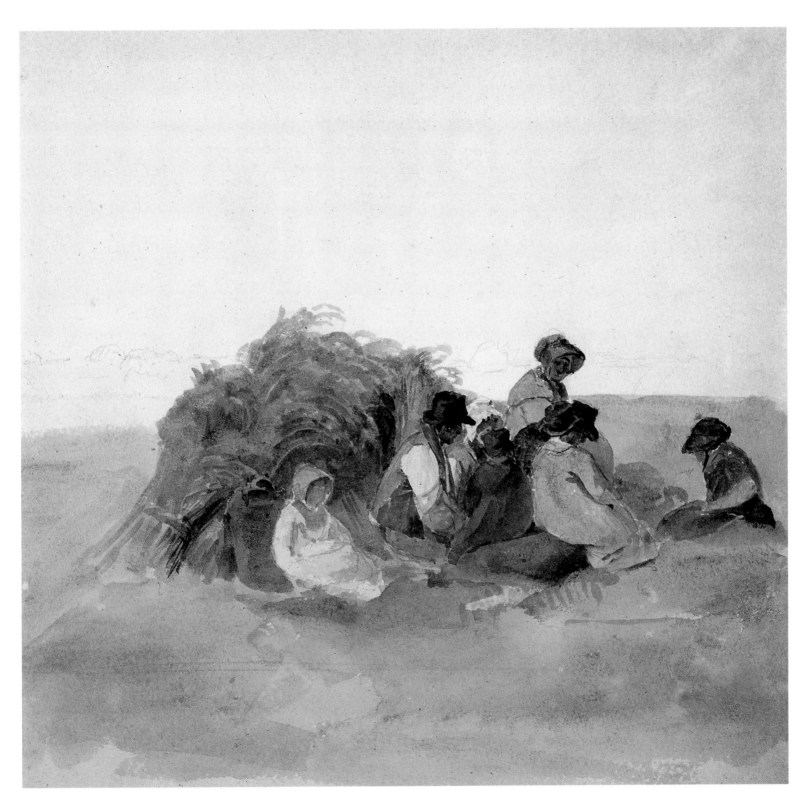

129 Peter de Wint, *Harvesters Resting, c.* 1820 (cat. 113)

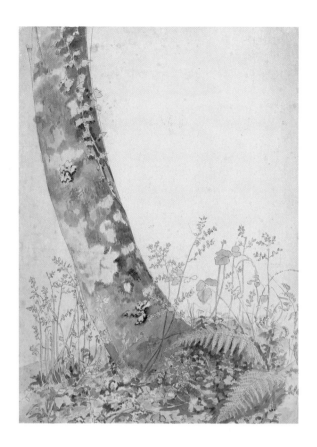

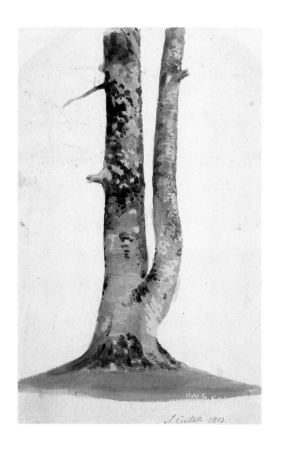

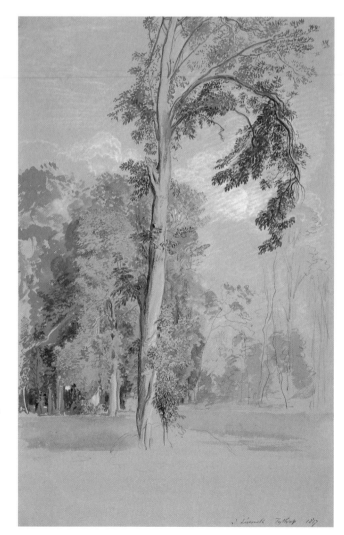

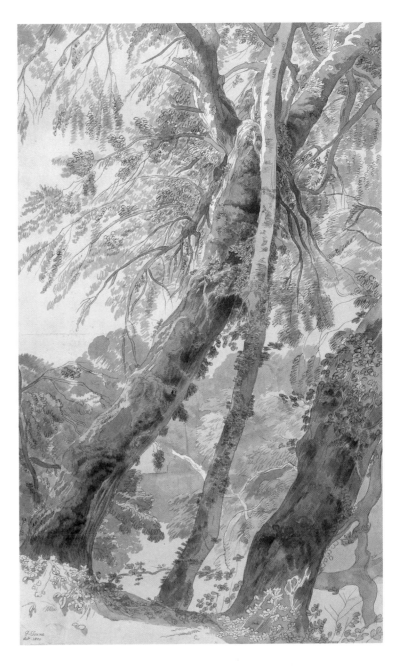

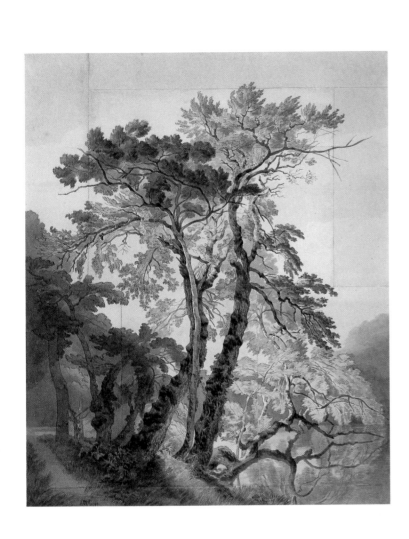

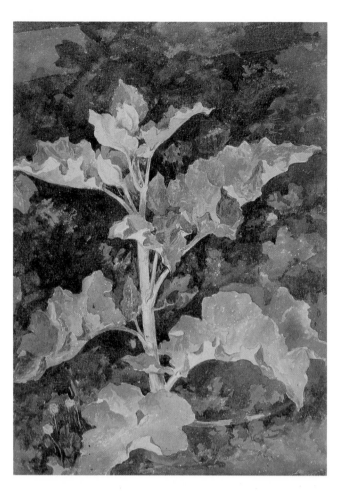

135 Patrick Nasmyth, *Burdock (Arctium)*,
(?)*c.* 1810 (cat. 221)

below
136 Patrick Nasmyth, *Broad Dock (Rumex
obtusifolius)*, (?)*c.* 1810 (cat. 220)

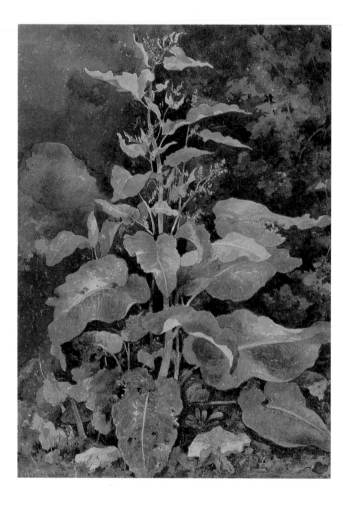

right page:

above
137 Peter de Wint, *Plants by a Stream*, *c.* 1810–15 (cat. 111)

lower left
138 David Cox, *Plants by a Brick Culvert*, *c.* 1815–20 (cat. 63b)

lower right
139 David Cox, *Dock Plants*, *c.* 1815–20 (cat. 63a)

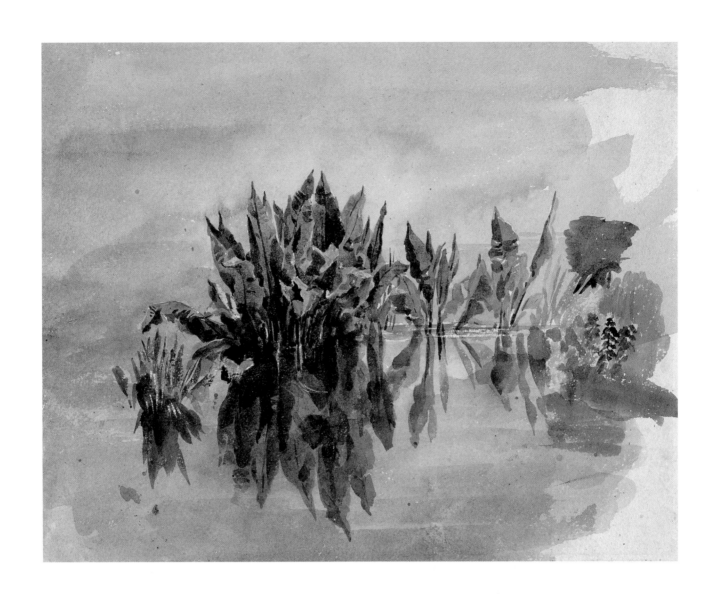

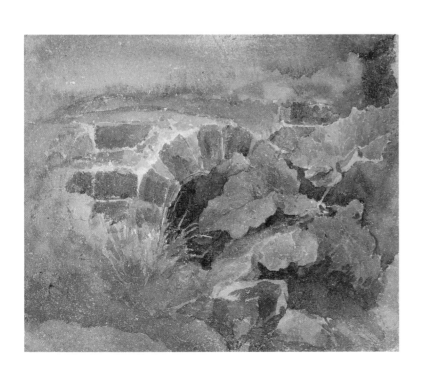

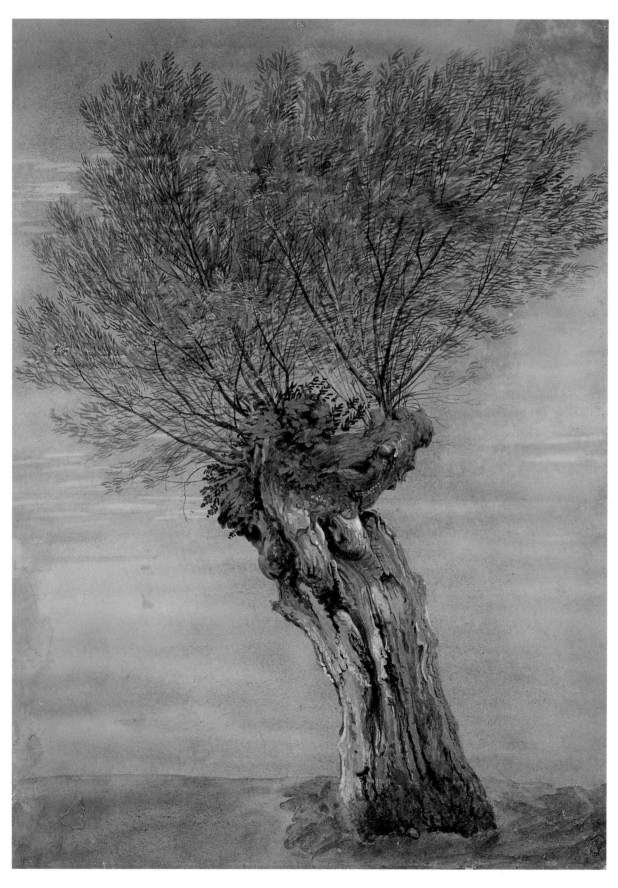

140 William Turner of Oxford, *A Pollarded Willow*, 1835 (cat. 308)

right
141 Albert Joseph Moore, *Study of an Ash Trunk*,
1857 (cat. 215)

below
142 John Ruskin, *Study of Ivy (Hedera Helix)*,
c. 1872 (cat. 247)

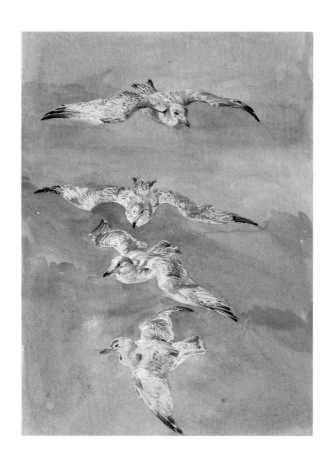

above
143 David Cox, *Studies of a Seagull in Flight*,
c. 1825–30 (cat. 67)

right
144 Joshua Cristall, *Study of a Skate*,
1807 (cat. 96)

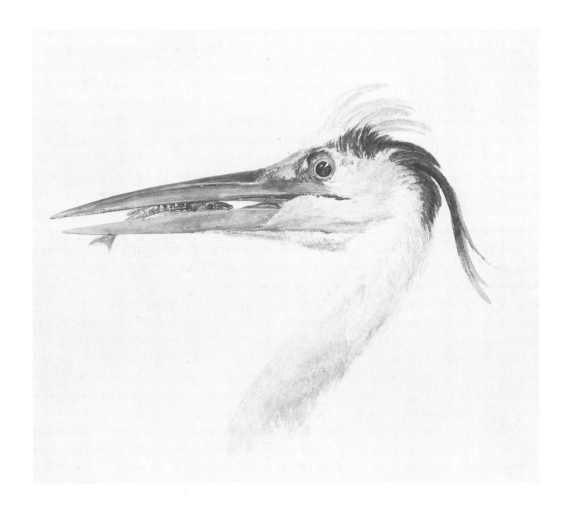

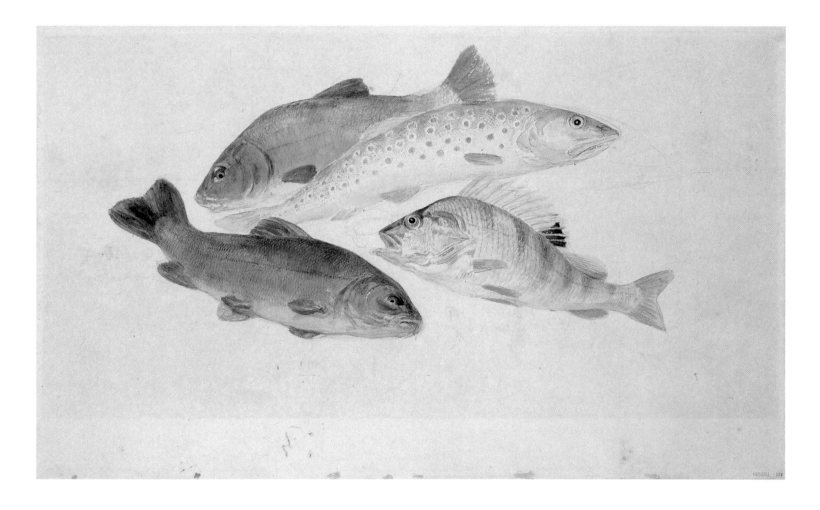

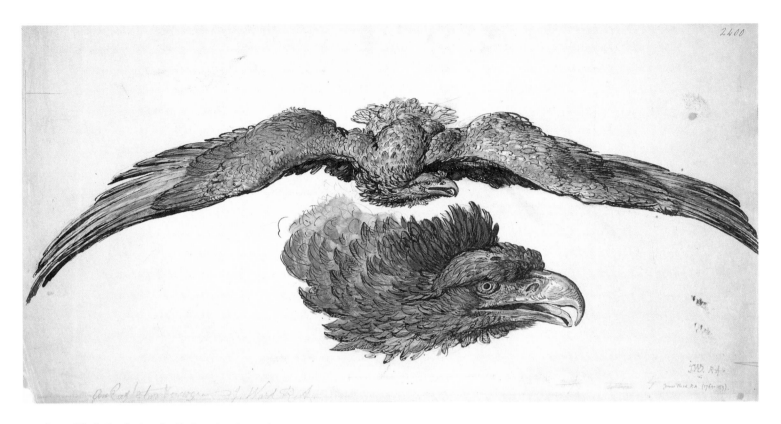

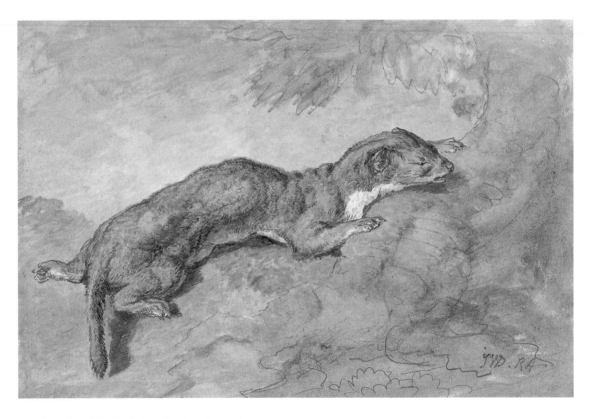

147 James Ward, *Two Studies of an Eagle, c.* 1815 (cat. 321)

148 James Ward, *Study of a Weasel, c.* 1805 (cat. 320)

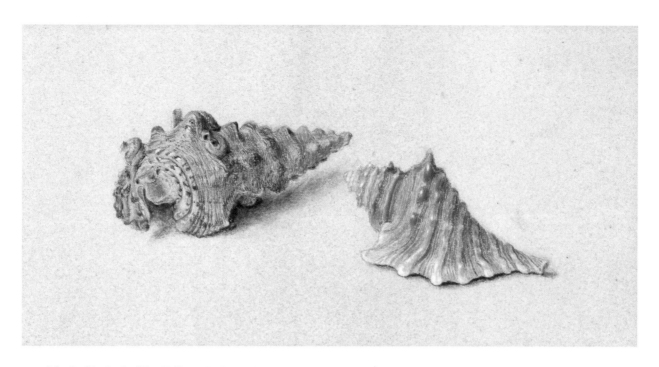

149 John Ruskin, *Study of Two Shells, c.* 1881 (cat. 248)

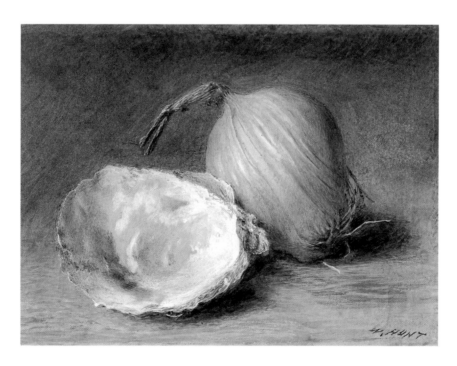

150 William Henry Hunt, *An Oyster Shell and an Onion, c.* 1859 (cat. 184)

above
151 David Cox, *Still-life,*
c. 1830 (cat. 70)

right
152 Peter de Wint, *Still-life with
a Ginger Jar and Mushrooms,*
(?)*c.* 1820 (cat. 114)

153 William Henry Hunt, *Still-life with Earthenware Pitcher, Coffee Pot and Basket, c.* 1825 (cat. 179)

154 Robert Hills, *Farm Buildings*, (?) *c*. 1815 (cat. 168)

155 William Collins, *Horses Watering by a Bridge*, *c*. 1815 (cat. 25)

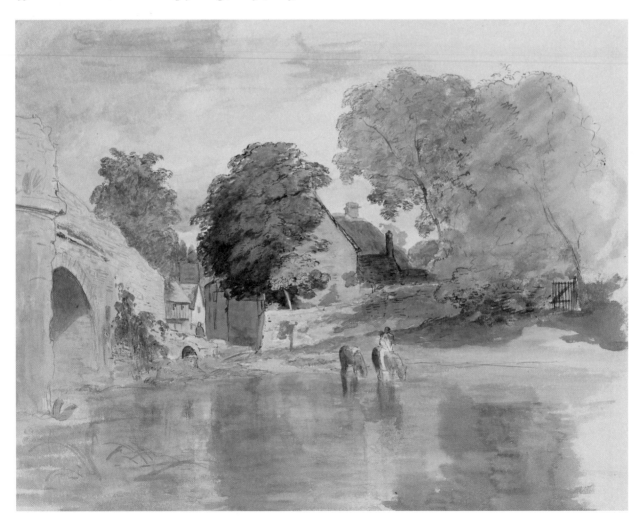

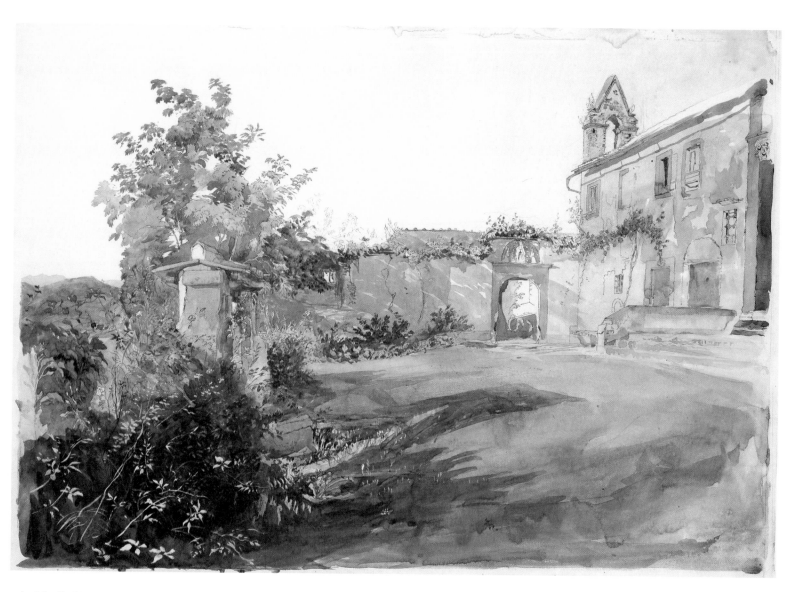

156 John Ruskin, *The Garden of S. Miniato, Florence*, 1845 (cat. 245)

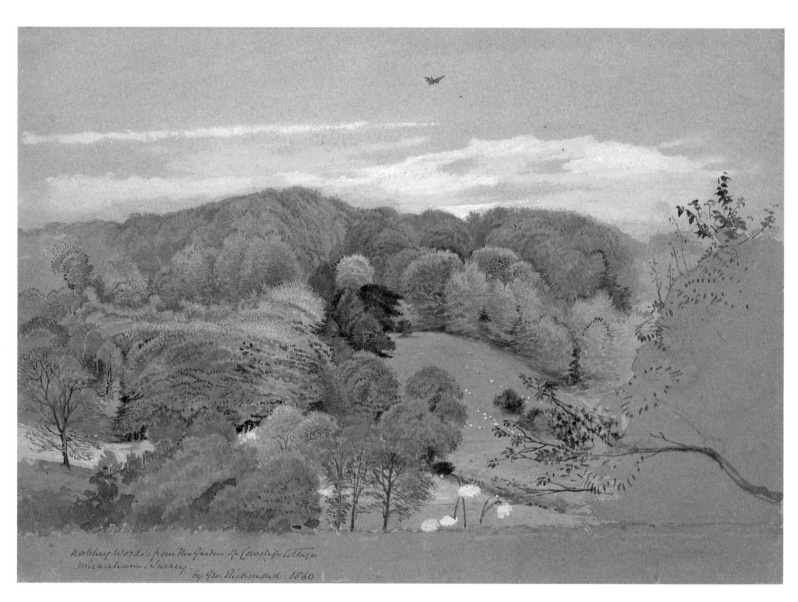

Norbury Woods from the Garden of Cowslip Cottage
Mickleham Surrey
by Geo. Richmond. 1860

157 George Richmond, *A View of Norbury Woods*, 1860 (cat. 236)

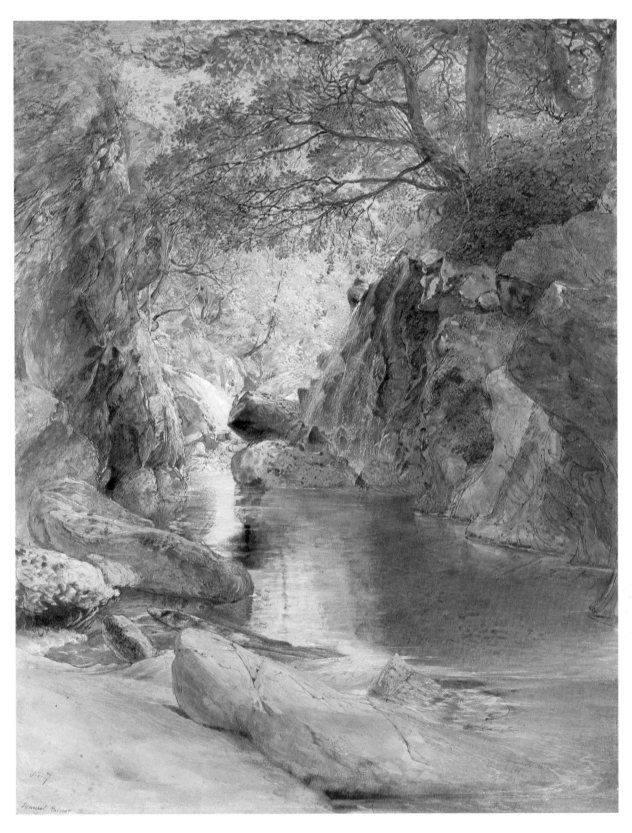

158 Samuel Palmer, *A Cascade in Shadow, c.* 1835–6 (cat. 226)

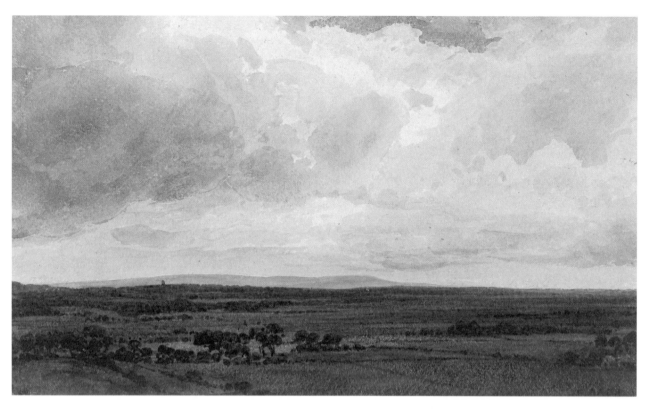

159 Frederick Nash, *Showery Day, Glastonbury Tor*, (?)*c*. 1820 (cat. 219)

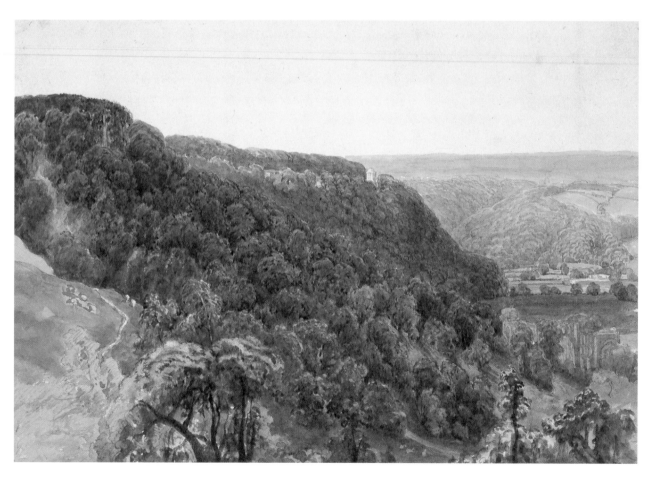

160 William Henry Bartlett, *View of Rievaulx Abbey from the Hills to the West*, *c*. 1829 (cat. 8)

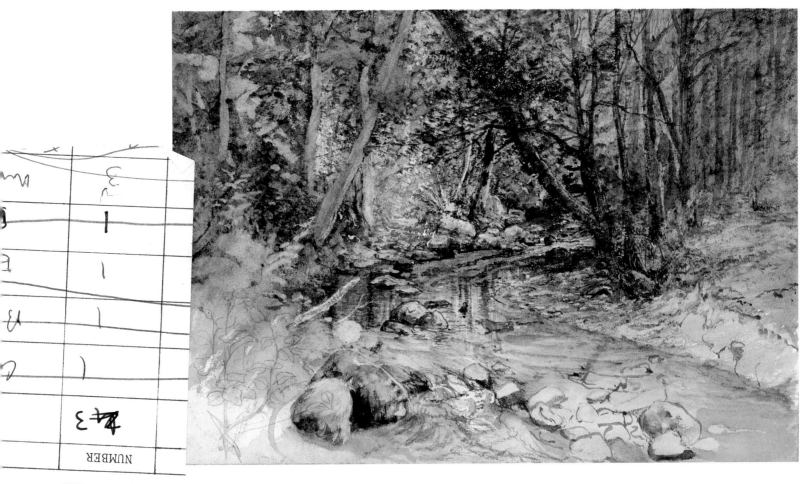

William Bell Scott, *Penwhapple Stream*, c. 1860 (cat. 261)

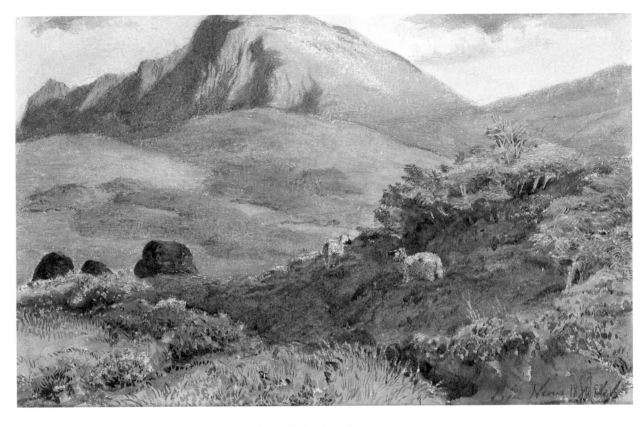

162 John Everett Millais, *A Mountainous Scene, Scotland – possibly Ben Nevis*, (?) 1854 (cat. 214)

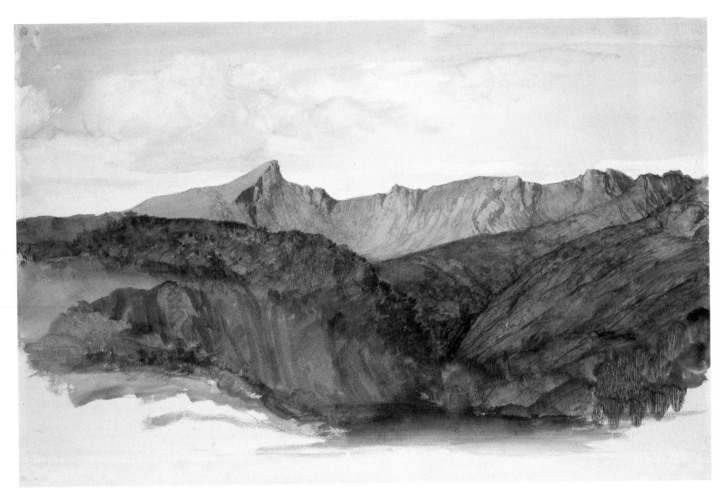

163 William Dyce, *Tryfan, Snowdonia*, 1860 (cat. 125)

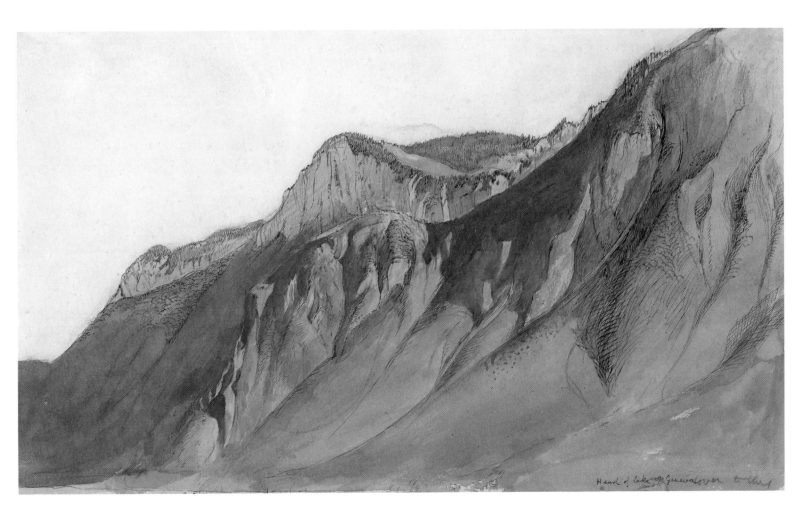

164　John Ruskin, *Head of Lake Geneva*, (?)1846　(cat. 246)

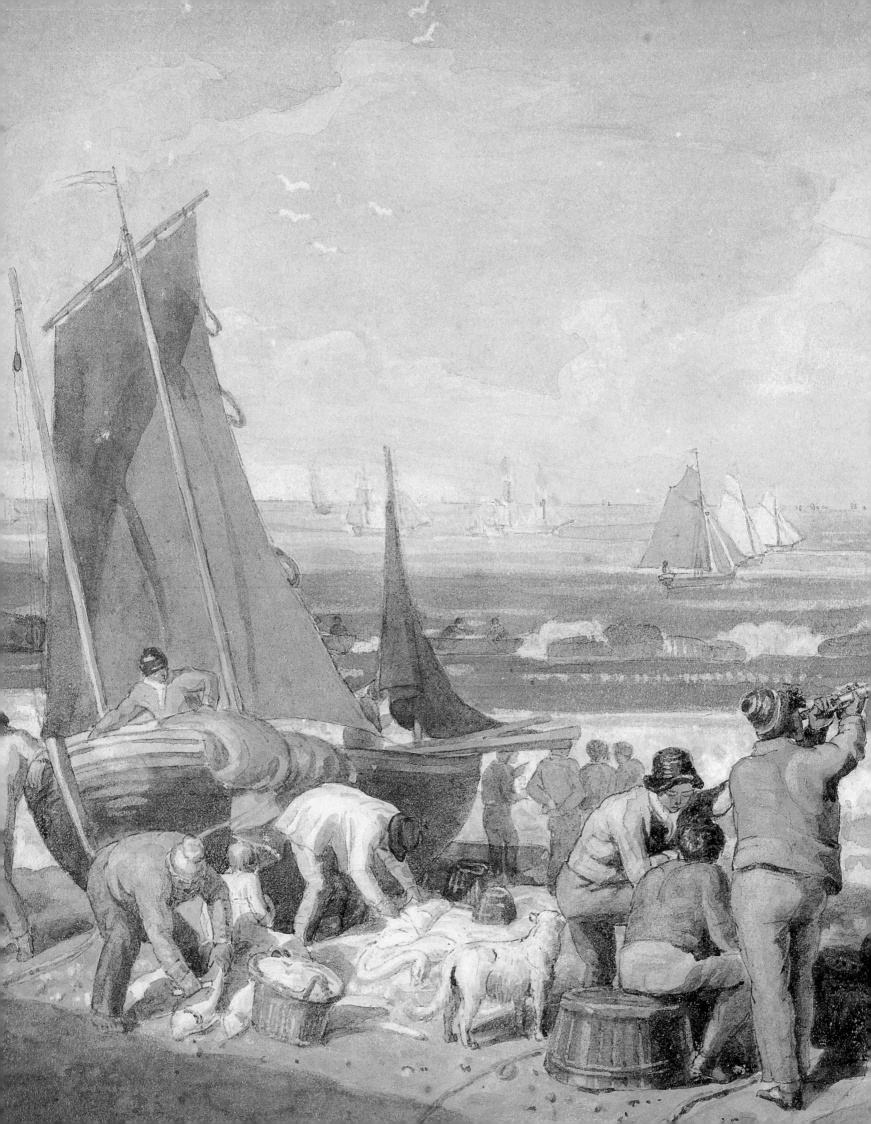

IV

Picturesque, Antipicturesque:
The Composition of Romantic Landscape

When the first of the watercolour societies was founded in 1804 the terms of reference of a serious new art form were already more or less defined. As a medium it was genuinely new: in many respects the kinds of works that the Society of Painters in Water-Colours existed to promote had been unknown and unthinkable fifteen or twenty years earlier.

Not, indeed, that 1804 was the year one would choose as marking the epoch; that was perhaps 1799, the year that Turner's first large classicising watercolour, a Claudean view of Caernarvon Castle at sunset, appeared at the Royal Academy (fig. 39). This brought to a climax the succession of increasingly ambitious topographical subjects that both he and Girtin were showing at the Academy in the later 1790s. Girtin died in 1802, and Turner was never a member of the OWCS. He was too closely integrated into the Academy, and was always content to exhibit both oils and watercolours there, though he was to show one important work, the *Tivoli* (pl. 277), with the OWCS in 1823. The very fact of his commitment to the Academy, together with his ambition and his success in both media, was the catalyst the watercolourists needed. It demonstrated what was possible, and provided the whole profession with a universally admired example.

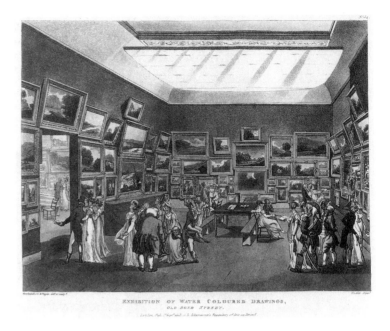

Fig. 40 *Exhibition of the Society of Painters in Water-Colours 1808*, from Ackermann's *Microcosm of London*, aquatint, 19.5 x 25.5. British Museum, London

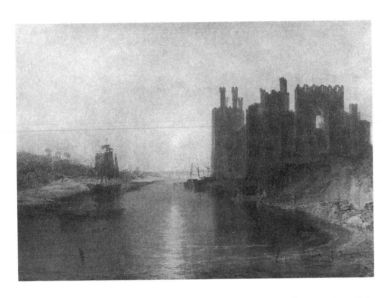

Fig. 39 J. M. W. Turner, *Caernarvon Castle: Sunset*, 1799, watercolour, 57 x 82.5. Private Collection

One crucial fact about the newly defined medium was that it was no longer simply a means of recording things seen. The eighteenth-century insistence on genius, on creative individuality, had now been unequivocally applied to watercolour, and it was incumbent on the members of the OWCS to demonstrate that they and their medium were capable of high art. This meant that historical themes were now regularly tackled by watercolourists; though, as with history painting in oil, there was usually a disparity between the conception and the execution of such pictures, which were, despite fashionable theory, by now an outdated form. That obsolescence was unconsciously acknowledged by the numbers of painters who preferred landscape. Landscape was, and remained, the primary channel for new ideas. But although topography was still the landscape painter's most usual starting-point, the provision of topographical information was no longer the principal intention of the work.

The establishment of an academy for watercolour inevitably led not only to more ambitious works, but to larger numbers of works being produced (fig. 40). Many artists were able and prolific, were admired and collected, but added little to the history of the medium as an aesthetic force. The heyday of the OWCS and its rivals, the New Society of Painters in Water-Colours (NWCS), founded in 1832, and, briefly from 1808 to 1812, the Associated Artists in Water-Colours, was dominated by the achievements of Turner and Girtin, and because Turner lived until 1851 and evolved continuously during that time, all developments have been seen as epitomised in his career and output. In fact, the early nineteenth century was a golden age for the medium in the sheer number of great exponents, and each of these in his own way influenced the development of watercolour from the state in which the OWCS found it in 1804 to the complex and many-sided medium that it was in the 1880s. The early members of the OWCS shared much in the way of inherited technical and aesthetic wisdom, and their work forms a clear and coherent group, in which certain common assumptions are apparent. But each brought a personal vision, and a particular type of preferred subject-matter; each developed a distinctive method of study from Nature, and a recognisable idiom. That idiom may be dependent on technique, on palette, or on any of the variables mentioned. One of the most personal and perhaps the subtlest in its operation is composition.

As we have seen, the great Continental conventions of landscape composition had been restated and revitalised in the

eighteenth century by Alexander Cozens and others; it is not possible to discuss meaningfully the compositional strategies of John Robert Cozens in terms of Claude and his contemporaries, although there is sometimes an indirect reference to such prototypes. If one can speak of Turner's work in relation to Claude, as he earnestly wished people to do, that is because he was able to approach Claude by a completely original route, thanks to what had been done in the eighteenth century to rethink Claude in terms of an empirical British aesthetic. Because Alexander Cozens's explorations had been so thorough, there did not exist a type of landscape composition that had not been reformulated for current use. It was impossible to be naive about landscape; if there was a loophole for simple-mindedness, Gilpin had plugged it with his exhaustive analysis of the different types of Picturesque.[1] Thanks to him, the most unsophisticated curate or maiden aunt knew how to reduce a view to a satisfactory pictorial formula. Thanks to the Cozenses, the professional artist had a vast range of landscape and compositional types to draw on. More significantly, the artist possessing genuine originality was provided with an aesthetic basis on which fruitfully to go on modifying the tradition. It is no accident that Constable, one of the most independent and inventive spirits of the age, transcribed the lists in Alexander's *Various Species of Landscape* and made copies of the illustrations.[2]

Whereas Constable's own art rarely betrays his interest in theories, many of the most original contributions of the time can be ascribed to such preoccupations. The dominance of theory in the period is entirely consistent with the intensity of creativity, though the popularity of watercolour has obscured its intellectual concerns. Rich and varied colour, sumptuous technical effects and attractive subject-matter were all characteristics of the early exhibitions mounted by the OWCS. None of these qualities was incompatible with significant works of art; indeed, there was an assumption that the former were positively necessary in the creation of the latter: 'experience has proved that water-colours, by the present improved process, have an intensity of depth, and splendour of effect which almost raises them to rivalry with cabinet pictures'.[3] But what lent the Society's displays their astringency as the clearing-house for a new aesthetic currency was the artists' far-reaching and inventive investigation of the problems of landscape composition. To the background theory supplied by Alexander Cozens and Gilpin, Girtin with his selfconscious Wilsonian generalisation added an acknowledged example of mastery. The key works all date from the last two or three years of Girtin's life; they include the panoramic views at Kirkstall and other North Country subjects including the views of Jedburgh (pl. 166, 167); the studies for Girtin's panorama of London, the 'Eidometropolis' (pl. 77, 78), the large *Bridgnorth* (pl. 41) and some others. The first thing to be said about them is that they display an emancipation from formal compositional theory that is in itself remarkable, and suggests an unusually sympathetic understanding of John Robert Cozens's achievement in this field. An eccentric design like that of *Lulworth Cove* (pl. 170), with its abrupt diagonals signalling a preoccupation with hitherto untried divisions of the picture-space, could not have been conceived without

Cozens's example. Second, Girtin's late works are all distinguished by a rigorous reduction of the image to the broadest possible planes of warm, rich colour. The principle is illustrated in an extreme form in the watercolour known as *Storiths Heights* (pl. 165), which seems to take as its subject a scene that Gilpin would have denominated quite unsuitable for use in a painting – 'disgusting', as he described his notional scene of two bare hillsides intersecting, with a third bare hill beyond (fig. 41) .[4] Girtin's colour, however, is applied to such subjects in a way that creates variety and depth of tone in a single stroke: the fragmented wash of Cozens, Hearne and Rooker is resynthesised to achieve an even greater weight and volume. Combined with the simplified compositional structure these washes are monumental in their effect, and take on a grandeur that is both abstract and evocative of the open spaces that Girtin was depicting. While he is one of the greatest of Romantic landscapists, this is in an important sense a neoclassical landscape art, obedient to the rules of economy and conciseness, simplicity and controlled strength that Neoclassicism advocated. If we interpret *Storiths Heights* as an unfinished work, which is not implausible, the point can be applied more broadly: examples of the preliminary lay-ins of artists as widely different as J.M.W. Turner (pl. 35) and David Cox (pl. 200) indicate a general concern with the solid structural basis of all compositions.

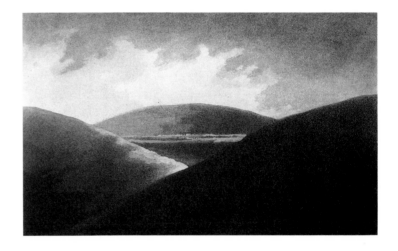

Fig. 41 William Gilpin, plate from *Three Essays*, 1792, aquatint, 13 x 21.3. British Museum, London

The restraint of Girtin was taken still further under the aegis of Cotman's essentially ascetic temperament. For Cotman, even a bank of weeds or a rustic gate took on monumental qualities, defined by a clarifying line that adds an almost musical subtlety to Girtin's grand simplicity (pl. 174). For Cotman, again, colour plays an important part in harmonising the linear counterpoint. His studies of groups of trees in the North Yorkshire woods, rendered in soft grey-greens and ochres, translate the sublime palette of Girtin into a gentler poetry that nevertheless retains an epic dignity: although drawn on the spot, 'from Nature . . . close copies of that fic[k]le Dame', as Cotman confirmed (pl. 171, 173, 176),[5] they cannot

easily be categorised as Nature studies of the kind shown here in Section III, but are deliberately cast as self-sufficient statements. Cotman might work them up further, but their essential completeness is undeniable. When he turned to more elaborate subject-matter, he applied the same reductive principles to create vast and intricate patterns that are both descriptive and purely formal. The large drawings of Norwich market (pl. 73), or the studies of Norfolk antiquities that he made in the 1810s (pl. 84), comprehend a range of complicated ideas, but unite them under a rigorous linear discipline that defines compositional structures and clarifies meaning.

As his career advanced, Cotman's system of colour developed in accordance with the changes of early nineteenth-century taste. The sombre hues of the Girtinian sublime gave way to a gentler, more naturalistic palette under the influence of the fashion for *plein-air* sketching (pl. 179), and this brightened still further in the 1820s and 1830s as the new bourgeois realism overtook both oil painting and watercolour. The series of elaborately finished views in Normandy that he executed in the 1820s (pl. 187–90) mark perhaps the

destinies were very different. Few either could or wished to imitate Cotman's remarkable idiosyncrasies as a draughtsman; the ability to invest a length of fencing with epic grandeur was not vouchsafed to many. But they all, more or less, felt the need for compositional rigour, and in the first decade of the century John Varley, William Havell, George Barret Jnr (1767–1842), Turner of Oxford and Joshua Cristall each subscribed to the prevailing Neoclassicism, and sought solutions not so much in isolated details of Nature but in grand, idealising compositional structures (pl. 201, 210, 214).[6]

With these artists we meet in its clearest form the polarity of Picturesque and Antipicturesque (as we may call it) that dominates the compositional thinking of the period. Whereas Girtin and Cotman evolved their compositions from an instinctively reductive attitude to form and structure, the pillars of the early OWCS began from a more consciously art-historical position. Far from equating the newly evolved medium with a wholly new departure in terms of subject-matter, the OWCS subscribed to the current view that British painting – and for them that included watercolour in its new

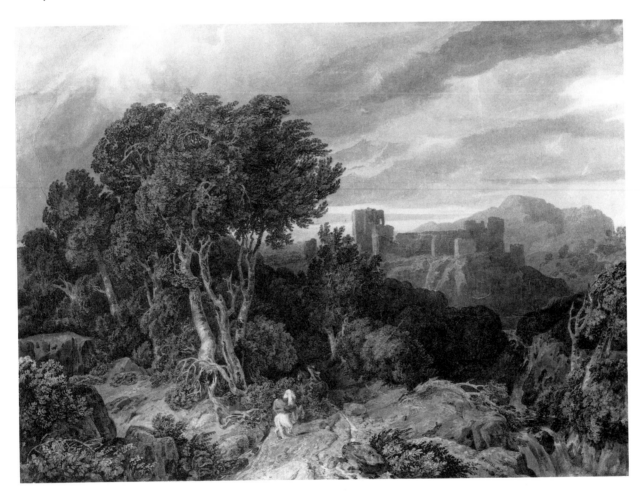

Fig. 42
William Havell, *Stormy Twilight*, 1807, watercolour with stopping-out and scraping-out, 78 x 106. Private Collection

high point of his development: in them topography is transmuted into the grandest of abstract designs, which nevertheless by some extraordinary creative power preserve the warmth and humanity that makes topography live. Cotman's later work is vividly coloured, making use of saturated reds, blues and yellows; yet its integrity is maintained by his firm linear and structural sense. Most of the Society's artists followed a similar path, although their individual

incarnation – was an art form in the great European tradition. Turner's Claudean *Caernarvon Castle*, produced immediately after seeing John Julius Angerstein's collection of Claudes,[7] had conclusively demonstrated the viability of that argument. Havell, Cristall and the others measured themselves, like Turner, against specific examples from the past, to the extent of sometimes imitating the 'varnished' appearance of Old Master paintings.[8] The resulting

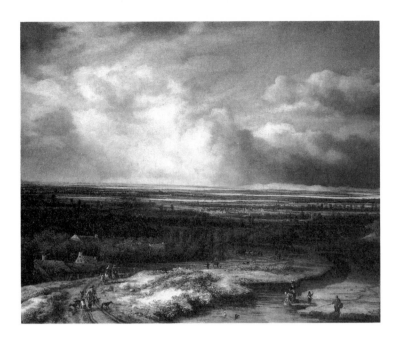

Fig. 43 Philips Koninck, *Landscape with a Hawking Party, c.* 1655, oil on canvas, 132.7 x 160.3. National Gallery, London

chromatic simplification with its opposition of warm browns and cool blues was, of course, also entirely in harmony with the aesthetic of the Sublime, and it is perhaps a moot point which consideration was uppermost in their minds. But like Turner, these artists were looking back in the aftermath of the eighteenth-century revision of landscape theory. When Havell referred to the opulent foliage of Poussin's landscapes, he did so with a developed sense of the aesthetic value of full-grown trees in groups, so that the Poussinesque elements in his designs are reintegrated into compositions that have a value of their own and of their own time (fig. 42). Similarly, Turner of Oxford adopted the insistent horizontal emphasis of some Dutch masters – Salomon van Ruysdael (*c.* 1600–70) and Philips Koninck (1619–88; fig. 43), for instance – and made of it something entirely his own. His flat panoramas have a very different flavour from those of his Dutch models, because they take a Romantic, rather than a realist, delight in the expanse of earth and sky. That delight, moreover, is tempered by a neoclassical *frisson* prompted by the sheer horizontality of the design, which is often accentuated by a figure, or group of figures, carefully placed to punctuate the movement of the eye from left to right. Turner of Oxford's early panoramas, like some of Havell's orchards and woods, are brooding and stormy; they became brighter in the course of his career, and the crisp sunniness of his mature views in Gloucestershire or round Chichester contributes to their exhilarating effect (pl. 206). The apparent informality of these compositions is deceptive. With a more intricate subject, such as *Wychwood Forest* (pl. 202), he displays a linear control reminiscent of that of Towne or Cotman, and proves conclusively that his broad sweeps of countryside are presented to us for the aesthetic interest of their rarefied rhythms as much as for any purely representational charm. The pictorial value of these panoramic compositions was to be exploited further by two of the most important figures of this generation, Cox and De Wint (pl. 208, 186).

Turner of Oxford's uncompromising approach to composition surely takes its cue from the theorising of Alexander Cozens. Similarly, the more apparently conventional landscapes of Barret and Francis Oliver Finch (1802–62), with their carefully opposed *repoussoirs* and sunlit recessions, must be seen not as mere imitations of Claude but as restatements of compositional problems enunciated by Cozens and Gilpin. The empirical and experimental nature of these works is never far from view, as the artists return over and over again to the problems of balance, rhythm and harmony of colour in the context of a unified mood. Both Barret and Finch made much use of the device of stopping-out in their search for intensity of effect, and their masses of dense foliage have a rich, heavy, sun-drenched quality that is essential to their intention of creating an Arcadian world within the limited space of a sheet of watercolour paper (pl. 214, 204).

Finch learned to express the intensity of a personal response to Nature from his mentor and fellow 'Ancient' at Shoreham in Kent, Samuel Palmer. The connection reaffirms the neoclassical links of the group, for Palmer was, of course, in his youth a friend and devotee of William Blake, who was essentially a historical painter in the high neoclassical style, despite his oddities and visionary quirks (pl. 218). The Ancients, indeed, began as a group of Blake devotees. That visionary gift seems almost a matter of course for this generation, for whom the preoccupations of the youthful Wordsworth and Coleridge became a universal principle. Blake himself responded to landscape painting with characteristic intensity: Palmer recalled him speaking of Claude 'with the greatest delight', and pointing out in some examples 'upon the focal lights of the foliage, small specks of pure white which made them appear to be glittering with dew which the morning sun had not yet dried up… The sun was set; but Blake's Claudes made sunshine in that shady place'.[9] Here we feel the interconnection of all the 'visionaries' of the Romantic period – Blake and Palmer, Constable, whose

Fig. 44 John Varley, *Landscape with Harlech Castle and Snowdon in the Background, c.* 1825, watercolour with gum arabic and scraping-out, 31.7 x 45. Victoria and Albert Museum, London

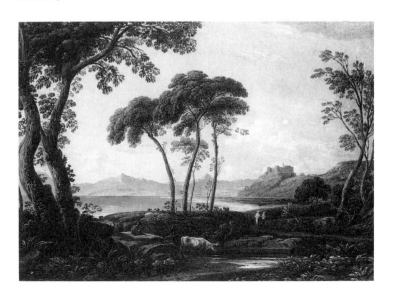

'snow' of dewy white highlights became legendary, and all the other passionate Claudians, led of course by Turner.[10]

The degree of intensity of the vision varied, inevitably, from artist to artist. The Irishman Francis Danby (1793–1861) pursued his own distinctive lights, working with meticulously wrought surfaces to portray scenes of local domesticity or elegiac grandeur equally intensely (pl. 195, 197). Samuel Jackson, Danby's colleague in the artists' colony at Bristol in the 1820s, could evoke a dreamlike world in the city's suburbs (pl. 193) or along the Avon Gorge (pl. 191), by means of his refinement of placing and touch.

One of Girtin's first interpreters – and not, on the face of it, one of the most 'inspired' of the group – John Varley, was an associate of Blake who took great interest in the supernatural, in signs and apparitions. The idealising landscapes (fig. 44) that replaced the Sublime Girtinian mountainscapes of Varley's early output (pl. 198) provide a kind of norm, or *locus classicus*, to which many other works of the time can be referred. The career of A. V. Copley Fielding (1787–1855), for instance, was largely spent in inventing variations on the type, though he could on occasion bring a more personal vision to bear on his subject-matter (pl. 207). Palmer himself, deeply idiosyncratic as his art was, never lost sight of the basic, or 'core' Ideal composition that Varley evolved. In the second half of his career, when he was as deeply influenced by Turner as ever he had been by Blake in his youth, Palmer had endless recourse to the compositional archetype that represented, for all these artists, a dream-world that has as much to do with Byron and Keats as with Claude and Poussin.

At his most original, in the 1820s and early 1830s, Palmer moved very far from the compositional prototypes that prevailed in the OWCS. He worked very largely in monochrome – an indication, perhaps, of the heightened importance in his images of an underlying idea, albeit not the abstract aesthetic concepts that had preoccupied the eighteenth century. There is, however, something reminiscent of the eighteenth century, and perhaps of Alexander Cozens, in the blot-like and extremely generalised rendering of form that characterises many of his most intense statements (pl. 222). Significantly, although Palmer frequently drew from Nature, the results bore no relation to the fresh naturalism that Linnell, Hunt and the rest had pursued in the 1800s and 1810s. It was not until the close of his so-called 'Shoreham' phase that Palmer began regularly to make closely observed and literal studies out of doors, and by then his purposes had shifted towards the more public aims of the OWCS, and his watercolours increased in size accordingly. He ended his career as a full-blown exponent of the High Victorian watercolour, and perfectly illustrates the continuity between the early, classic phase of the watercolour school and its later flowering in the second half of the nineteenth century.

A. W.

1 See Section 1, p. 36, and reference 1.

2 See *Alexander and John Robert Cozens: The Poetry of Landscape*, pp. 55, 86.

3 *Somerset House Gazette*, II, p. 46.

4 Gilpin, loc. cit.: 'In a mountain scene what composition could arise from the corner of a smooth knoll coming forward on one side, intersected by a smooth knoll on the other; with a smooth plain perhaps in the middle, and a smooth mountain in the distance? The very idea is disgusting.'

5 See S. C. Kitson, *The Life of John Sell Cotman*, London 1937, p. 80.

6 Havell, for instance, produced classical subjects in oils, such as his *Cephalus and Procris* of 1806, and judged Turner to be 'superior to Claude, Poussin or any Other' (see *William Havell, 1782–1857*, p. 9). Although individual painters like Turner and Cristall have been explicitly associated with the fashion for classical landscape, the crucial role that fashion played in shaping the early landscapes of the OWCS, and especially its derivation from Girtin, has not been stressed.

7 'When Turner was very young [in 1799] he went to see [John Julius] Angerstein's pictures. Angerstein came into the room while the young painter was looking at the Sea Port by Claude, and spoke to him. Turner was awkward, agitated, and burst into tears. Mr Angerstein enquired the cause and pressed for an answer, when Turner said passionately, "Because I shall never be able to paint anything like that picture."' George Jones, 'Recollections of J. M. W. Turner', *Collected Correspondence of J. M. W. Turner, with an Early Diary and a Memoir by George Jones*, ed. J. Gage, Oxford 1980, p. 4.

8 The point is made (in relation to Girtin's palette) in *Works of Splendor and Imagination: The Exhibition Watercolour, 1770–1870*, exh. cat. by J. Bayard; New Haven, Yale Center for British Art, 1981, p. 17.

9 *The Letters of Samuel Palmer*, ed. R. Lister, 1974, II, p. 573.

10 See reference 7 above; and Constable's remark 'How paramount is Claude!' (Leslie, *Memoirs*, p. 132).

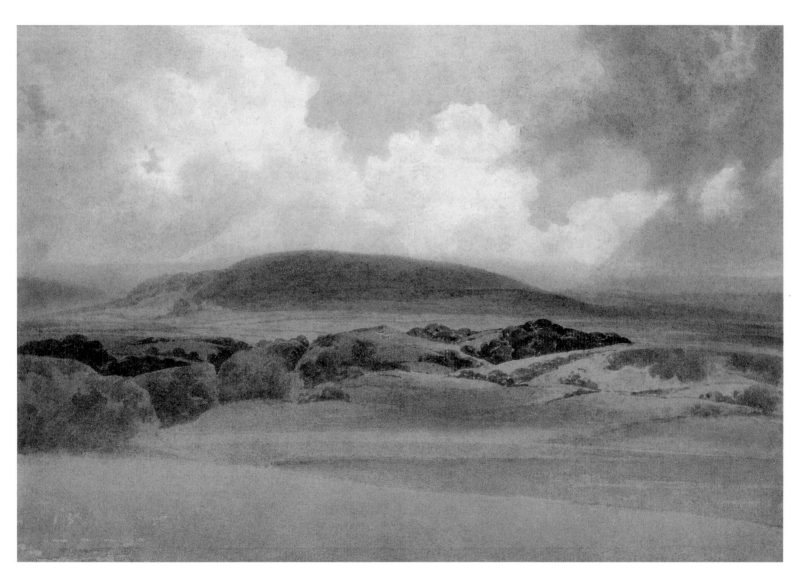

165 Thomas Girtin, *Storiths Heights, Wharfedale, Yorkshire, c.* 1802 (cat. 153)

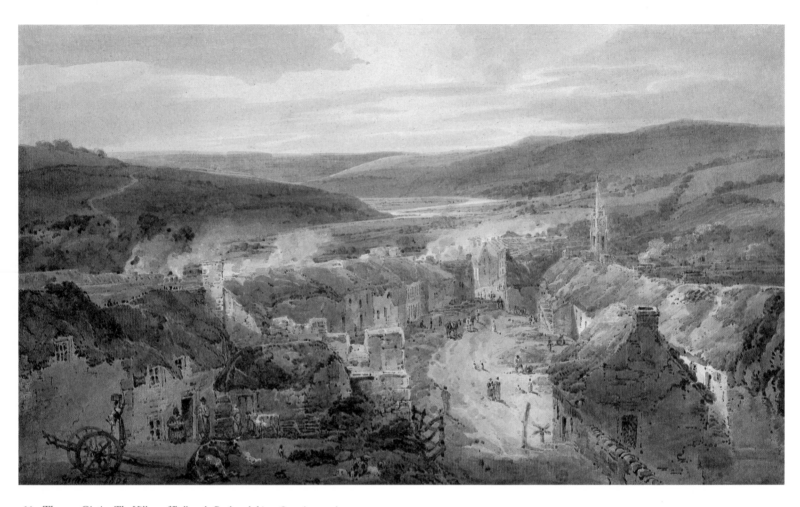

166 Thomas Girtin, *The Village of Jedburgh, Roxburghshire*, 1800 (cat. 142)

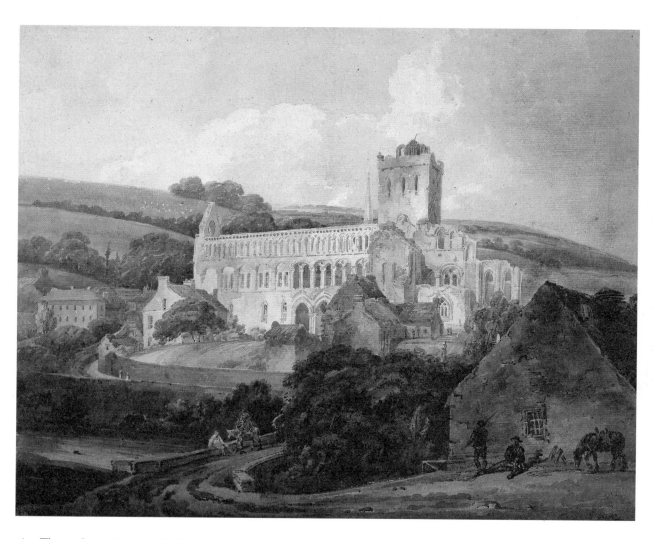

167 Thomas Girtin, *Jedburgh Abbey from the South-east*, *c.* 1800 (cat. 146)

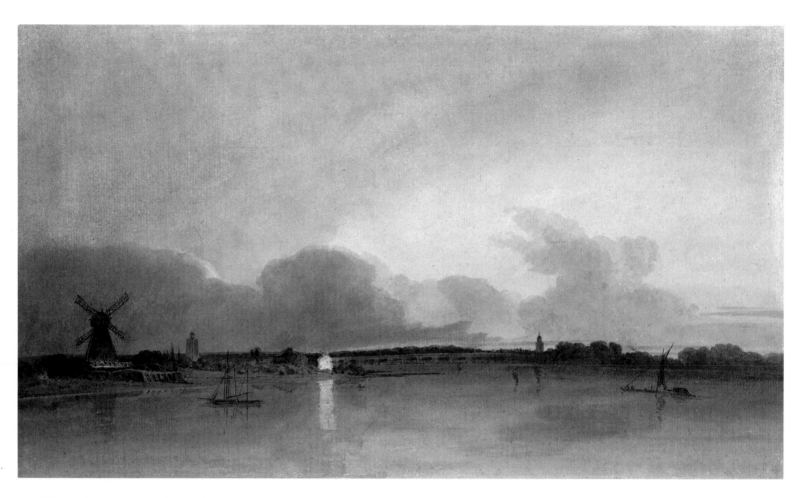

168 Thomas Girtin, *The White House at Chelsea*, 1800 (cat. 143)

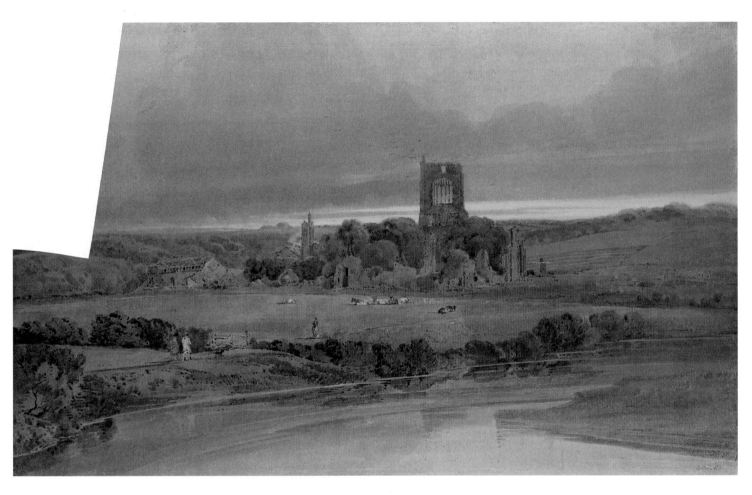

169 Thomas Girtin, *Kirkstall Abbey, Yorkshire: Evening*, c. 1800–1 (cat. 147)

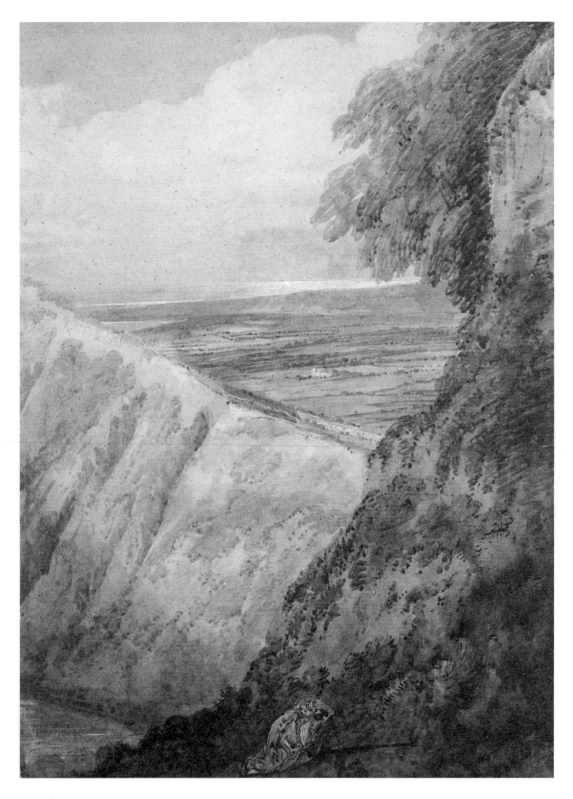

170 Thomas Girtin, *Coast of Dorset near Lulworth Cove*, *c.* 1798 (cat. 138)

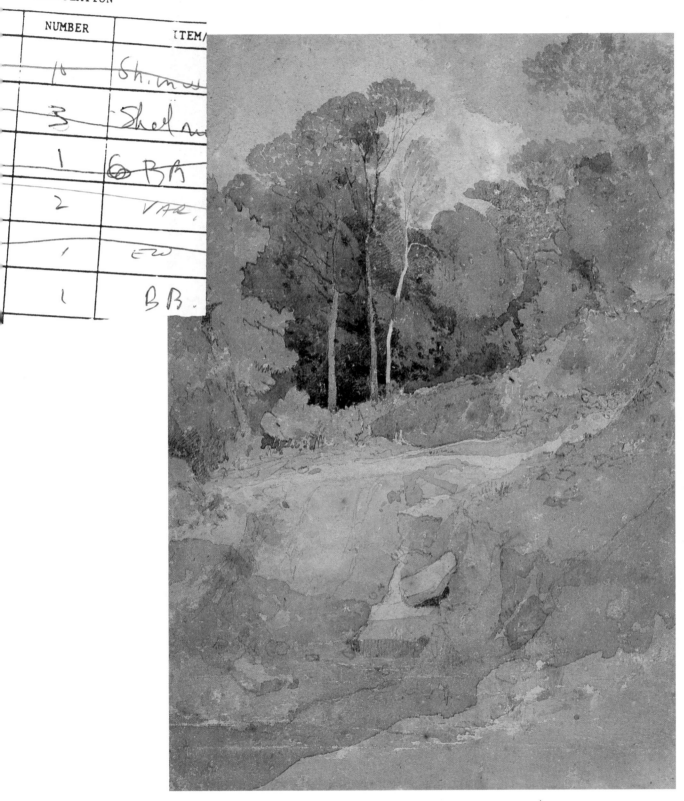

171 John Sell Cotman, *Duncombe Park, Yorkshire, c.* 1806 (cat. 44)

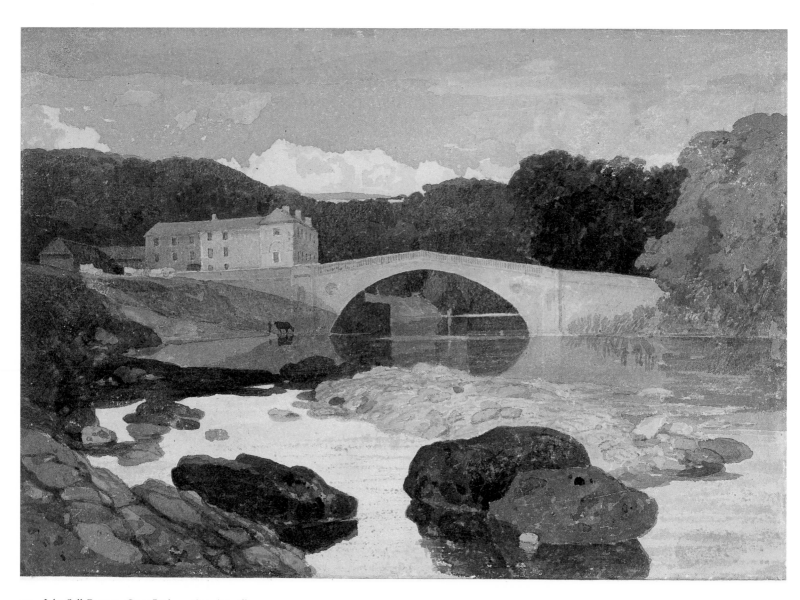

172 John Sell Cotman, *Greta Bridge, c.* 1807 (cat. 48)

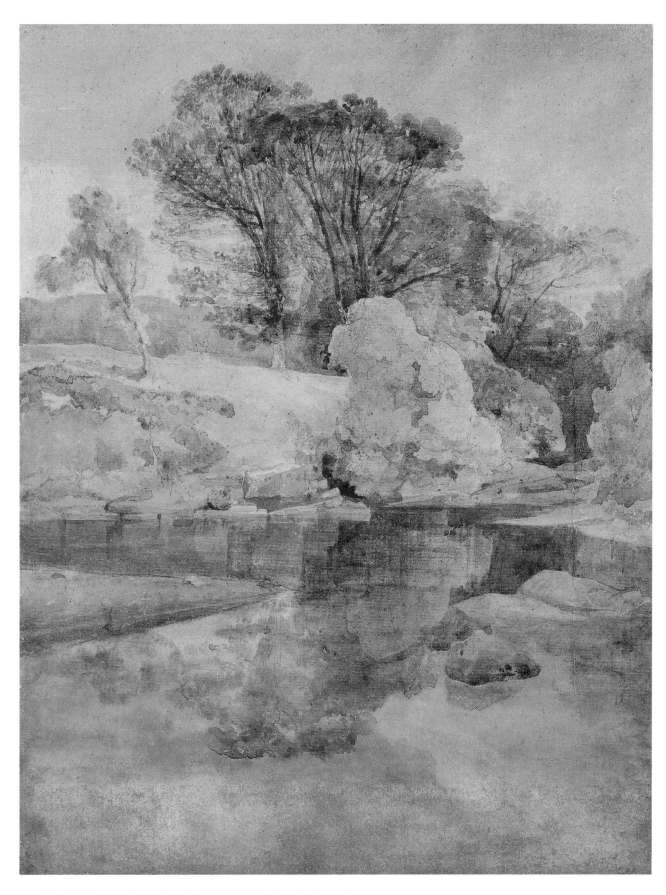

173 John Sell Cotman, *On the Greta* *(called 'Hell Cauldron')*, *c*. 1806 (cat. 42)

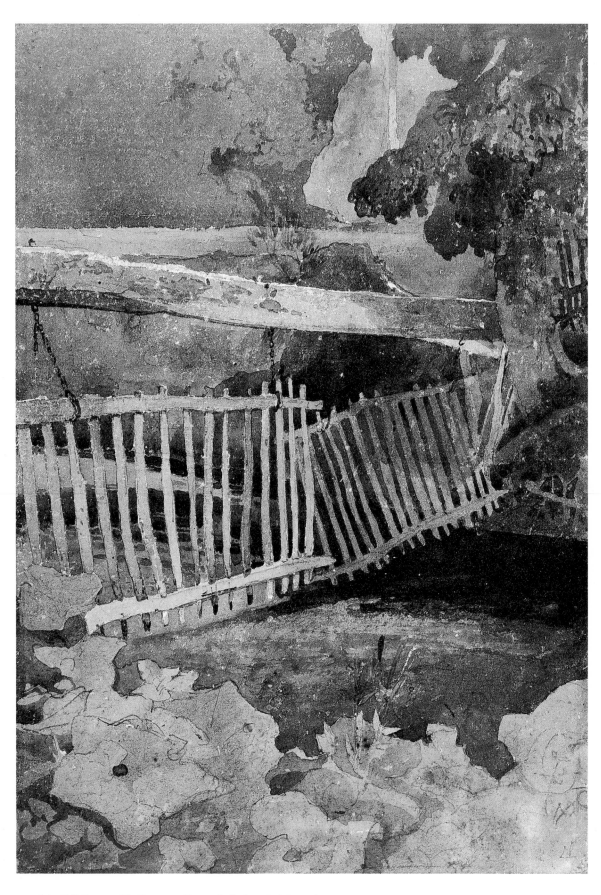

174 John Sell Cotman, *The Drop-gate, Duncombe Park, c.* 1806 (cat. 43)

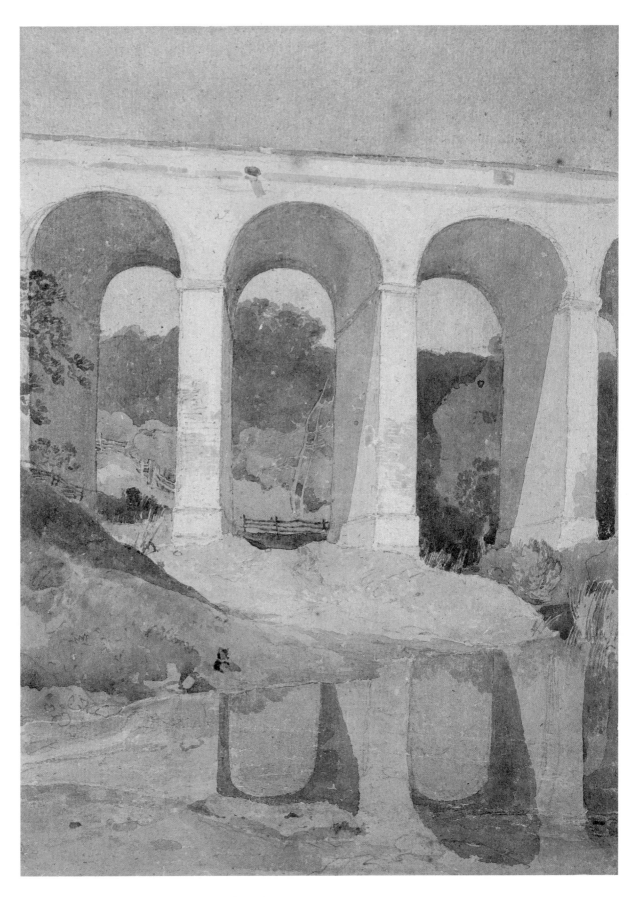

175 John Sell Cotman, *Chirk Aqueduct*, 1806–7 (cat. 47)

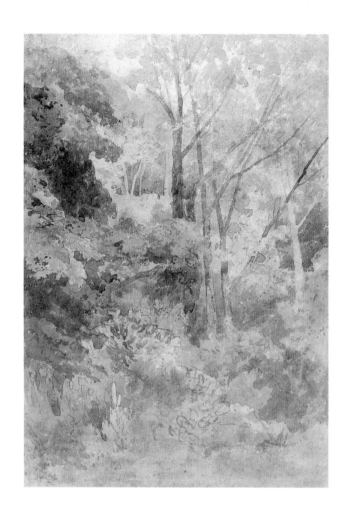

CIRCULATION

NUMBER	ITEM/
1	VIDEO
1	SEX
2	ART m
1	AB
1	AD

F. 26, 1995

| 6 | VF Fil |

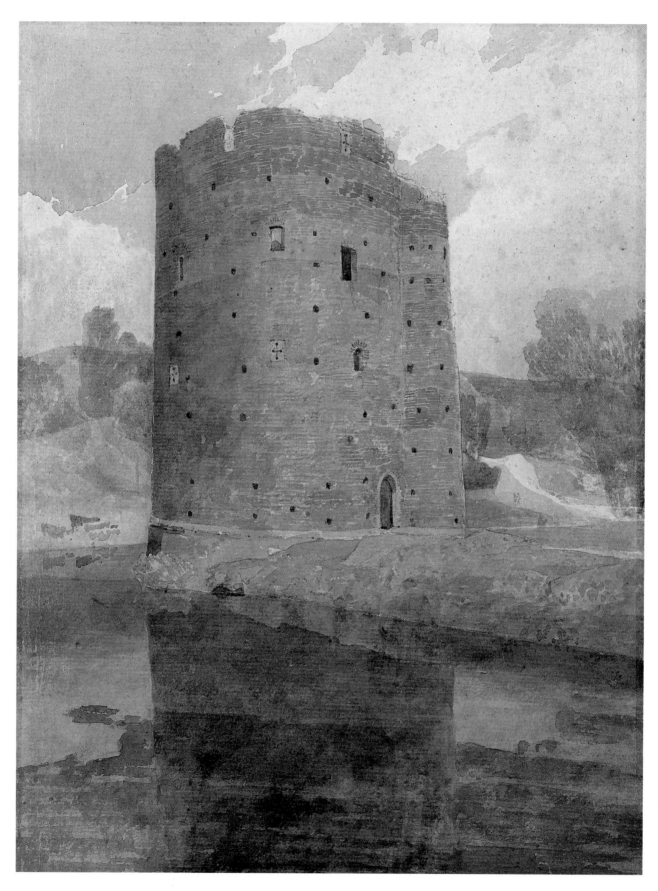

178 John Sell Cotman, *Norwich: The Cow Tower*, c. 1807 (cat. 49)

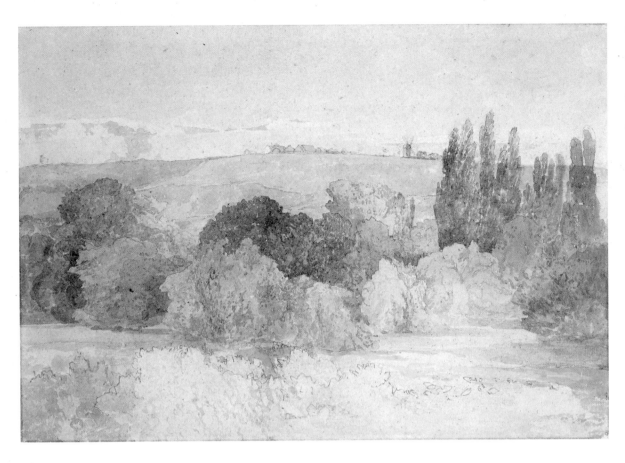

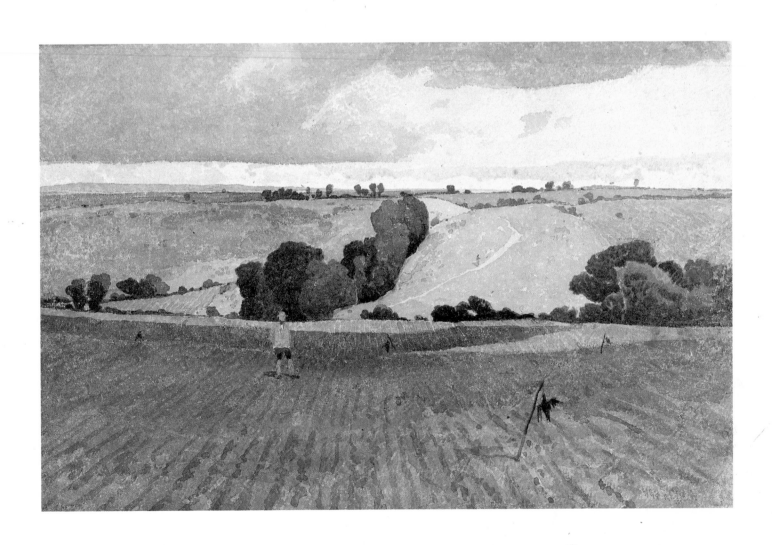

left
179 John Sell Cotman, *River Landscape (Probably on the Greta, Yorkshire)*, *c.* 1806 (cat. 46)

below
180 John Sell Cotman, *A Ploughed Field*, *c.* 1808 (cat. 51)

right
181 Peter de Wint,
Lincoln: The Devil's Hole,
c. 1810 (cat. 109)

below
182 Peter de Wint,
Yorkshire Fells,
c. 1812 (cat. 112)

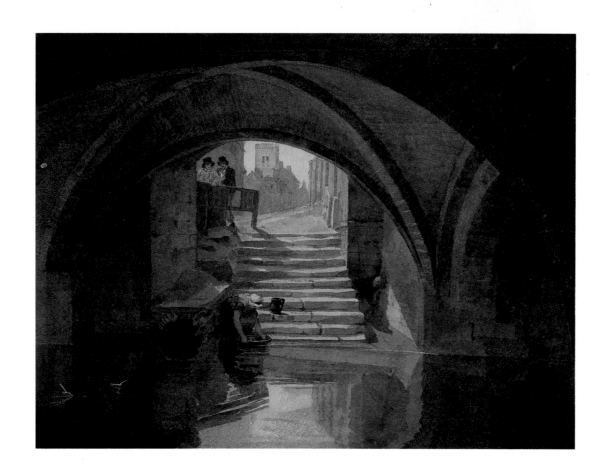

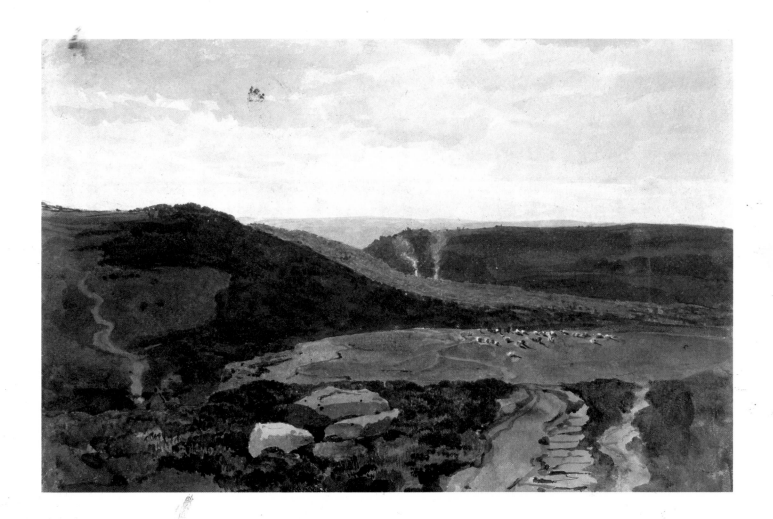

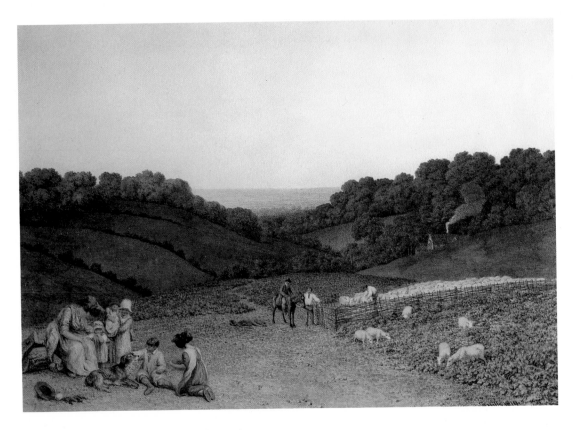

183 Robert Hills, *The Turnip Field*, 1819 (cat. 167)

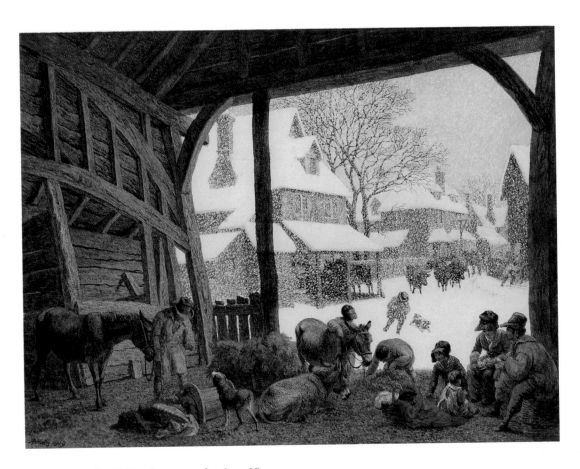

184 Robert Hills, *A Village Snow-scene*, 1819 (cat. 166)

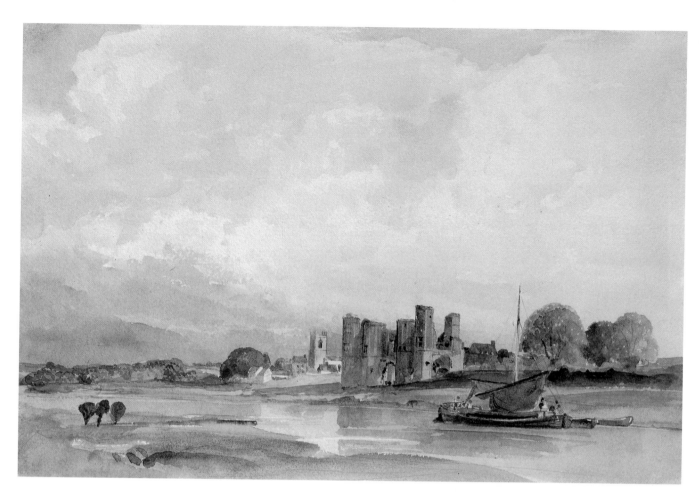

185 Peter de Wint, *Torksey Castle (Study)*, *c.* 1835 (cat. 117)

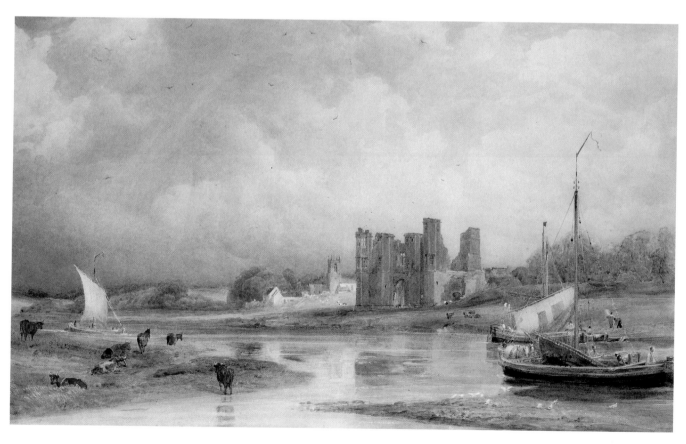

186 Peter de Wint, *Torksey Castle, Lincolnshire*, *c.* 1835 (cat. 118)

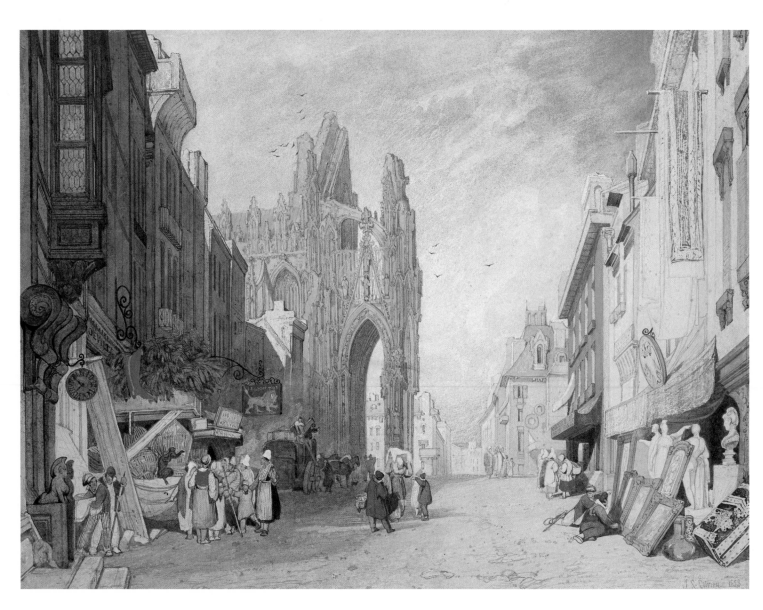

187 John Sell Cotman, *Street Scene at Alençon*, 1828 (cat. 57)

188 John Sell Cotman, *Domfront*, 1823 (cat. 55)

189 John Sell Cotman, *Dieppe Harbour*, 1823 (cat. 56)

190 John Sell Cotman, *Mont St Michel*, 1828 (cat. 58)

191 Samuel Jackson, *View of the Hotwells and Part of Clifton near Bristol*, (?) 1823 (cat. 187)

192 Joshua Cristall, *Coast Scene: The Beach at Hastings, with a Fleet in the Distance, c.* 1814 (cat. 97)

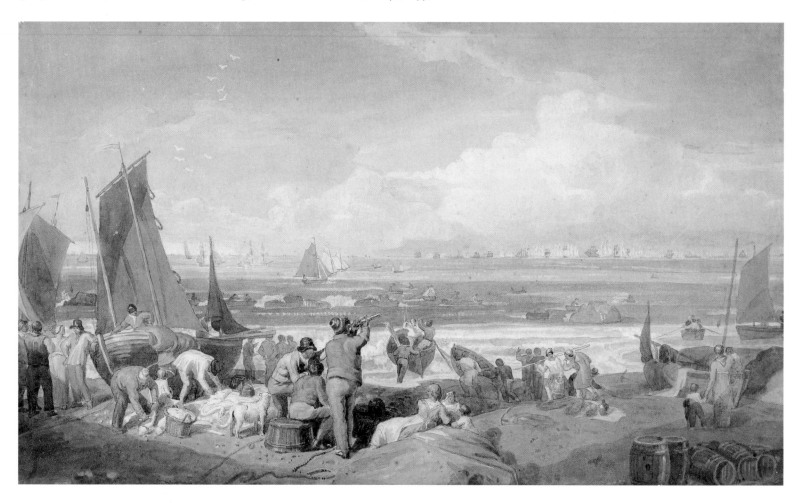

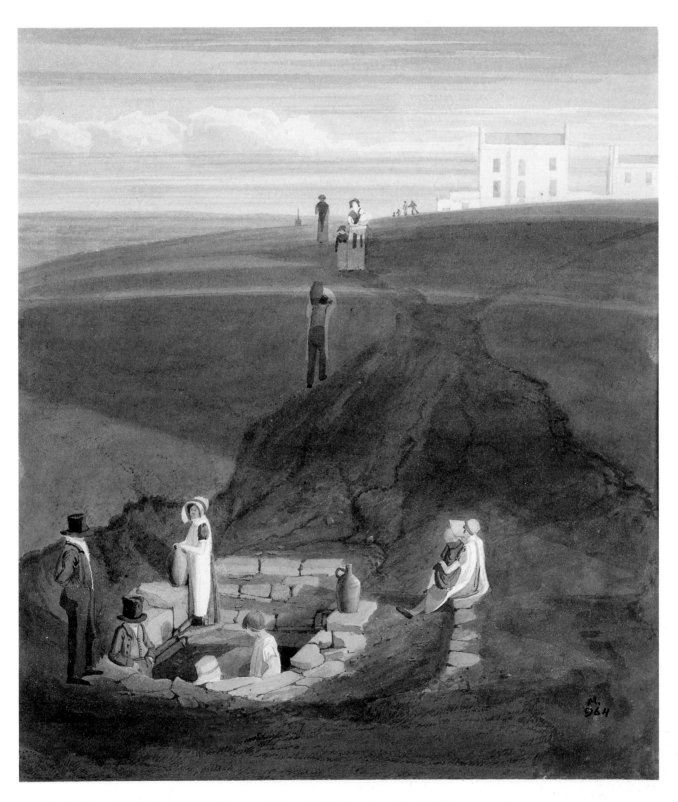

193 Samuel Jackson, *Mother Pugsley's Well, looking towards Somerset Street, Kingsdown*, 1823 (cat. 186)

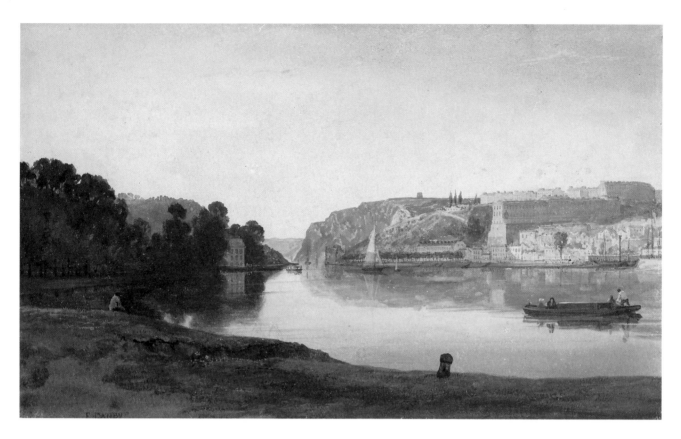

194 Francis Danby, *The Avon at Clifton*, c. 1821 (cat. 101)

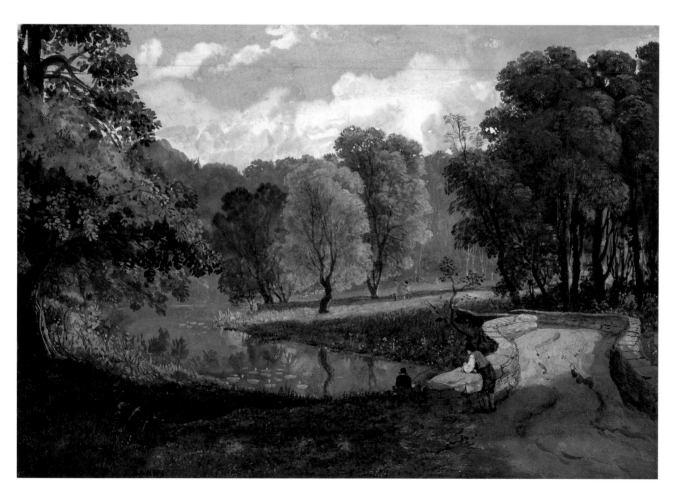

195 Francis Danby, *The Frome at Stapleton, Bristol*, c. 1823 (cat. 103)

196 Francis Danby, *The Avon from Durdham Down*, *c.* 1821 (cat. 102)

197 Francis Danby, *An Ancient Garden*, 1834 (cat. 104)

198 John Varley, *Harlech Castle and Tygwyn Ferry*, 1804 (cat. 317)

199 Anthony Vandyke Copley Fielding, *Landscape with Limekiln*, 1809 (cat. 127)

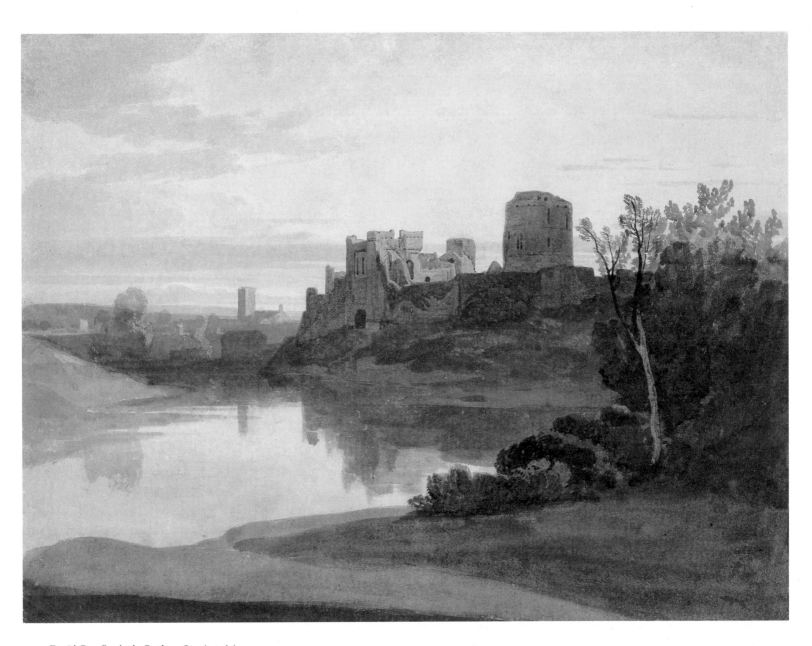

200 David Cox, *Pembroke Castle*, c. 1810 (cat. 62)

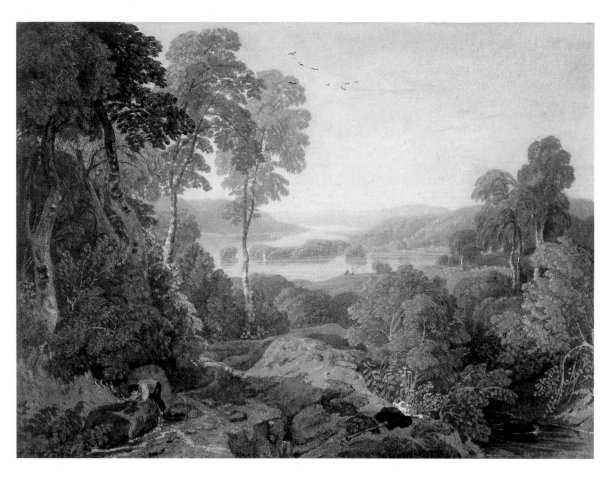

201 William Havell, *Windermere*, 1811 (cat. 160)

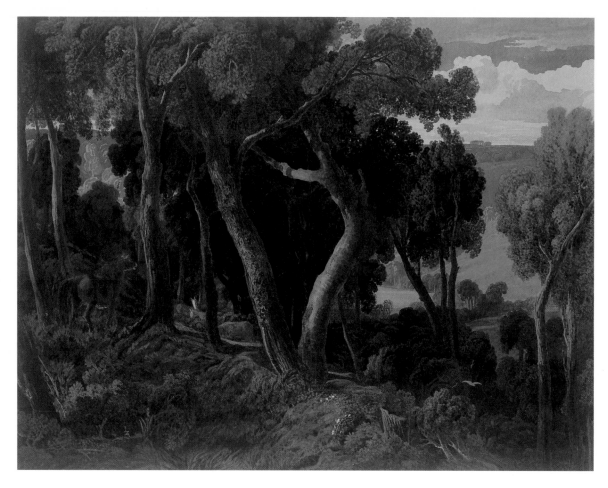

202 William Turner of Oxford,
Wychwood Forest, Oxfordshire,
1809 (cat. 307)

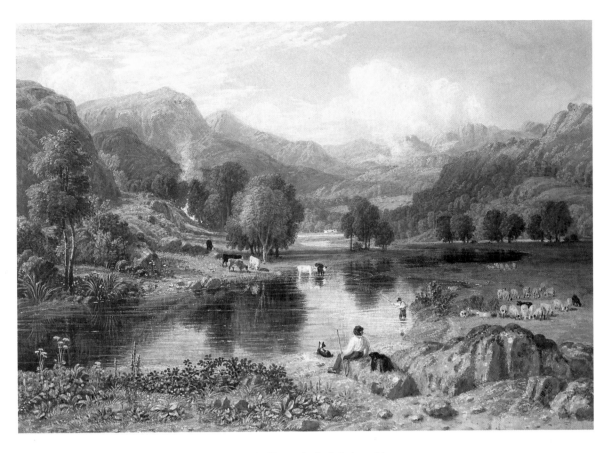

203 William Havell, *View on the Brathay near Ambleside, Westmorland*, 1828 (cat. 161)

204 Francis Oliver Finch, *Arcadia*, (?) *c.* 1840 (cat. 131)

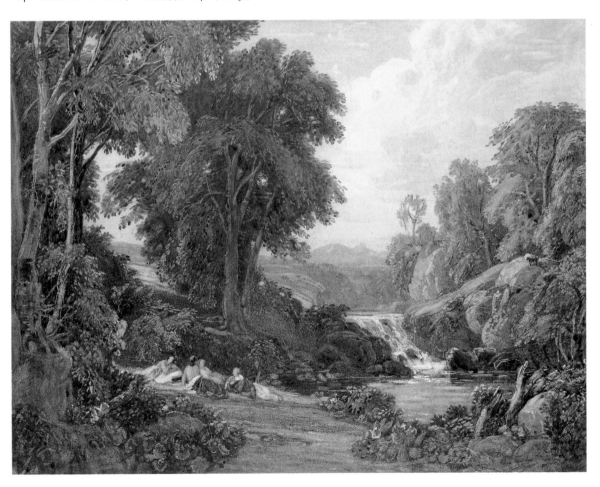

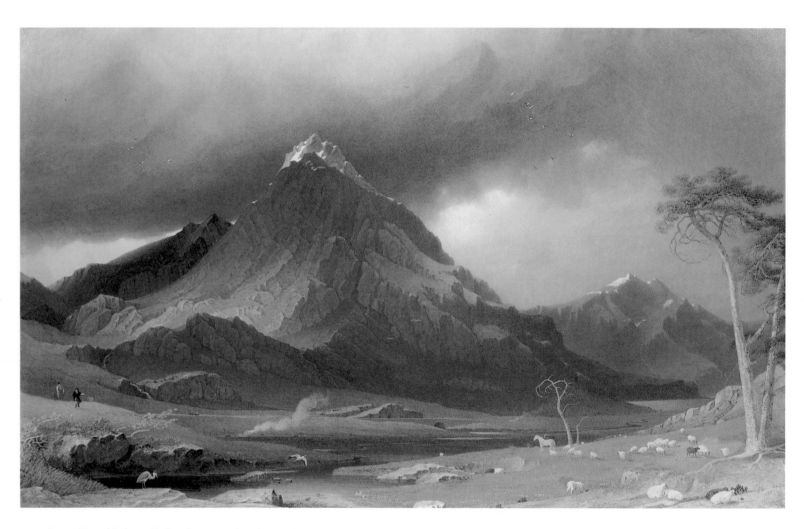

205 George Fennel Robson, *Tryfan, Caernarvonshire*, (?)1827 (cat.239)

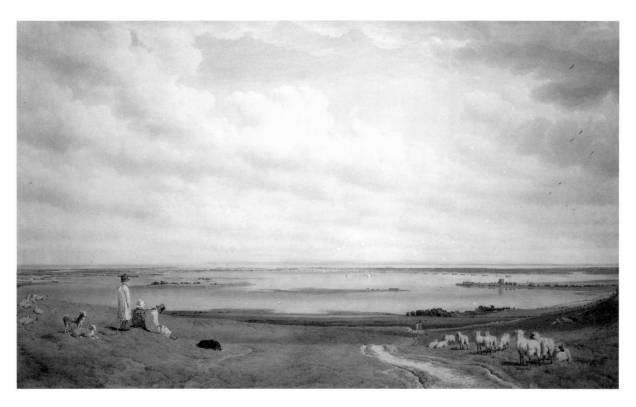

206 William Turner of Oxford, *Portsmouth Harbour from Portsdown Hill*, *c.* 1840 (cat. 310)

207 Anthony Vandyke Copley Fielding, *Shakespeare's Cliff, near Dover*, (?)*c.* 1830 (cat. 128)

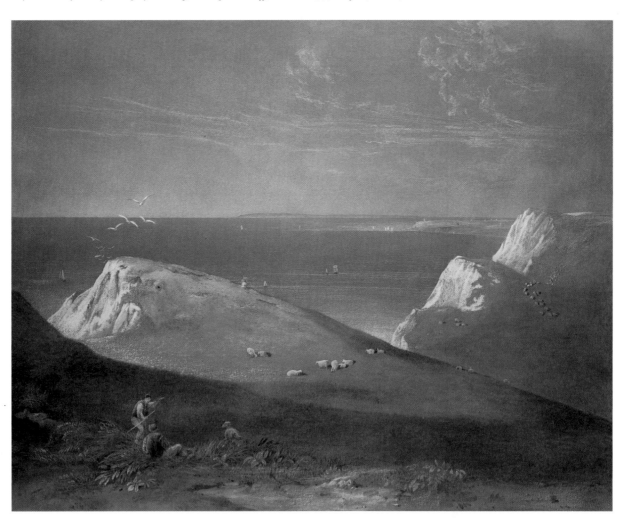

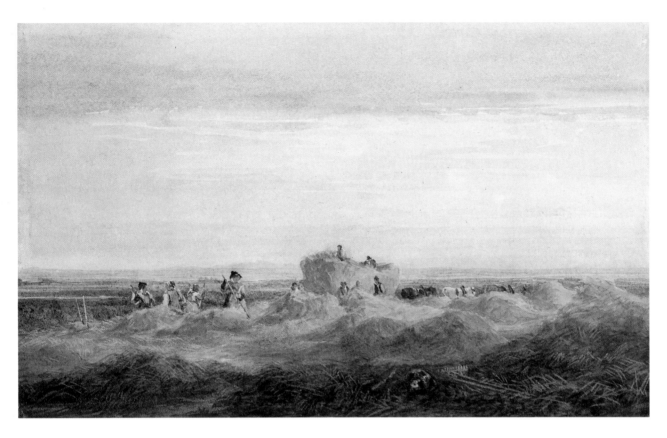

208 David Cox, *The Hayfield, c.* 1832 (cat. 71)

209 David Cox, *Cader Idris, with Women Washing Clothes in a Stream in the Foreground, c.* 1820 (cat. 64)

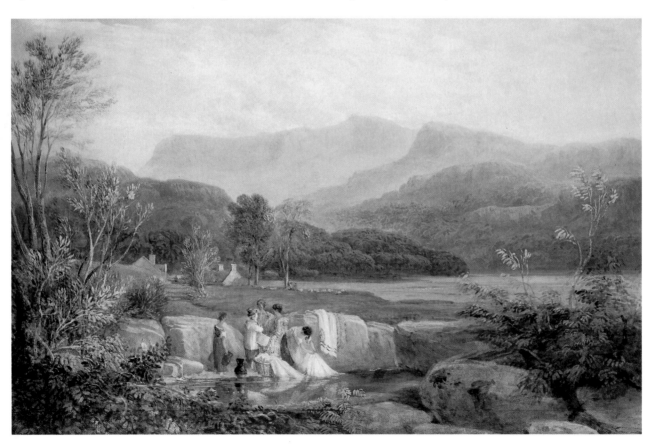

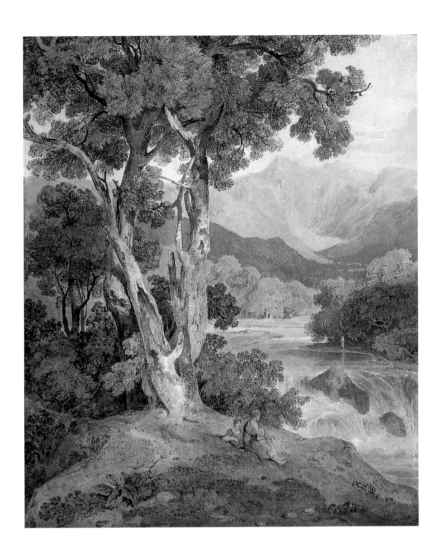

210 William Havell, *Classical Figures in a Mountainous Landscape (Moel Siabod)*, 1805 (cat. 159)

below
211 John Glover, *A Scene in Italy*, *c.* 1820 (cat. 155)

212 Cornelius Varley, *Pastoral, with Cattle and Figures in a Glade*, c. 1810 (cat. 315)

below
213 Francis Oliver Finch, *Religious Ceremony in Ancient Greece*, c. 1835 (cat. 130)

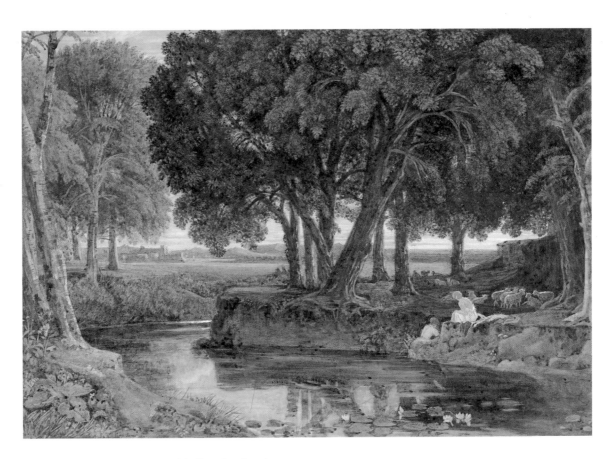

214 George Barret Jnr, *The Close of the Day*, 1829 (cat. 7)

215 Joshua Cristall, *The Grove of Accademia – Plato Teaching*, 1820 (cat. 98)

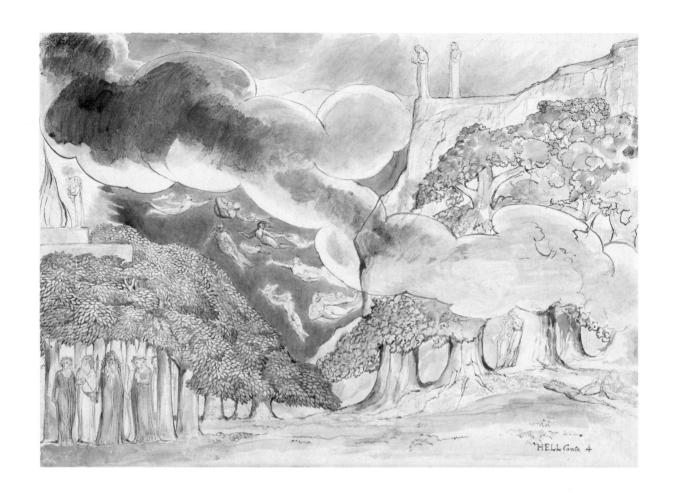

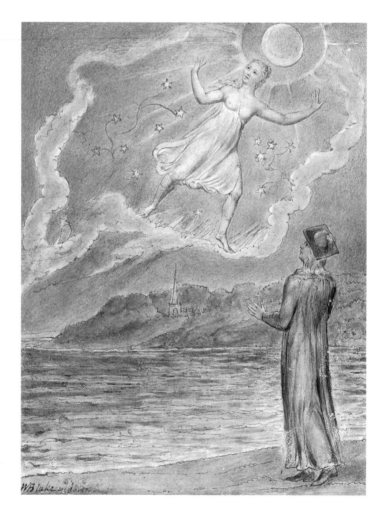

above
216 William Blake, *Homer and the Ancient Poets*, 1824–7 (cat. 11)

right
217 William Blake, *The Wand'ring Moon*, *c*. 1816–20 (cat. 9)

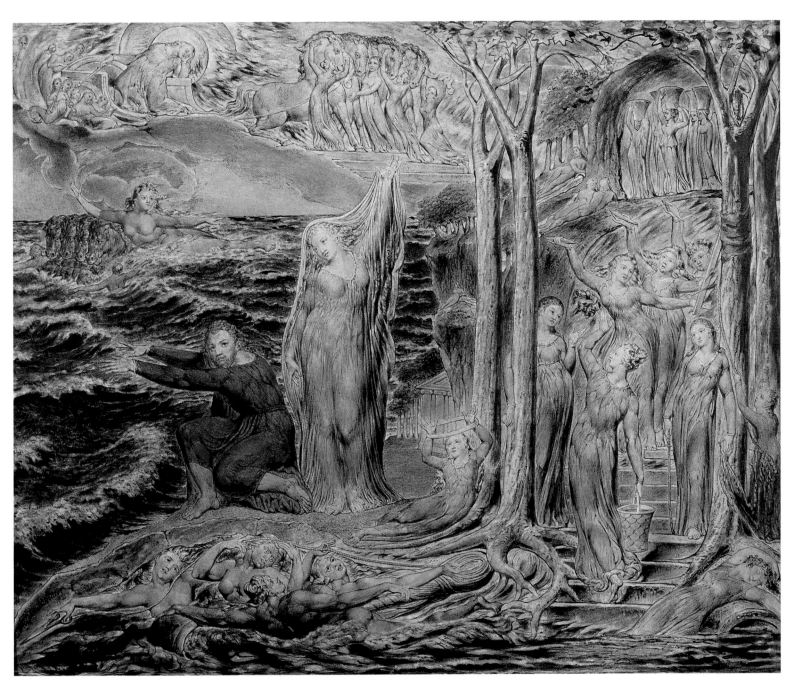

218 William Blake, *The Arlington Court Picture ('The Sea of Time and Place')* 1821 (cat. 10)

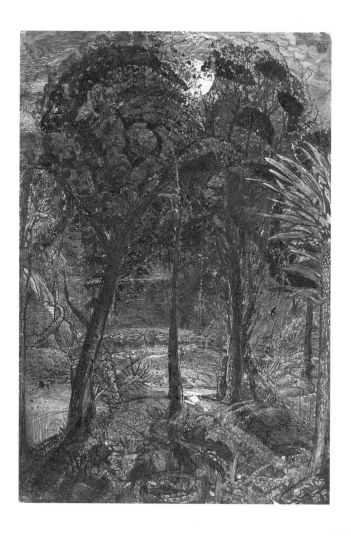

right
219 Samuel Palmer, *Moonlit Scene with a Winding River, c.* 1827 (cat. 223)

below
220 Samuel Palmer, *Harvesters by Firelight, c.* 1830 (cat. 224)

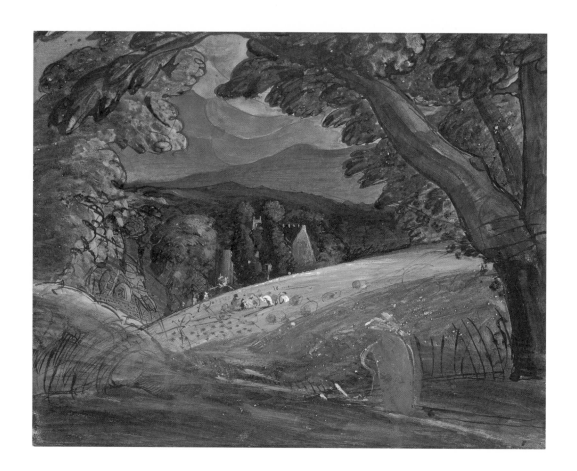

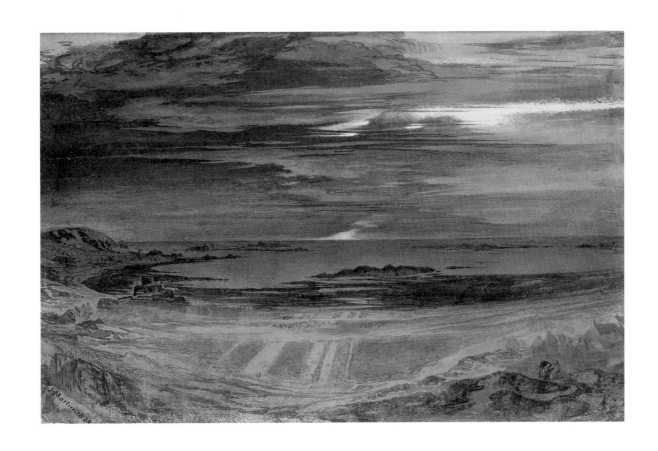

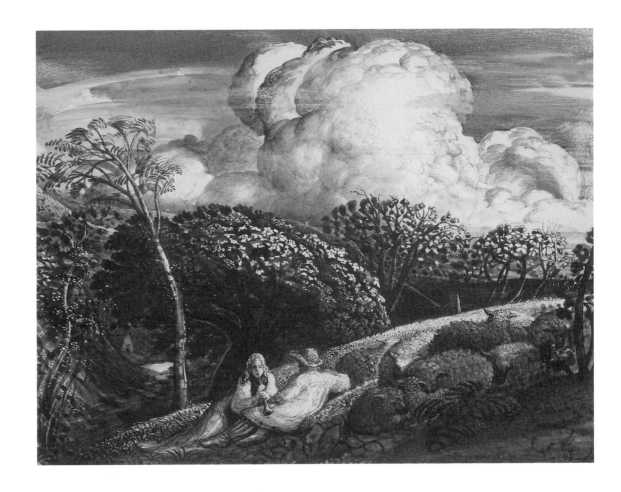

above
221 John Martin, *Sunset over a Rocky Bay*, 1830 (cat. 210)

right
222 Samuel Palmer, *The Bright Cloud*, *c.* 1833–4 (cat. 225)

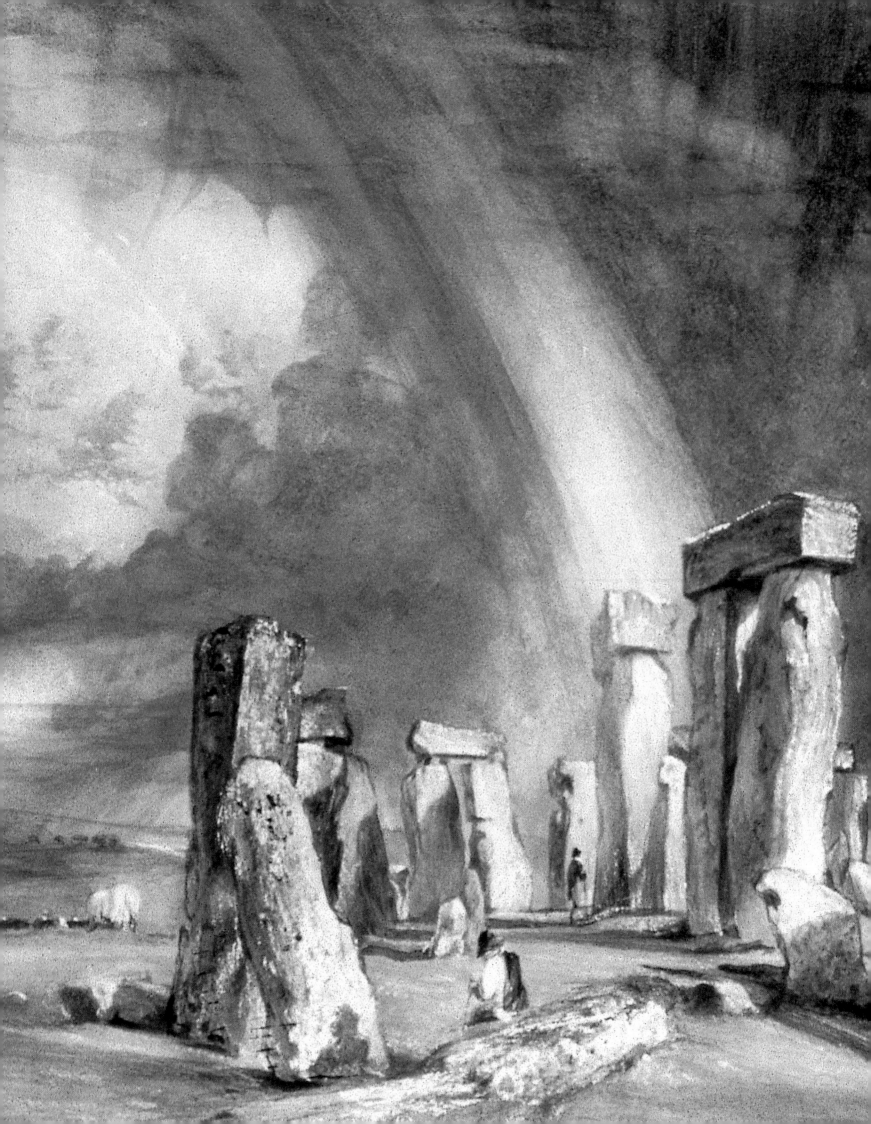

Light and Atmosphere

If watercolour seems to us the obvious medium in which to make studies of fleeting, changing effects of Nature, it was many years before that fact began to be exploited significantly. In the work of Alexander Cozens, who devoted much time to the discussion of how skies should be treated in landscape painting, there is a distinction between the poetic atmosphere or mood of the work as a whole and capturing a particular atmospheric effect. Paradoxically, Alexander's most adventurous attempts to do this are in oils (fig. 45). There is in any case a staginess about his effects that is consistent with his essentially abstract preoccupations. It was left to a different kind of experimenter, another sort of empiricist, to develop the potential of watercolour as an atmospheric medium.

At first, the topographers obeyed their original brief to concentrate on the landscapes, buildings and antiquities they were primarily engaged to draw. As their familiarity with the medium grew, they became increasingly inclined to develop their views into more rounded statements, to which all the component elements materially contributed. A schematic suggestion of sky and clouds ceased to be adequate: the view must subsist in its own climate and atmosphere, the sun casting shadows, the aerial perspective of the distance duly rendered. In the mid-eighteenth century the new

Fig. 45 Alexander Cozens, *Before a Storm*, c. 1770, oil on paper, 24.1 x 34.0. Tate Gallery, London

theoretical selfconsciousness that affected all artists, watercolourists among them, demanded the investigation of the technical procedures whereby these effects might be achieved, and gave rise to a rapid and startling development of awareness of hitherto peripheral concerns. Later, the balance shifted again. Climate became not merely a necessary adjunct of landscape but, as Constable said of the sky, 'the chief organ of sentiment'.

The friction between objectivity and expression is the reason for the enormous aesthetic energy that studies of climate generate. They are, in any case, an integral part of the movement towards a

closer observation of Nature that was inherent in Romanticism, and which gave watercolour so much of its vital force. The devotees of naturalism in the first two decades of the century were as concerned to register atmospheric effects as the less evanescent details of the rural scene; Constable was not alone in looking skywards at that date. He was, however, a pioneer in the free adaptation of the medium to this restless subject-matter, and, it should be noted, was working in oils in this way before he transferred the principle to watercolour (fig. 46). The parallel with Alexander Cozens is not without significance: as noted, Constable, however unlike Cozens, was also working in what he wished to see as an objective way.

It is striking that two of the most influential artists in the development of landscape perception should both have made use of oil when approaching the study of atmosphere: the fact would seem to contradict the notion that watercolour was the natural medium in which such ideas could be expressed. It goes to underline the close relationship between oil and watercolour, and the importance of that connection at the critical junctures in the history of watercolour. Turner's lifelong alternation between the two media was of particular significance in the evolution of his ideas about the treatment of atmospheric effects. We are, then, confronted by the paradox that an aspect of watercolour that seems to be unique to that medium is, in practice, the area in which it most overlaps with oil painting. All the most important practitioners of watercolour as *the* medium for depicting air and light – Turner, Constable, Cox, Bonington, De Wint, even Holland and Müller – also produced significant work in oil. When artists sit down in front of Nature to record its details – the plants of the hedgerow, the ivy on a tree-trunk, or the alternation of light and shadow across a field – they all bring themselves to the condition that Constable aspired to, stripping away individual mannerisms and painting, as simply and directly as possible, what is seen. When they observe effects of air and light, of cloud and mist, the same passionate objectivity should obtain. But whereas studies of plants are often difficult to attribute, the methods by which individual artists express climate and atmosphere are as varied as their personalities. The latitude for invention is greater because the object studied is more intangible. The vastness of the sky, the endless shifting of light and movement of clouds – these things are not susceptible of definitive description, and must in the end be rendered by some form of interpretation, some extreme compromise with the limitations of the medium.

The history of atmospheric painting is, then, a history of inspired compromises. The first crucial one in British watercolour was that of John Robert Cozens in the 1770s, and it fired the succession of experiments that J. M. W. Turner was to make throughout his career. Cozens's very personal combination of tight hatching and broad washes gave Turner the clue to an unlimited freedom in his handling of the medium, of which he availed himself with brilliant inventiveness. On one hand he extended the principle of tight hatching to include the whole surface of the watercolour, including the farthest distance, pressing the subtlest of hazes and melting twilights by means of tiny juxtaposed strokes of the brush. This miniature technique has the advantage of elucidating every minute

Fig. 46 John Constable, *Study of Cirrus Clouds*, c. 1822, oil on paper, 11.4 x 17.8. Victoria and Albert Museum, London

change of surface or of light with the greatest precision, and is the mainstay of all the finished watercolours of Turner's maturity (pl. 260, 261). In them and in his colour studies it is often combined with a much broader use of wash, and frequently in the studies the loose wash is encountered on its own, conveying the luminous depths of a morning sky, the satin reflection of a still lake or the occlusion of mist over distant mountains (pl. 262, 264, 267). The versatility of this simple wash is hardly susceptible of analysis: it was regarded as one of the miracles of painting and was enormously admired by other artists. Turner's working studies were not generally seen by the public, or even by his professional colleagues; but his technical range was to be deduced from the many watercolours that he exhibited throughout his life. Because these were for the most part highly finished exhibition pieces, it was the technique involving minute hatching that exercised the widest influence over later generations; indeed, few later nineteenth-century artists were not indebted to it.

But there was in any case an inevitable interest in the free notation of broad atmospheric effects among the Nature painters of Turner's time. The very fact that they subscribed to the criteria of an established academy entailed that they attached great importance to the study of Nature. The subtleties of atmosphere and climate were as much a part of their professional stock-in-trade as the details of plant growth or architectural structure. They did not necessarily require Turner's example to stimulate them, however inspiring it was. The incentive lay partly in a change of fashion. The neoclassicism of the Girtinian sublime allowed little room for freedom or spontaneity of notation. Atmosphere was a matter of theatre, achieved by grand design and powerful colouring. The mists that wrap the early subjects of Cotman (pl. 44) and Havell in melodramatic obscurity are linear, structural, permanent; they are generalised as Sublime theory would require, not the evanescent wisps of vapour that the young Constable was trying to capture among the Lakeland hills in 1806 (pl. 47). At that date the neoclassical style was at its height, but already some artists were seeking to escape from its somewhat artificial discipline. Cornelius Varley and

Joshua Cristall were making studies direct from the motif on mountain-tops in North Wales, forcing themselves out of the prevailing style into a new informality and freedom. The results are sometimes strange: in a single drawing, Varley is both tightly structured and imaginatively free, creating discordances and frictions that testify to the energy with which the problem is being tackled (pl. 113).

It was quickly solved. By 1812 the high neoclassical style was *passé*; the naturalists had established control. The followers of John Varley, Cornelius's more traditionalist brother, gradually evolved away from his formulas and sought ways of dealing with the imponderable and unexpected in Nature. Cox began to break down the dense Girtinian washes of his early style towards a new fragmentation, not at all the fine hatching and stippling of the OWCS stalwarts, but a looser, highly flexible method of painting in nervous flicks of the brush (pl. 233). This reinterpreted the technique of John Robert Cozens in a way that was to become Cox's unmistakable style. He abandoned the sombre colour of the earlier manner and adopted a fresh, naturalistic palette that set a standard of informal realism matched by none of his contemporaries except Constable. His delight in the open air revealed itself in a quantity (perhaps too large a quantity) of views based on a low flat horizon and a dominant breezy sky rendered with economy and luminosity. In the latter part of his long career this was to be combined with a loose charcoal underdrawing in some of the most uninhibited landscapes and skyscapes ever painted (pl. 232). Long before the end of his life Cox was exemplifying the inherently 'impressionist' qualities of watercolour with an originality, a range of ideas and of technical mastery, that greatly impressed a new generation. These younger exponents of the style are exemplified by Thomas Collier (1840–91; pl. 249, 251), whose work is contemporaneous with, and entirely sympathetic to, the new landscape art emerging from France in the 1870s.

De Wint, another follower of John Varley, similarly evolved towards a loose, free style of painting that left Varley's work far behind, but never abandoned, as Cox's did, the restricted palette of

Fig. 47 Louis Francia, *St Benet's Abbey*, 1802, watercolour, 28.5 x 41.1. Cecil Higgins Art Gallery, Bedford

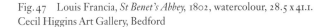

the neoclassical phase. De Wint's work is characterised by a warm range of browns and greens that obviously derives from Girtin; later, he varied this with touches of unmixed red or blue (pl. 236, 238). But he did not make the study of climate a priority. His chief concern remained the creation of subtle and beautifully articulated compositions based on stretches of open or wooded country, often in the broad Wolds of his own Lincolnshire. The tendency of his pigments to fade particularly drastically no doubt impedes our appreciation of his non-formal qualities: his skies are now mostly non-existent. When well preserved, his watercolours often display fine atmospheric effects. This is especially true of the mountain views that he made in the Lake District in the 1830s, in which the old classical grandeur is combined with a more modern understanding of light and air to produce some of the most imposing of Romantic landscape studies (pl. 235).

of Cox and De Wint in its concern with horizontals and their deft articulation. This typical compositional pattern gave him, like Cox, plenty of scope for depicting the sky as the 'chief organ of sentiment' (pl. 240, 241).

There is, then, a solidity of structure in Bonington's work that may be said to derive from British Neoclassicism, and it underpins even his airy cloudscapes. The interplay of experience in oil and watercolour is always evident: the structural value of a stroke of the brush well loaded with oil paint is translated into watercolour as an acute concern for the placing of each touch, however apparently random or spontaneous it may seem. There is a parallel here with the work of that instinctive classicist, Cotman, whose depictions of clouds are positively architectonic, and whose late atmospheric studies in often brilliant, saturated colour contain their own built-in plasticity in the form of pigment mixed with paste as a thickening

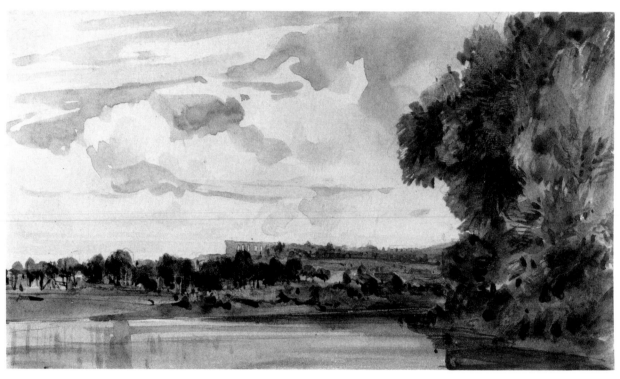

Fig. 48
William Callow, *Marly from Saint-Germain*, c. 1830, watercolour, 12 x 21.3. National Galleries of Scotland, Edinburgh

The tension between classical control and Romantic freedom that underlies De Wint's work is something he shares with other major figures of the time. Turner was throughout his life a classicist at heart, and his freest studies must be seen in the context of that temperamental priority. The same cannot necessarily be said of the artists of the next generation, though the work of their doyen, Richard Parkes Bonington, is founded on a formal sense that is probably attributable to neoclassical influence. Bonington did not begin his brief career until about 1818 and spent it almost entirely in France, but nevertheless came indirectly under the influence of Girtin through his teacher Louis Francia (1772–1839). Francia, though a Frenchman, had been a member of Girtin's circle in London around 1800, and had absorbed the sober palette and strong formal preoccupations of that group (fig. 47). Certainly Bonington's art is founded on a rigorous feeling for pictorial structure, similar to that

agent (pl. 243). The same quality can be found in some of the studies that James Holland made in North Wales, using bodycolour as if it were oil paint (pl. 247); although on other occasions Holland's work in pencil and pure watercolour can be almost Turnerian in its allusive fluidity. The sketches, and even many of the finished works, of other Bonington associates, William Callow (1812–1908; fig. 48) and Thomas Shotter Boys for instance, derive their energy from Bonington's example in the virtuoso manipulation of materials, though their work is often extremely close to that of Cox, an artist who seems to have arrived at similar solutions by quite separate routes.

A figure who follows Bonington particularly closely in some respects is James Abbott McNeill Whistler (1834–1903). Whistler was an American who, like Bonington, gained much of his training in France, and like him again delighted in composing with self-conscious poise small-scale scenes that consist of little more than air

and light. If there is a strong French element in his watercolours, that element almost certainly derives from what the French learnt through Bonington. Whistler takes much further than Bonington the structural use of carefully placed touches of pigment, building these up into patterns that contain their own abstract dynamic, while retaining a representational function (pl. 269, 270). This combination of roles is typical of the uses to which British artists put watercolour, albeit the idea is here taken to an extreme.

Because the study of atmosphere was inherent in the study of landscape, the watercolourists did not make rigid distinctions between the 'impressionistic' and the 'Pre-Raphaelite' approaches, as we are inclined to do today. William Henry Hunt, one of the most elegantly spontaneous of the naturalists in his youth, produced in later life the most precise and highly worked interiors and still-lifes (pl. 304–7); Samuel Palmer (whose late work is mostly very densely worked), aiming at grand academic effects, could also on occasion use his brush with impressive freedom, even on a large scale (pl. 255). Holman Hunt, while preserving an undeviatingly 'finished' mode of execution, made the study of evanescent effects a frequent subject of his watercolours (pl. 271). There is no categorising an artist like Alfred William Hunt, who, applying the lessons of Turner with an entirely original sensibility, moves from one manner to the other within a single drawing, uniting his effects, however they are achieved, with a sure sense of overall pictorial purpose (pl. 253, 254).

That feeling for unity is hardly to be expected in impromptu studies of mist or clouds, yet so firmly had the tradition of *plein-air* sketching become integrated into the practice of creating finished works in watercolour that most artists would instinctively couch their observations in the formally disciplined terms of an achieved composition. The impulse to create a 'complete' object was very strong. Indeed, after the OWCS inaugurated regular winter exhibitions of sketches and studies, in the 1860s, it was soon noted that the content of these shows varied hardly at all from that of the summer exhibitions – except that the sketches had white mounts, while the more elaborate works were 'closely framed in gold'.[1] For it seems to have been felt throughout much of the nineteenth century that while highly finished exhibition watercolours ought naturally to be set 'in gorgeous frames, bearing out in effect against a mass of glittering gold, as powerfully as pictures in oil;[2] any less complete work needed a white mount. This distinction was by no means universally subscribed to,[3] but it indicates an awareness of the distinct functions and aesthetic requirements of different sorts of watercolours that is not so acute today.

A.W.

1 The issue is discussed in Roget, *History of the 'Old Water-Colour Society'*, II, pp. 108–9.
2 *Somerset House Gazette*, I, p. 67.
3 Roget, loc. cit.

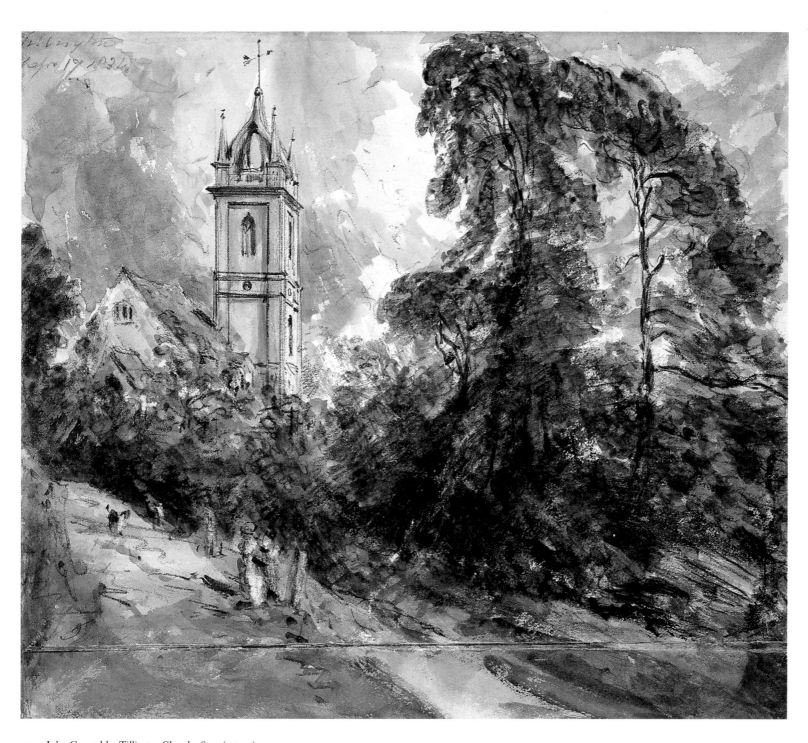

223 John Constable, *Tillington Church*, 1834 (cat. 32)

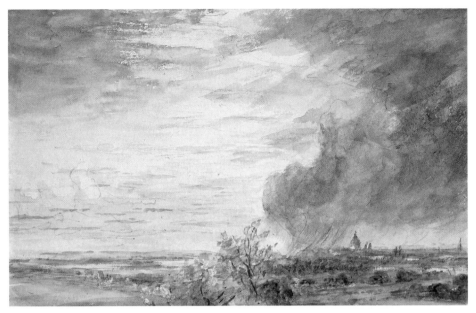

left
224 John Constable, *View over London from Hampstead*, 1830–3 (cat. 29)

center
225 John Constable, *London from Hampstead*, *c.* 1830–33 (cat. 28)

below
226 John Constable, *Hampstead Heath from near Well Walk*, 1834 (cat. 33)

227 John Constable, *Folkestone from the Sea*, 1833 (cat. 31)

228 John Constable, *View at Hampstead, Looking towards London*, 1833 (cat. 30)

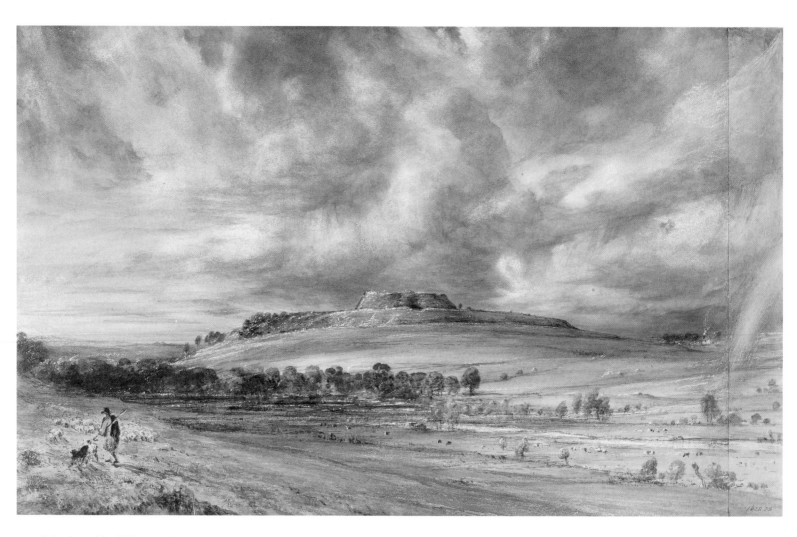

229 John Constable, *Old Sarum*, 1834 (cat. 34)

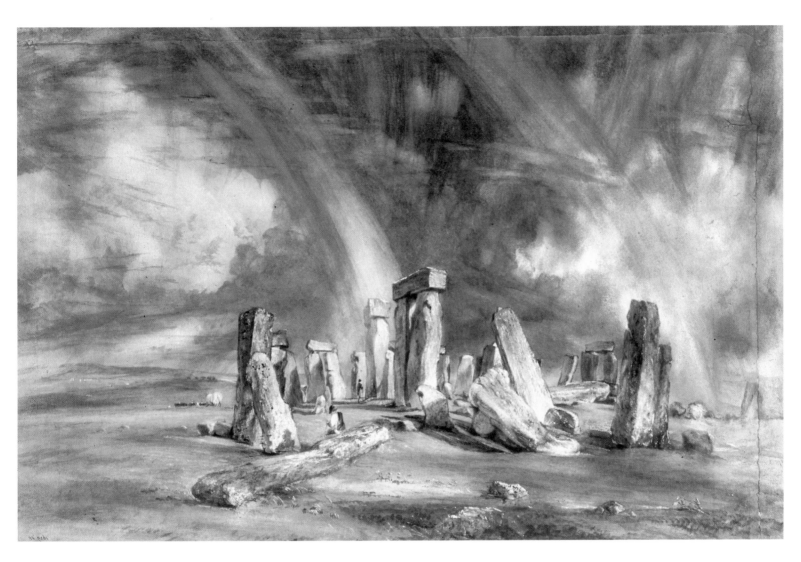

230 John Constable, *Stonehenge*, 1836 (cat. 35)

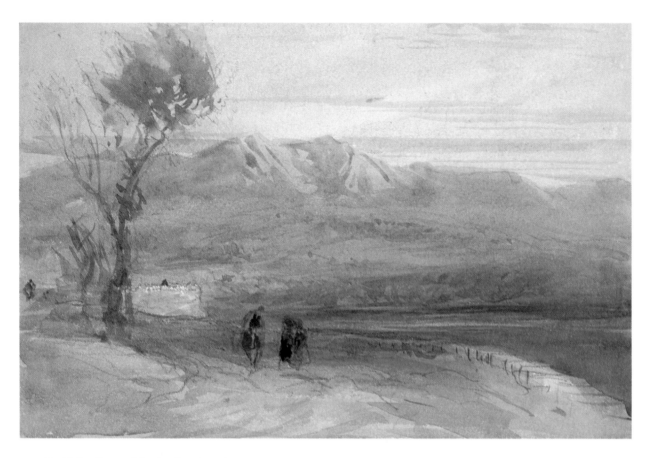

231 David Cox, *Barmouth Road*, c. 1850 (cat. 74)

232 David Cox, *'An Impression': The Crest of a Mountain*, c. 1853 (cat. 76)

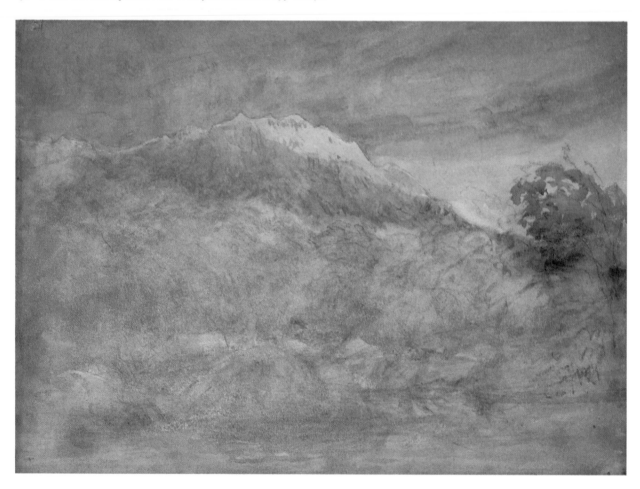

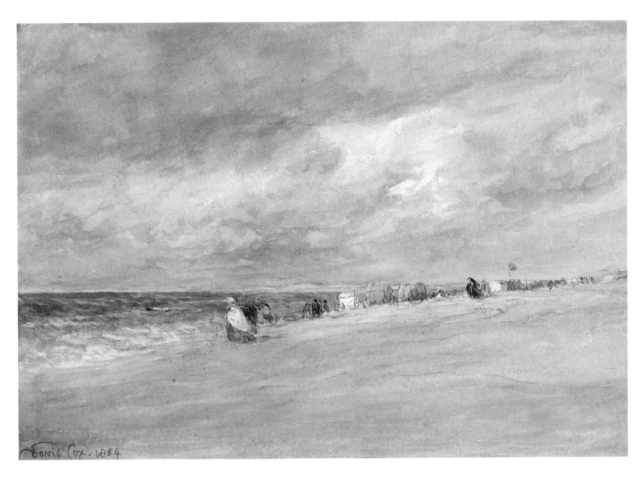

233 David Cox, *The Beach at Rhyl*, 1854 (cat. 77)

234 David Cox,
A Train near the Coast,
c. 1850 (cat. 75)

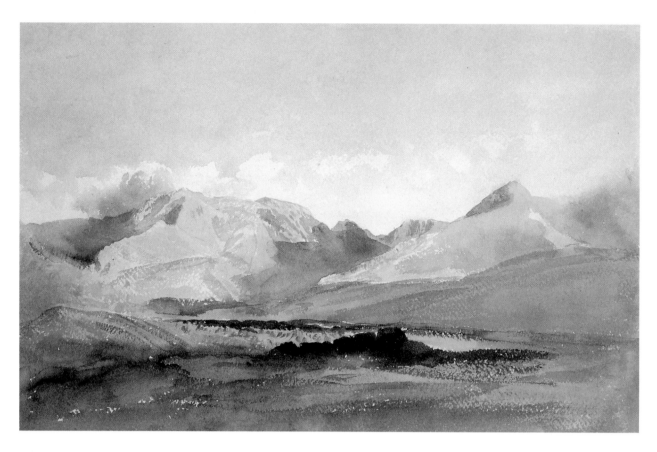

235 Peter de Wint, *Mountain Scene, Westmorland*, *c.* 1840 (cat. 119)

236 Peter de Wint, *Clee Hill, Shropshire*, (?)*c.* 1845 (cat. 122)

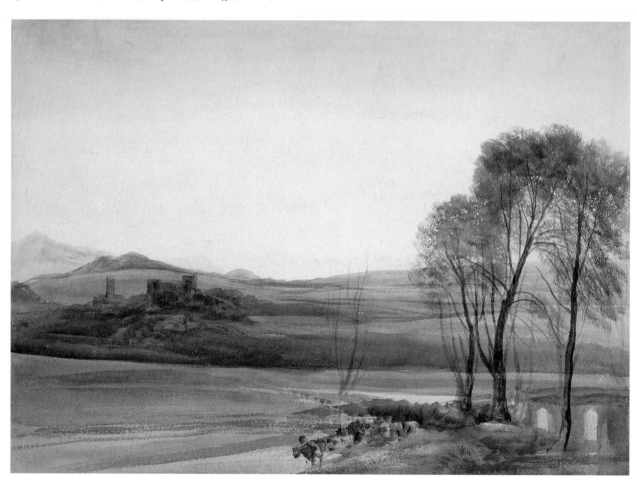

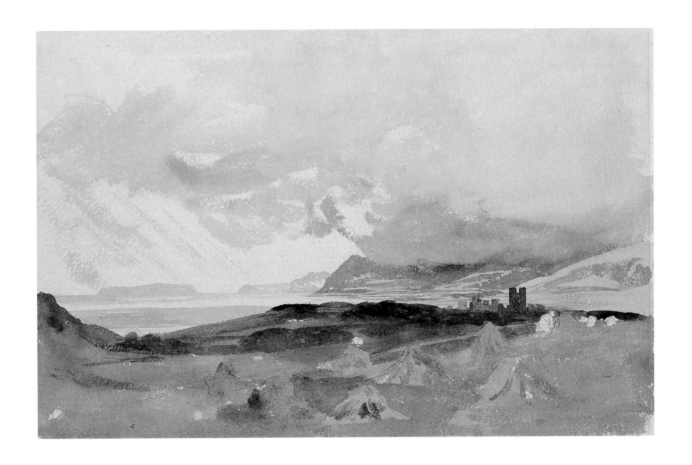

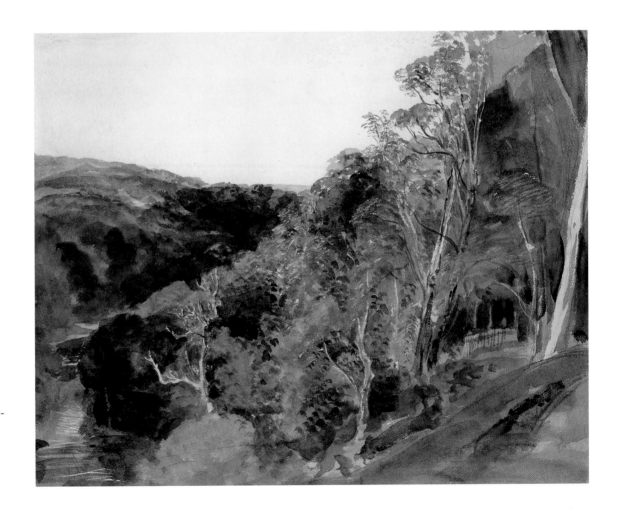

above
237 Peter de Wint, *View near Bangor,*
North Wales: Penrhyn Castle with Penmaen-
mawr beyond, (?)*c.* 1840 (cat. 120)

right
238 Peter de Wint, *Trees at Lowther,*
Westmorland, c. 1840–5 (cat. 121)

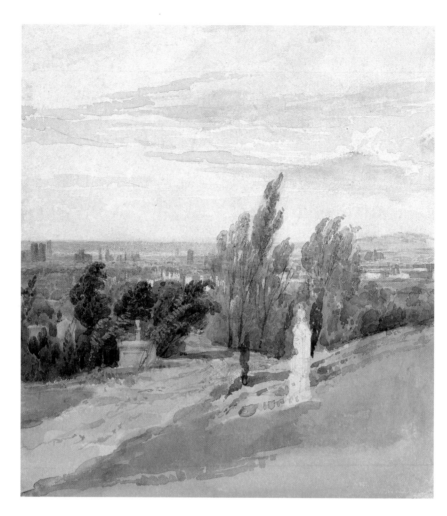

239 Richard Parkes Bonington, *Paris from Père Lachaise, c.* 1825 (cat. 12)

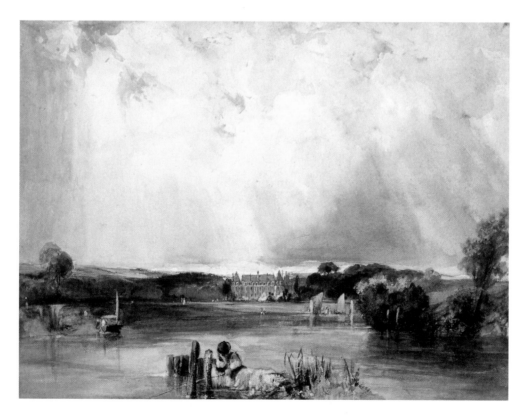

240 Richard Parkes Bonington, *Château of the Duchesse de Berri, c.* 1825 (cat. 13)

right
241 Richard Parkes Bonington,
Near Burnham, Norfolk, c. 1825 (cat. 14)

below
242 Richard Parkes Bonington,
A Fisherman on the Banks of a River,
a Church Tower in the Distance,
c. 1825–6 (cat. 15)

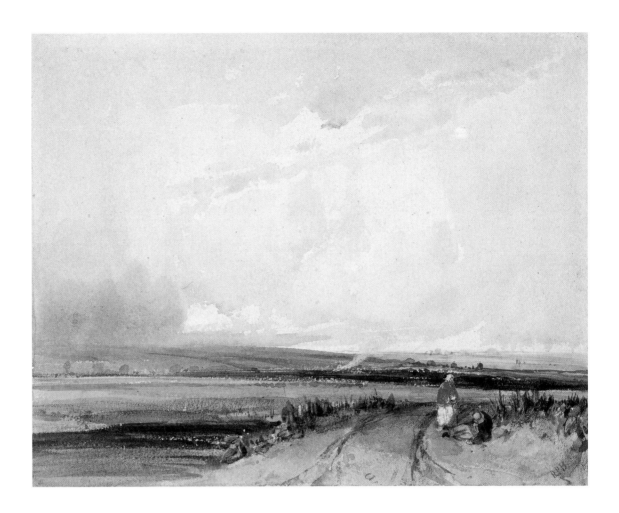

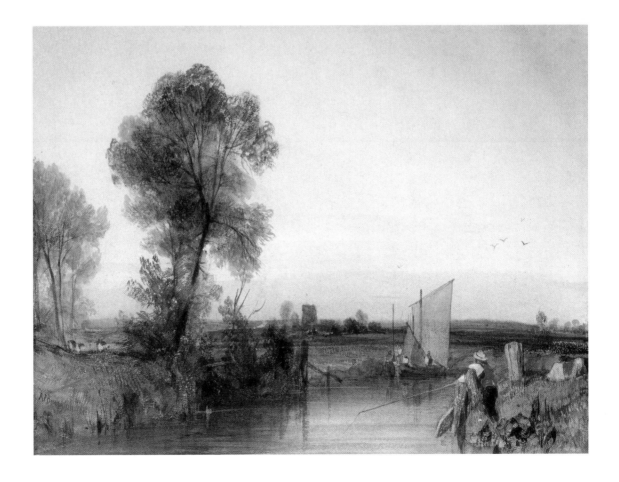

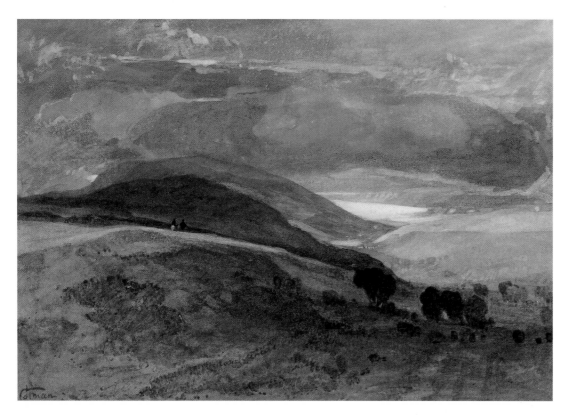

243 John Sell Cotman, *On the Downs*, c. 1840 (cat. 61)

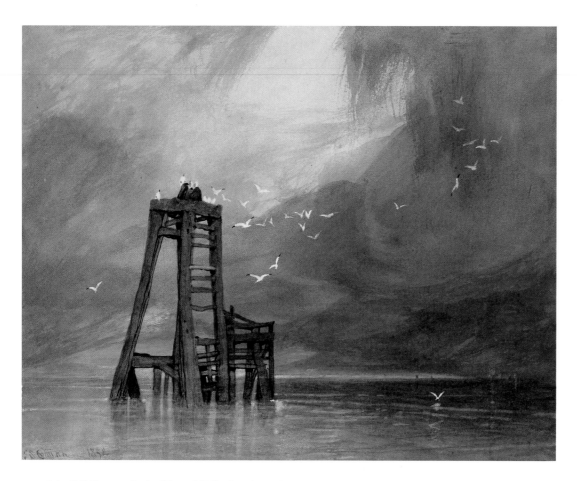

244 John Sell Cotman, *Study of Sea and Gulls*, 1832 (cat. 60)

245 John Sell Cotman, *The Shepherd on the Hill*, 1831 (cat. 59)

246 John Martin, *Landscape*, 1835 (?1839) (cat. 211)

247 James Holland, *View in North Wales: Arenig, with Snowdon Beyond*, 1852 (cat. 172)

248 John Middleton, *A Shady Lane, Tunbridge Wells, Kent*, 1847 (cat. 213)

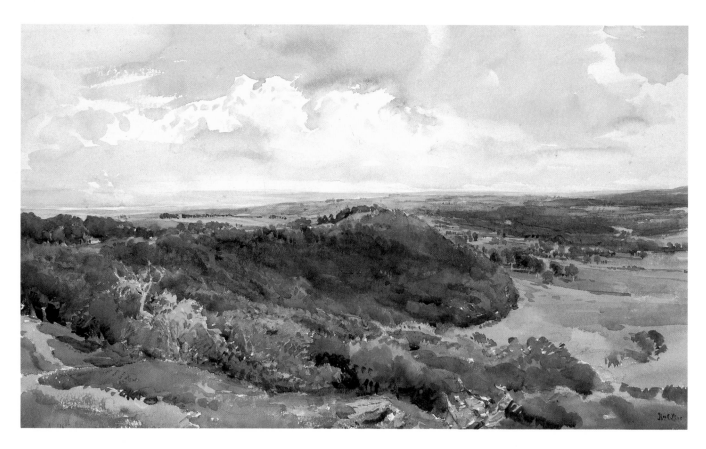

249 Thomas Collier, *Haresfield Beacon*, c. 1880 (cat. 23)

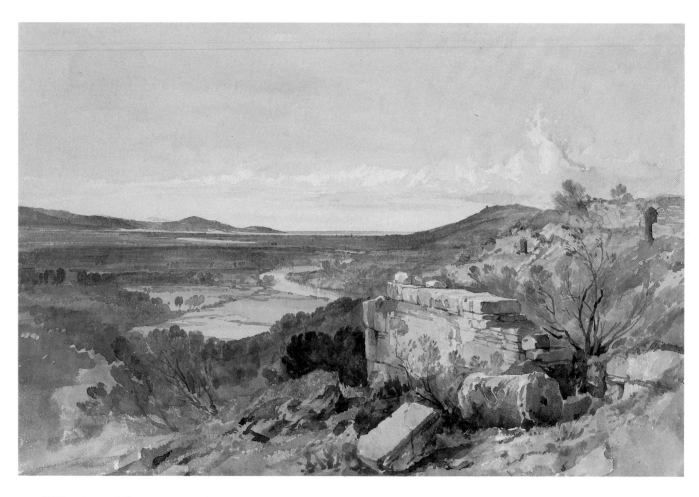

250 William James Müller, *Distant View of Xanthus*, 1843 (cat. 217)

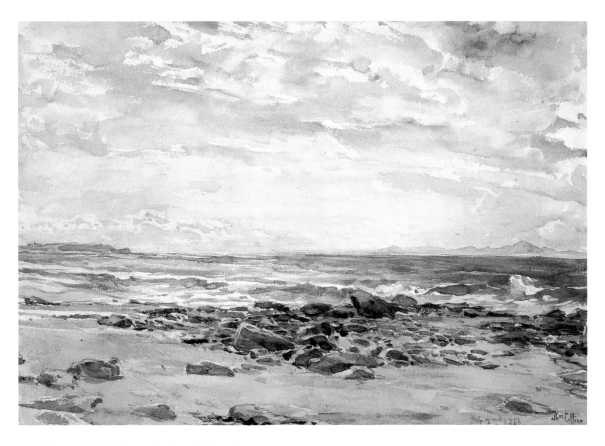

251 Thomas Collier, *Pensarn Beach*, 1886 (cat. 24)

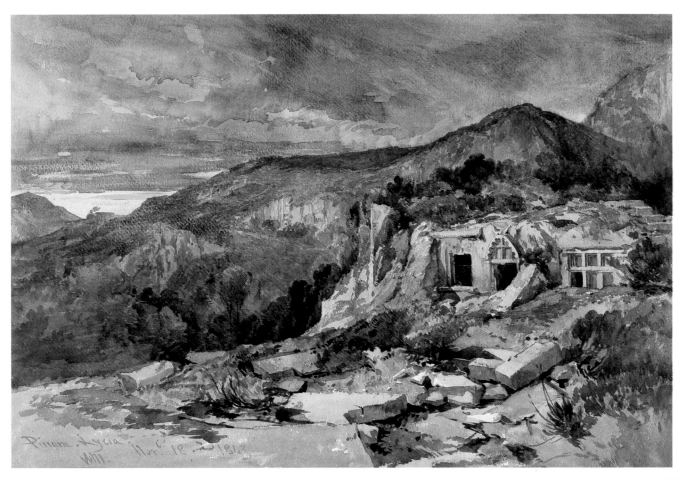

252 William James Müller, *Rock Tombs at Pinara*, 1843 (cat. 218)

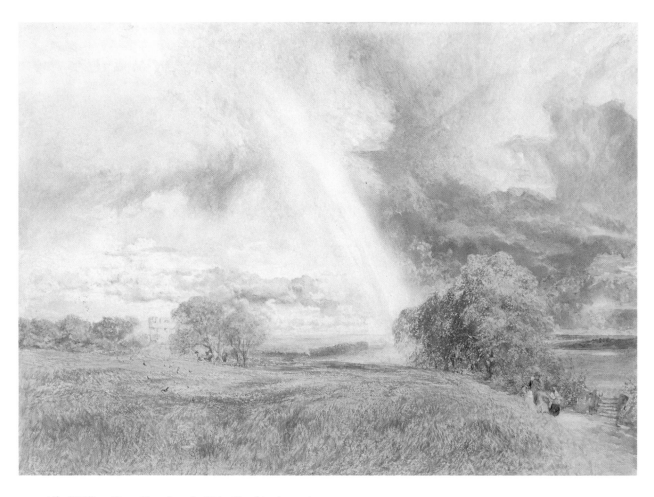

253 Alfred William Hunt, *Near Abergele, Wales*, (?)*c.* 1860 (cat. 174)

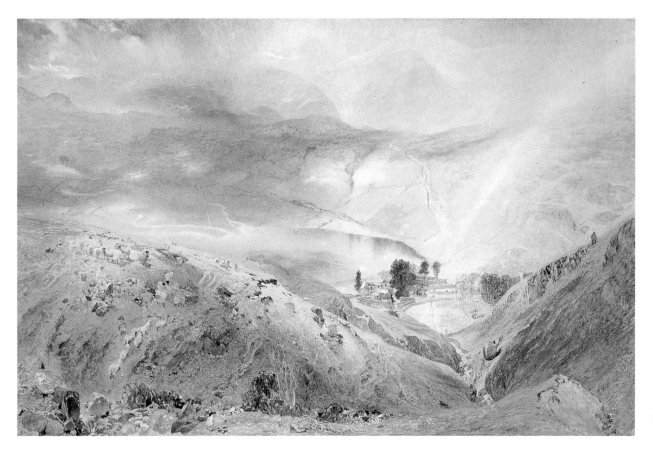

254 Alfred William Hunt,
*The Tarn of Watendlath
between Derwentwater and
Thirlmere*, 1858 (cat. 173)

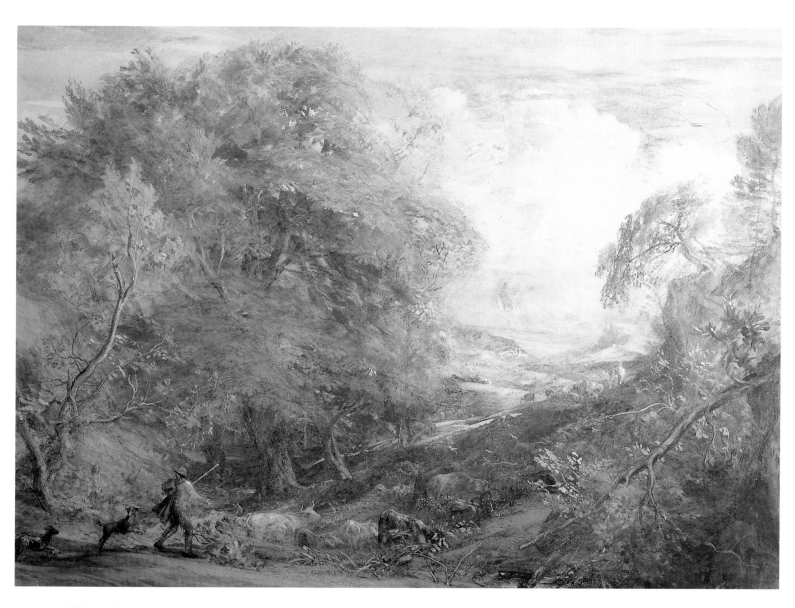

255 Samuel Palmer *The Herdsman*, c. 1850 (cat. 227)

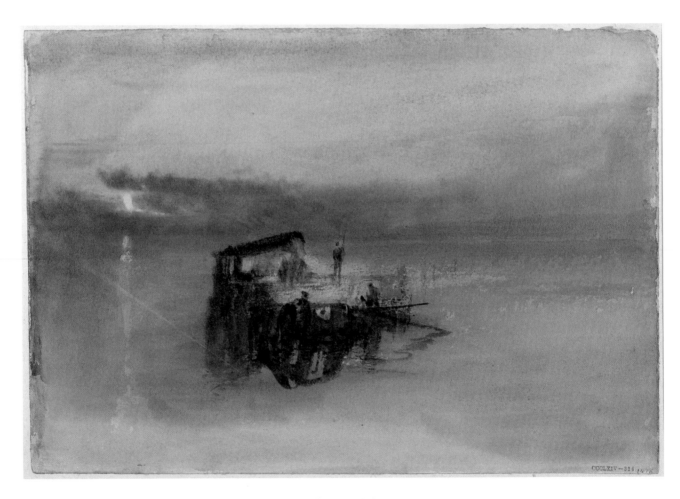

256 Joseph Mallord William Turner, *A Raft and Rowing-boat on a Lake by Moonlight*, c. 1840 (cat. 298)

257 Joseph Mallord William Turner, *The Sun Setting over the Sea in Orange Mist*, *c.* 1825 (cat. 291)

258 Joseph Mallord William Turner,
Storm off the East Coast,
(?)*c.* 1835 (cat. 296)

259 Joseph Mallord William Turner, *The Rigi at Sunset*, c. 1841 (cat. 303)

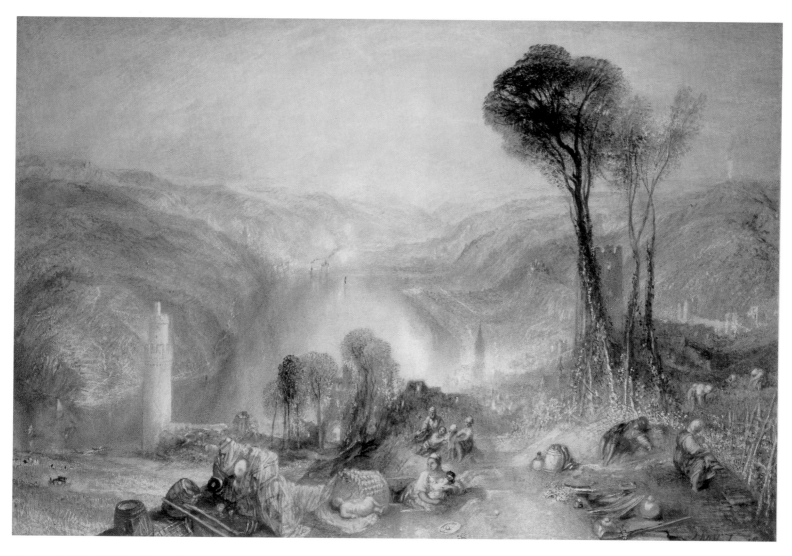

261 Joseph Mallord William Turner, *Oberwesel*, 1840 (cat. 297)

left page below
260 Joseph Mallord William Turner,
Lake Lucerne: The Bay of Uri from above
Brunnen, 1842 (cat. 304)

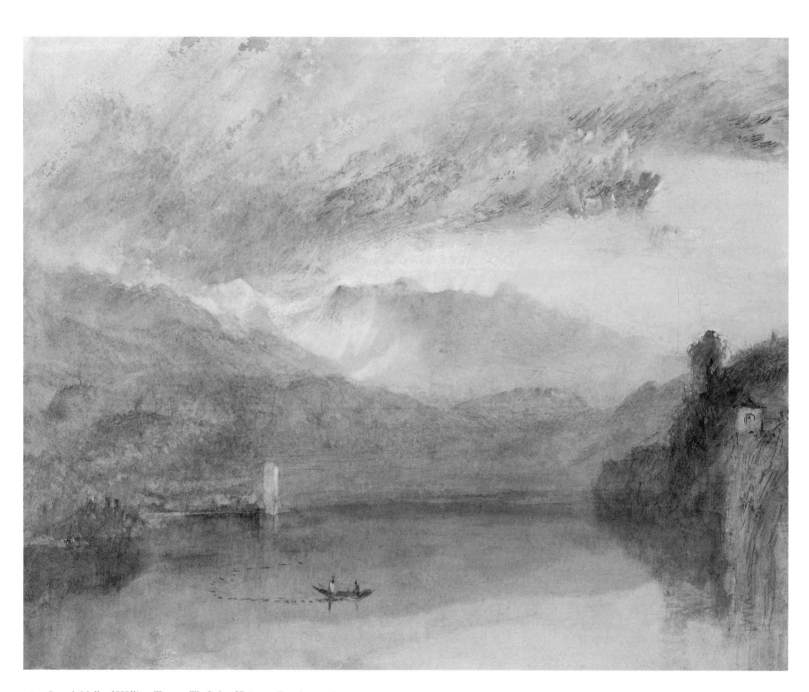

262 Joseph Mallord William Turner, *The Lake of Brientz*, 1841 (cat. 301)

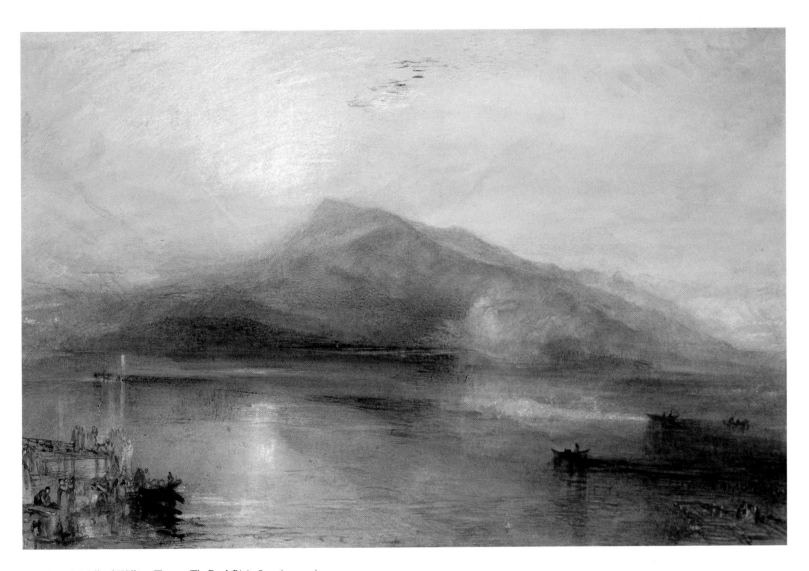

263　Joseph Mallord William Turner, *The Dark Rigi*, 1842　(cat. 305)

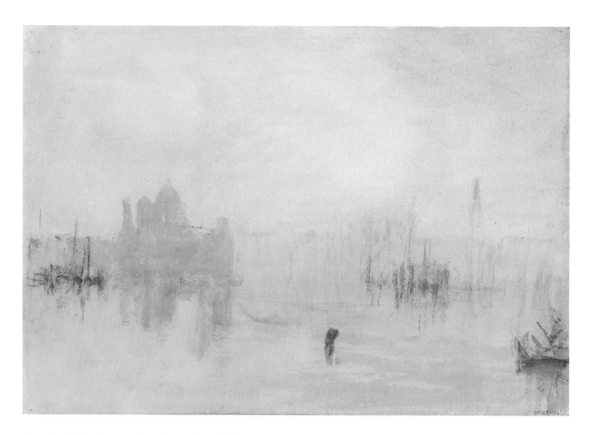

264 Joseph Mallord William Turner, *Venice: S. Maria della Salute and the Dogana, c.* 1840 (cat. 299)

265 Joseph Mallord William Turner, *Venice: The Riva degli Schiavoni from the Channel to the Lido, c.* 1840 (cat. 300)

266 Joseph Mallord William Turner, *The Cathedral at Eu*, 1845 (cat. 306)

267 Joseph Mallord William Turner, *The Rhine at Reichenau*, (?)1841 (cat. 302)

Southampton River Isle of Wight in Distance 1819 J Linnell

268 John Linnell, *Sailing-boats on Southampton Water*, 1819 (cat. 208)

right page

above

269 James Abbott McNeill Whistler,
St Ives, c. 1883 (cat. 324)

below

270 James Abbott McNeill Whistler,
Beach Scene, c. 1883 (cat. 325)

272 George Price Boyce, *Night Sketch of the Thames near Hungerford Bridge, c.* 1860–2 (cat. 18)

left page above
271 William Holman Hunt, *Fishing-boats by Moonlight*, *c*. 1869 (cat. 185)

273 James Abbott McNeill Whistler, *Seascape, A Grey Note*, (?)*c*. 1880 (cat. 323)

274 James Abbott McNeill Whistler, *Seascape with Schooner*, (?)*c*. 1880 (cat. 322)

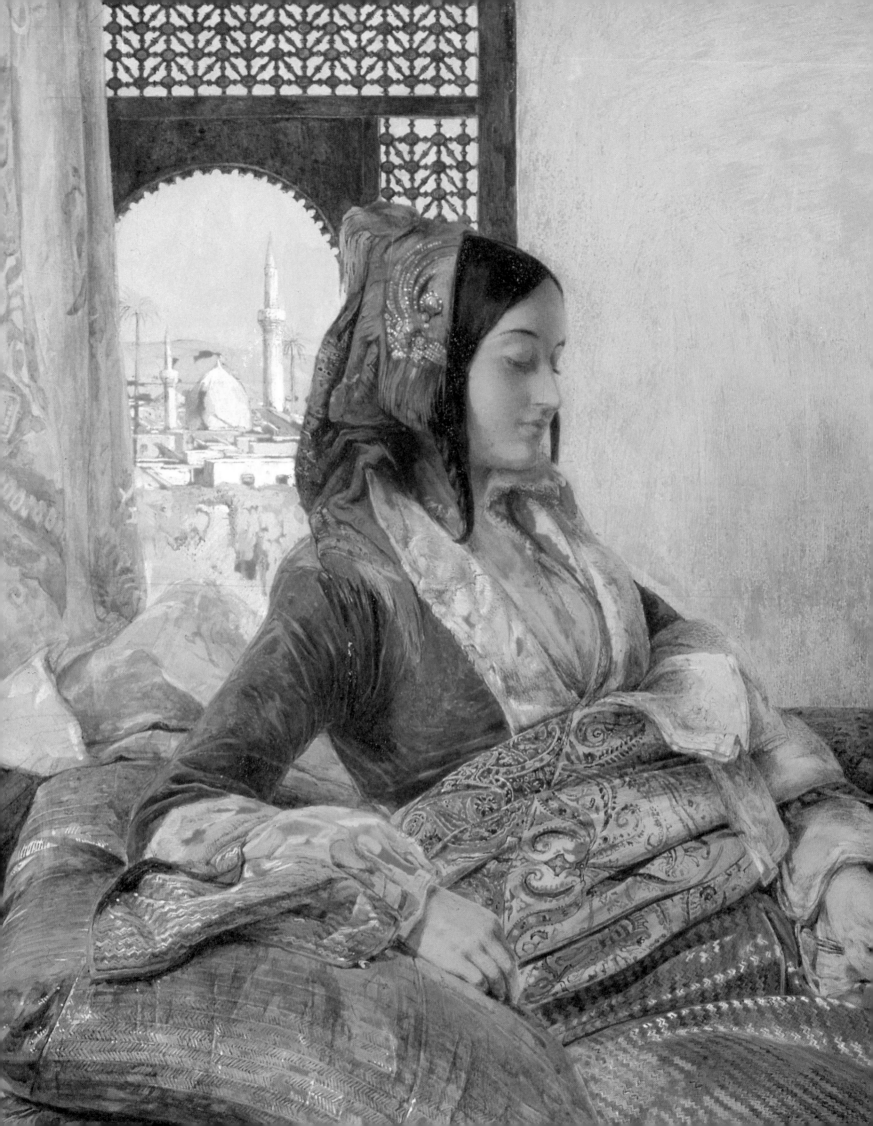

VI

The Exhibition Watercolour

W atercolourists were among the original members of the
Society of Artists that was founded in London in 1760,
and the most distinguished of them, Paul Sandby, was
one of the founder-members of the Royal Academy. The idea that
watercolours might be public objects as opposed to private records
was, then, taken for granted at an early stage. The terms of reference
of the ensuing battle between the two media, watercolour and oil,
were already set out. In the next few decades, as the Royal Academy
was confirmed as the most prestigious public exhibition in the land,
watercolourists came under increasing pressure to create works that
would measure up to the competitive conditions there. Size was
clearly of importance; the traditional intimacy of the medium was at
a discount. Both the small scale and the delicate colour of the old
'tinted drawings' seemed unsatisfactory beside the paintings that
jostled them on the overcrowded walls at Somerset House, the
Academy's London home. Narrow frames and pretty washline
mounts, which artists customarily made themselves to complement

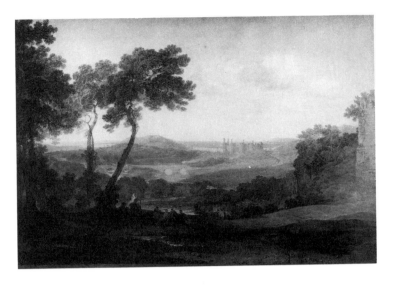

Fig. 50 J. M. W. Turner, *Caernarvon Castle, North Wales*, 1800, watercolour with
stopping-out and scraping-out, 66 x 99.4. Tate Gallery, London

Fig. 49
Richard Westall,
The Legend of Mab's Cross,
illustration for the *Forget-
me-not* magazine, 1821,
pencil and watercolour,
13 x 9.6. Private Collection

their work, could not hold their own with the richly encrusted gilt
frames of the oil paintings. The solution was for watercolour to
imitate oil in these respects, and that goal stimulated the enormous
technical strides taken by watercolourists in the closing years of the
eighteenth century. Just as this odd competition was fuelled by a
fierce professional pride, so too the race was conducted according to
self-imposed rules of integrity and truth to the medium that created
their own difficulties and inspired new and ever more ingenious
technical developments.

The evolution of the exhibition watercolour was not, of
course, occasioned solely by the economics of public display. Dur-
ing the same decades the watercolourists had come to believe,
equally passionately, that watercolour was a medium eminently
suited to the expression of important ideas. This belief was subject
to the same considerations as the Academy's judgement of the relat-

ive status of all branches of painting. Historical subjects were more
significant than landscapes, portraits or genre. Portraiture had long
been practised in watercolour, usually on a miniature or near-mini-
ature scale; larger portrait drawings were the domain of the pastel-
lists, and throughout the developments of the Romantic period pure
portraiture was affected relatively little. History was being attemp-
ted in watercolour by a few, notably Henry James Richter (1772–
1857) and Richard Westall (fig. 49). It might reasonably have been
supposed, since watercolourists were generally topographical paint-
ers by training, that the historicised landscape of Richard Wilson
would be their natural preference. In fact, they approached this
form somewhat gingerly. John Robert Cozens had executed some
monochrome drawings illustrating Milton's *Paradise Lost*, and
another, probably dating from the mid-1770s, of *Hannibal Showing
his Army the Fertile Plains of Italy*;[1] but it was Turner, the most pas-
sionately committed watercolourist of them all, and, significantly,
also the most ambitious landscape painter in oils, who really
pioneered the new genre. His contribution to the Academy's exhib-
ition in 1800, a view of *Caernarvon Castle* with a bard singing to his
followers of the destruction of Welsh civilisation by the invading
armies of Edward I (fig. 50),[2] was in effect a modern topographical
view couched in Claudean terms, with small historical figures. He
then regularly showed large-scale landscape watercolours that were
nominally topographical but actually highly expressive Romantic
landscapes, featuring the mountains, lakes and waterfalls of Wales,
Scotland or Switzerland. In 1803, for the first time, he included his-
torical figures on an appreciable scale, in his Alpine spectacular
St Hugh Denouncing Vengeance on the Shepherd of Courmayeur
(fig. 51). The display in the Academy's Council Room of these works
and other watercolours of a like splendour by Turner's colleagues
became a focus of popular interest: 'Here crowds first collected, and
here they lingered longest, because it was here the imagination was
addressed, through the means of an art which added the charm of
novelty to excellence'.[3]

These large, highly finished works were, then, not simply an improved manifestation of the old-fashioned watercolour drawing. Indeed, they were not 'drawings' at all. They constituted a new art-form: the watercolour painting. It was only right that this art-form should be accorded the dignity of its own academy. In 1804 the Society of Painters in Water-Colours (OWCS) was founded.

Given these circumstances, it is not surprising that the conditions that prevailed at the Society's exhibitions were not congenial to all the old forms of watercolour. There was no attempt to put the clock back; on the contrary, watercolourists were, if anything, more competitive than ever. The Society was constituted on the same lines as the Academy, and enshrined the same high ambitions. There was this difference: now the leading watercolourists had no need to fear crowding out by the oil painters, and were given more space on the Society's walls than they had hitherto enjoyed. The proliferation of work, which was a chronic problem with watercolourists who taught for a living, was now positively encouraged among the most respected members of the profession. Talents of all kinds flourished – some of a high order, others minor. The moving spirit behind the foundation of the Society was William Frederick Wells (1762–1836), a close friend of Turner's but in retrospect among the least important of the watercolourists of the time. Another minor artist, W. H. Pyne, is of interest as the promulgator of the *Microcosm* (see p. 84). Pyne was also a lively documenter of the Society's early

Fig. 52 Samuel Shelley, *Lorenzo and Jessica at Belmont*, c. 1786, 25.4 x 30.8. British Museum, London

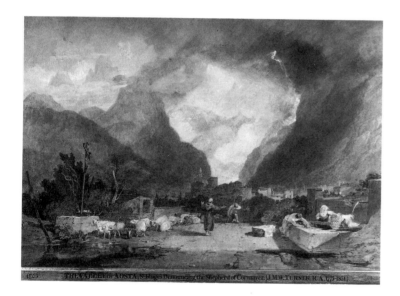

Fig. 51 J. M. W. Turner, *St Hugh Denouncing Vengeance on the Shepherd of Cour-mayeur in the Valley of d'Aoust*, 1803, watercolour, 67.3 x 101. Sir John Soane's Museum, London

history in his *Somerset House Gazette*, issued in parts in 1824. The other founder-members covered a wide spectrum of subject-matter, from the figure subjects of Samuel Shelley (1750–1808; fig. 52) and Joshua Cristall (who were differentiated by their interest in, respectively, sentimental scenes and pastoral landscapes), to the rustic views with animals of Robert Hills (1769–1844; pl. 183), the Claudean idylls of John Glover and the dramatic mountainscapes of John Var-

ley and William Havell (fig. 53). The first exhibition, held in the spring of 1805, was a considerable popular success, though not all the professionals were impressed. The Academician Joseph Farington, who himself practised as a (somewhat retardataire) topographical watercolourist, thought less of the display than portrait and history painters in oils like John Hoppner (1758–1810) and Benjamin West (1738–1820). Farington contrasted the 'powerful & masterly mind & hand' of someone like Turner with the work of Glover which he thought 'too artificial – too equally detailed & finished'.[4] These reactions suggest the extent to which landscape painters were used to a discipline requiring breadth of handling, while painters who specialised in other branches of art were happy to commend the 'delicate and careful' rendering of Nature without concern for a more serious underlying purpose. This clash between the general and the specific was to be a recurrent motif of early nineteenth-century painting, and by the 1850s was to have particularly important consequences for watercolour.

Despite the range of preoccupations of the artists, the early exhibitions of the Society were dominated by landscapes that betrayed the enduring influence of Girtin, who had epitomised the late eighteenth-century Sublime. Welsh scenery was particularly popular as embodying the essence of landscape grandeur. It was also recommended by Gilpin, and easier for tourists to reach than most other beauty-spots, though the Lake District and Scotland were also much drawn. Scotland became increasingly fashionable as the century advanced and Sir Walter Scott's novels came into fashion. As tastes changed, new subjects entered the repertory and younger talents introduced fresh ideas. Most of the older artists remained faithful to their chosen subject-matter, but that was often very varied in the first place. Cox, for instance, was astonishingly versatile, sometimes essaying full-scale historical landscapes (pl. 296)

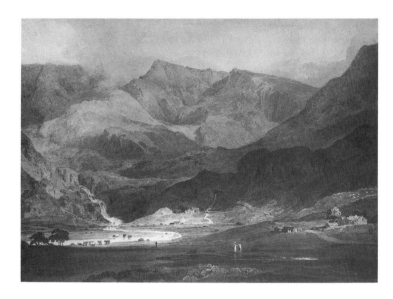

Fig. 53 William Havell, *The Valley of Nant Francon, North Wales*, 1804, watercolour, 47.2 x 67.8. Private Collection

and equally at home with architectural views, interiors, breezy heathland or the lowering Welsh hills. The opulently free technique of his North Wales subjects, with their slaty tonality and wet, mountainous air, contrasts surprisingly with the precise, stippled work of George Fennel Robson (1788–1833) in the Scottish mountains (fig. 54/cat. 238). Robson, working in a highly evolved version of the 'Society' style, making use of dense, rich hatching and stippling with enamelled colours and clearly defined forms, brings an almost Renaissance sense of order to his panoramas of the wilderness.

Inevitably, competition remained acute, and the incentive to ostentatious display very great (fig. 55). It did stimulate remarkable inventiveness, however, and led to the breakdown of the old professional pride in the 'purity' of the medium. By the 1830s, the unalloyed use of watercolour was becoming rare. The brilliant technical inventiveness of Turner and his contemporaries had endowed the medium with a breathtaking range of devices to suggest the flash and sparkle of water in motion, the glitter of light on a bird's wing or on thick foliage, the reflections of a still lake or the texture of feathers, fish and fur. All these things were evoked by the use of watercolour alone, aided simply by scratching-out or various methods of sponging, wiping and stopping-out. There was nothing primitive in any of this; Turner rarely used any other means. Bodycolour, unless the whole work was executed in that medium, was reserved for local foreground highlights, usually the caps or jackets of figures.

That rigorous self-denial was gradually eroded. By the 1830s some artists were regularly employing white bodycolour for highlights, and it was becoming common for 'mixed media' to be used – that is, for a sizeable composition to be executed in a combination of watercolour and bodycolour, sometimes with gum arabic as well. Early in his career Samuel Palmer learned the value of thick applications of creamy bodycolour to evoke the richness of spring blossom or autumn harvests. When he re-emerged after his Italian sojourn (1837–9), a committed Turnerian, he adopted much of Turner's vision, but continued to use bodycolour in a wholly unTurnerian

way. In 1873 he described his watercolour as 'now a kind of tempera (safely free from Chinese white "lights" so called)'[5] – an interesting testimony to the strength of the old prejudice against unmixed white bodycolour. His late works are vivid, powerful statements of the Romantic vision of Nature; indeed they combine elements of the three great visionaries of the earlier part of the century (Blake, Turner, and the young Palmer himself).

The drift towards denser, richer media can be traced in many of the most important figures. For one thing, it abbreviated the drudgery of building up a complete and elaborate subject in watercolour alone. More important for the apologists of watercolour, it enlarged the expressive potential of the medium and opened up new avenues that were to take the story on through several decades of further development. An example of the process is the work of William Henry Hunt. Unlike Palmer, Hunt began life as a topographical watercolourist in the pure eighteenth-century tradition, but became more and more concerned with the minutiae of Nature and of domestic life, to which he brought an intensity of vision that, on its much smaller scale, almost parallels Palmer's. His adoption of a stronger, more loaded medium was therefore almost inevitable. His virtuoso rendering of the minutest details of Nature gives him a special place among the grander, more wide-ranging works of his time. In due course it came to be recognised as something more than a minor talent, when Ruskin saw that Hunt stood for a significant aspect of the new, bourgeois aesthetic that dominated Britain by the 1850s: Hunt's gem-like studies of bird's-nests, hedgerow flowers and fruit, he said, 'gave an unquestionable tone of liberalmindedness to a suburban villa, and were the cheerfullest possible decorations for a moderate-sized breakfast parlour, opening on a nicely mown lawn . . . Mr Hunt . . . never painted a cluster of nuts without some expression, visible enough by the manner of presentation, of the pleasure it gave him to see them in the shell, instead of in a bag at the greengrocer's.'[6]

For some artists the new intensity of watercolour, its concern with the precise description of a multitude of objects in vivid, dense colour, seemed to invalidate it as a medium: the same effects could be achieved in oil paint for a fraction of the effort. One watercolourist whose achievement was hailed by Ruskin as of exceptional importance was J. F. Lewis, who had been producing highly elaborate finished scenes in Spain and Egypt since the 1830s. The Egyptian subjects in particular are works of great aesthetic subtlety, making bold play with the intricacies of Arabic ornament and its interplay with patterns of light and shadow. Like William Henry Hunt, Lewis adopted a technique close to the methods in oil of the early Pre-Raphaelites: painting into a white and still-wet ground. The process results in a sharpness of focus and a clarity of lighting that seems to epitomise the age. Ruskin marvelled at the accuracy with which Lewis could paint the eyelashes of the camels in the *Frank Encampment in the Desert* of 1856.[7] Yet, in their decorative brilliance, several of Lewis's oriental subjects anticipate the interiors with figures painted by Henri Matisse in the 1920s (pl. 311). In the end, Lewis forsook watercolour for oil, and in doing so made an important point about much of the watercolour work of his time.

But at the same moment, a new generation of painters was finding fresh inspiration in the masterpieces of the Romantic period. Encouraged by Ruskin's dictum that 'from young artists nothing might be tolerated but simple *bona fide imitation* of nature' and that they should 'go to nature ... selecting nothing, rejecting nothing, scorning nothing',[8] they grafted the principles of Pre-Raphaelitism on to the practice of the societies to endow water-colour with an important new lease of life. The highly wrought studies of Nature produced by the original Pre-Raphaelites, John Everett Millais, Holman Hunt and their associates, gave the medium a new canon of excellence to work to, and Ruskin's enthusiastic endorsement provided a theoretical framework as vigorous as any the practitioners of the medium had enjoyed since the end of the last century.

The key to Ruskin's significance for the watercolourists was his pronouncement that Turner – always their hero and exemplar – was, in truth, a Pre-Raphaelite himself. His sharp observation of Nature, his fidelity to the reality of atmosphere and climate, of cloud formation or growth of leaf, qualified him as the real master of the High Victorians. His beautifully wrought, finished water-colours (which by the second half of his career had become much smaller, intended as they were only for engraving and for sale to collectors, and almost never for exhibition in Academy conditions) were both the high point of the topographical tradition and the inspiration for a new school, in which minute observation and broad atmospheric effect went hand in hand.

The close relationship between developments in painting and the progress of the watercolour 'establishment' is perhaps illustrated by the fact that by the time the Pre-Raphaelites had become accepted or modern masters, the London watercolour societies were beginning to be officially recognised. The OWCS was granted a royal charter in 1881, and the NWCS became the Royal Institute of Painters in Water-Colours three years later. The medium had lost none of its relevance for the public, but there was a danger that its practitioners might succumb to the malaise that afflicts successful academies, and continue to produce too many works inadequately inspired and impelled solely by the need to attract attention. Much of the watercolour painting of the later Victorian period is, indeed, in this category; but landscape continued to be stimulated by interacting currents of the greatest value. The younger generation of artists cut their teeth in the 1860s on the problems of book illustration, working especially for the numerous popular weekly magazines that published the novels of George Eliot, Anthony Trollope and others. In this, the already established Millais led the way. The construction of psychologically telling vignettes containing figures and landscape or buildings for this work gave a new lease of life to the subject-matter of the watercolourists. The illustrators – men like Frederick Walker (1840–75) and John William North (1842–1924; pl. 317) – worked up their designs on a larger scale for exhibition, and in doing so created a new breed of work in which the expressive burden is shared more evenly between figures and background, and in which a deliberately 'psychological' atmosphere is aimed at. The association with Pre-Raphaelitism signalled by Millais's concern for the medium is further marked by the technical preoccupations of these artists. They often concentrate on concatenations of intensely observed detail rendered in colours that maintain a consistent tonality over the whole surface of the work. This, combined with their use of a thick, rather muddy bodycolour, gives rise to a flat, dense atmospheric effect that is also found in the landscapes of a true Pre-Raphaelite associate, George Price Boyce (1826–97; pl. 322). The quiet, flat tonality of many of these works is distinctly of its time, and creates a new aesthetic based on the juxta-

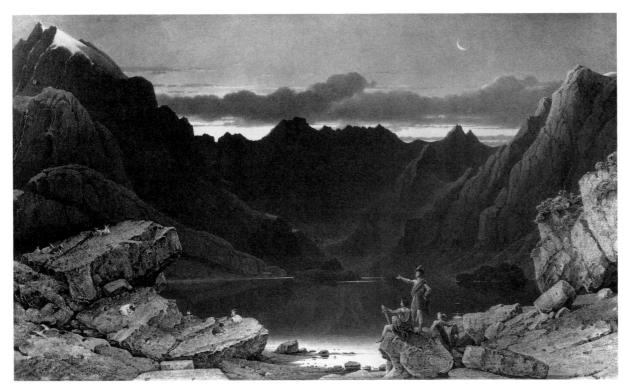

Fig. 54
George Fennel Robson,
Loch Coruisk and the Cuchullin Mountains, Isle of Skye, 1826,
watercolour with scraping-out,
64.2 x 111.8. Victoria and
Albert Museum, London
(*see* cat. 238)

position of equal tones in a sort of twilight, the twilight of a dull summer's evening or of an overcast winter afternoon – a twilight in which human drama may occur. The art-historical implications of this style are particularly interesting, for it leads directly to the lush but subdued colour schemes of the Aesthetic Movement, and anticipates some of the chromatic experiments of the French Post-Impressionists, such as Paul Gauguin or Pierre Bonnard.

In their compositional invention these High Victorian works continued to make innovative use of the example of Turner. Alfred William Hunt combined a passion for Turner's work with a laborious stippling technique that enabled him to bring off complex evocations of mist and cloud, sunlight and rain across expanses of moorland or mountain. In such works the atmospheric impressionism of Cox is married with the techniques of the Pre-Raphaelites to create an entirely legitimate continuation of the tradition. In Hunt's remarkable output, intricate perspectives and busy crowds owe much to Turner's densely populated topography; but whereas Turner, even – indeed, especially – at the end of his career, filled his landscapes with milling hordes of people, Hunt often subsumes the activities of humanity in a thick envelope of atmosphere – of sunlight so drenched with moisture that it is a fine film of haze over everything seen; or dust and smoke gathering in a multicoloured, semi-opaque pall over a town; or a broad lowering swathe of darkness punctured with lights (pl. 326).

The dynamics of landscape, so thoroughly exploited by Turner, are also taken still further by Hunt and by Albert Goodwin. Their panoramas of the Yorkshire coast or the Swiss or Scottish mountains plunge dizzyingly from the minutely traced foreground detail of thistles or fencing defined with sharp brushstrokes or precise scratching-out, to the blur of light and atmosphere across a twilit distance, rendered with broad smears of wash and vigorous ponging-out. This union of a complex vision with an equally complex technique results in highly sophisticated interpretations of Nature.

Some of these densely atmospheric landscapes recreate the 'visionary' intensity of the earlier masters, but not, as Palmer did, by building on and extending an existing vision. The work of Hunt and Goodwin, Boyce and North marks an entirely new phase, linked to, but distinct from, what went before. The sheer opulence of the new

view of landscape invests it with a satiated languor that, for all these artists' Pre-Raphaelite vigour of eye, seems to admit at least something of the Aestheticism that was to dominate new painting in the 1870s and 1880s. It is difficult to resist attributing even this development to the all-pervasive precepts of Ruskin. Indeed, it might almost be thought that he had just such an art in mind when he wrote, after adjuring students to learn in all humility from Nature: 'Then, when their memories are stored, and their imaginations fed, and their hands firm, let them take up the scarlet and gold, give the reins to their fancy, and show us what their heads are made of'.[9] In the best work of these watercolourists, that injunction seems to be fulfilled.

A.W.

1 See *Alexander and John Robert Cozens: The Poetry of Landscape*, pp. 102–5.
2 TB LXX-M. The subject-matter of this watercolour is discussed in *Turner and the Sublime*, p. 133, no. 41.
3 *A Memoir of T. Uwins*, I, p. 31.
4 Farington, *The Diary*, 11 May 1805.
5 *The Letters of Samuel Palmer*, II, p. 886.
6 Ruskin, *The Works*, XIV, pp. 373–4.
7 Ruskin, *The Works*, XIV, p. 74. This picture is reproduced in A. Wilton, *British Watercolours, 1750–1850*, Oxford 1977, pls 145 and 149 (detail).
8 Ruskin, *The Works*, III, pp. 623–4.
9 Ruskin, *The Works*, III, p. 624.

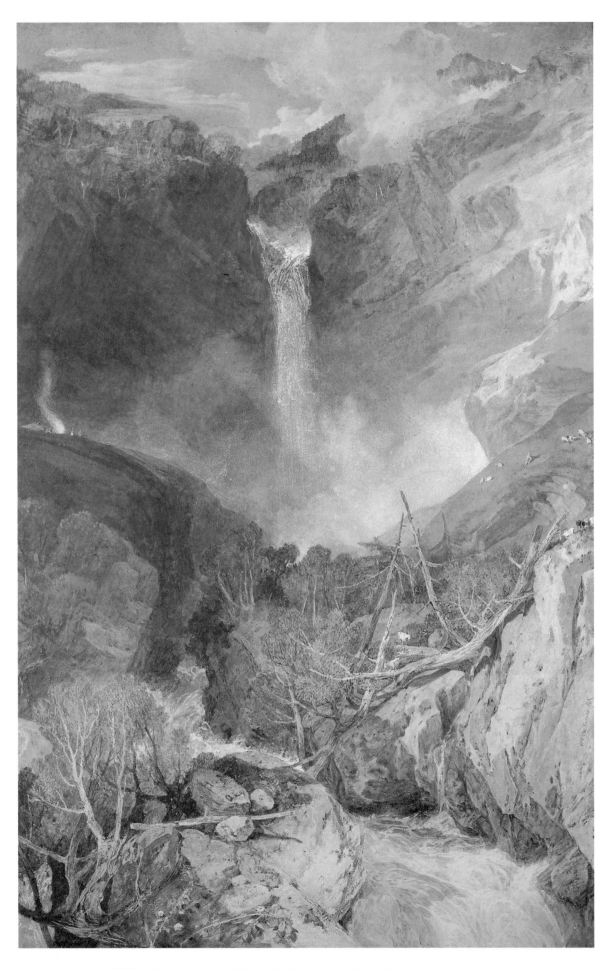

275 Joseph Mallord William Turner, *The Great Falls of the Reichenbach*, 1804 (cat. 284)

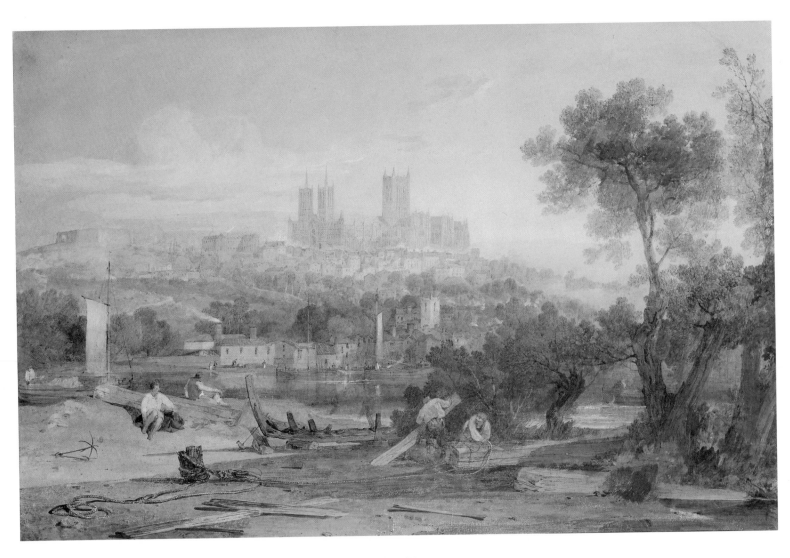

276 Joseph Mallord William Turner, *A View of Lincoln from the Brayford, c.* 1802–3 (cat. 283)

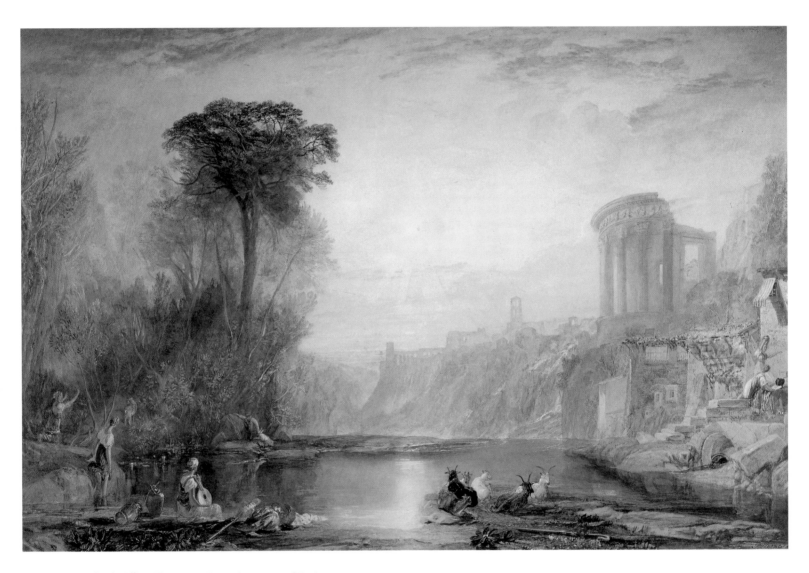

277 Joseph Mallord William Turner, *Landscape: Composition of Tivoli*, 1817 (cat. 287)

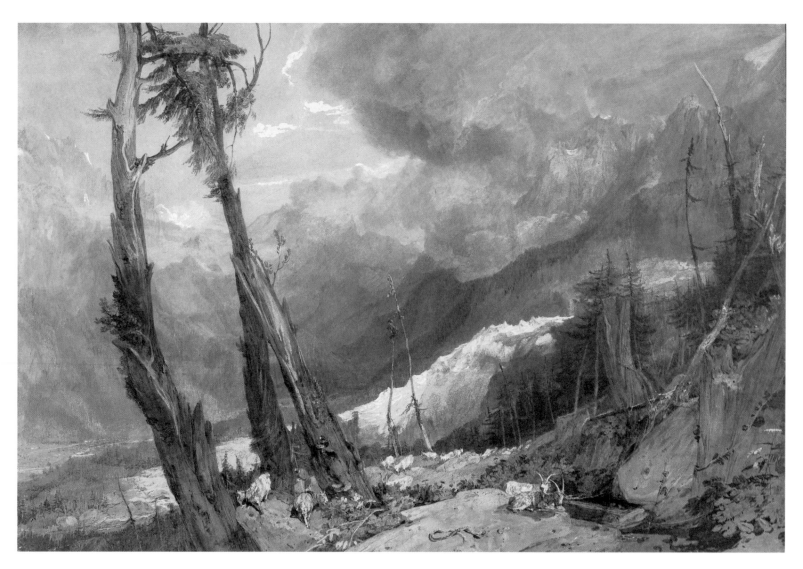

278 Joseph Mallord William Turner, *Glacier and Source of the Arveiron, Going up the Mer de Glace, Chamonix*, 1802–3 (cat. 282)

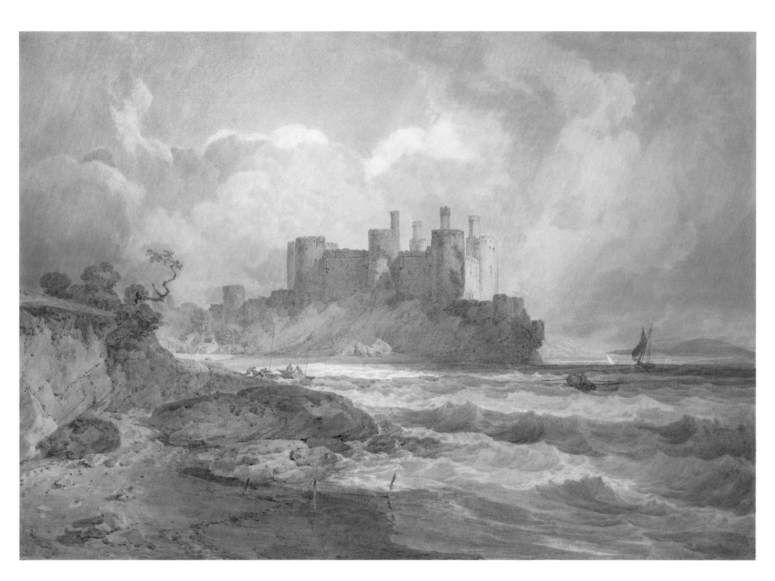

279 Joseph Mallord William Turner, *Conway Castle*, 1800 (cat. 281)

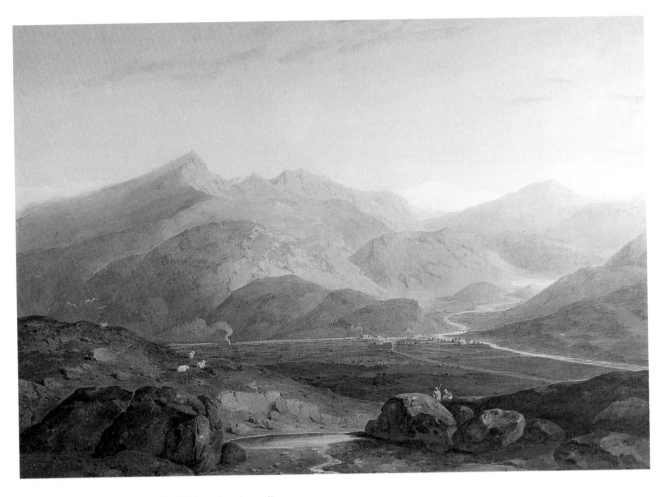

280 John Varley, *Snowdon from Moel Hedog*, 1805 (cat. 318)

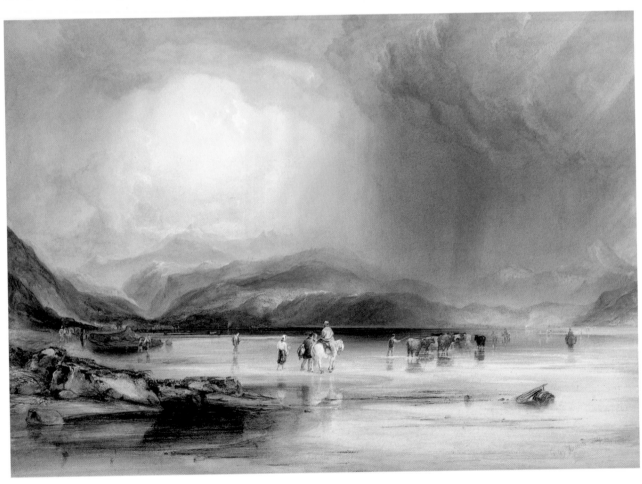

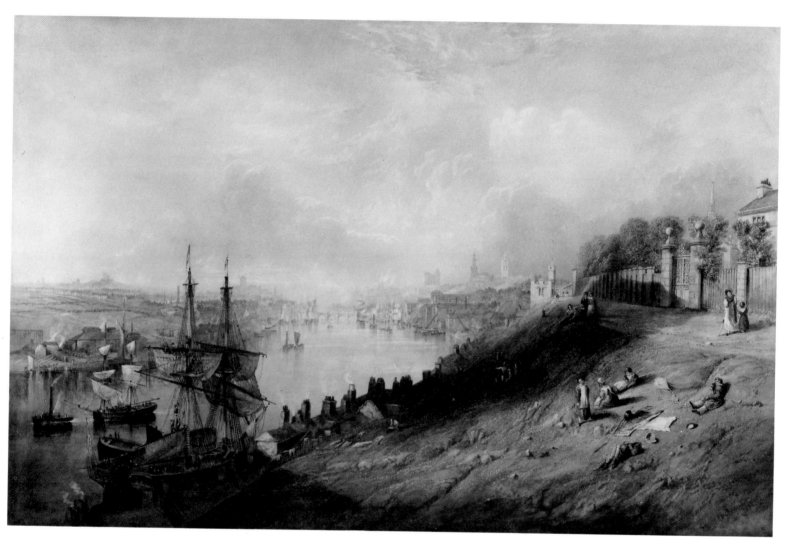

282　John Wilson Carmichael, *Newcastle from St Ann's*, 1835　(cat. 22)

left page below
281　Anthony Vandyke Copley Fielding,
View of Snowdon from the Sands of Traeth Mawr,
Taken at the Ford between Pont Aberglaslyn
and Tremadoc, 1834　(cat. 129)

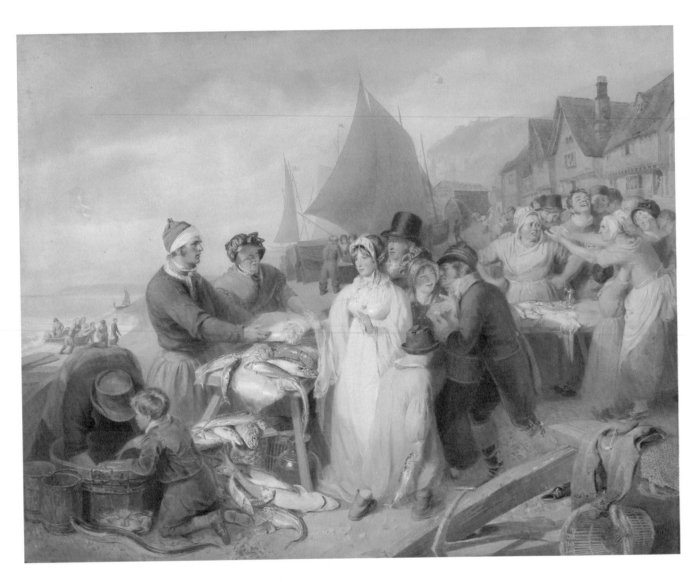

283 Thomas Heaphy, *Fish Market, Hastings*, 1809 (cat. 162)

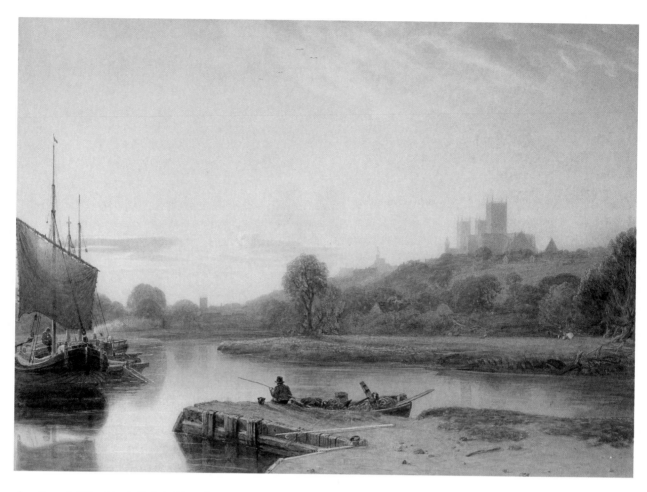

284 Peter de Wint, *Lincoln Cathedral from the River*, *c.* 1825 (cat. 115)

285 Peter de Wint, *Cookham on Thames*, (?)*c.* 1830 (cat. 116)

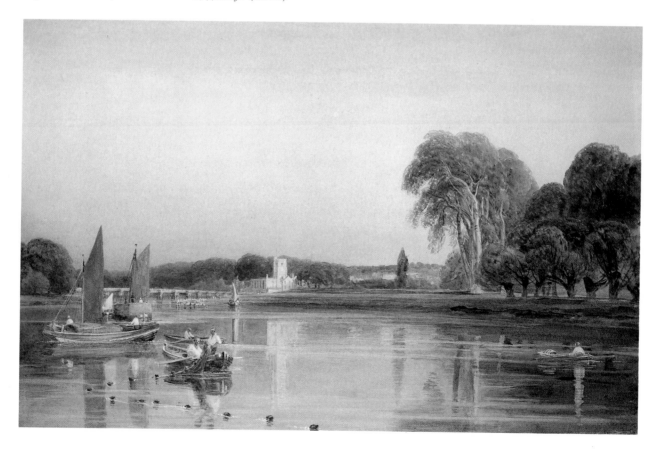

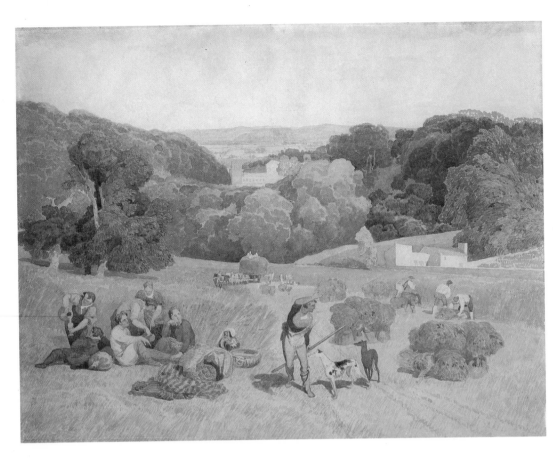

286 John Sell Cotman, *The Harvest Field, A Pastoral, c.* 1810 (cat. 53)

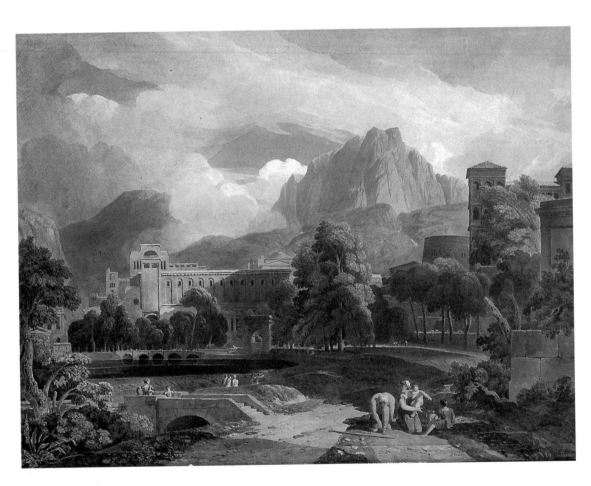

287 John Varley, *Suburbs of an Ancient City,* 1808 (cat. 319)

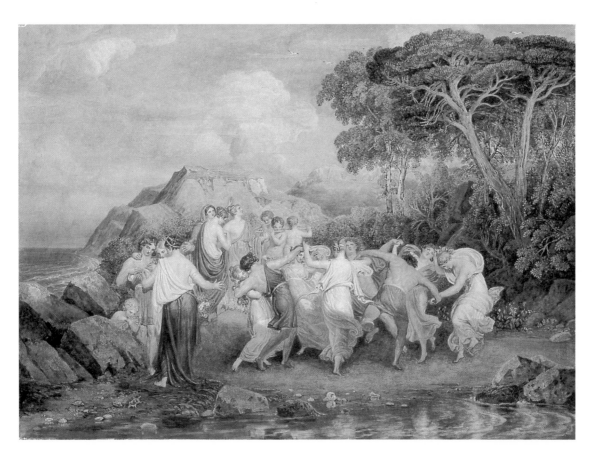

288 Joshua Cristall, *Nymphs and Shepherds Dancing*, *c.* 1825 (cat. 100)

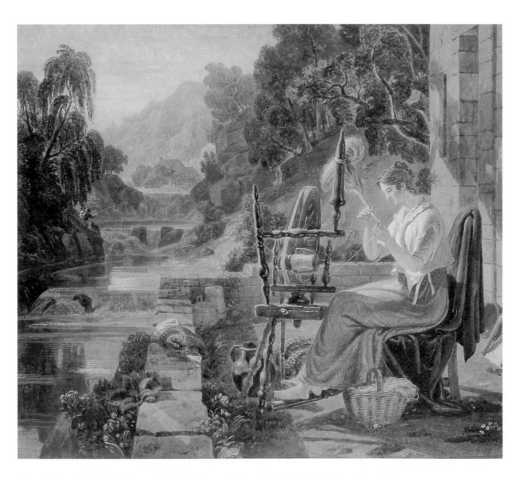

289 Joshua Cristall, *A Woman Spinning* ('*Bessy and her Spinning Wheel*'), 1824 (cat. 99)

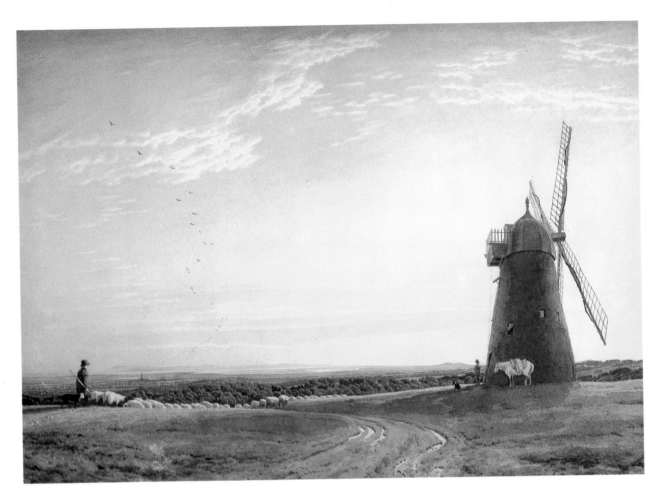

290 William Turner of Oxford, *Halnaker Mill, near Chichester, Sussex, c.* 1837 (cat. 309)

291 Hugh William 'Grecian' Williams, *View of the Forum in Rome,* 1828 (cat. 326)

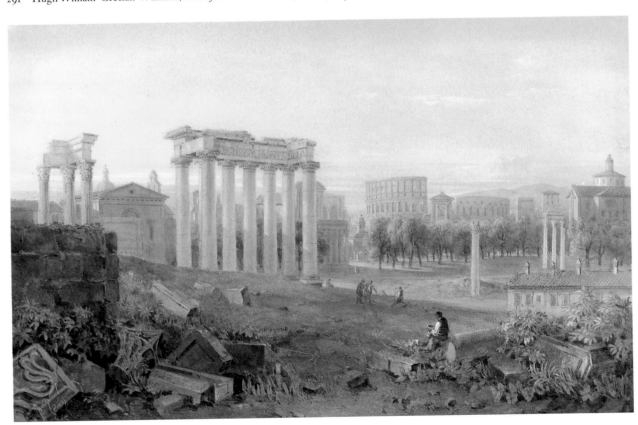

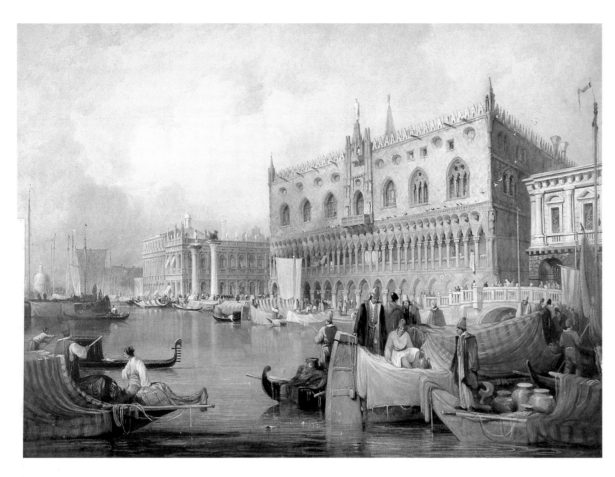

92 Samuel Prout, *The Ducal Palace, Venice*, 1830 (cat. 234)

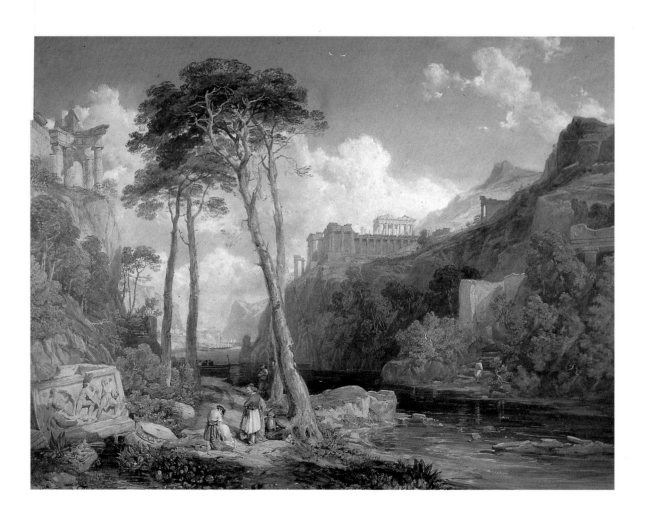

293 James Duffield Harding,
Modern Greece, 1828 (cat. 158)

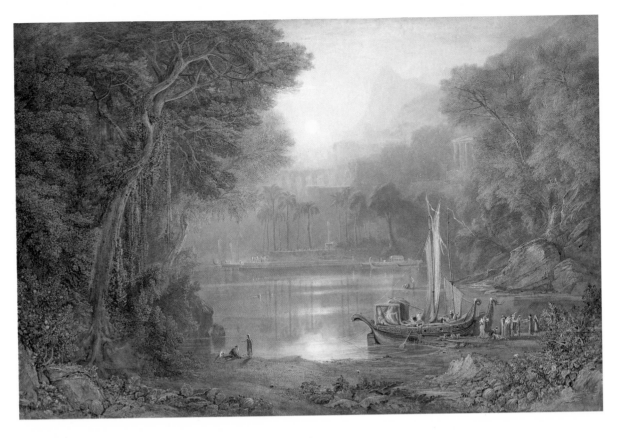

294 Samuel Jackson, *Composition: A Land of Dreams*, 1830 (cat. 190)

295 George Barret Jnr, *Solitude: An Italianate Landscape with a Figure Reclining beneath Trees*, 1823 (cat. 6)

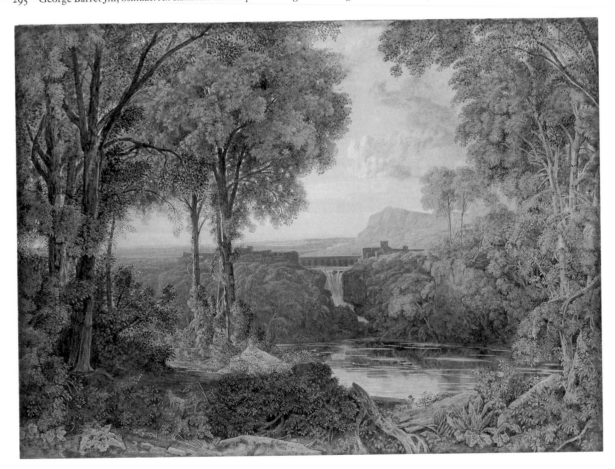

right page below
297 David Cox, *Pastoral Scene in Herefordshire*, (?)1824 (cat. 65)

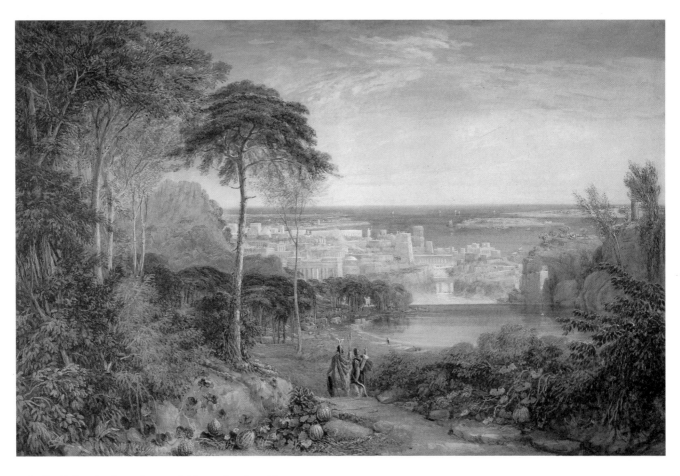

296 David Cox, *Carthage: Aeneas and Achates*, 1825 (cat. 66)

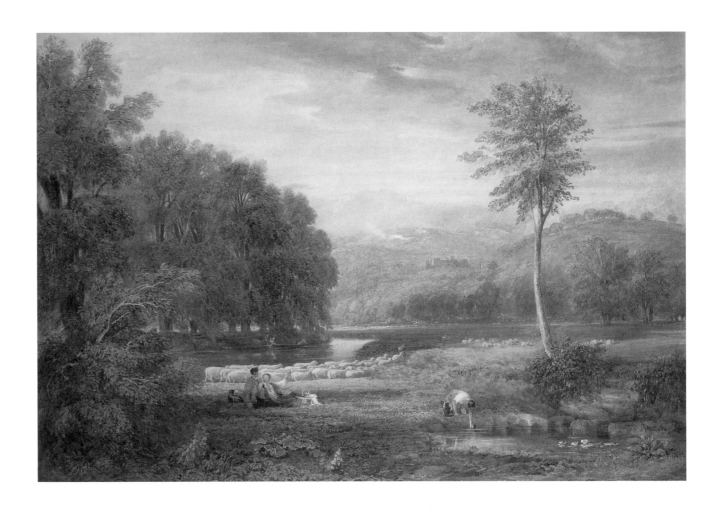

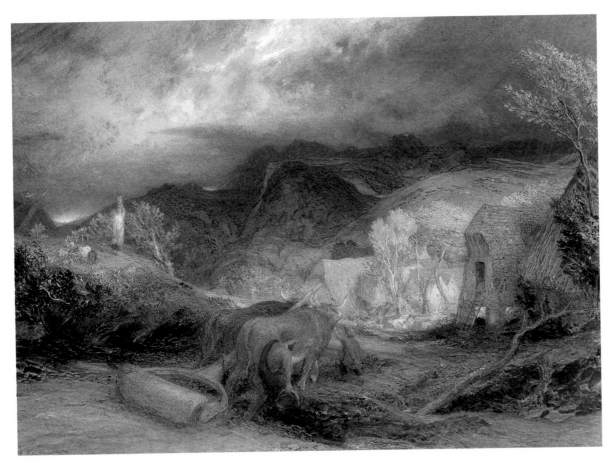

298 Samuel Palmer, *Morning (Illustration to Milton's 'Il Penseroso')*, 1869 (cat. 230)

299 Samuel Palmer, *The Lonely Tower (Illustration to Milton's 'Il Penseroso')* 1868 (cat. 228)

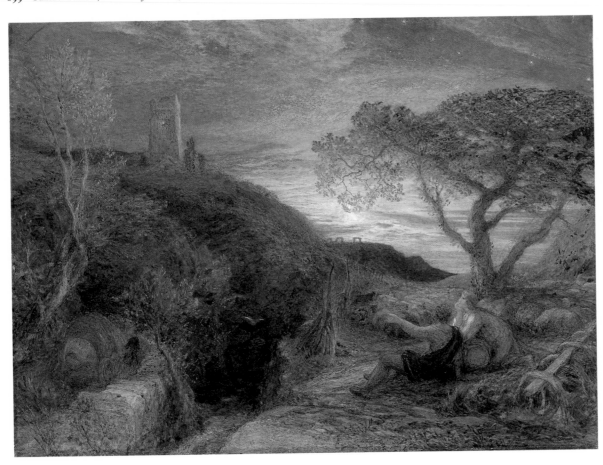

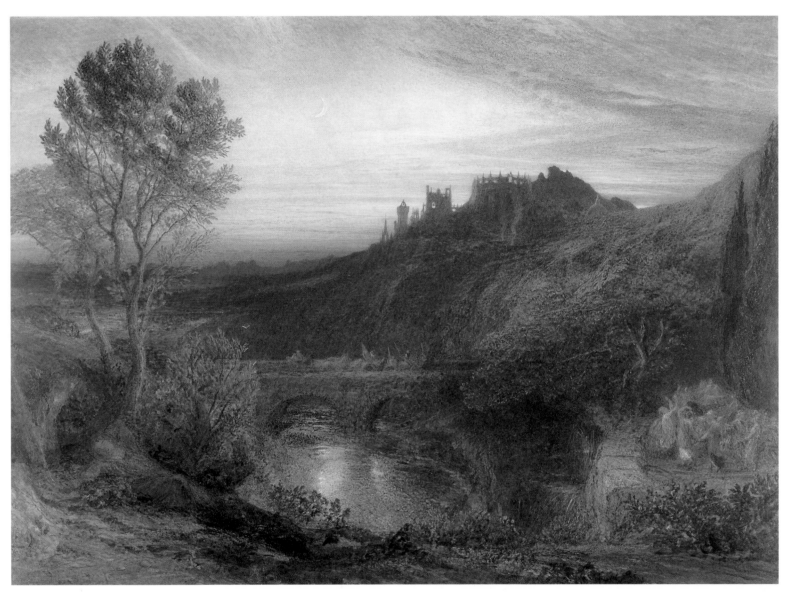

300　Samuel Palmer, *A Towered City (Illustration to Milton's 'L'Allegro')*, 1868　(cat. 229)

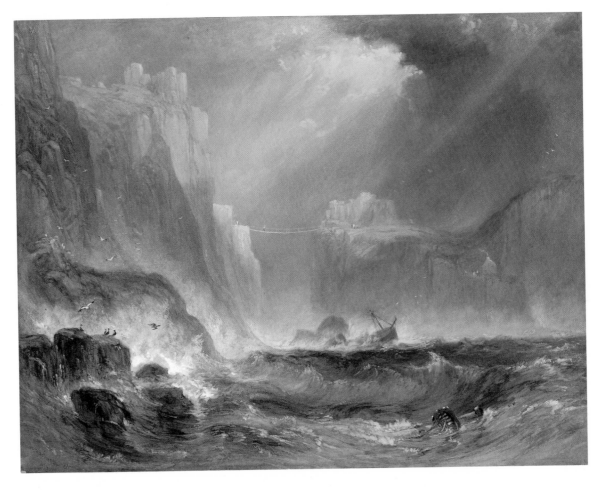

301 Henry Gastineau, *Carrick-y-Rede, Antrim*, 1839 (cat. 135)

302 Samuel Jackson, *Composition: Hunters Resting after the Chase*, 1827 (cat. 189)

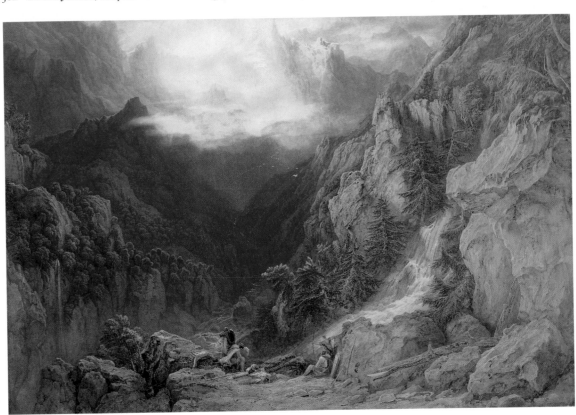

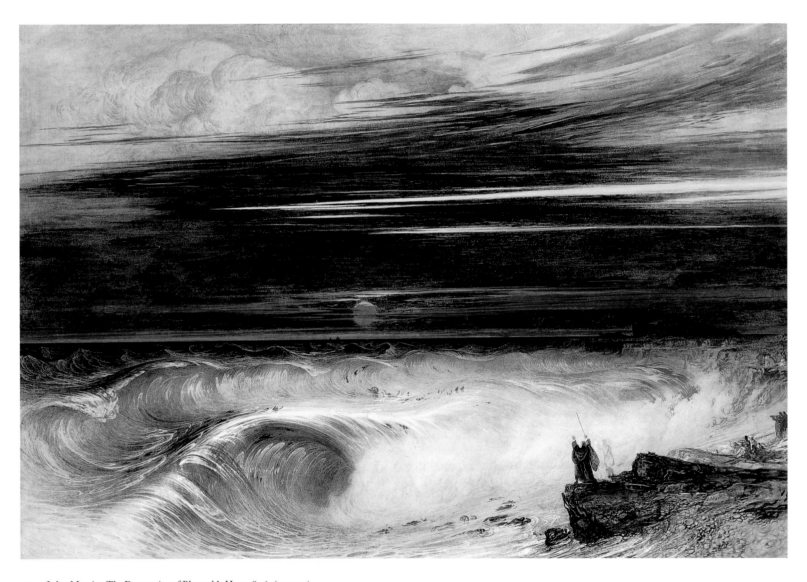

303　John Martin, *The Destruction of Pharaoh's Host*, 1836　(cat. 212)

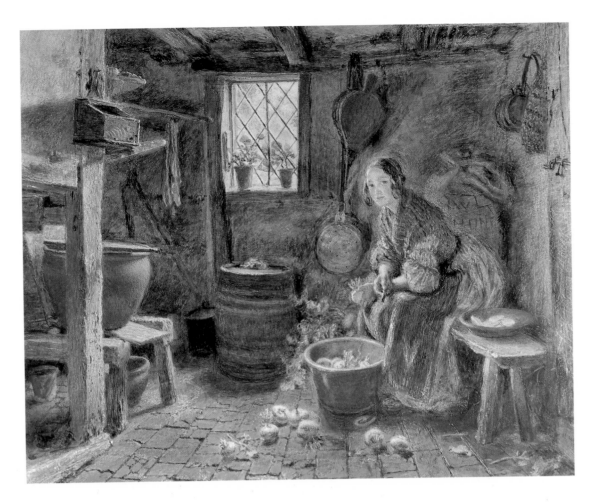

304 William Henry Hunt, *The Kitchen Maid*, c. 1833 (cat. 181)

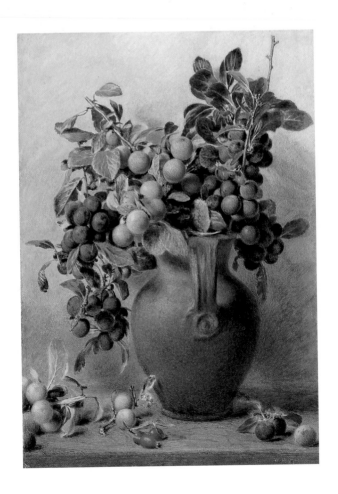

305 William Henry Hunt, *Jug with Plums and Rosehips*, c. 1840 (cat. 182)

306 William Henry Hunt, *Preparing for Sunday, c.* 1832 (cat. 180)

307 William Henry Hunt,
Primroses with Bird's Nest,
c. 1850 (cat. 183)

308 John Frederick Lewis, *Highland Hospitality*, 1832 (cat. 196)

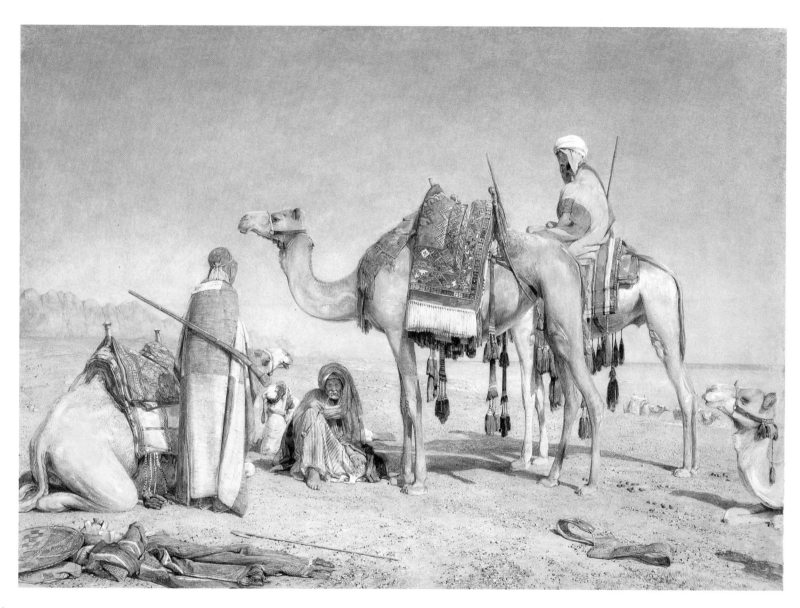

310 John Frederick Lewis, *The Noonday Halt*, 1853 (cat. 199)

left page below
309 John Frederick Lewis,
The Suburbs of a Spanish City (Granada)
on the Day of a Bull-fight, 1836 (cat. 198)

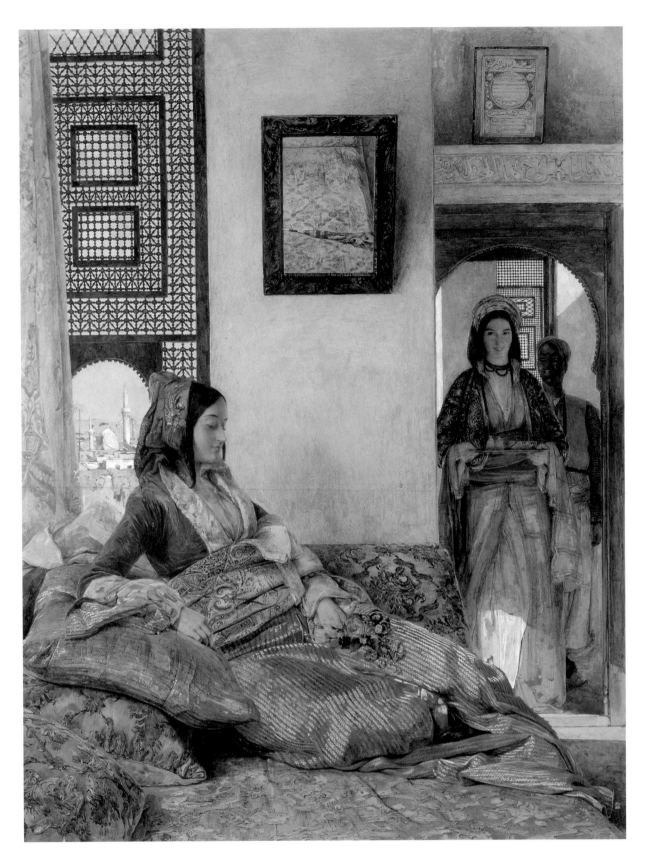

311　John Frederick Lewis, *Life in the Hhareem, Cairo*, 1858　(cat. 200)

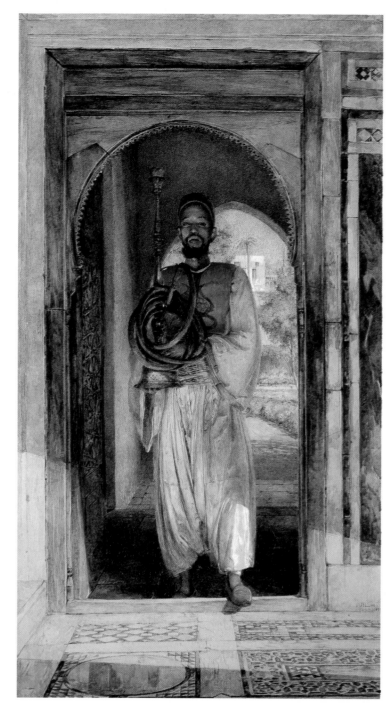

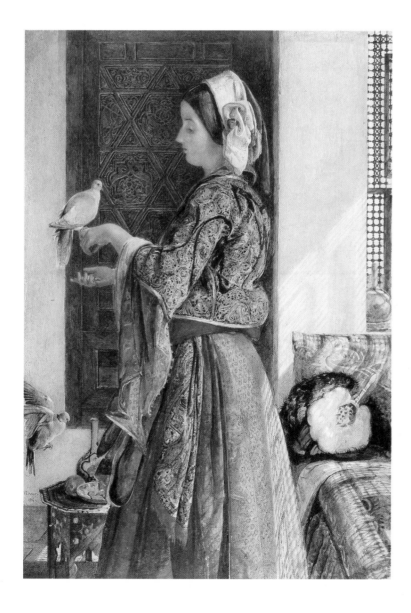

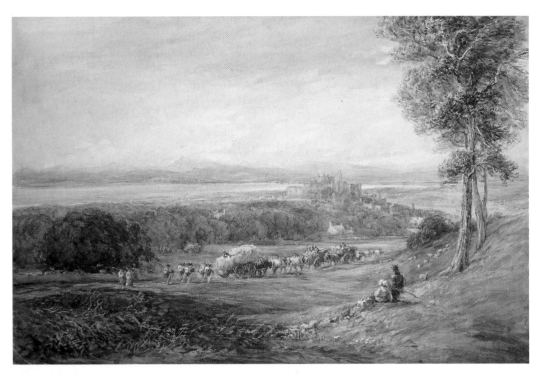

314　David Cox, *Lancaster: Peace and War*, 1842　(cat. 73)

right page above
316　Myles Birket Foster, *Highland Scene near Dalmally*, 1885　(cat. 132)

below
317　John William North, *Gypsy Encampment*, 1873　(cat. 222)

315　David Cox, *The Challenge: A Bull in a Storm on a Moor, c.* 1856　(cat. 78)

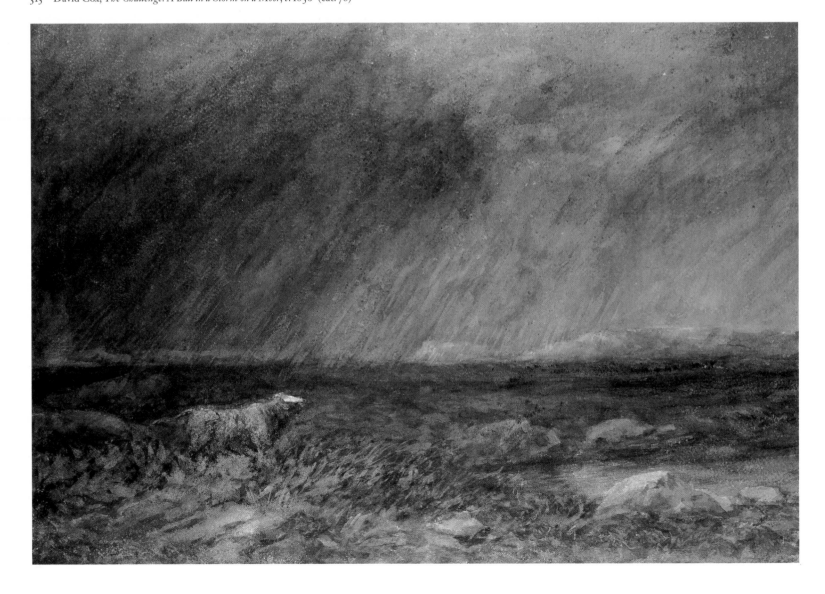

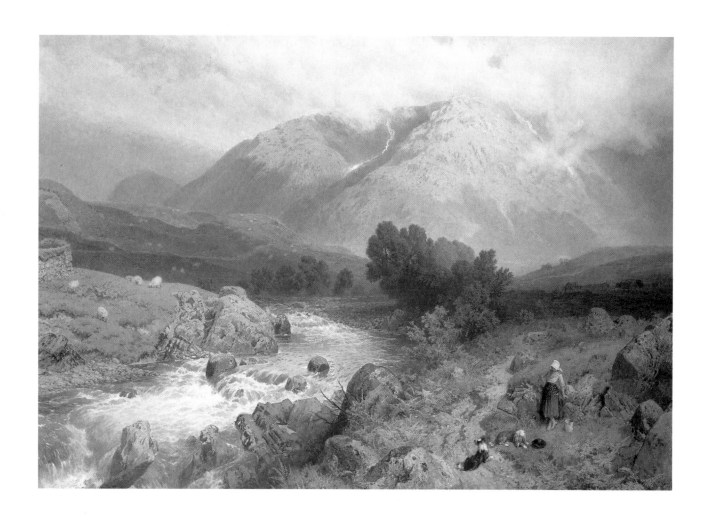

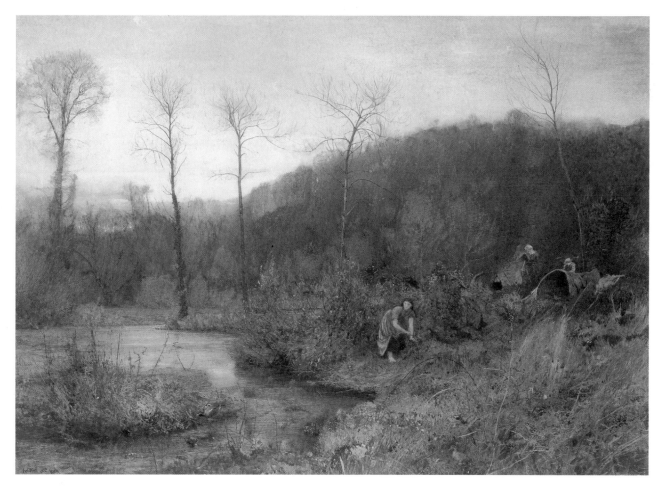

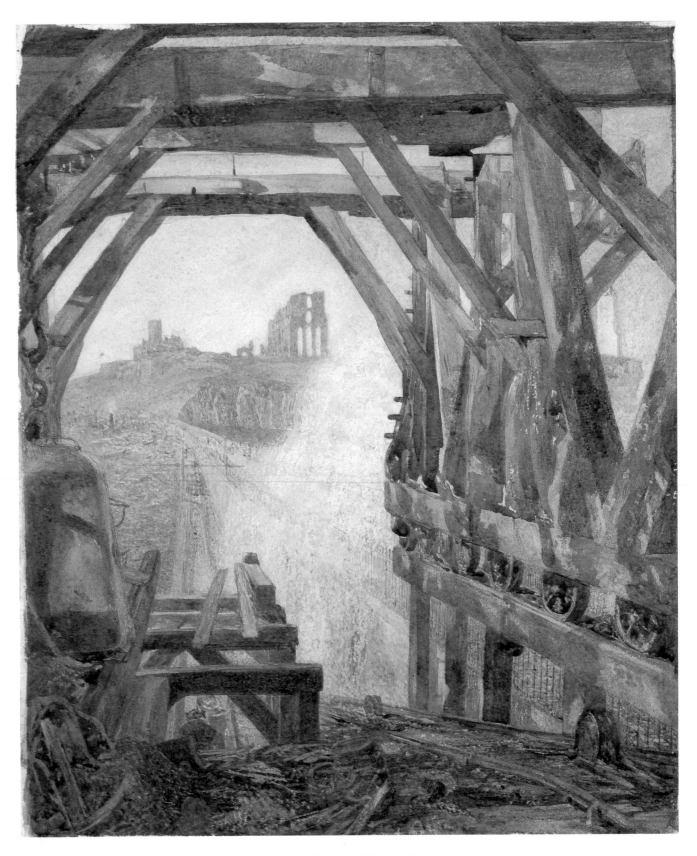

318 Alfred William Hunt, *Travelling Cranes, Diving Bells, etc. on the Extremity of Tynemouth Pier*, c. 1867 (cat. 175)

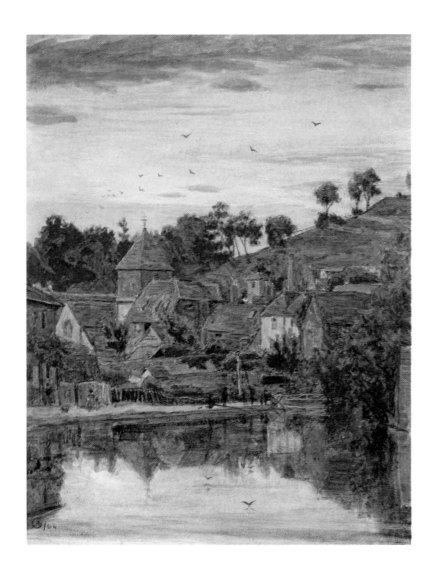

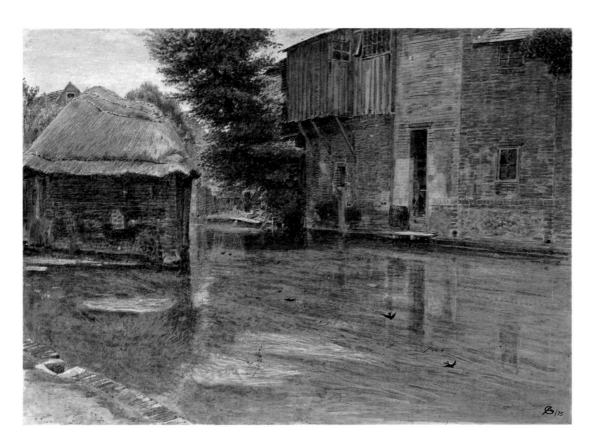

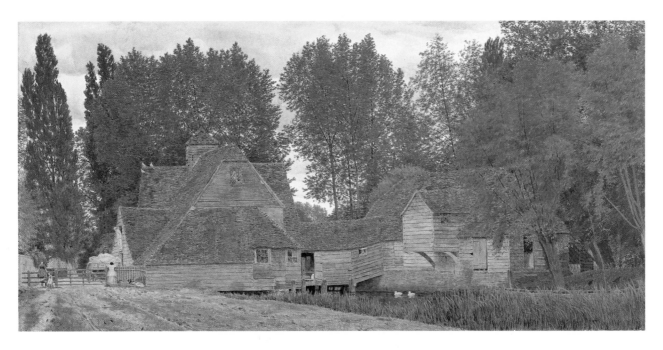

321　George Price Boyce, *The Mill on the Thames at Mapledurham, Oxfordshire*, 1860　(cat. 17)

322　George Price Boyce, *Black Poplars at Pangbourne, Berkshire*, (?)1868　(cat. 19)

323 Henry George Hine, *Amberley Castle, Sussex, Seen from the Marshes*, 1867 (cat. 169)

324 Alfred William Hunt, *Whitby*, (?)1878 (cat. 177)

325 Henry George Hine, *Nine Barrow Down near Swanage, Dorset*, c. 1875 (cat. 170)

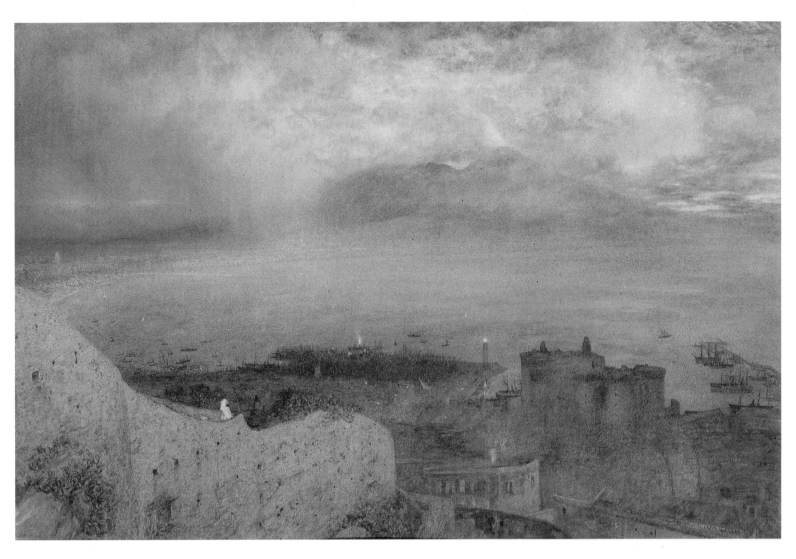

326 Alfred William Hunt, *Naples, or Land of Smouldering Fire*, 1871 (cat. 176)

GLOSSARY OF TECHNICAL TERMS

BODYCOLOUR

Lead white mixed with watercolour pigment to make it opaque. Lead white has a tendency to discolour (it blackens on exposure to hydrogen sulphide), and was gradually replaced by the more stable zinc white ('Chinese white'), manufactured by Winsor & Newton from 1834. A 'watercolour' can be executed entirely in bodycolour, or the use of bodycolour can be restricted to highlights, especially white highlights.

BRUSH

Watercolour brushes (known as 'pencils' in the eighteenth century) were mostly made of the hair of red sable, which is durable yet pliant and firm, and can be readily twisted to a point.

CAMERA OBSCURA

An apparatus that projects the image of an object or scene on to a sheet of paper, ground glass or other surface so that its outlines can be traced. It consists of a closed box (it can also be a room) that admits light through a small hole or lens, projecting an inverted image on the principle of the photographic camera. A mirror is usually installed in order to reflect the image the right way up. The *camera lucida* (patented in 1807 by W.H. Wollaston) is a more portable version of the *camera obscura* with a wider field of vision, and is so-called because it performs the same function in full daylight. It consists of a glass prism that can be revolved on the end of an adjustable arm: the user looks down it with one eye while looking past it with the other at a reduced image projected on to the paper. The Graphic Telescope that Cornelius Varley patented in 1811 has a more compact shape than the *camera lucida* and a greater facility for adjustment. Internal mirrors automatically correct the direction of the image. Originally designed for landscapes, it was also used for portraits and architectural drawings, and when reducing images for the engraver.

CHALK

Natural *black chalk* is a mineral, a species of carbonaceous shale whose principal ingredients are carbon and clay. It is very adhesive to paper and makes an indelible mark. Natural *white chalk* is of two varieties: carbonate of calcium, or soapstone (steatite). Although chalk can be sharpened to a point, it quickly wears down, hence it produces a softer line than one made by a pencil.

CLAUDE GLASS

A darkened, slightly convex mirror, cased like a pocket-book, that was used extensively in the late eighteenth century to obtain an image of Nature. The artist or traveller turned his back to the landscape in order to use it. The low-key reflections of Nature in the mirror resemble the landscape effects to be seen in paintings by Claude Lorrain. A silvered mirror was available for days too overcast for effective use of the darkened kind. The Claude Glass was both a viewing-glass and a popular drawing device.

GOUACHE see BODYCOLOUR.

GUM ARABIC

A vegetable gum obtained from the acacia tree. It differs from resins in being soluble in water, and is thus well suited for binding watercolour pigment.

INK

Used by some eighteenth-century topographers as the foundation of a 'stained' or 'tinted' drawing, or as a reinforcement to a finished watercolour, ink was applied with a brush, quill pen or reed pen. *Carbon ink* is generally made from soot (or some other easily available carbon) dissolved in water, often with a binder such as GUM ARABIC. *Indian ink* is a waterproof form of carbon ink in which some kind of resin has been dissolved. A more brown ink can be made with *bistre*, obtained from the soot of burning wood, resin or peat. *Sepia* is made from the secretion of the cuttle-fish, although the term is often used to mean dark brown ink in general.

PAPER

The basis of all paper is cellulose fibre, which is derived from plants. Until the 1840s, when wood pulp was introduced, most papers were made from cotton or linen rags. Hand-made paper is made in a mould that has a fine wire grid as its base. The mould is dipped into liquid pulp, and then removed for drying. Until *c.* 1750 all paper made in Europe was *laid* paper, identifiable by the ribbed (or 'chain') pattern impressed by the mould's wire grid. By the end of the eighteenth century watercolourists were beginning to prefer the smoother and more even appearance of *wove* papers, produced by using a wire mesh woven much like a piece of fabric. The majority of papers used by watercolourists were white, but some artists, such as J.M.W. Turner, experimented with coloured papers and papers prepared with a coloured wash.

PENCIL

Made of graphite, a crystalline form of carbon also known as plumbago, it leaves a shiny deposit on paper.

SCRAPING-OUT

Sometimes described as *scratching-out*, this is a means of creating a highlight by removing an area of watercolour with a knife, the point of a brush or even a fingernail to expose the paper beneath.

SCUMBLING

A method of dragging almost dry colour (either watercolour or bodycolour) across the support in order to obtain a crumbly surface texture.

SPONGING-OUT

Like SCRAPING-OUT, this is a method of creating a highlight, but by removing an area of watercolour with a soft sponge.

STAMP

A small, distinctive mark, sometimes embossed and usually composed of initials, often found on drawings. A *studio stamp* was applied to material sold from an artist's studio after his or her death. If the stamp is impressed on the sheet without ink, it is known as a *blind stamp*. Drawings in private collections were also often given a stamp: this is known as a *collector's mark*. In the late nineteenth century, facsimiles of artists' signatures were sometimes printed on drawings as a form of studio stamp.

STIPPLE

The application of minute spots or flecks of watercolour using the point of a fine brush, or of lifting spots of colour from a wash so as to break up the colour into myriad dots or specks.

STOPPING-OUT

A method of preserving a highlight by masking a selected area of watercolour pigment with a 'stopping-out' agent, such as gum, in order to prevent that area being obscured or qualified by subsequent layers of wash.

VARNISH

Watercolours destined for exhibition alongside oils, or intended to compete with oils in size or force, were sometimes varnished, either over the whole surface or in the darkest areas of the composition, especially shadows. Varnishes were usually made from GUM ARABIC, although other recipes, such as isinglass dissolved in water or Zapon mixed with alcohol, were sometimes preferred.

WASH

An application of colour over a larger field than can conveniently be covered by the brush at one stroke. A wash must be continued and extended while the colour is still wet, and show no joins; great skill is required when laying a flat or, especially, a gradated one. Washes can be broken (or *dragged*) by charging a brush with almost dry colour, and then dragging the brush on its side to deposit particles of pure colour – a useful method for obtaining texture or sparkle. Washes can also be run or 'bled' into one another when still wet.

WASHLINE MOUNT

A type of mount commonly used in the eighteenth century that incorporates a tinted border, and sometimes additional ruled borders. Watercolours mounted in this way were often stored in a portfolio rather than framed and hung.

WATERCOLOUR

A finely ground pigment combined with a watersoluble binding agent, commonly GUM ARABIC. It is usually distributed either in tubes or cakes. Water is used as the vehicle to spread and dilute the colour, and it subsequently evaporates. It is the gum arabic that binds the pigments to the surface of the support, which is invariably PAPER. Watercolour papers tend to have a granular surface that make for variations in the reflective luminosity in the surface of the sheet; the chief source of brilliancy in pure watercolour, however, derives from the white of the paper shining through the transparent pigment. Because the watercolour painting has its technical origins in the 'tinted' or 'stained' drawing, it is sometimes referred to as a watercolour drawing, and thus the terms 'watercolour' and 'drawing' are sometimes used synonymously.

CATALOGUE OF WORKS

This Catalogue is organised alphabetically by artist; works are listed by date of execution, earliest first. Dimensions refer to image size and are given in centimetres, height before width. Unless otherwise specified, the support is white, wove paper. Inscriptions on the front or back (verso) of a work are transcribed literally, but are recorded only when (or assumed to be) in the artist's own hand.
Abbreviations: Engr. = engraved; Exh. = exhibited; Inscr. = inscribed; NSA: Norwich School of Artists (founded 1803); NWCS: 'New Water-Colour Society' (founded 1832); OWCS: 'Old Water-Colour Society' (founded 1804); RA: Royal Academy of Arts (founded 1768).

JOHN WHITE ABBOTT
1763–1851

1 (section III)
Trees in Peamore Park, Exeter 1799
Watercolour with pen and black ink,
43.1 x 35.5
Inscr. lower left: *JWA* (monogram) *1799* and verso: *Peamore – 1799. Given to John Abbott, March 1. 1832.*
Lent by the Syndics of the Fitzwilliam Museum, Cambridge (PD 42-1980)
plate 133

ROBERT ADAM 1728–1792

2 (section I)
River Landscape with a Castle c. 1780
Pencil and watercolour with pen and brown ink, 30.1 x 44.5
National Gallery of Art, Washington DC, Ailsa Mellon Bruce Fund (1988.23.1)
plate 10

WILLIAM ALEXANDER
1767–1816

3 (section II)
The Pagoda of Lin-ching-shih, on the Grand Canal, Peking c. 1795
Pencil and watercolour, 28.6 x 43.2
Inscr. below centre: *W. Alexander f.*
Engr. by William Byrne in Sir G. L. Staunton, *An Authentic Account of an Embassy from the King of Great Britain to the Emperor of China,* 1797, pl. 33
John Swire & Sons Ltd
plate 57

SAMUEL AUSTIN 1796–1834

4 (section II)
EXHIBITED LONDON ONLY
Dort, Holland c. 1830
Pencil and watercolour, 21.7 x 50.2
Oldham Art Gallery (9.88/64)
plate 97

GEORGE BARRET JNR
1767–1842

5 (section III)
View on the Coast Seen through a Window c. 1815
Watercolour with pen and black ink, 40 x 26
Royal Library, Windsor Castle (RL 13371)
plate 109

6 (section VI)
Solitude: An Italianate Landscape with a Figure Reclining beneath Trees 1823

Pencil and watercolour with gum arabic,
114 x 160
Inscr. below, centre: *G. Barret / 1823*
Exh. OWCS 1823 (no. 221)
James Swartz Esq.
plate 295

7 (section IV)
The Close of the Day 1829
Watercolour over pencil with gum arabic, sponging, stopping-out and scraping-out, 35.8 x 51.9
Inscr. lower left: *George Barret / 1829*
Birmingham Museums and Art Gallery (P 40'53)
plate 214

WILLIAM HENRY BARTLETT 1809–1854

8 (section III)
View of Rievaulx Abbey from the Hills to the West c. 1829
Watercolour over pencil, 21.7 x 31.6
Leeds City Art Galleries (9.7/52)
plate 160

WILLIAM BLAKE 1757–1827

9 (section IV)
EXHIBITED WASHINGTON ONLY
The Wand'ring Moon c. 1816–20
Watercolour with pen and black ink,
16.2 x 12.2
Inscr. lower left: *W Blake inv*
This subject is an illustration to Milton's *Il Penseroso*, ll. 67–76
The Pierpont Morgan Library, New York, Purchased with the support of the Fellows, with the special assistance of Mrs Landon K. Thorne and Mr Paul Mellon (1949.4:8)
plate 217

10 (section IV)
EXHIBITED LONDON ONLY
The Arlington Court Picture ('The Sea of Time and Place') 1821
Watercolour with pen and black ink with bodycolour over a gesso ground, 40 x 49.5
Inscr. lower left: *W Blake inventor 1821*
The title in parentheses is a quotation from Blake's Prophetic Book *Vala, or the Four Zoas*
Arlington Court, Devon, The Chichester Collection (The National Trust)
plate 218

11 (section IV)
Homer and the Ancient Poets 1824–7
Pencil and watercolour with pen and black ink, 37.1 x 52.8
Inscr. lower right: *HELL Canto 4*
This subject is an illustration to Dante's *Inferno*

The Tate Gallery, London, Purchased with the assistance of a special grant from the National Gallery and donations from The National Art Collections Fund, Lord Duveen and others, and presented through the National Art Collections Fund 1919
plate 216

RICHARD PARKES BONINGTON 1802–1828

12 (section V)
Paris from Père Lachaise c. 1825
Pencil and watercolour, 23.5 x 21.5
Private Collection
plate 239

13 (section V)
EXHIBITED LONDON ONLY
Château of the Duchesse de Berri c. 1825
Watercolour and bodycolour, 20.3 x 27.2
Trustees of the British Museum, London (1910-2-12-223)
plate 240

14 (section V)
Near Burnham, Norfolk c. 1825
Watercolour and scraping-out, 14.3 x 18.2
Inscr. lower right: *RPB*
The identification of this subject is doubtful
Sheffield City Art Galleries
plate 241

15 (section V)
A Fisherman on the Banks of a River, a Church Tower in the Distance c. 1825–6
Pencil and watercolour, 17.5 x 23.7
Inscr. lower left: *R P Bonington*
Private Collection, New York
plate 242

16 (section II)
Verona: The Castelbarco Tomb 1827
Watercolour and bodycolour over pencil, 19.1 x 13.3
Inscr. lower left: *RPB 1827*
City of Nottingham Museums: Castle Museum and Art Gallery (53-22)
plate 85

GEORGE PRICE BOYCE
1826–1897

17 (section VI)
EXHIBITED LONDON ONLY
The Mill on the Thames at Mapledurham, Oxfordshire 1860
Watercolour, 27.3 x 56.8
Inscr. lower left: *G.P. Boyce. July 1860;* and verso: *Mill at Mapledurham Oxfordshire / Boyce – July 1860 – forenoon*

Lent by the Syndics of the Fitzwilliam Museum, Cambridge (PD 52-1971)
plate 321

18 (section V)
Night Sketch of the Thames near Hungerford Bridge c. 1860–2
Watercolour, 22.2 x 33.7
Inscr. on artist's mount (removed): *Southern Bank of the Thames between Hungerford and Waterloo Bridges,* and *From my studio window 15 Buckingham St. Adelphi / GP Boyce*
Exh. OWCS 1866–7 (no. 364)
The Tate Gallery, London, Bequeathed by Miss Morris 1939 (N 0500)
plate 272

19 (section VI)
Black Poplars at Pangbourne, Berkshire (?)1868
Watercolour with scraping-out, 36.7 x 53.3
Inscr. lower left: *G.P. Boyce 18[?68]*
Exh. OWCS 1871 (no. 258)
Christopher and Jenny Newall
plate 322

THOMAS SHOTTER BOYS
1803–1874

20 (section II)
EXHIBITED LONDON ONLY
Paris: Le Pavillon de Flore, Tuileries
c. 1830
Watercolour and pen and brown ink, 45.2 x 33
Engr. in chromolithography by Boys for *Picturesque Architecture in Paris, Ghent, Antwerp, Rouen etc.,* 1839, pl. XXI
Lent by the Syndics of the Fitzwilliam Museum, Cambridge (PD1-1967)
plate 94

WILLIAM CALLOW 1812–1908

21 (section II)
Paris: Quai de l'Horloge c. 1835
Watercolour and bodycolour with scraping-out, 31.8 x 74.3
City of Nottingham Museums: Castle Museum and Art Gallery (1953-2)
plate 92

JOHN WILSON CARMICHAEL 1799–1868

22 (section VI)
Newcastle from St Ann's 1835
Pencil, watercolour and bodycolour with scraping-out, 63.2 x 97.5
Inscr. lower right: *J.W. Carmichael 1835*
Laing Art Gallery, Newcastle upon Tyne (Tyne and Wear Museums) (G 9629)
plate 282

THOMAS COLLIER
1840–1891

23 (section V)
Haresfield Beacon *c.* 1880
Pencil and watercolour, 30.9 x 52.7
Inscr. lower left: (?)*Augst 14ᵗʰ*; stamped lower
right: *Thᵒˢ Collier*
Lent by the Syndics of the Fitzwilliam
Museum, Cambridge (73-1950)
plate 249

24 (section V)
Pensarn Beach 1886
Pencil and watercolour, 23.6 x 34.7
Inscr. lower right: *Oct. 2.ⁿᵈ 1886* and stamped
Thᵒˢ Collier
Lent by the Syndics of the Fitzwilliam
Museum, Cambridge (PD 68-1950)
plate 251

WILLIAM COLLINS
1788–1847

25 (section III)
Horses Watering by a Bridge *c.* 1815
Pencil, watercolour and pen and brown ink on
grey paper, 26.5 x 34.7
Private Collection
plate 155

JOHN CONSTABLE
1776–1837

26 (section I)
View in Langdale 1806
Pencil and grey wash, 34.4 x 48.6
Inscr. verso: *19 Oct 1806 Langdale*
The Board of Trustees of the Victoria and
Albert Museum, London (1256-1888)
plate 47

27 (section III)
Study of Clouds at Hampstead 1830
Pencil and watercolour, 19 x 22.8
Inscr. verso: *about 11 – Noon – Sepr 15 1830.
Wind – W.*
The Board of Trustees of the Victoria and
Albert Museum, London (240-1888)
plate 125

28 (section V)
EXHIBITED LONDON ONLY
London from Hampstead *c.* 1830–3
Watercolour, 11.2 x 18.7
Trustees of the British Museum, London
(1888-2-15-53)
plate 225

29 (section V)
EXHIBITED LONDON ONLY
View over London from Hampstead
c. 1830–3
Watercolour, 11.2 x 17.8
Trustees of the British Museum, London
(1888-2-15-52)
plate 224

30 (section V)
*View at Hampstead, Looking towards
London* 1833
Watercolour, 11.5 x 19
Inscr. verso: *Hampd December 7, 1833 3 oclock –
very stormy afternoon – & High Wind –*; and: *21*

The Board of Trustees of the Victoria and
Albert Museum, London (220-1888)
plate 228

31 (section V)
EXHIBITED LONDON ONLY
Folkestone from the Sea 1833
Pencil and watercolour, 12.7 x 21
Inscr. lower right: *16 Oct 1833/Folkestone*
Trustees of the British Museum, London
(1888-2-15-46)
plate 227

32 (section V)
EXHIBITED LONDON ONLY
Tillington Church 1834
Pencil and watercolour, 23.2 x 26.4
Inscr. upper left: *Tillington / Sepr 17 1834*
Trustees of the British Museum, London
(1888-2-15-49)
plate 223

33 (section V)
Hampstead Heath from near Well Walk
1834
Watercolour, 11.1 x 18
Inscr. verso: *Spring Clouds – Hail Squalls – April
12. 1834 – Noon Well Walk –*
The Board of Trustees of the Victoria and
Albert Museum, London (175-1888)
plate 226

34 (section V)
EXHIBITED LONDON ONLY
Old Sarum 1834
Watercolour and scraping-out, 30 x 48.7
Exh. RA 1834 (no. 481)
The Board of Trustees by the Victoria and
Albert Museum, London (1628–1888)
plate 229

35 (section V)
EXHIBITED WASHINGTON ONLY
Stonehenge 1836
Watercolour, 38.7 x 59.1
Exh. RA 1836 (no. 581)
Inscr. on artist's mount: *Stonehenge 'The myst-
erious monument of Stonehenge, standing remote
on a bare and boundless heath, as much uncon-
nected with the events of past ages as it is with the
uses of the present, carries you back beyond all his-
torical records into the obscurity of a totally
unknown period.'*
The Board of Trustees of the Victoria and
Albert Museum, London (1629-1888)
plate 230

RICHARD COOPER JNR
c. 1740 – *c.* 1814

36 (section I)
Landscape: Trees and Rocky Hills *c.* 1780
Pencil and wash with pen and brown ink on
laid paper (oval image on rectangular sheet),
37.5 x 53.2
Inscr. lower right on artist's mount: *R Cooper
delᵗ*
Leeds City Art Galleries (13.66/53)
plate 9

JOHN SELL COTMAN
1782–1842

37 (section I)
Brecknock *c.* 1801

Watercolour with gum arabic, scraping-out
and stopping-out, 37.6 x 54.6
Exh. RA 1801 (no. 311)
Private Collection
plate 43

38 (section I)
EXHIBITED LONDON ONLY
St Mary Redcliffe, Bristol: Dawn *c.* 1802
Pencil and watercolour, 38 x 53.5
Trustees of the British Museum, London
(1859-528-117)
plate 42

39 (section I)
*Bedlam Furnace, near Irongate,
Shropshire* 1802–3
Pencil and watercolour with scraping-out and
stopping-out, 26 x 48.6
Private Collection
plate 44

40 (section I)
EXHIBITED LONDON ONLY
Croyland Abbey, Lincolnshire *c.* 1804
Pencil and watercolour with scraping-out on
laid paper, 29.5 x 53.7
Inscr. lower right: *J. S. Cotman*
Exh. (?) NSA 1807 (no. 45)
Trustees of the British Museum, London
(1859-5-28-118)
plate 45

41 (section I)
York: The Water Tower 1804
Pencil and watercolour on laid paper,
22.3 x 43.2
Inscr. lower right: *J. S. Cotman 1804;* and
verso: *York*
Whitworth Art Gallery, University of
Manchester (D 1914-4)
plate 46

42 (section IV)
EXHIBITED LONDON ONLY
On the Greta (called 'Hell Cauldron')
c. 1806
Pencil and watercolour on laid paper,
43.7 x 33.9
Leeds City Art Galleries (16.2/55)
plate 173

43 (section IV)
EXHIBITED LONDON ONLY
The Drop-gate, Duncombe Park *c.* 1806
Pencil and watercolour on laid paper, 33 x 23
Trustees of the British Museum, London
(1902-5-14-14)
plate 174

44 (section IV)
EXHIBITED LONDON ONLY
Duncombe Park, Yorkshire *c.* 1806
Pencil and watercolour on laid paper, 33 x 23
Trustees of the British Museum, London
(1902-5-14-13)
plate 171

45 (section IV)
EXHIBITED WASHINGTON ONLY
In Rokeby Park *c.* 1806
Pencil and watercolour on laid paper,
32.9 x 22.9
Yale Center for British Art, New Haven, Paul
Mellon Collection (B 1977.14.4671)
plate 176

46 (section IV)
EXHIBITED WASHINGTON ONLY
*River Landscape (Probably on the Greta,
Yorkshire)* *c.* 1806
Pencil and watercolour, 27.3 x 40
Mellon Bank Corporation, Pittsburgh
plate 179

47 (section IV)
Chirk Aqueduct 1806–7
Pencil and watercolour on laid paper,
31.5 x 23.1
The Board of Trustees of the Victoria and
Albert Museum, London (115-1892)
plate 175

48 (section IV)
EXHIBITED LONDON ONLY
Greta Bridge *c.* 1807
Pencil and watercolour, 22.7 x 32.9
Trustees of the British Museum, London
(1902-5-14-17)
plate 172

49 (section IV)
EXHIBITED WASHINGTON ONLY
Norwich: The Cow Tower *c.* 1807
Pencil and watercolour on laid paper, 35 x 26.5
Private Collection
plate 178

50 (section IV)
EXHIBITED WASHINGTON ONLY
A Shady Pool 1807
Pencil and watercolour on laid paper,
45.4 x 35.2
National Galleries of Scotland, Edinburgh
(DNG 1136)
plate 177

51 (section IV)
EXHIBITED LONDON ONLY
A Ploughed Field *c.* 1808
Pencil and watercolour, 22.8 x 35
Leeds City Art Galleries (508/23)
plate 180

52 (section II)
Norwich Market Place *c.* 1809
Watercolour, 40.6 x 64.8
Engr. in aquatint by Freeman *c.* 1809; later
lithographed by Henry Ninham
Exh. (?) NSA 1809 (no. 208)
The Tate Gallery, London, Presented by
Francis E. Halsey 1933 (N 05636)
plate 73

53 (section VI)
The Harvest Field, A Pastoral *c.* 1810
Pencil and watercolour with gum arabic,
53.7 x 70.7
Exh. NSA 1810 (no. 124)
Leeds City Art Galleries (1.6/39)
plate 286

54 (section II)
*Interior of Walsoken Church, Norfolk: The
Chancel, North Arcade* *c.* 1811
Pencil and watercolour, 25 x 32.5
Inscr. top left: *Very grey* and *This zig-zag more
to the left;* lower left: *?Walsoken;* lower right:
J. S. Cotman

A finished watercolour of this subject dated 1830 (Christie, 29 March 1983, lot 128), was engr. by Cotman for *A series of etchings illustrative of the Architectural Antiquities of Norfolk*, 1818
Birmingham Museums and Art Gallery (147'22)
plate 84

55 (section IV)
EXHIBITED LONDON ONLY
Domfront 1823
Pencil and watercolour, reed pen and brown ink with scraping-out, 29.5 x 41.6
Inscr. lower left: *J. S. Cotman / 1823*
Courtauld Institute Galleries, London (Spooner Bequest 1967)
plate 188

56 (section IV)
EXHIBITED LONDON ONLY
Dieppe Harbour 1823
Pencil, watercolour and bodycolour, reed pen and brown ink with scraping-out, 28.7 x 53.2
Inscr. lower left: *J. S: Cotman 1823*
The Board of Trustees of the Victoria and Albert Museum, London (P 26-1934)
plate 189

57 (section IV)
Street Scene at Alençon 1828
Pencil and watercolour with bodycolour, 42.8 x 57.8
Inscr. lower right: *J. S. Cotman 1828*
Exh. NSA 1828 (no. 163)
Birmingham Museums and Art Gallery (28'08)
plate 187

58 (section IV)
Mont St Michel 1828
Pencil, watercolour and bodycolour with scraping-out, 29.2 x 54.3
Inscr. lower right: *J. S. Cotman/1828*
Exh. (?)NSA 1829 (no.159)
Manchester City Art Galleries (1917-72)
plate 190

59 (section V)
The Shepherd on the Hill 1831
Watercolour, 23 x 33.6
Inscr. lower left: *JS Cotman 1831*
Trustees of the National Museums and Galleries on Merseyside Walker, Art Gallery (154)
plate 245

60 (section V)
Study of Sea and Gulls 1832
Watercolour and bodycolour with pen and black ink, and scraping-out, 23.3 x 29.8
Inscr. lower left: *J. S. Cotman – 1832*
The Board of Trustees of the Victoria and Albert Museum, London (P. 17-1973)
plate 244

61 (section V)
On the Downs c. 1840
Watercolour with stopping-out, 23.5 x 33
Inscr. lower left: *Cotman*
Private Collection
plate 243

DAVID COX 1783–1859

62 (section IV)
Pembroke Castle c. 1810
Pencil and watercolour on laid paper with stopping-out, 44.9 x 60.3
Private Collection
plate 200

63 (section III)
Two Studies of Plants:
(a) Dock Plants c. 1815–20
Watercolour, 19 x 14.5
(b) Plants by a Brick Culvert c. 1815–20
Watercolour, 14 x 16.9
Birmingham Museums and Art Gallery (681-682'27)
plates 139, 138

64 (section IV)
Cader Idris, with Women Washing Clothes in a Stream in the Foreground c. 1820
Pencil and watercolour with bodycolour, gum arabic, stopping-out and scraping-out, 52 x 82
Exh. (?)OWCS 1820 (no. 362)
Abbott and Holder, London
plate 209

65 (section VI)
Pastoral Scene in Herefordshire (?)1824
Watercolour with gum arabic, stopping-out and scraping-out, 73.6 x 106.7
Exh. (?)OWCS 1824 (no. 65, as *Shepherds Collecting their Flocks – Evening, from Scenery in Herefordshire*)
Private Collection, Courtesy Agnew's, London
plate 297

66 (section VI)
Carthage: Aeneas and Achates 1825
Watercolour and bodycolour with gum arabic, stopping-out and scraping-out, 76 x 116
Exh. OWCS 1825 (no. 107, as *Carthage – Aeneas and Achates, 'they climb the next ascent, and looking down …', Eneid, Book I*)
Birmingham Museums and Art Gallery (1985.P.31)
plate 296

67 (section III)
Studies of a Seagull in Flight c. 1825–30
Pencil, watercolour and bodycolour, 18.6 x 14
Birmingham Museums and Art Gallery (38'31)
plate 143

68 (section II)
Paris: (?) A Street in the Marais c. 1829
Pencil and watercolour, 34 x 25
Inscr. on building at right: *No 233 /… No. 253*
Birmingham Museums and Art Gallery (P 30'48)
plate 100

69 (section II)
Rouen: Tour d'Horloge 1829
Pencil and watercolour, 34.3 x 25.7
The Tate Gallery, London, Presented by the National Art Collections Fund (Herbert Powell Bequest) 1967 (T 00977)
plate 101

70 (section III)
Still-life c. 1830
Black chalk and watercolour, 17.2 x 22.2
The Tate Gallery, London, Bequeathed by

J. R. Holliday 1927 (N 04307)
plate 151

71 (section IV)
The Hayfield c. 1832
Watercolour with stopping-out, 15.3 x 24.7
University of Liverpool Art Gallery and Collections, Sir Sydney Jones Collection (210)
plate 208

72 (section III)
Landscape with Sunset (?) c. 1835
Pencil and watercolour on coarse off-white paper, 25.5 x 37.9
Private Collection
plate 124

73 (section VI)
EXHIBITION WASHINGTON ONLY
Lancaster: Peace and War 1842
Watercolour and gum arabic, 49.7 x 76
Exh. OWCS 1842 (no. 33)
Art Institute of Chicago, Gift of Dr William D. Shorey, H. Karl and Nancy von Maltitz Endowment (1990.144)
plate 314

74 (section V)
Barmouth Road c. 1850
Black chalk and watercolour with scraping-out, 16.5 x 25
Lent by the Syndics of the Fitzwilliam Museum, Cambridge (1272)
plate 231

75 (section V)
A Train near the Coast c. 1850
Pencil and watercolour, 26.9 x 37.2
National Museum of Wales, Cardiff (3036)
plate 234

76 (section V)
'An Impression': The Crest of a Mountain c. 1853
Black chalk and watercolour, 27 x 38
Birmingham Museums and Art Gallery (329'25)
plate 232

77 (section V)
The Beach at Rhyl 1854
Pencil and watercolour, 25.4 x 36.9
Inscr. lower left: *David Cox. 1854*
University of Liverpool Art Gallery and Collections, Sir Sydney Jones Collection (209)
plate 233

78 (section VI)
The Challenge: A Bull in a Storm on a Moor c. 1856
Watercolour with bodycolour and scraping-out, 45.4 x 64.8
Inscr. verso: *on the Moors near Bettws y Coed – N.W.*
Exh. (?) OWCS 1856 (no. 179)
The Board of Trustees of the Victoria and Albert Museum, London (1427–1869)
plate 315

ALEXANDER COZENS
c. 1717–1786

79 (section I)
Figures by a Pool below a Fortress in an

Italianate Landscape c. 1765
Brown and black washes with some bodycolour on laid paper, varnished, 48.5 x 65
Inscr. upper right: *1*
Hazlitt, Gooden & Fox, London
plate 4

80 (section I)
The Prophet Elijah Fed by Ravens c. 1765
Pen and black and brown washes on laid paper, 48 x 68.5
Private Collection, through Hazlitt, Gooden & Fox, London
plate 3

81 (section I)
A Villa by a Lake (?) c. 1770
Pencil, brown and black washes on laid paper, 15 x 19.1
Inscr. on artist's washline mount, lower left *Alex.r Cozens.*
Agnew's, London
plate 7

82 (section I)
EXHIBITED LONDON ONLY
Mountain Peaks c. 1785
Brown and black washes on pale buff, prepared laid paper, 22.9 x 30.3
Inscr. on artist's washline mount lower left: *Alexr Cozens*
Engr. in etching and aquatint for *A New Method of Assisting the Invention in Drawing Original Compositions of Landscape*, 1785–6, Blot no. 2
Trustees of the British Museum, London (1928-4-17-4)
plate 1

83 (section I)
A Rocky Island c. 1785
Pen and brown ink and wash on tinted laid paper, 46.3 x 62.4
Whitworth Art Gallery, University of Manchester (D 1926-26)
plate 2

84 (section I)
Mountain Landscape with a Hollow c. 1785
Watercolour with pen and brown ink and gum arabic on laid paper, 23 x 30.3
Inscr. upper right: *13*
This drawing is a version of Blot drawing no. 13 in *A New Method*, 1785–6
National Gallery of Art, Washington DC, Ailsa Mellon Bruce Collection (1984.68.1)
plate 5

JOHN ROBERT COZENS
1752–1797

85 (section I)
EXHIBITED LONDON ONLY
The Reichenbach between Grindelwald and Oberhaslital c. 1776
Pen and brown ink and grey wash on laid paper, 23.2 x 35.5
Trustees of the British Museum, London (1900-4-11-14)
plate 25

86 (section I)
Cavern in the Campagna 1778
Pencil and watercolour on laid paper, 38.1 x 50.8

Inscr. on artist's washline mount lower left: *Jn° Cozens. Rome. 1778*
The Board of Trustees of the Victoria and Albert Museum, London (P. 6-1986)
plate 29

87 (section I)
Interior of the Colosseum 1778
Pencil and watercolour on laid paper, 36.1 x 51.6
Inscr. lower left on artist's washline mount: *Jn° Cozens Rome 1778*
Leeds City Art Galleries (13.92/53)
plate 26

88 (section I)
EXHIBITED LONDON ONLY
Ruins of Paestum, near Salerno: The Three Temples c. 1782
Pencil and watercolour with pen and black ink on laid paper, 25.5 x 37
Oldham Art Gallery
plate 30

89 (section I)
EXHIBITED LONDON ONLY
The Two Great Temples at Paestum c. 1782
Pencil and watercolour with pen and black ink on laid paper, 25.5 x 37
Oldham Art Gallery
plate 31

90 (section I)
Entrance to the Valley of the Grande Chartreuse in the Dauphiné c. 1783
Watercolour, 26.2 x 37.3
Inscr. on verso: *Approach to the Grand Chartreuse in Dauphiny*
The Visitors of the Ashmolean Museum, Oxford
plate 28

91 (section I)
Florence from a Wood near the Cascine, c. 1785
Pencil and watercolour on laid paper, 26.2 x 36.8
Private Collection
plate 32

92 (section I)
Lake Albano and Castel Gandolfo c. 1790
Watercolour, 44.1 x 62.2
Leeds City Art Galleries (846/28)
plate 33

93 (section I)
EXHIBITED LONDON ONLY
Lake Albano and Castel Gandolfo – Sunset c. 1790
Pencil and watercolour on laid paper, 43 x 62
Stamped lower left by Thomas Lawrence: *TL* (monogram)
Private Collection, UK
plate 34

94 (section I)
Cetara, on the Gulf of Salerno 1790
Pencil and watercolour, 36.5 x 52.5
Inscr. on artist's washline mount (removed): *Jn° Cozens. 1790*
National Gallery of Art, Washington DC, Gift in honor of Paul Mellon by the Patrons' Per-

manent Fund, with additional support from Dick and Ritchie Scaife, Catherine Mellon Conover, Rachel Mellon Walton, Mr and Mrs James M. Walton and an anonymous donor (1992.19.1)
plate 27

JOSHUA CRISTALL 1768–1847

95 (section III)
EXHIBITED LONDON ONLY
Study of a Beech-tree Stem 1803
Pencil and watercolour, 23.4 x 14.9
Inscr. lower right: *J. Cristall 1803.*
Trustees of the British Museum, London (1876-12-9-1043)
plate 131

96 (section III)
Study of a Skate 1807
Pencil and watercolour on laid paper, 25.5 x 15.2
Inscr. on lower right-hand edge of sheet: *J. Cristall 1807 Hastings*
Hereford City Museum and Art Gallery (227)
plate 144

97 (section IV)
EXHIBITED LONDON ONLY
Coast Scene: The Beach at Hastings, with a Fleet in the Distance c. 1814
Watercolour, 38.4 x 65.7
Exh. OWCS 1814 (no. 117, as *Fleet sailing up Channel off Hastings*)
National Galleries of Scotland, Edinburgh (482)
plate 192

98 (section IV)
EXHIBITED WASHINGTON ONLY
The Grove of Accademia – Plato Teaching 1820
Watercolour with stopping-out, 29.9 x 39.7
Inscr. lower right: *J. Cristall / 1820 –*
Exh. OWCS 1821 (no. 7, as *Instruction – A Composition*)
National Galleries of Scotland, Edinburgh (DNG 476)
plate 215

99 (section VI)
A Woman Spinning ('Bessy and her Spinning Wheel') 1824
Watercolour on paper, 51.8 x 60
Inscr. lower right: *J. Cristall 1824*
Exh. OWCS 1824 (no. 232, as *Bess and her Spinning Wheel, 'I'll sit me down and sing and spin...', Vide Burns.*)
Hereford City Museum and Art Gallery (1176)
plate 289

100 (section VI)
Nymphs and Shepherds Dancing c. 1825
Pencil and watercolour with stopping-out and sponging-out, 79.5 x 112.5
Hereford City Museum and Art Gallery (583)
plate 288

FRANCIS DANBY 1793–1861

101 (section IV)
The Avon at Clifton c. 1821
Pencil, watercolour and bodycolour, 12.9 x 21.7

Inscr. lower left: *F. DANBY*
Bristol City Museums and Art Gallery (K 4658)
plate 194

102 (section IV)
The Avon from Durdham Down c. 1821
Watercolour and bodycolour, 12.7 x 19.7
Inscr. lower left: *F. DANBY*
Bristol City Museums and Art Gallery (K 4659)
plate 196

103 (section IV)
The Frome at Stapleton, Bristol c. 1823
Pencil, watercolour and bodycolour, 14.6 x 21.5
Inscr. lower left: *F. DANBY*
Bristol City Museums and Art Gallery (K 195)
plate 195

104 (section IV)
An Ancient Garden 1834
Watercolour and bodycolour, 17.4 x 25.7
Bristol City Museums and Art Gallery (K 4654)
plate 197

WILLIAM DANIELL 1769–1837

105 (section II)
Windsor 1827
Pencil and watercolour with scraping-out, 30.5 x 30.5
Inscr. lower left: *W. DANIELL / 1827*
National Museum of Wales, Cardiff (431 a)
plate 93

EDWARD DAYES 1763–1804

106 (section II)
Queen Square, London 1786
Watercolour, 37.2 x 53.2
Inscr. lower left: *E Dayes / 1786*
Engr. in aquatint by Dodd and Pollard, 1 July 1789, as one in a set of four London Squares.
Yale Center for British Art, New Haven, Paul Mellon Collection (B 1977.14.4639)
plate 66

JAMES DEACON c. 1728–1750

107 (section I)
Landscape Fantasy 1740–3
Pencil and watercolour with pen and black ink and varnish on laid paper, 22.0 x 23.5
Inscr. verso: *James Deacon fecit / 1743 / Drawn by Jm.ˢ Deacon / 1740*
Private Collection
plate 13

108 (section I)
Rocky Landscape with Classical Buildings 1745–50
Pencil and watercolour with pen and black ink on laid paper, 18.3 x 23.2
Yale Center for British Art, New Haven, Paul Mellon Collection (B 1977.14.5653)
plate 15

PETER DE WINT 1784–1849

109 (section IV)
Lincoln: The Devil's Hole c. 1810
Pencil and watercolour with scraping-out, 38.7 x 51.5
Private Collection
plate 181

110 (section II)
Winchester Gateway c. 1810–15
Watercolour, 51 x 68.6
The Trustees of the Cecil Higgins Art Gallery, Bedford (P 706)
plate 82

111 (section III)
EXHIBITED WASHINGTON ONLY
Plants by a Stream c. 1810–15
Watercolour with scraping-out, 26.1 x 33.1
National Galleries of Scotland, Edinburgh (D 4700)
plate 137

112 (section IV)
EXHIBITED LONDON ONLY
Yorkshire Fells c. 1812
Pencil and watercolour with gum arabic, 36.3 x 56.6
Lent by the Syndics of the Fitzwilliam Museum, Cambridge (PD 130-1950)
plate 182

113 (section III)
EXHIBITED LONDON ONLY
Harvesters Resting c. 1820
Pencil and watercolour with gum arabic, 32.4 x 34
Lent by the Syndics of the Fitzwilliam Museum, Cambridge (1583)
plate 129

114 (section III)
EXHIBITED LONDON ONLY
Still-life with a Ginger Jar and Mushrooms (?) c. 1820
Pencil and watercolour, 21.5 x 29.2
Trustees of the British Museum, London (1890-5-12-61)
plate 152

115 (section VI)
Lincoln Cathedral from the River c. 1825
Watercolour and scraping-out, 49.5 x 69.8
Lincolnshire County Council: Usher Art Gallery, Lincoln (U.G. 2270)
plate 284

116 (section VI)
Cookham on Thames (?) c. 1830
Watercolour with scraping-out, 46.7 x 74.6
University of Liverpool Art Gallery and Collections, Sir Sydney Jones Collection (222)
plate 285

117 (section IV)
Torksey Castle (Study) c. 1835
Pencil and watercolour, 29.8 x 46.6
Lincolnshire County Council: Usher Art Gallery, Lincoln (U.G.71/88)
plate 185

118 (section IV)
Torksey Castle, Lincolnshire c. 1835
Pencil and watercolour with scraping-out, 46 x 77

Exh. owcs 1835 (no. 31)
Lincolnshire County Council: Usher Art Gallery, Lincoln (u.g.86/13)
plate 186

119 (section V)
Mountain Scene, Westmorland c. 1840
Watercolour, 29.2 x 45.5
Lent by the Syndics of the Fitzwilliam Museum, Cambridge (pd 135-1950)
plate 235

120 (section V)
View near Bangor, North Wales: Penrhyn Castle with Penmaenmawr beyond
(?) c. 1840
Pencil and watercolour, 29.5 x 46.5
Private Collection
plate 237

121 (section V)
Trees at Lowther, Westmorland
c. 1840-5
Pencil and watercolour, 44.5 x 57.7
Private Collection
plate 238

122 (section V)
Clee Hill, Shropshire (?) c. 1845
Watercolour, 38.1 x 52.7
Private Collection
plate 236

JOHN DOWNMAN 1750-1824

123 (section III)
View over Nice out of my Window 1773
Pencil and watercolour with pen and black ink on laid paper, 26.5 x 36.5
Inscr. top left: *City of Nice Dec.ʳ 20th. 1773*; lower right: *View of the Tops of Buildings / from my Bed Room window in the City of Nice on a bad Day / 1773 J.D*
Private Collection
plate 110

124 (section III)
A Tree-trunk near Albano 1774
Watercolour with pen and black ink on laid paper, 54 x 36.5
Inscr. lower left: *in the Wood near Albano 1774 by Jᵒ D*
Private Collection
plate 130

WILLIAM DYCE 1806-1864

125 (section III)
Tryfan, Snowdonia 1860
Watercolour, 22.8 x 34.9
The Visitors of the Ashmolean Museum, Oxford
plate 163

HENRY EDRIDGE 1769-1821

126 (section II)
Old Houses, with a Castellated Wall
c. 1810
Pencil and watercolour on laid paper, 26 x 21.3
Private Collection
plate 80

ANTHONY VANDYKE COPLEY FIELDING 1787-1855

127 (section IV)
Landscape with Limekiln 1809
Pencil and watercolour with gum arabic and scraping-out, 23.2 x 32.1
Inscr. lower left: *C.V.F. 1809*
Yale Center for British Art, New Haven, Paul Mellon Collection (b 1977.14.4678)
plate 199

128 (section IV)
Shakespeare's Cliff, near Dover
(?) c. 1830
Watercolour with scraping-out, 44 x 55.7
Inscr. on verso: *View from the Top of Skakespeare's Cliff near Dover with Fokestone in the middle distance. Extreme distance is Fairlight Down above Hastings, Sussex.*
Exh. (?) owcs 1846 (no. 290)
Private Collection, Courtesy Martyn Gregory Gallery
plate 207

129 (section VI)
View of Snowdon from the Sands of Traeth Mawr, Taken at the Ford between Pont Aberglaslyn and Tremadoc 1834
Pencil, watercolour and bodycolour with gum arabic and scraping-out, 64.7 x 92
Inscr. lower right: *Copley Fielding 1834*
Exh. owcs 1834 (no. 93)
Yale Center for British Art, New Haven, Paul Mellon Collection (b.1977.14.4640)
plate 281

FRANCIS OLIVER FINCH
1802-1862

130 (section IV)
Religious Ceremony in Ancient Greece
c. 1835
Watercolour and bodycolour with gum arabic and scraping-out, 46.8 x 64.7
Yale Center for British Art, New Haven, Paul Mellon Collection (b 1975.3.1245)
plate 213

131 (section IV)
Arcadia (?) c. 1840
Watercolour and gum arabic with scraping-out and stopping-out, 23.7 x 31
The Visitors of the Ashmolean Museum, Oxford (1952.82)
plate 204

MYLES BIRKET FOSTER
1825-1899

132 (section VI)
Highland Scene near Dalmally 1885
Watercolour and bodycolour with scraping-out, 73.7 x 124.5
Inscr. lower left *bf* (monogram), and verso with artist's name and address
Exh. owcs 1885-6 (no. 88)
Private Collection, Courtesy Peter Nahum, London
plate 316

THOMAS GAINSBOROUGH
1727-1788

133 (section I)
Wooded Landscape with Shepherd and Sheep c. 1780
Pen and black ink and wash, with white chalk on laid paper, 28 x 36.5
Private Collection
plate 11

134 (section I)
Figures in a Wooded Landscape
c. 1785
Black and white chalk and grey wash on laid paper, 26.6 x 39
Private Collection, Courtesy the Leger Galleries, London
plate 12

HENRY GASTINEAU
1791-1876

135 (section VI)
Carrick-y-Rede, Antrim 1839
Watercolour and bodycolour with scraping-out and stopping-out, 62.5 x 82
Inscr. lower left: *H Gastineau delᵗ / 1839*
Exh. owcs 1839 (no. 101)
Birmingham Museums and Art Gallery (47'23)
plate 301

WILLIAM GILPIN 1724-1804

136 (section I)
Landscape with Ruined Castle c. 1790
Black chalk, with pen and black ink and grey and brown washes, 36.1 x 26.9
Lower right: artist's blind stamp wg (monogram)
Lent by the Syndics of the Fitzwilliam Museum, Cambridge (no. 1355)
plate 8

137 (section I)
A View into a Winding Valley c. 1790
Pencil and grey wash, 27.5 x 36.9
Lower right: blind stamp wg (monogram); inscr. on a piece of paper mounted with the drawing: *A view into a winding valley. / The high ground, on ye right, is a / part of one of ye side-skreens; & / ye inlightened ground, on ye left is / a part of ye other. The valley winds / round a knoll with a castle upon / it, just touched with light; & goes / off between ye mountains.*
Leeds City Art Galleries (5.111/52)
plate 6

THOMAS GIRTIN 1775-1802

138 (section IV)
EXHIBITED LONDON ONLY
Coast of Dorset near Lulworth Cove
c. 1798
Pencil and watercolour on laid paper, 38 x 28
Leeds City Art Galleries (16/35)
plate 170

139 (section II)
Lindisfarne c. 1798
Pencil and watercolour on laid paper, 41 x 28.7

Lent by the Syndics of the Fitzwilliam Museum, Cambridge (1608)
plate 76

140 (section III)
EXHIBITED LONDON ONLY
Near Beddgelert, North Wales c. 1798
Watercolour on laid paper, 29 x 43.2
Stamped lower right Chambers Hall: ch (monogram)
Trustees of the British Museum, London (1855-2-14-52)
plate 114

141 (section I)
Hawes, Yorkshire 1800
Pencil and watercolour on laid paper, 36.1 x 31.9
Inscr. lower left on river-bank: *Girtin 1800*
Birmingham Museums and Art Gallery (i'10)
plate 36

142 (section IV)
EXHIBITED WASHINGTON ONLY
The Village of Jedburgh, Roxburghshire
1800
Watercolour on laid paper, 30.1 x 51.1
Inscr. lower left: *Girtin 1800*
National Galleries of Scotland, Edinburgh
plate 166

143 (section IV)
The White House at Chelsea 1800
Watercolour on laid paper, 29.8 x 51.4
Inscr. near base of windmill: *Girtin 1800*
The Tate Gallery, London, Bequeathed by Mrs Ada Montefiori 1933 (n 04728)
plate 168

144 (section I)
EXHIBITED WASHINGTON ONLY
A Village Street and Church with Spire
1800
Pencil and watercolour on laid paper, 31.6 x 12.5
Inscr. lower left: *Girtin 1800*
Whitworth Art Gallery, University of Manchester (d 1892-111)
plate 37

145 (section I)
EXHIBITED WASHINGTON ONLY
Richmond Castle, Yorkshire 1800
Watercolour, 32.2 x 47.2
Inscr. lower right: *Girtin 1800*
Leeds City Art Galleries (503/23)
plate 38

146 (section IV)
Jedburgh Abbey from the South-east
c. 1800
Watercolour with some pen on laid paper, 42.4 x 55.5
Inscr. lower right: *Girtin*
Private Collection
plate 167

147 (section IV)
Kirkstall Abbey, Yorkshire: Evening
c. 1800-1

Watercolour on laid paper, 31.7 x 52
The Board of Trustees of the Victoria and
Albert Museum, London (405-1885)
plate 169

148 (section II)
EXHIBITED LONDON ONLY
London: The Albion Mills *c.* 1801
Pencil and watercolour on laid paper,
32.7 x 53.9
Stamped lower left by Chambers Hall: CH
(monogram)
Trustees of the British Museum, London
(1855-2-14-24)
plate 78

149 (section II)
EXHIBITED LONDON ONLY
*London: The Thames from Westminster to
Somerset House* *c.* 1801
Watercolour on laid paper, 24 x 53.9
Stamped lower right by Chambers Hall: CH
(monogram)
Trustees of the British Museum, London
(1855-2-14-27)
plate 77

150 (section I)
Ilkley, Yorkshire, from the River Wharfe
c. 1801
Pencil and watercolour on laid paper,
30.5 x 51.8
Inscr. verso: *Mr Lascelles*
Leeds City Art Galleries (5.113/52)
plate 39

151 (section II)
Paris: Rue St Denis 1801-2
Pencil and watercolour, 39.4 x 48.9
Etched in soft-ground by Girtin in 1802 as a
more distant view entitled *View of the Gate of
St. Denis, taken from the Suburbs,* for *Twenty of
the Most Picturesque Views of Paris,* and later
aquatinted by F.C. Lewis
Private Collection
plate 79

152 (section I)
EXHIBITED LONDON ONLY
Bridgnorth, Shropshire 1802
Watercolour, 62.3 x 94.6
Inscr. below, centre: *Girtin 1802*
Trustees of the British Museum, London
(1840-6-9-75)
plate 41

153 (section IV)
Storiths Heights, Wharfedale, Yorkshire
c. 1802
Watercolour on laid paper, 28.3 x 41.8
Private Collection
plate 165

154 (section I)
Morpeth Bridge *c.* 1802
Pencil and watercolour with some pen,
31.4 x 52.7
Laing Art Gallery, Newcastle upon Tyne
(Tyne and Wear Museums)
plate 40

JOHN GLOVER 1767–1849

155 (section IV)
A Scene in Italy *c.* 1820
Watercolour, 29 x 41.5
Private Collection
plate 211

ALBERT GOODWIN
1845–1932

156 (section VI)
Near Winchester 1864
Pencil and watercolour with bodycolour,
14.9 x 12.1
Inscr. lower left: *AG* (monogram) / *64*
Private Collection, Courtesy Peter Nahum,
London
plate 319

157 (section VI)
Old Mill, near Winchester 1875
Watercolour and pen and ink with bodycolour,
22.2 x 31.7
Inscr. lower right: *AG* (monogram) *1[8]75*
Chris Beetles
plate 320

JAMES DUFFIELD
HARDING 1797–1863

158 (section VI)
Modern Greece 1828
Watercolour with some bodycolour and scrap-
ing-out, 74.9 x 100
Exh. RA 1828 (no. 159, as *Modern Greece, 'And
many a summer flower is there…', Childe Harold*)
The Sudeley Castle Collection
plate 293

WILLIAM HAVELL 1782–1857

159 (section IV)
*Classical Figures in a Mountainous
Landscape (Moel Siabod)* 1805
Pencil and watercolour with scraping-out,
60.3 x 51.1
Inscr. lower left: *W HAVELL 1805*
Exh. OWCS 1805 (no. 252, as *Moel Siabod, North
Wales;* or no. 23 or 145, both titled *A Composi-
tion*)
Reading Museum and Art Gallery
(358.72)
plate 210

160 (section IV)
EXHIBITED LONDON ONLY
Windermere 1811
Watercolour with scraping-out and stopping-
out, 24.8 x 34.0
Inscr. below centre:
W HAVELL / 1811
Exh. OWCS 1811 (no. 12)
Trustees of the British Museum, London
(1859-5-28-140)
plate 201

161 (section IV)
*View on the Brathay near Ambleside,
Westmorland* 1828
Bodycolour on card, 35.5 x 50.9
Inscr. lower right on rock: *W. Havell/1828*

Although engr. by F.J. Havell under the pre-
sent title, this subject has recently been identi-
fied as *Wetherlam from Little Langdale*
Reading Museum and Art Gallery (279.73)
plate 203

THOMAS HEAPHY 1775–1835

162 (section VI)
Fish Market, Hastings 1809
Watercolour, with some bodycolour and
scraping-out, 69.8 x 90.2
Exh. OWCS 1809 (no. 22)
Private Collection
plate 283

THOMAS HEARNE 1744–1817

163 (section II)
Edinburgh Castle from Arthur's Seat
c. 1778
Pencil and watercolour, 35.6 x 50.8 cm
Inscr. lower left: *Hearne*
The Tate Gallery London; Presented by
Frederick John Nettlefold 1947 (N 05792)
plate 64

ROBERT HILLS 1769–1844

164 (section III)
Two Studies of Skies, at Windsor *c.* 1810
Pencil and watercolour, 23.5 x 19
Inscr. lower right: *July 28th Windsor Forest.
8 Evening A… [shorthand notes] …C…;*
and *A, A, C* in drawing
Lent by the Syndics of the Fitzwilliam
Museum, Cambridge (1377)
plate 123

165 (section III)
Sheet of Studies of Country Childen
c. 1815
Pencil and watercolour, 30.2 x 22.2
Lent by the Syndics of the Fitzwilliam
Museum, Cambridge (1564d)
plate 128

166 (section IV)
A Village Snow-scene 1819
Pencil and watercolour with bodycolour and
scraping-out, 32.4 x 42.5
Inscr. lower right: *R. Hills 1819*
Yale Center for British Art, New Haven, Paul
Mellon Collection (B 1977.14.4907)
plate 184

167 (section IV)
EXHIBITED LONDON ONLY
The Turnip Field 1819
Watercolour and bodycolour, 29.2 x 41.3
Inscr. lower right: *R. Hills 1819*
Oldham Art Gallery (9.88/11)
plate 183

168 (section III)
Farm Buildings (?)*c.* 1815
Pencil and watercolour, 33 x 18.4
Inscr. in shorthand above cottage
Lent by the Syndics of the Fitzwilliam
Museum, Cambridge (1369)
plate 154

HENRY GEORGE HINE
1811–1895

169 (section VI)
*Amberley Castle, Sussex, Seen from
the Marshes* 1867
Watercolour and bodycolour with
scraping-out, 26 x 57.2
Inscr. lower right: *HG HINE 1867*
Exh. NWCS 1867 (no. 141)
Christopher and Jenny Newall
plate 323

170 (section VI)
*Nine Barrow Down near Swanage,
Dorset* *c.* 1875
Pencil, watercolour and scraping-out, 50 x 89
Inscr. lower left: *HG HINE*
Abbott and Holder, London
plate 325

JAMES HOLLAND 1799–1870

171 (section II)
Villa do Conde, near Oporto, Portugal
1837
Pencil and watercolour with bodycolour,
29.9 x 43.2
Inscr. lower right: *JH* (monogram) *Villa de
Conde / Sept 2d*
Exh. (?) OWCS 1838 (no. 141, as *Convent of
Santa Clara, at Ville de Conde, near Oporto*)
The Board of Trustees of the Victoria and
Albert Museum, London (FA 30)
plate 95

172 (section V)
*View in North Wales: Arenig, with
Snowdon Beyond* 1852
Pencil, watercolour and bodycolour,
37.3 x 53.6
Inscr. lower right: *JH* [monogram] *N W Octr
19th 52*
Bill Thomson, Albany Gallery, London
plate 247

ALFRED WILLIAM HUNT
1830–1896

173 (section V)
EXHIBITED LONDON ONLY
*The Tarn of Watendlath between Derwent-
water and Thirlmere* 1858
Watercolour with bodycolour and scraping-
out, 32.2 x 49.2
Inscr. lower left: *A. W. Hunt/1858*
Trustees of the British Museum, London
(1969-9-20-1)
plate 254

174 (section V)
Near Abergele, Wales (?) *c.* 1860
Watercolour with scraping-out, 23 x 32
Chart Analysis Ltd
plate 253

175 (section VI)
*Travelling Cranes, Diving Bells, etc. on the
Extremity of Tynemouth Pier* *c.* 1867
Watercolour with scraping-out, 31.8 x 26.7
Exh. OWCS 1867 (no. 274)
Christopher and Jenny Newall
plate 318

176 (section VI)
Naples, or Land of Smouldering Fire
1871
Watercolour with bodycolour, sponging and
scraping-out, 49 x 75
Inscr. lower right: *A W Hunt 1871*
Exh. owcs 1871 (no. 70)
Chart Analysis Ltd
plate 326

177 (section VI)
Whitby (?) *c.* 1878
Watercolour with scraping-out, 38.5 x 56
Chart Analysis Ltd
plate 324

WILLIAM HENRY HUNT
1790–1864

178 (section II)
Old Bell Yard, Bushey c. 1815
Pencil and watercolour with pen and brown
ink, 50.8 x 68.4
The Trustees of the Cecil Higgins Art Gallery,
Bedford (P 109)
plate 81

179 (section III)
*Still-life with Earthenware Pitcher, Coffee
Pot and Basket c.* 1825
Pencil and watercolour with bodycolour,
17.0 x 25
Inscr. lower right: *W. HUNT*
The Visitors of the Ashmolean Museum,
Oxford (RUD 59)
plate 153

180 (section VI)
Preparing for Sunday c. 1832
Watercolour and bodycolour with scraping-
out, 33.7 x 43.6
Inscr. lower right: *W. HUNT*
Harris Museum and Art Gallery, Preston
(P 1273)
plate 306

181 (section VI)
The Kitchen Maid c. 1833
Pencil, watercolour and bodycolour with
scraping-out, 47.9 x 58.5
Inscr. lower right: *W. HUNT*, and again on sack
City of Nottingham Museums: Castle
Museum and Art Gallery (1957.38)
plate 304

182 (section VI)
Jug with Plums and Rosehips c. 1840
Watercolour and bodycolour, 39.1 x 28.3
Inscr. lower right: *W. HUNT*
The Board of Trustees of the Victoria and
Albert Museum, London (1926–1900)
plate 305

183 (section VI)
Primroses with Bird's Nest c. 1850
Watercolour and bodycolour, 28 x 22.9
Inscr. lower right: *W. HUNT*
The Robertson Collection, Orkney, Courtesy
Peter Nahum, London
plate 307

184 (section III)
An Oyster Shell and an Onion c. 1859
Watercolour and bodycolour, 12.2 x 16.5
Inscr. lower right: *W. HUNT*

Exh. owcs 1859 (no. 226, as 'Painted for
J. Ruskin, Esq.')
Private Collection
plate 150

WILLIAM HOLMAN HUNT
1827–1910

185 (section V)
Fishing-boats by Moonlight c. 1869
Pencil, watercolour and some bodycolour,
40.5 x 55.8
Inscr. lower left: *WHH* (monogram)
The Trustees of the Cecil Higgins Art Gallery,
Bedford (P 351)
plate 271

SAMUEL JACKSON 1794–1869

186 (section IV)
*Mother Pugsley's Well, looking towards
Somerset Street, Kingsdown* 1823
Pencil and watercolour, 22.3 x 19.7
Bristol City Museums and Art Gallery
(M 964)
plate 193

187 (section IV)
*View of the Hotwells and Part of Clifton
near Bristol* (?) 1823
Pencil and watercolour with some bodycolour
and scraping-out, 39.3 x 90.1
Exh. (?) owcs 1823 (no. 223)
Bristol City Museums and Art Gallery
(K 2238)
plate 191

188 (section II)
Bristol: St Augustine's Parade c. 1825
Pencil and watercolour, 27.8 x 45.2
Engr. by Fenner Sears & Co as the frontispiece
for J. Chilcott's *New Guide to Bristol*, 2nd edn,
c. 1831
Bristol City Museums and Art Gallery
(Mb 700)
plate 71

189 (section VI)
*Composition: Hunters Resting after the
Chase* 1827
Watercolour and bodycolour with scraping-
out, 57.7 x 85
Inscr. verso: *Sir Humphrey de Trafford*
Exh. owcs 1827 (no. 121)
Bristol City Museums and Art Gallery
(K 4363)
plate 302

190 (section VI)
Composition: A Land of Dreams 1830
Watercolour with gum arabic, 56.8 x 86.7
Inscr. on label on reverse: *No. 1 Composition 'A
Land of dreams where the spirit strays in the silent
time [of night] / And friends meet friends – long
lost – in the glow of the evening l[ight]'/ 940
Guineas, S Jackson. Cotham /.*
Exh. owcs 1830 (no. 180; the quotation on the
label gives the approximate title under which
the work was exhibited)
Bristol City Museums and Art Gallery
(K 4083)
plate 294

JAMES JOHNSON 1803–1834

191 (section II)
*Bristol: Interior of St Mary Redcliffe; the
North Aisle looking East* 1828
Pencil and watercolour, 25.9 x 19.4
Inscr. lower right: *JJ – 1828 –*
Bristol City Museums and Art Gallery
(M 1950)
plate 83

EDWARD LEAR 1812–1888

192 (section II)
*The Monastery of Esphigmenou, Mount
Athos, Greece* 1856
Watercolour with pen and brown ink,
30.5 x 22.8
Inscr. lower left: *Esphyménu / 19. Sepr 1856*,
and elsewhere with colour notes
Private Collection
plate 105

193 (section II)
The Pyramids with Sphinx and Palms
1858
Pencil and watercolour, 16.5 x 51.4
Inscr. lower right: *Cairo / 21 March 1858* and
elsewhere with colour notes
The Tate Gallery, London, Presented by the
Earl of Northbrook 1910 (N 02796)
plate 104

194 (section II)
*Mount Parnassus, with a Group of
Travellers in the Foreground* 1879
Watercolour, 25.7 x 51.8
Inscr. lower right: *EL* (monogram) *1879*
Private Collection, Courtesy of the Leger Gal-
leries, London
plate 106

GEORGE ROBERT LEWIS
1782–1871

195 (section III)
*Clearing a Site in Paddington for
Development c.* 1820
Pencil and watercolour, 26.7 x 49.5
Inscr. lower right: *G. R. Lewis Paddington*
The Tate Gallery, London, Purchased 1975
(T 02009)
plate 120

JOHN FREDERICK LEWIS
1805–1876

196 (section VI)
Highland Hospitality 1832
Pencil, watercolour and bodycolour with gum
arabic and scraping-out, 56 x 78
Exh. owcs 1832 (no. 192)
Yale Center for British Art, New Haven, Paul
Mellon Collection (B 1978.43.167)
plate 308

197 (section II)
EXHIBITED LONDON ONLY
*Torre de las Infantas: One of the Towers in
the Grounds of the Alhambra, Granada*
1833

Pencil and watercolour with bodycolour on
grey paper, 36.2 x 25.4
Inscr. lower left: *Torre de las Infantas / Sept. 19,
1833*
Lithographed by J.D. Harding, *Lewis's
Sketches and Drawings of the Alhambra*, plate 24
Sir Brinsley Ford
plate 103

198 (section VI)
*The Suburbs of a Spanish City (Granada)
on the Day of a Bull-fight* 1836
Pencil and watercolour with bodycolour,
64.7 x 85
Inscr. lower right: *J. F. Lewis / 1836*
Exh. owcs 1836 (no. 302)
Whitworth Art Gallery, University of
Manchester (D 1887-44)
plate 309

199 (section VI)
EXHIBITED LONDON ONLY
The Noonday Halt 1853
Pencil and watercolour with bodycolour,
40.5 x 56.5
Inscr. lower right (in strap): *JFL. 1853*
Exh. RA 1854 (no. 248)
Lent by the Syndics of the Fitzwilliam
Museum, Cambridge (716)
plate 310

200 (section VI)
Life in the Hhareem, Cairo 1858
Watercolour and bodycolour, 60.6 x 47.7
Inscr. lower right: *JFL* (monogram) / *1858*
The Board of Trustees of the Victoria and
Albert Museum, London (679-1893)
plate 311

201 (section VI)
The Pipe-bearer 1859
Pencil, watercolour and bodycolour,
55.9 x 40.6
Inscr. lower right: *JFL ARA / 1859*
Exh. (?) RA 1862 (no. 812, as Egyptian Servant)
The Trustees of the Cecil Higgins Art Gallery,
Bedford (P 305)
plate 313

202 (section VI)
Girl with Two Caged Doves 1864
Pencil, watercolour and bodycolour,
32.4 x 22.5
Inscr. lower left: *J F Lewis / 1864*
Exh. RA 1864 (no. 577, as Caged Doves, Cairo)
Lent by the Syndics of the Fitzwilliam
Museum, Cambridge (PD 6-1959)
plate 312

JOHN LINNELL 1792–1882

203 (section III)
EXHIBITED LONDON ONLY
Primrose Hill 1811
Watercolour with pen and brown ink and
white chalk, 39.5 x 67.8
Inscr. below, centre: *Primrose Hill. J. Linnell
1811*; and lower right: *part of primrose hill*
Lent by the Syndics of the Fitzwilliam
Museum, Cambridge (PD 16-1970)
plate 119

204 (section III)
Bayswater and Kensington Gardens 1811
Pencil and watercolour on laid paper, 24 x 37.7

Inscr. below, centre: *Bayswater & Kensington Garden. 1811 J. Linnell*
Martyn Gregory Gallery
plate 122

205 (section III)
Regent's Park 1812
Watercolour, 10.6 x 14.9
Inscr. lower left: *J.L.* and *1812*; and lower right: *Regents Park*
Martyn Gregory Gallery
plate 126

206 (section III)
Dovedale 1814
Pencil and watercolour, 32.3 x 52.8
Inscr. below, centre: *J. Linnell. 1814 – Dovedale Derbyshire*
Martyn Gregory Gallery
plate 117

207 (section III)
Tree Study at Tythrop 1817
Pencil and watercolour with black and white chalks on grey paper, 44.3 x 28.7
Inscr. lower right: *J Linnell Tythrop 1817*
Lent by the Syndics of the Fitzwilliam Museum, Cambridge (PD 4-1957)
plate 132

208 (section V)
Sailing-boats on Southampton Water 1819
Watercolour, 15.6 x 22.3
Inscr. below: *Southampton River Isle of Wight in distance 1819 J Linnell*
National Gallery of Art, Washington DC, Paul Mellon Collection (1986.72.10)
plate 268

THOMAS MALTON JNR 1748–1804

209 (section II)
St Paul's Church, Covent Garden, London, from the Piazza c. 1787
Pencil and watercolour with pen and black ink on laid paper, 31.7 x 47.2
Engr. for the *Picturesque Tour through the Cities of London and Westminster*, 1792, plate 32
Exh. RA 1787 (no. 587)
Whitworth Art Gallery, University of Manchester (D 1951-14)
plate 67

JOHN MARTIN 1789–1854

210 (section IV)
Sunset over a Rocky Bay 1830
Watercolour with scraping-out, 24 x 36.8
Inscr. lower left: *J. Martin 1830*
Private Collection, through Hazlitt, Gooden & Fox
plate 221

211 (section V)
EXHIBITED LONDON ONLY
Landscape 1835 (?1839)
Watercolour and scraping-out, 23.5 x 31.8
Inscribed lower right: *J. Martin 1835 (?1839)*
Oldham Art Gallery (9.88/56)
plate 246

212 (section VI)
The Destruction of Pharoah's Host 1836

Watercolour and bodycolour with gum arabic and scraping-out, 57.5 x 85
Inscr. lower right: *1836 / J. Martin*
Private Collection
plate 303

JOHN MIDDLETON 1827–1856

213 (section V)
A Shady Lane, Tunbridge Wells, Kent 1847
Pencil and watercolour, 31 x 47
Inscr. lower left: *Tonbridge Wells / JM* (monogram) *1847*
Private Collection, USA
plate 248

JOHN EVERETT MILLAIS 1829–1896

214 (section III)
A Mountainous Scene, Scotland – possibly Ben Nevis (?) 1854
Watercolour and bodycolour with scraping-out, 12.1 x 19.5
Inscr. lower right: *Ben Nevis 4 Sep*, and by the artist (?later) *JEM* (monogram) *1853*
Whitworth Art Gallery, University of Manchester (D 1928-38)
plate 162

ALBERT JOSEPH MOORE 1841–1893

215 (section III)
Study of an Ash Trunk 1857
Watercolour and bodycolour with gum arabic, 30.3 x 22.9
Inscr. lower left: *AM* (monogram) *1857*
Exh. RA 1858 (no.633)
The Visitors of the Ashmolean Museum, Oxford (1959.59)
plate 141

WILLIAM JAMES MÜLLER 1812–1845

216 (section II)
Cairo: A Street with a Minaret c. 1838
Pencil and watercolour, 34.9 x 24.7
Private Collection
plate 98

217 (section V)
Distant View of Xanthus 1843
Watercolour, 35.2 x 53.1
Private Collection
plate 250

218 (section V)
EXHIBITED LONDON ONLY
Rock Tombs at Pinara 1843
Pencil, watercolour and bodycolour, 35.6 x 53.3
Inscr. lower left: *Pinara. Lycia. / Nov 18 1843 / WM*
Trustees of the British Museum, London (1878-12-28-123)
plate 252

FREDERICK NASH 1782–1856

219 (section III)
Showery Day, Glastonbury Tor (?) c. 1820
Watercolour, 21.9 x 36.2
Inscr. lower right: *F. NASH*
The Board of Trustees of the Victoria and Albert Museum, London (P. 135-1931)
plate 159

PATRICK NASMYTH 1787–1831

220 (section III)
Broad Dock (Rumex obtusifolius) (?) c. 1810
Watercolour, 29.2 x 20.9
Lent by the Syndics of the Fitzwilliam Museum, Cambridge (1404)
plate 136

221 (section III)
Burdock (Arctium) (?) c. 1810
Watercolour, 29.2 x 20.9
Lent by the Syndics of the Fitzwilliam Museum, Cambridge (1405)
plate 135

JOHN WILLIAM NORTH 1842–1924

222 (section VI)
Gypsy Encampment 1873
Watercolour and bodycolour with scraping-out, 64.1 x 92.7
Inscr. lower left: *J. W. North 1873 March*
The Board of Trustees of the Victoria and Albert Museum, London (68-1895)
plate 317

SAMUEL PALMER 1805–1881

223 (section IV)
Moonlit Scene with a Winding River c. 1827
Pen and black ink and brown wash with bodycolour on buff paper, 28.6 x 18.4
Yale Center for British Art, New Haven, Paul Mellon Collection (1977.14.4643)
plate 219

224 (section IV)
Harvesters by Firelight c. 1830
Pencil, watercolour and bodycolour with pen and black ink, 28.7 x 36.7
National Gallery of Art, Washington DC, Paul Mellon Collection (1986.72.12)
plate 220

225 (section IV)
The Bright Cloud c. 1833-4
Pen and black ink and wash with white bodycolour, 22.9 x 30.5
The Tate Gallery, London, Presented by Hugh Blaker through the National Art Collections Fund 1917 (N 03312)
plate 222

226 (section III)
EXHIBITED WASHINGTON ONLY
A Cascade in Shadow c. 1835–6
Watercolour and bodycolour, 47.3 x 37.5
Inscr. lower left: *No 7 / Samuel Palmer*; and

(party obscured): *Cascade… at the junction of the rivers… Machno, Wales*
Exh. OWCS 1871 (no. 317)
Private Collection, New York
plate 158

227 (section V)
EXHIBITED LONDON ONLY
The Herdsman c. 1850
Black chalk and watercolour with bodycolour, gum arabic and scraping-out, 52 x 73.7
Oldham Art Gallery (9.88/69)
plate 255

228 (section VI)
EXHIBITED WASHINGTON ONLY
The Lonely Tower (Illustration to Milton's 'Il Penseroso') 1868
Pencil, watercolour, bodycolour and gum arabic with scraping-out on board, 51.7 x 70.8
Inscr. on label on reverse: *No: 1 / The Lonely Tower / 'Or let my lamp, at midnight hour, / Be seen in some high lonely tower, / Where I may oft outwatch the Bear, / With thrice great Hermes.' / Samuel Palmer*
Exh. OWCS 1868 (no. 16)
Yale Center for British Art, New Haven, Paul Mellon Collection (B 1977.14.147)
plate 299

229 (section VI)
A Towered City (Illustration to Milton's 'L'Allegro') 1868
Watercolour and bodycolour with gum arabic and scraping-out, 51.1 x 70.8
Inscr. lower left: *S. PALMER*
This subject is also known as *The Haunted Stream*
Rijksprentenkabinet, Rijksmuseum, Amsterdam (1978-39)
plate 300

230 (section VI)
Morning (Illustration to Milton's 'Il Penseroso') 1869
Watercolour and bodycolour with gum arabic and scraping-out, 51 x 78
Inscr. lower left: *S. PALMER*; and on label on reverse: *No. 2, Samuel Palmer / Morn, / Not trickt and frounct, as she was wont / With the Attic Boy to hunt; / But kerchieft in a comely cloud, / While rocking winds are piping loud, / Or usher'd with a shower still / When the gust hath blown his fill, / Ending on the rustling leaves, / With minute drops from off the eaves.*
This subject is also known as *The Dripping Eaves*
The Duke of Devonshire and the Chatsworth Settlement Trustees
plate 298

WILLIAM PARS 1742–1782

231 (section II)
EXHIBITED LONDON ONLY
A Ruin near the Port of Aegina c. 1766
Pencil and watercolour with gum arabic, 28.7 x 49
Engr. William Byrne, *Ionian Antiquities*, II, 1797, plate 1; and as an aquatint by Paul Sandby, 1777
Trustees of the British Museum, London (Mm 11-10)
plate 58

232 (section II)
A Picnic Party in Ireland 1771
Pencil and watercolour, with pen and black ink
on laid paper, 33.6 x 48.2
Birmingham Museums and Art Gallery
(P. 296'53)
plate 56

SAMUEL PROUT 1783–1852

233 (section II)
A View in Strasbourg (?) 1822
Watercolour with reed pen and brown ink,
61.9 x 47.6
Inscr. lower left: HANDLUN[G] *von S.* PROU[T]
Exh. (?) owcs 1822 (no.85)
The Visitors of the Ashmolean Museum,
Oxford
plate 99

234 (section VI)
The Ducal Palace, Venice 1830
Watercolour, 74.9 x 104.1
Exh. owcs (no. 58)
The Sudeley Castle Collection
plate 292

ALLAN RAMSAY 1713–1784

235 (section II)
EXHIBITED WASHINGTON ONLY
*Study of Part of the Ruins of the Colos-
seum* 1755
Watercolour, 37.6 x 26.6
National Galleries of Scotland, Edinburgh
(D 3774)
plate 61

GEORGE RICHMOND
1809–1896

236 (section III)
A View of Norbury Woods 1860
Black chalk, watercolour and bodycolour on
blue paper, 27.2 x 38.7
Inscr. lower left: *Norbury Woods – from the Gar-
den of Cowslip Cottage / Mickleham, Surrey, / by
Geo. Richmond, 1860*
Lent by the Syndics of the Fitzwilliam
Museum, Cambridge (PD 43-1971)
plate 157

DAVID ROBERTS 1796–1864

237 (section II)
Madrid: Palacio Real 1833–5
Pencil and watercolour, 27.3 x 35.5
University of Liverpool Art Gallery and Col-
lections, Sir Sydney Jones Collection (FA 236)
plate 96

GEORGE FENNEL ROBSON
1788–1833

238 (section VI)
EXHIBITION LONDON ONLY
*Loch Coruisk and the Cuchullin Mountains,
Isle of Skye* 1826
Watercolour with scraping-out, 64.2 x 111.8
Exh. owcs 1826 (no. 136, with a quotation
from Scott's *Lord of the Isles*)
The Board of Trustees of the Victoria and
Albert Museum, London (1426-1869)
see fig. 54

239 (section IV)
Tryfan, Caernarvonshire (?) 1827
Watercolour and bodycolour with gum arabic
and scraping-out, 46.4 x 76
Exh. (?) owcs 1827 (no. 152)
Yale Center for British Art, New Haven, Paul
Mellon Collection (B 1981.25.2048)
plate 205

MICHAEL 'ANGELO'
ROOKER 1746–1801

240 (section I)
EXHIBITED LONDON ONLY
Entrance to a Park (?) c. 1790
Watercolour with pen and ink on laid paper,
45.7 x 35.1
Inscr. lower left (?in a later hand): *M. A. Rooker.*
Trustees of the British Museum, London
(1889-6-3-261)
plate 16

241 (section II)
The Gatehouse at Battle Abbey, Sussex
1792
Pencil and watercolour, 41.9 x 59.6
Inscr. lower right: *MA Rooker / MAR* in mono-
gram / *1792*; and on artist's washline mount:
Battle Abbey and *M A Rooker / MAR* in mono-
gram / *Delin*ᵗ
Exh. (?) RA 1792 (no. 438)
Royal Academy of Arts, London
plate 65

242 (section II)
*Interior of the Abbot's Kitchen,
Glastonbury* c. 1795
Pencil and watercolour, 35.6 x 45.1
Inscr. lower left: *MA Rooker* (*MAR* in monog-
ram)
The Tate Gallery, London, Presented by the
Art Collections Fund (Herbert Powell
Bequest) 1967 (T 01013)
plate 74

THOMAS ROWLANDSON
1756–1827

243 (section II)
EXHIBITED LONDON ONLY
London: Skaters on the Serpentine 1784
Pencil and watercolour with pen and black ink,
42.4 x 73.9
Exh. RA 1784 (no. 511, as *The Serpentine River*)
National Museum of Wales, Cardiff (748)
plate 69

JOHN RUSKIN 1819–1900

244 (section II)
*Milan: The Pulpit in the Church of S.
Ambrogio* (?) 1845
Pencil and watercolour on buff paper, 43.8 x 33
The Board of Trustees of the Victoria and
Albert Museum, London (226-1887)
plate 102

245 (section III)
The Garden of S. Miniato, Florence 1845
Pencil, watercolour and bodycolour with pen
and black ink, 33.3 x 47.3

National Gallery of Art, Washington DC,
Patrons' Permanent Fund (1991.88.1 [GD])
plate 156

246 (section III)
Head of Lake Geneva (?) 1846
Pencil and watercolour with pen and brown
ink, 23.8 x 39.9
Inscr. lower right: *Head of Lake Geneva*
Rijksprentenkabinet, Rijksmuseum, Amster-
dam (1987-19)
plate 164

247 (section III)
EXHIBITED LONDON ONLY
Study of Ivy (Hedera Helix) c. 1872
Black chalk, watercolour and bodycolour with
gum arabic, 42 x 28
Inscr. verso: *Study of ivy, Coniston*
Trustees of the British Museum, London
(1979-1-27-11)
plate 142

248 (section III)
Study of Two Shells c. 1881
Watercolour and bodycolour on blue paper,
14.4 x 24.2
Whitelands College Archive, London
plate 149

PAUL SANDBY 1731–1809

249 (section II)
EXHIBITED LONDON ONLY
*Horsefair on Bruntsfield Links, Edinburgh
in the Background* 1750
Watercolour, bodycolour and pen and black
ink on laid paper, 24.4 x 37.3
Inscr. lower right: *P. Sandby Delin 1750*
National Galleries of Scotland, Edinburgh
(D 5184)
plate 48

250 (section III)
EXHIBITED LONDON ONLY
*Figure Studies at Edinburgh and in the
Vicinity* c. 1750
(a) *Street Groups*
Pencil and watercolour with pen and ink on
laid paper, 7.6 x 18.7
(b) *Pedlars etc.*
Pencil and watercolour with pen and ink on
laid paper, 8.6 x 22.6
(c) *A Meat Market*
Pencil and watercolour with pen and ink on
laid paper, 12.1 x 23.5
Trustees of the British Museum, London
(Nn 6-19, 65, 38)
plate 127

251 (section II)
*Windsor: The Lodge Kitchen at Sandpit
Gate* c. 1751
Pencil, watercolour and some bodycolour with
pen and black ink and scraping-out on laid
paper, 25 x 32.5
Inscr. lower left: *The Kitchen at Sandpit Gate Wᵗ
Park 1754 PS.*
This inscription appears to have been added by
Sandby at a later date, and may be inaccurate
by two or three years
Royal Library, Windsor Castle (RL 14331)
plate 54

252 (section II)
*Windsor: The Curfew Tower from the
Horseshoe Cloister, Windsor Castle* c.1765

Pencil and watercolour with pen and black ink
on laid paper, 34.5 x 50.7
Royal Library, Windsor Castle (RL 14555)
plate 52

253 (section II)
*Windsor: View of the Ascent to the Round
Tower, Windsor Castle* c. 1770
Pencil and watercolour with pen and black ink
on laid paper, 36.3 x 43.6
Inscr. on label attached to artist's washline
mount: *Windsor / View of the Ascent to the Round
Tower*
Royal Library, Windsor Castle (RL 17876)
plate 53

254 (section III)
The Tide Rising at Briton Ferry 1773
Pencil and watercolour on laid paper,
29.7 x 53.3
Inscr. verso: *This view pointed out by Sir Joseph
Banks, Bart, in the year 1773. He stood by while I
made the Sketch, his servant holding an umbrella
to keep the glare of the sun from my paper. I was so
attentive in making this Drawing correct as not to
perceive the Tide approach, it flowing very fast and
follow us upward of a mile before we was in Safety,
when looking back to sand hillocks on which I had
sat to sketch, they was under water, the Tide gener-
ally rising 8 feet. P. Sandby, R.A. N.B. On the left
hand of the Ferry House rises smoke from the Cop-
per Works at Neath over Lord Vernon's Wood, on
the Right hand Mr. Morriss's Plantations.*
National Gallery of Art, Washington DC, Gift
of the Circle of the National Gallery of Art
(1988.19.1)
plate 112

255 (section I)
A Rocky Coast by Moonlight (?) c. 1790
Bodycolour, 31.8 x 47
City of Nottingham Museums: Castle
Museum and Art Gallery (1971–86)
plate 24

256 (section II)
EXHIBITED LONDON ONLY
View of Eton College from the River
c. 1790
Bodycolour, 54.7 x 76.5
The Nivison Loan to the Laing Art Gallery,
Newcastle upon Tyne
plate 51

257 (section III)
EXHIBITED LONDON ONLY
Bayswater 1793
Pencil and watercolour on laid paper,
18.4 x 40.6
Inscr. lower right: *Bayswater 1793 P.S.*
Trustees of the British Museum, London
(1904-8-19-67)
plate 111

258 (section II)
Tea at Englefield Green, near Windsor
c. 1800
Pencil and bodycolour with pen and black ink
on laid paper, 28.6 x 43.2
Inscr. lower right on back of artist's seat:
P Sandby / R.A. pinxt
City of Nottingham Museums: Castle
Museum and Art Gallery (1945-146)
plate 55

THOMAS SANDBY 1721–1798

259 (section II)

Windsor, from the Lodge Grounds in the Great Park early 1750s
Pencil and watercolour with pen and black ink on laid paper, 26.6 x 49.5
Inscr. verso: *Windsor, from the Lodge grounds in / the Great Park Nº 1*
Royal Library, Windsor Castle (RL 17751)
plate 50

260 (section II)
EXHIBITED LONDON ONLY

The Camp on Cox Heath (?)1754
Pencil and watercolour with pen and black ink on laid paper, 49.1 x 147.3
Traditionally dated to 1778, when an encampment took place on Cox Heath, but more likely a view of the one there in 1754
Royal Library, Windsor Castle (RL 14729)
plate 49

WILLIAM BELL SCOTT 1811–1890

261 (section III)

Penwhapple Stream 1860
Pencil, watercolour and bodycolour, 22.6 x 31.6
National Galleries of Scotland, Edinburgh (D 4715A)
plate 161

WILLIAM SIMPSON 1823–1899

262 (section II)

Valley of Vardan, Caucasus 1855–8
Watercolour and bodycolour, 30.7 x 46.8
Inscr. lower left: *Valley of Vardan, Circassia / 19th Octr 1855*; and lower right: *Wm Simpson 1858*
Bill Thomson, Albany Gallery, London
plate 107

JONATHAN SKELTON c. 1735–1759

263 (section I)

In Greenwich Park 1757
Pencil and watercolour with pen and black ink on laid paper, 24.9 x 53.7
Inscr. verso of artist's washline mount: *In Greenwich Park / J. Skelton. 1757*
Lent by the Syndics of the Fitzwilliam Museum, Cambridge (1710)
plate 14

264 (section III)
EXHIBITED LONDON ONLY

A Study at Tivoli 1758
Pencil and watercolour with pen and black ink on laid paper, 26.4 x 37.5
Inscr. lower right: *a View of one side of Tivoli / up the River J Skelton 1758*
Lent by the Syndics of the Fitzwilliam Museum, Cambridge (1163 verso)
plate 108

JOHN 'WARWICK' SMITH 1749–1831

265 (section II)

Study of Part of the Interior of the Colosseum 1776
Pencil and watercolour with pen and brown ink, 39 x 53.3
Inscr. on artist's washline mount: *in the Colleseo*; and verso: *In the Collesseum Rome 17[7]6*
Trustees of the British Museum, London (1936-7-4-13)
plate 62

JAMES 'ATHENIAN' STUART 1713–1788

266 (section II)

Athens: The Monument of Philopappos c. 1755
Pencil and bodycolour on laid paper, 31.5 x 45.5
Engr. for *The Antiquities of Athens*, III, 1795, ch. v, plate 1
British Architectural Library Drawings Collection / Royal Institute of British Architects, London (Y30[12])
plate 59

267 (section II)

Salonica: The Incantada or Propylaea of the Hippodrome c. 1755
Pencil and bodycolour on laid paper, 33 x 47
Engr. for *The Antiquities of Athens*, III, 1795, ch. IX, plate 1
British Architectural Library Drawings Collection / Royal Institute of British Architects, London (Y30[15])
plate 60

FRANCIS TOWNE 1740–1816

268 (section II)
EXHIBITED LONDON ONLY

Rome: A Gateway of the Villa Ludovisi 1780
Watercolour with pen and black ink on laid paper, 46.4 x 32.1
Inscr. lower right: *F Towne del / No 19 Decr 9 178[0]*; and on backing sheet: *Nº 19 Going into the Villa Ludovisi Dec 9 1780 Rome Francis Towne delt*
Trustees of the British Museum, London (1972 u 731)
plate 63

269 (section I)
EXHIBITED LONDON ONLY

Lake Albano with Castel Gandolfo 1781
Watercolour with pen and brown ink on laid paper, 32.1 x 70.2
Inscr. lower left: *No 7 Francis Towne / delt July 12 1781*; and on backing sheet: *Italy / No. 7 Lake of Albano taken July 12th 1781 / Francis Towne / Morning light from the left hand*
Trustees of the British Museum, London (1972 u 646)
plate 22

270 (section I)

Naples: A Group of Buildings Seen from an Adjacent Hillside 1781
Pen and black ink and wash on laid paper, 32.6 x 47
Inscr. verso: *Naples / March 19th 1781 / from 10 till 12 o'clock / sun from the left in the morning out / of the picture and the right in the after / -noon // Nº 6*
Private Collection, Courtesy of the Leger Galleries, London
plate 17

271 (section I)

The Source of the Arveiron: Mont Blanc in the Background 1781
Watercolour with pen and brown ink, 42.5 x 31.1
Inscr. lower right: *F. Towne. delt / 1781 / Nº 53*
The Board of Trustees of the Victoria and Albert Museum, London (P. 20-1921)
plate 21

272 (section I)

The Source of the Arveiron 1781
Watercolour with pen and brown ink on laid paper, 31 x 21
Inscr. lower right: *F. Towne / Nº 52 1781*; and verso: *Nº. 52. A view of the Source of the Arviron drawn by Francis Towne, Sept… 1781*
Private Collection
plate 20

273 (section I)

Head of Lake Geneva from Vevay 1781
Pen and brown ink with blue and grey washes on laid paper, 26.4 x 37.9
Inscr. verso: *Head of the Lake of Geneva Taken at Vevay Nº 2 Septr. 11n, 1781 Francis Towne*
Leeds City Art Galleries (13.211/53)
plate 18

274 (section I)

Pantenbruck 1781
Pen and black ink and wash on laid paper, 46.5 x 28.5
Inscr. verso: *Panten-Bruck Morning light from the right Hand / No. 29 Septr 3d. 1781 / Francis Towne*
Leeds City Art Galleries (13.209/53)
plate 19

275 (section I)

A View at the Head of Lake Windermere 1786
Pencil and watercolour with pen and brown ink on laid paper, 15.6 x 47.4
Inscr. lower right: *F. Towne delt / No. 14 1786*; and verso: *No. 14. A view taken near the Turnpike coming from Low Wood to Ambleside, at the head of the Lake of Windermere, in Westmorland. Drawn on the spot by Francis Towne, August 12th 1786. Also inscribed verso with a list of hills indicated by letters: A, Rydal Peak; B, Rydal Cragg; C, Rydal head; B. Lower Greaves and A, Higher Greaves in Rydal Park; C, Rydal Lower peak or cragg; D, Rydal higher peak; E, Great Ridge; F, Red Crease. Leicester Square, 1791.*
Birmingham Museums and Art Gallery (91'21)
plate 23

276 (section III)

Trees Overhanging Water 1800
Watercolour with pen and brown ink, 36.7 x 22.2
Inscr. lower left: *F. Towne / del.t 1800*
Leeds City Art Galleries (13.204/53)
plate 134

JOSEPH MALLORD WILLIAM TURNER 1775–1851

277 (section II)

The Pantheon, Oxford Street, London 1792
Pencil and watercolour, 51.6 x 64
Inscr. lower left: *W Turner Del*
Exh. RA 1792 (no. 472)
The Tate Gallery, London, Bequeathed by the artist, 1856 TB IX-A (D 00121)
plate 68

278 (section II)

Wolverhampton, Staffordshire 1796
Pencil and watercolour, 31.8 x 41.9
Exh. RA 1796 (no. 651)
Wolverhampton Art Gallery and Museums
plate 70

279 (section II)

Transept of Ewenny Priory, Glamorganshire 1797
Pencil and watercolour with scraping-out and stopping-out, 40 x 55.9
Exh. RA 1797 (no. 427)
National Museum of Wales, Cardiff (497a)
plate 75

280 (section I)

View across Llanberis Lake towards Snowdon c. 1799
Watercolour, 43.5 x 56.4
One of a series of preparatory colour studies
The Tate Gallery, London, Bequeathed by the artist, 1856 TB LXX-C (D 04180)
plate 35

281 (section VI)

Conway Castle 1800
Watercolour with scraping-out and stopping-out, 52.5 x 77
The Leger Galleries, London
plate 279

282 (section VI)
EXHIBITED WASHINGTON ONLY

Glacier and Source of the Arveiron, Going up the Mer de Glace, Chamonix 1802–3
Pencil and watercolour with scraping-out and stopping-out, 68.5 x 101.5
Exh. RA 1803 (no. 396)
Yale Center for British Art, New Haven, Paul Mellon Collection (B 1977.14.4650)
plate 278

283 (section VI)

A View of Lincoln from the Brayford c. 1802–3
Pencil, watercolour and some bodycolour with scraping-out and stopping-out, 66 x 102
Lincolnshire County Council: Usher Art Gallery, Lincoln (U.G. 2379)
plate 276

284 (section)

The Great Falls of the Reichenbach 1804
Watercolour woth scraping-out and stopping-out, 103 x 70.4
Inscr. lower right: *IMW TURNER RA1804*
Exh. RA1805 (no. 292)
The Trustees of the Cecil Higgins Art Gallery, Bedford (P98)
plate 275

285 (section III)
Benson (or Bensington), near Wallingford
c.1805
Pencil and watercolour, 25.9 x 37.1
A sheet from the *Thames from Reading to Walton* sketchbook
The Tate Gallery, London, Bequeathed by the artist, 1856 TB XCV-13
(D 05917)
plate 118

286 (section III)
Head of a Heron c. 1815
Pencil and watercolour with scraping-out, 24.9 x 28.9
A detached sheet from the *Ornithological Collection*, III; frontispiece to 'Of the Heron'
Leeds City Art Galleries (I/85)
plate 145

287 (section VI)
Landscape: Composition of Tivoli 1817
Pencil, watercolour and bodycolour with scraping-out and stopping-out, 67.6 x 102
Inscr. lower right: *IMW TURNER 1817*
Exh. RA 1818 (no. 474) and OWCS 1823 (no. 88)
Private Collection
plate 277

288 (section II)
Caley Hall, Yorkshire c. 1818
Bodycolour, 29.9 x 41.4
National Galleries of Scotland, Edinburgh
(D 5023/41)
plate 87

289 (section II)
Rome: The Church of SS Giovanni e Paolo 1819
Watercolour and bodycolour on white paper prepared with a grey wash, 23 x 36.9
A sheet from the *Rome: C. Studies* sketchbook
The Tate Gallery, London, Bequeathed by the artist, 1856 TB CLXXXIX-39
(D 16366)
plate 90

290 (section III)
Study of Fish: Two Tench, a Trout and a Perch c. 1822
Pencil and watercolour, 27.5 x 47
The Tate Gallery, London, Bequeathed by the artist, 1856 TB CCLXIII-339
(D 25462)
plate 146

291 (section V)
The Sun Setting over the Sea in Orange Mist c. 1825
Watercolour, 24.5 x 34.6
The Tate Gallery, London, Bequeathed by the artist, 1856 TB CCLXIII-210
(D 25332)
plate 257

292 (section II)
Dartmouth Cove c. 1826
Watercolour and scraping-out, 27.5 x 39.5
Engr. by W. R. Smith, 1827, for *Picturesque Views in England and Wales*
Exh.: Moon, Boys and Graves Gallery, 1833
The Leger Galleries, London
plate 88

293 (section II)
Stamford, Lincolnshire c. 1828
Watercolour and some bodycolour with scraping-out, 29.3 x 42

Engr. by W. Miller, 1830, for *Picturesque Views in England and Wales*
Exh.: Moon, Boys and Graves Gallery, 1833
Lincolnshire County Council: Usher Art Gallery, Lincoln
plate 86

294 (section II)
Paris: Pont Neuf and Ile de la Cité c. 1832
Watercolour and bodycolour on blue paper, 14.3 x 18.8
Engr. by W. Miller for *Turner's Annual Tour – the Seine*, 1835
The Tate Gallery, London, Bequeathed by the artist, 1856 TB CCLIX-118
(D 24683)
plate 91

295 (section II)
Kidwelly Castle, Carmarthenshire
1832–3
Watercolour, 29 x 44.8
Engr. by T. Jeavons, 1837, for *Picturesque Views in England and Wales*
Exh. Moon, Boys and Graves Gallery, 1833
Harris Museum and Art Gallery, Preston
(P1280)
plate 89

296 (section V)
Storm off the East Coast (?) c. 1835
Watercolour, chalk and bodycolour on buff paper, 20.9 x 27.3
Sheffield City Art Galleries (2205)
plate 258

297 (section V)
Oberwesel 1840
Watercolour and bodycolour with scraping-out, 34.6 x 53.3
Inscr. lower right: *IMWT.1840*
Private Collection, Courtesy the Leger Galleries, London
plate 261

298 (section V)
A Raft and Rowing-boat on a Lake by Moonlight c. 1840
Watercolour, 19.2 x 28
Inscr. verso: *Now from a… [illegible] / [?] thrills… / as the Moon [?] descends yet Venice gleams of many winking lights / and like the… sails when she [?] wanes*
The Tate Gallery, London, Bequeathed by the artist, 1856 TB CCCLXIV-334 (D 36192)
plate 256

299 (section V)
Venice: S. Maria della Salute and the Dogana c. 1840
Watercolour, 22.1 x 32.1
The Tate Gallery, London, Bequeathed by the artist, 1856 TB CCCXV-14 (D 32130)
plate 264

300 (section V)
Venice: The Riva degli Schiavoni from the Channel to the Lido c. 1840
Watercolour and bodycolour with pen and brown and red ink, 24.5 x 30.6
The Tate Gallery, London, Bequeathed by the artist, 1856 TB CCCXVI-18 (D 32155)
plate 265

301 (section V)
The Lake of Brientz 1841
Watercolour and bodycolour with pen and

brown ink, 23.1 x 28.8
Private Collection
plate 262

302 (section V)
The Rhine at Reichenau (?)1841
Watercolour, 24.4 x 31.1
The Tate Gallery, London, Bequeathed by the artist, 1856 TB CCCLXIV-217 (D 36063)
plate 267

303 (section V)
The Rigi at Sunset c. 1841
Watercolour with some pen, 24.5 x 36
Private Collection, England
plate 259

304 (section V)
EXHIBITED LONDON ONLY
Lake Lucerne: The Bay of Uri from above Brunnen 1842
Pencil and watercolour with scraping-out, 29.2 x 45.7
Private Collection, New York
plate 260

305 (section V)
EXHIBITED LONDON ONLY
The Dark Rigi 1842
Watercolour with scraping-out, 30.5 x 45.5
The Nivison Loan to the Laing Art Gallery, Newcastle upon Tyne
plate 263

306 (section V)
The Cathedral at Eu 1845
Pencil and watercolour, 23.2 x 32.8
The Tate Gallery, London, Bequeathed by the artist, 1856 TB CCCLIX-16 (D 35451)
plate 266

WILLIAM TURNER OF OXFORD 1789–1862

307 (section IV)
Wychwood Forest, Oxfordshire 1809
Watercolour and bodycolour with gum arabic, sponging and scraping-out, 60.7 x 79.3
Inscr. lower left: *W. Turner Shipton on Cher. Oxon*; and verso: *Scene near where a pleasure fair was formerly held in Whichwood Forest, Oxfordshire, William Turner, Shipton on Cherwell, Oxon, 1809*
Exh. OWCS 1809 (no. 243)
The Board of Trustees of the Victoria and Albert Museum, London (P. 136-1929)
plate 202

308 (section III)
EXHIBITED WASHINGTON ONLY
A Pollarded Willow 1835
Watercolour and bodycolour with some gum arabic, 37.3 x 27.1
Inscr. verso: *Godstow Oct'r 13 1835*
National Galleries of Scotland, Edinburgh
(D 5023/44)
plate 140

309 (section VI)
EXHIBITED LONDON ONLY
Halnaker Mill, near Chichester, Sussex c. 1837
Watercolour, 52.2 x 75
Inscr. lower left: *W. Turn[er]*
Exh. (?)OWCS 1837 (no. 35, as *Shepherds returning with their Flocks – Evening Scene, Halnacker Down, near Goodwood, Sussex*)

National Galleries of Scotland, Edinburgh
(DNG 1520)
plate 290

310 (section IV)
Portsmouth Harbour from Portsdown Hill c. 1840
Pencil and watercolour with bodycolour and scraping-out, 59 x 99
Inscr. lower right: *W. Turner Oxford*
Private Collection
plate 206

CORNELIUS VARLEY 1781–1873

311 (section III)
EXHIBITED LONDON ONLY
Lord Rous's Park, Henham, Suffolk 1801
Pencil and watercolour with touches of white bodycolour, 26.4 x 37.3
Inscr. lower left: *Lord Rouses Park / 1801 / C.V.*
Trustees of the British Museum, London
(1973-4-14-15)
plate 121

312 (section III)
Near Pont Aberglaslyn, North Wales 1805
Pencil and watercolour, 21.3 x 30.7
Inscr. below, centre: *Near Pont Aber Glas Lyn C. Varley 1805*
Michael C. Jaye
plate 113

313 (section III)
Evening at Llanberis, North Wales 1805
Watercolour, 20 x 23.8
Inscr. below: *Evening at Llanberis C. Varley 1805*
The Tate Gallery, London, Purchased 1973
(T 01710)
plate 115

314 (section III)
Mountainous Landscape, Ireland 1808
Watercolour, 19 x 25.6
Inscr. lower left: *Ireland 1808 C Varley*
Whitworth Art Gallery, University of Manchester (D 1973.4)
plate 116

315 (section IV)
Pastoral, with Cattle and Figures in a Glade c. 1810
Pencil and watercolour, 54.2 x 37.4
Birmingham Museums and Art Gallery
(P 420'53)
plate 212

JOHN VARLEY 1778–1842

316 (section II)
Market Place at Leominster, Hereford 1801
Pencil and watercolour, 28.3 x 40
Inscr. lower left on wooden tub:
J. VARLEY / 1801
Exh. (?)RA 1802 (no.965, as *View of the town hall, Leominster*)
Hereford City Museum and Art Gallery
(N3229)
plate 72

317 (section IV)
Harlech Castle and Tygwyn Ferry 1804
Pencil and watercolour, 39.2 x 51.5
Inscr. lower left: *J. VARLEY 1804*
Exh. OWCS 1805 (no. 5)
Yale Center for British Art, New Haven, Paul
Mellon Collection (B 1986.29.578)
 plate 198

318 (section VI)
Snowdon from Moel Hedog 1805
Watercolour, 54 x 79.4
Inscr. lower right: *J VARLEY*
Exh. OWCS 1805 (no. 111)
Private Collection
 plate 280

319 (section VI)
Suburbs of an Ancient City 1808
Pencil and watercolour with stopping-out
and sponging-out, 72.2 x 96.5
Inscr. lower right: *J VARLEY/1808*
Exh. OWCS 1808 (no. 163) and, lent by Thomas
Hope, OWCS 1823 (no. 196)

The Tate Gallery, London, Presented by the
Patrons of British Art through the Friends of
the Tate Gallery 1990 (T 05764)
 plate 287

JAMES WARD 1769–1859

320 (section III)
Study of a Weasel c. 1805
Pencil and watercolour on card, varnished,
14.9 x 22.5
Inscr. lower right: *JWD* (monogram) *RA*
Lent by the Syndics of the Fitzwilliam
Museum, Cambridge (3395)
 plate 148

321 (section III)
Two Studies of an Eagle c. 1815
Watercolour with pen and brown ink,
25.8 x 50.4
Inscr. lower left: *An Eagle two [?versions]
J. Ward R.A*; lower right: *JWD* (mono-
gram) *RA*
Lent by the Syndics of the Fitzwilliam
Museum, Cambridge (3390)
 plate 147

JAMES ABBOTT MCNEILL
WHISTLER 1834–1903

322 (section V)
Seascape with Schooner (?) c. 1880
Watercolour, 14.4 x 24
With artist's butterfly symbol lower left
Birmingham Museums and Art Gallery
(335'30)
 plate 274

323 (section V)
Seascape, A Grey Note (?) c. 1880
Watercolour, 16.5 x 26.8
With artist's butterfly symbol lower right
Lent by the Syndics of the Fitzwilliam
Museum, Cambridge (PD 74-1959)
 plate 273

324 (section V)
St Ives c. 1883
Watercolour, 19.7 x 13.5
Lent by the Syndics of the Fitzwilliam
Museum, Cambridge (PD 16-1960)
 plate 269

325 (section V)
Beach Scene c. 1883
Watercolour and bodycolour on board,
12.5 x 21.2
With artist's butterfly symbol lower right
National Gallery of Art, Washington DC, Gift
of Mr and Mrs Paul Mellon, in Honor of the
fifteenth Anniversary of the National Gallery
of Art (1991.7.3)
 plate 270

HUGH WILLIAM 'GRECIAN'
WILLIAMS 1773–1829

326 (section VI)
View of the Forum in Rome 1828
Pencil and watercolour with stopping-out and
scraping-out, 40.5 x 65.3
Inscr. lower right: *H. W. Williams / 1828*
Yale Center for British Art, New Haven, Paul
Mellon Collection (B 1978.16.2)
 plate 291

ARTISTS' BIOGRAPHIES

Note: The biographies are listed alphabetically by surname. The appended bibliographies are selective, and the emphasis is on recent publications, where further guidance to writings on these artists will be found. For general works see the Select Bibliography (pp. 333–335).

JOHN WHITE ABBOTT 1763–1851

The pupil, friend and patron of FRANCIS TOWNE, Abbott was a talented amateur artist who practised as a surgeon and apothecary in his home city of Exeter in Devon. Although many of his landscapes, a genre in which he specialised, are views made in and around Exeter, he did undertake one important sketching tour to Scotland and the Lake District in 1791. He also made copies of Towne's Italian views, and after the Old Masters. Several times between 1793 and 1812 Abbott exhibited his watercolours at the Royal Academy, but never sold a picture at any point in his career. In 1825 he inherited an estate near Exeter, to which he retired, briefly serving as the county's Lord Lieutenant in the following decade.

BIBLIOGRAPHY *Paintings and Drawings by Francis Towne and John White Abbott*, exh. cat.; Exeter, Royal Albert Memorial Museum, 1971.

ROBERT ADAM 1728–1792

The leading architect and interior designer in late-18th-century England and Scotland, he was born in Kirkcaldy, Fife. In 1754 he went to Rome to study antiquities and draughtsmanship, and also undertook a survey in Dalmatia, the results of which he published as *The Ruins of the Palace of the Emperor Diocletian at Spalato* (1764). Following his return in 1758 Adam set up an office in London, and quickly established himself as a fashionable and innovative Neoclassical designer of country house interiors. By the 1780s, however, his work was confined largely to Scotland, where he designed and built several/picturesque castles. Many of his romantic monochrome and tinted watercolours date from this period, a number of which are of dramatically lit fantasy castles set in mountainous landscapes.

BIBLIOGRAPHY J. Fleming, *Robert Adam and his Circle in Edinburgh and Rome*, London 1962. *Robert Adam and Scotland: The Picturesque Drawings*, exh. cat. introd by A. A. Tait; Scottish Arts Council, 1972.

WILLIAM ALEXANDER 1767–1816

Born at Maidstone, Kent, in 1792 he accompanied George, 1st Earl Macartney's embassy to China, an expedition aimed at opening up that little-known land to increased trade and communication. Alexander's views of the Emperor's gardens in Peking (Beijing) and other scenic curiosities attracted enormous interest at Royal Academy exhibitions in the late 1790s, reaching a wider audience in the form of engravings and aquatints in various books. From 1798 Alexander published numerous illustrated works on the costumes and manners of Russians, Turks, Chinese and other peoples. He taught at the military college at Great Marlow until 1808, when he took up the post of Keeper of Prints and Drawings at the British Museum in London. In his later years he produced a number of picturesque landscapes as well as drawings of antiquities.

BIBLIOGRAPHY *William Alexander: An English Artist in Imperial China*, exh. cat. by P. Conner and S. Legouix Sloman; Brighton, Royal Pavilion, Art Gallery & Museums; Nottingham, University Art Gallery; 1981.

SAMUEL AUSTIN 1796–1834

Although he began life modestly enough as a clerk in Liverpool, Austin studied painting assiduously during his youth and eventually set himself up as a drawing-master, at which he was highly successful. He became an associate member of the Liverpool Academy *c.* 1820, and in 1824 an associate of the OWCS as well as a founder-member of the Society of British Artists. Austin frequently exhibited the views he made on his sketching trips in the Lancashire countryside and North Wales, working in a style strongly influenced by PETER DE WINT, from whom he had received several formative lessons. At the end of the 1820s Austin began visiting the Continent, notably the Low Countries, the Rhine Valley and Normandy, and some of his finest works are of scenes he sketched on these trips. His premature death came just months after he had been elected to full membership of the OWCS.

BIBLIOGRAPHY B. S. Long, 'Samuel Austin, Water-Colour Painter', *The Connoisseur*, LXXXIV, 1929, pp. 239–41.

GEORGE BARRET JNR 1767–1842

The son of a landscape painter in oils, Barret was born in London, a city he was rarely to leave except for sketching excursions in the Home Counties and, less often, in Wales. His early works are chiefly topographical views in oils, but after the formation of the OWCS in 1804, in which Barret played a part, he concentrated on painting in watercolours, regularly showing at the Society's exhibitions. His later works are poetic inventions influenced by Claude Lorrain and other Ideal landscape painters. From time to time Barret collaborated with other artists, notably JOSHUA CRISTALL around 1830, and in 1840 he published *The Theory and Practice of Water-Colour Painting*. Like his father before him, he died destitute.

BIBLIOGRAPHY A. Bury, 'George Barret Jnr', *The Connoisseur*, CV, 1940, pp. 237–41. A. Bury, 'Some Letters of George Barrett Junior', *Old Water-Colour Society's Club*, XXVI, 1948, pp. 41–5.

WILLIAM HENRY BARTLETT
1809–1854

A leading illustrator of travel books in the second quarter of the 19th century, Bartlett served his apprenticeship under the antiquary John Britton. During the 1830s and 1840s he worked as an illustrator, which involved numerous explorations over the Alps, down the Danube, and several times to the Near East and North America. In 1844 Bartlett published his illustrated *Walks about the City and Environs of Jerusalem*, the first of three books on the Holy Land he wrote himself. This literary bent led him to assume the editorship of *Sharpe's London Journal* five years later, to which he contributed numerous reviews. In the 1850s he made several voyages in the western Mediterranean, his last travel book being *Pictures from Sicily* (1853).

BIBLIOGRAPHY A. M. Ross, *William Henry Bartlett: Artist, Author and Traveller*, Toronto 1973.

WILLIAM BLAKE 1757–1827

He trained in London in 1772–9 as a reproductive engraver, although from 1780 Blake regularly exhibited works in watercolour at the Royal Academy, and during the 1780s began to include washes and watercolour in his printmaking experiments. His early efforts culminated in the *Songs of Innocence* (1789), in which verse and design – printed from the same plate etched in relief – were finished in watercolour by hand. Over the next two decades Blake produced a series of Prophetic Books, notably *Jerusalem* (begun 1804), involving this technique, but the arcane and elaborate personal mythology set forth in these apocalyptic visions was not widely appreciated. In 1795 he also watercolour-printed a dozen large monotypes, including *Newton*. Several years of obscurity followed the failure of his one-man exhibition in London in 1809–10, but in 1818 he met JOHN LINNELL, who generously commissioned work from him, and through Linnell became acquainted with SAMUEL PALMER and GEORGE RICHMOND, who afterwards brought together The Ancients, a small band of Blake devotees.

BIBLIOGRAPHY D. Bindman, *Blake as an Artist*, Oxford 1977. *William Blake*, exh. cat. by M. Butlin; London, Tate Gallery, 1978. M. Butlin, *The Paintings and Drawings of William Blake*, 2 vols, London 1981. M. Butlin, *Tate Gallery Collections, V: William Blake*, London 1990.

RICHARD PARKES BONINGTON
1802–1828

Born near Nottingham, his father took the family to Calais in 1817 in order to set up a lace-making

business. Bonington attended classes at the Ecole des Beaux-Arts in Paris in 1820–22, the period when he visited Normandy and the Low Countries. In London in 1825 Bonington met the French artist Eugène Delacroix, with whom he briefly shared a studio on their return to Paris. He spent several months in Italy in 1826, and exhibited views of Venice and other north Italian cities at the Salons of 1827 and 1828. He also exhibited in London, where he died, overtaken by consumption. His example was instrumental in encouraging painting in watercolours among the French.

BIBLIOGRAPHY M. Pointon, *The Bonington Circle: English Watercolour and Anglo-French Landscape, 1790–1855*, Brighton 1985. M. Pointon, *Bonington, Francia and Wyld*, London 1985. M. Cormack, *Bonington*, Oxford 1989. *Richard Parkes Bonington 'On the Pleasures of Painting'*, exh. cat. by P. Noon; New Haven, Yale Center for British Art; Paris, Petit Palais; 1991–2.

GEORGE PRICE BOYCE 1826–1897

The son of a well-to-do wine merchant, Boyce was born in London. He first trained as an architect, but in 1849 DAVID COX encouraged him to take up landscape painting. Boyce exhibited with the Royal Academy in 1853–61 and then with the OWCS, of which he became an associate in 1864 and a full member in 1877. By the 1860s Boyce had freed himself from Cox's manner and was producing vividly coloured landscapes of scenes in the Thames Valley and elsewhere; the meticulously delineated barns and mills he frequently included in these works reveal his deep knowledge of vernacular construction and materials. Boyce was closely acquainted with the Pre-Raphaelites, notably Dante Gabriel Rossetti, whose drawings he collected, and his *Diary*, published in full in 1980, is a vivid record of their activities.

BIBLIOGRAPHY *George Price Boyce*, exh. cat. by C. Newall & J. Egerton; London, Tate Gallery, 1987.

THOMAS SHOTTER BOYS
1803–1874

Born in London, he trained as an engraver under George Cooke 1817–23, following which he moved to Paris. There he became acquainted with RICHARD PARKES BONINGTON, who encouraged him to take up painting in watercolours. In the early 1830s Boys shared a studio with WILLIAM CALLOW. In 1837 he returned to London with sheaves of watercolours that he colour-lithographed for his *Picturesque Architecture in Paris, Ghent, Antwerp, Rouen etc.* (1839). Three years later he published his equally celebrated *Original Views of London as it is*. These volumes of chromolithographed urban scenes are translations of watercolour painting into printmaking of a standard never previously achieved, but, despite the acclaim they received, Boys found himself increasingly obliged to depend on work as a jobbing engraver and itinerant drawing-master. His later watercolours are less accomplished.

BIBLIOGRAPHY *Thomas Shotter Boys (1803–1874): Centenary Exhibition*, exh. cat. introd A. Smart; Nottingham, University Art Gallery; London, Thomas Agnew & Sons; 1974. J. Roundell, *Thomas Shotter Boys*, London 1974.

WILLIAM CALLOW 1812–1908

He first trained in London as an engraver under a brother of COPLEY FIELDING, moving to Paris in 1829, where he shared a studio with THOMAS SHOTTER BOYS. He soon began exhibiting at the Salon, and established a successful practice as a drawing-master to the French nobility. By the mid-1830s he was undertaking regular walking tours in various parts of Central Europe, the source of much of his subject-matter. He was elected an associate member of the OWCS in 1838, and a full member ten years later. In 1855 Callow returned to England and settled at Great Missenden, Buckinghamshire, where he lived to a ripe old age painting numerous watercolours of the local countryside.

BIBLIOGRAPHY *William Callow: An Autobiography*, ed. H. M. Cundall, London 1908. J. Reynolds, *William Callow, R.W.S.*, London 1980.

JOHN WILSON CARMICHAEL
1799–1868

Born in Newcastle upon Tyne, Carmichael went to sea early in life and then trained as a shipwright before taking painting lessons in Newcastle under Thomas Miles Richardson the elder. For a while he finished plans and perspectives for the city's leading architect, John Dobson, but from 1838 he regularly sent watercolours of Tyneside and the Northumbrian coast to the Royal Academy's exhibitions. He moved to London in 1845 and later made several trips to the Continent, including one to the Baltic on behalf of *The Illustrated London News* during the Crimean War. By the early 1860s his deteriorating health had forced him to settle at Scarborough on the Yorkshire coast. There he continued to concentrate on maritime subjects, having published *The Art of Marine Painting in Watercolours* in 1859.

BIBLIOGRAPHY *John Wilson Carmichael, 1799–1868: Paintings, Watercolours and Drawings*, exh. cat.; Newcastle upon Tyne, Laing Art Gallery, 1982.

THOMAS COLLIER 1840–1891

Born in Derbyshire, in 1854 he moved to Betws-y-coed in North Wales, partly because of that district's associations with DAVID COX, who, along with PETER DE WINT, Collier particularly admired. After 1869 he lived briefly in Birmingham and Manchester before moving to London. He was made an associate member of the NWCS in 1870, and a full member two years later. Collier always preferred to paint out of doors, and during the 1870s frequently travelled in Wales and East Anglia. Unlike most of his contemporaries he worked in a restricted palette range, which suited his favoured subject-matter: open moor, heath and downland under expansive skies.

BIBLIOGRAPHY A. Bury, *The Life and Art of Thomas Collier: Chevalier of the Legion of Honour, 1840–1891*, Leigh-on-Sea 1944, reprd 1977.

WILLIAM COLLINS 1788–1847

At an early age in London, Collins became acquainted with George Morland (1763–1804) through his father, who (in 1805) published the first biography of that painter. Collins's early genre works show Morland's influence. He entered the Royal Academy Schools in 1807, began exhibiting two years later, and was made ARA in 1814. Although he worked chiefly as a painter in oils, Collins produced numerous watercolours, some of them copies after his works in oil. He specialised in landscapes and seashores, frequently enlivened with rustic figures or children, and from *c.* 1815 often visited the East Anglia coast in search of subject-matter. Elected RA in 1820, he visited the Continent several times, spending two years in Italy in 1836–8. Collins's son, the novelist Wilkie Collins, published an appreciative biography the year after his death.

BIBLIOGRAPHY W.W. Collins, *Memoirs of the Life of William Collins, Esq., R.A.*, 2 vols, London 1848, reprd Wakefield 1978.

JOHN CONSTABLE 1776–1837

One of the greatest English painters of landscapes in oils, Constable also worked in watercolours, although he only exhibited examples in this medium in 1805–6 and again in 1832–6, and only at the Royal Academy. Most of his early watercolours are essentially tinted drawings, but during his Lake District tour of 1806 he was painting in watercolours more freely and out of doors, a habit he continued to refine into the 1820s for his sketchbook cloud and sky studies. Constable was elected ARA in 1819, the year he moved out of central London to suburban Hampstead, whose adjacent Heath became an endless source of inspiration, and RA in 1829. During the early 1830s he gave a number of lectures on landscape painting and its history, an adroit commentary by a Romantic artist, although, inevitably, less revealing than his more personal writings.

BIBLIOGRAPHY I. Fleming-Williams, *Constable: Landscape Watercolours and Drawings*, London 1976. M. Rosenthal, *Constable: The Painter and his Landscape*, London 1983. G. Reynolds, *The Later Paintings and Drawings of John Constable*, 2 vols, London 1984. I. Fleming-Williams, *Constable and his Drawings*, London 1990. *Constable*, exh. cat. by L. Parris & I. Fleming-Williams; London, Tate Gallery, 1991.

RICHARD COOPER JNR
c. 1740–*c.* 1814

Born in Edinburgh, he was taught by his father before moving to Paris to train under the engraver J. P. Le Bas. Cooper went to Italy *c.* 1770, but by 1778 he was back in Britain, based initially in Edinburgh and then in London. In the 1780s he was

employed as a drawing-master at Eton College, Berkshire, and he also gave some instruction in painting to members of the royal family. Between 1787 and 1809 he was a regular exhibitor at the Royal Academy; most of the watercolours he showed there are views of Rome and elsewhere based on sketches he had done much earlier in Italy. During his years in London he frequently worked up views he made along the banks of the River Thames below Richmond Park.

BIBLIOGRAPHY Hardie, *I: The Eighteenth Century*, pp. 87–8.

JOHN SELL COTMAN 1782–1842

Born in Norwich, he moved to London in 1798, where he became acquainted with Dr Thomas Monro and members of the Sketching Club set up by THOMAS GIRTIN. In 1803–5 he spent his summers in Yorkshire, notably at Brandsby Hall near York, and Rokeby Hall on the River Greta. In 1806 he returned to Norwich, where he worked as a drawing-master until 1834, apart from 1812–23 when he lived at Yarmouth near his lifelong patron, Dawson Turner. Turner was the motive force behind Cotman's tours to Normandy in 1817, 1818 and 1820, which resulted in a cache of superb architectural watercolours, a genre in which Cotman excelled, and two volumes of etchings. He was elected an associate member of the OWCS in 1825, and in 1834 became Professor of Drawing at King's College, London. In 1841 he made a valedictory sketching tour in Norfolk.

BIBLIOGRAPHY S. Kitson, *The Life of John Sell Cotman*, London 1937. *John Sell Cotman, 1782–1842*, exh. cat. ed. M. Rajnai; London, Victoria & Albert Museum; Manchester, Whitworth Art Gallery; Bristol, Museums & Art Gallery; 1982. A. Hemingway, 'Meaning in Cotman's Norfolk Subjects', *Art History*, VII, 1984, pp. 57–77.

DAVID COX 1783–1859

The son of a Birmingham blacksmith, he was briefly apprenticed to an ornamental painter of cheap jewellery and then worked as a scene-painter. He moved to London in 1804, took lessons from JOHN VARLEY and, in 1808, set up as a drawing-master in Dulwich, south of London. He published several popular instruction manuals, and in 1812 was made an associate member of the OWCS. From 1815 to 1827 Cox lived and taught in Hereford, frequently touring in Wales and northern England and, in the late 1820s, in Flanders and France. In the 1830s he was once again based in London, and then, from 1841, at Harborne near Birmingham. Having received some guidance in oil painting from W. J. MÜLLER, during the 1840s and 1850s Cox worked in both media, spending the summer months sketching in and around Betws-y-coed in North Wales.

BIBLIOGRAPHY *David Cox, 1783–1859*, exh. cat. by S. Wildman, with essays by R. Lockett & J. Murdoch; Birmingham, Museums & Art Gallery; London, Victoria & Albert Museum; 1983–4.

ALEXANDER COZENS *c.* 1717–1786

Born in Russia, where his English father was employed in Tsar Peter the Great's new shipyards, Cozens was in England by 1742. In 1746 he travelled to Rome, where he studied drawing, painting and etching. He was a drawing-master at Christ's Hospital (1749–54), and taught at Eton College, Berkshire, from 1766. He was involved in the circle of painters that set up the Incorporated Society of Artists in 1765, although his attempts to become an ARA were unsuccessful. Cozens began experimenting in painting in watercolours without preliminary pencil or ink outline during his time in Italy, although most of his works in this medium are either washed drawings or 'blots'. The latter formed the basis of the system he devised and set out in *A New Method of Assisting the Invention in Drawing Original Compositions in Landscape* (1785–6).

BIBLIOGRAPHY *The Art of Alexander and John Robert Cozens*, exh. cat. by A. Wilton; New Haven, Yale Center for British Art, 1980. *Alexander and John Robert Cozens: The Poetry of Landscape*, exh. cat. by K. Sloan; London, Victoria & Albert Museum; Toronto, Art Gallery of Ontario; 1986.

JOHN ROBERT COZENS 1752–1797

The son of ALEXANDER COZENS, he was born in London, where his first exhibited drawing was shown in 1767. In 1776 Cozens travelled through Switzerland to Italy with Richard Payne Knight. He spent the next two years drawing in and around Rome, and following his return to London was employed by William Beckford to work up his sketches into finished landscapes. In 1782 Cozens accompanied Beckford on a tour through the Alps to Rome and Naples. Soon after his return to London in 1783 the pair fell out, but Cozens found a ready market for his finished Alpine and Italian views, many of which exist in several versions. By 1794, however, he was suffering from an incurable mental illness, and his final years were spent in the care of Dr Thomas Monro.

BIBLIOGRAPHY *The Art of Alexander and John Robert Cozens*, exh. cat. by A. Wilton; New Haven, Yale Center for British Art, 1980. *Alexander and John Robert Cozens: The Poetry of Landscape*, exh. cat. by K. Sloan; London, Victoria & Albert Museum; Toronto, Art Gallery of Ontario; 1986.

JOSHUA CRISTALL 1768–1847

Born in Camborne, Cornwall, but brought up in London, he worked as a painter on chinaware before attending the Royal Academy Schools and Dr Thomas Monro's 'academy'. He toured North Wales in 1802, returning there the following year with his friend CORNELIUS VARLEY, and over the next 20 years he frequently travelled in Britain, including Scotland and the Lake District, and spent periods in Hastings, the Isle of Wight and elsewhere on the south coast. Although many of his works record the scenery he encountered on these expeditions, he also undertook classical and mythological subjects. Cristall served as President of the OWCS in 1816, 1819 and 1821–31, but having moved to Goodrich in the Wye Valley in the early 1820s he became somewhat isolated from contemporary developments. In 1841 he returned to London, where he continued to show works until his death.

BIBLIOGRAPHY *Joshua Cristall, 1768–1847*, exh. cat. by B. Taylor; London, Victoria & Albert Museum, 1975.

FRANCIS DANBY 1793–1861

Born in Wexford, he studied in Dublin, where he first exhibited in 1812. Soon after this he travelled to London, but on running out of funds on the return journey, settled in Bristol, where he became a prominent member of the local school of artists. Over the next few years he painted landscapes and genre scenes in oils and in watercolour, and some apocalyptic subjects in the manner of JOHN MARTIN. He began exhibiting at the Royal Academy in 1817, and was elected ARA in 1826, but three years later failed to achieve RA, losing to JOHN CONSTABLE by one vote. That year domestic difficulties forced him to move to Switzerland, where he lived until his return to London in 1841. Six years later he retired to Exmouth on the south coast of Devon.

BIBLIOGRAPHY E. Adams, *Francis Darby*, London 1973. *Francis Danby*, exh. cat. by F. Greenacre; Bristol, Museums & Art Gallery; London, Tate Gallery; 1988–9.

WILLIAM DANIELL 1769–1837

He was trained by his uncle Thomas Daniell prior to their departure for the Far East in 1785. The pair spent several years in India making watercolours of its cities and countryside, returning to London in 1794. For the next few years William worked on the aquatints for their *Oriental Scenery*, published in parts in 1795–1808. He was elected ARA in 1807 and RA in 1822, with the intervening years taken up travelling round the British coast in order to produce the 308 aquatints he contributed to the *Voyage Round Great Britain* (1804–25). In the late 1820s he made numerous watercolours of Windsor, Eton and elsewhere in the Thames Valley, not far from the family home at Chertsey.

BIBLIOGRAPHY T. Sutton, *The Daniells: Artists and Travellers*, London 1954. *Artist Adventurers in Eighteenth-century India: Thomas and William Daniell*, exh. cat. by M. Archer; London, Spink & Sons, 1974. M. Archer, *Early Views of India: The Picturesque Journeys of Thomas and William Daniell, 1786–1794: The Complete Aquatints*, London 1980.

EDWARD DAYES 1763–1804

Born in London, he trained under the engraver William Pether. In the course of his life Dayes produced prints, book illustrations, miniatures, and history paintings in oils and watercolours as well as topographical views. From *c.* 1790 he made annual sketching trips in Wales and England, one of which

he wrote up as 'An Excursion through Derbyshire and Yorkshire', which appeared in *The Works of Edward Dayes* (1805), a volume that includes his diary for 1798, 'Essays on Painting: Instructions for Colouring and Drawing Landscapes' and the opinionated 'Professional Sketches of Modern Artists'. During the latter part of his career he was draughtsman to the Duke of York and, from 1788, taught THOMAS GIRTIN.

BIBLIOGRAPHY *The Works*, ed. E. W. Brayley, London 1805; reprd 1971 with an introduction by R. W. Light-bown. J. Dayes, 'Edward Dayes', *Old Water-Colour Society's Club*, XXXIX, 1964, pp. 45–55. D. B. Brown, 'Edward Dayes: Historical Draughtsman', *Old Water-Colour Society's Club*, LXII, 1991, pp. 9–21.

JAMES DEACON *c.* 1728–1750

He worked in London chiefly as a portrait painter in miniature, for which he used wash and water-colour, but he also produced a number of ink and wash landscapes in the 1740s of imaginary, idealised scenes. Deacon's promising career was cut short, however: still in his early twenties, he died from the 'gaol fever' caught at the Old Bailey while attending a trial there as a witness.

BIBLIOGRAPHY *Dictionary of National Biography*.

PETER DE WINT 1784–1849

The son of a physician from New York who had settled in Stoke-on-Trent, De Wint moved to London in 1802 and became an apprentice to the engraver John Raphael Smith. Four years later he began taking lessons in painting under JOHN VARLEY, and entered the Royal Academy Schools in 1809. He was made an associate member of the OWCS in 1810 and a full member the following year. By then he was an established drawing-master, spending the summer months out of London teaching well-to-do provincial families. He frequently visited his wife's home city, Lincoln; many of his panoramic landscapes and haymaking scenes are of that county. Occasionally he toured in Wales, and in 1828 travelled to Normandy.

BIBLIOGRAPHY *Drawings and Watercolours by Peter De Wint*, exh. cat by D. Scrase; Cambridge, Fitzwilliam Museum, 1979. H. Smith, *Peter de Wint, 1784–1849*, London 1982.

JOHN DOWNMAN 1750–1824

Born at Ruabon near Wrexham, he left Wales in 1768 in order to study in London, first under the American painter Benjamin West and then at the Royal Academy Schools. He began exhibiting portraits in watercolour two years later, the genre in which he went on to earn his livelihood, although he also showed subject pictures from time to time. In 1774 he travelled through France to Rome, where he painted a number of landscapes. He returned to Britain in September 1775, after which he lived in turn in Cambridge, London, Exeter and

Plymouth. He was made ARA in 1795. He toured the Lake District in 1812, and continued to exhibit at the Royal Academy until 1819, the year he retired and returned home to Wrexham.

BIBLIOGRAPHY B. S. Long, 'Downman and the Mortlocks', *The Connoisseur*, LXXXVIII, 1931, pp. 10–19. E. Croft-Murray, 'John Downman's "Original First Studies of Distinguished Persons"', *British Museum Quarterly*, XIV, Sept 1939–40, pp. 60–66.

WILLIAM DYCE 1806–1864

Born in Aberdeen, he studied briefly in Edinburgh and London, then lived in Rome in 1825–6 and again in 1827–30. There he was captivated by Quattrocento art, Raphael and the challenge of working in fresco, but during the 1830s, when he was based in Edinburgh, Dyce was almost wholly engaged in painting portraits in oils. In 1836 he moved to London and began his involvement in educational matters with the Government Schools of Design. He was elected ARA in 1844 and RA four years later. In the 1840s he began his labours at the House of Lords, providing the new building with frescoes on Arthurian and other themes. Dyce eschewed such lofty subjects in his watercolours, however, which are chiefly landscapes. An early supporter of the Pre-Raphaelites, he published his *Theory of the Fine Arts* in 1844.

BIBLIOGRAPHY M. Pointon, *William Dyce, 1806–1864: A Critical Biography*, Oxford 1979.

HENRY EDRIDGE 1769–1821

Born in London, he trained as an engraver under William Pether; during his apprenticeship Edridge also studied at the Royal Academy Schools. Initially he set aside engraving in order to concentrate on painting portrait miniatures on ivory, but by degrees moved to working in pencil and ink on paper, and afterwards in watercolour. In 1789 he became friendly with THOMAS HEARNE, with whom he frequently went on excursions, and in the 1790s became closely associated with Dr Thomas Monro and his circle. Although Edridge specialised in small full-length portraits in pencil and water-colour, he also painted rustic landscapes. In 1817 and 1819 he toured Normandy and visited Paris, making numerous picturesque watercolours. In 1820 he was elected ARA.

BIBLIOGRAPHY H. Smith, 'The Landscapes of Henry Edridge, ARA', *Old Water-Colour Society's Club*, LII, 1977, pp. 9–24.

ANTHONY VANDYKE COPLEY FIELDING 1787–1855

Born near Halifax, Yorkshire, but brought up in London and the Lake District, by 1807 he was giving drawing lessons in Liverpool; two years later he settled in London, studied under JOHN VARLEY, and married Varley's sister-in-law. He was made an associate of the OWCS in 1810, and a full member

two years later. For several years Fielding made trips to Wales, and also to County Durham and Yorkshire (1813) and the Wye Valley (1816). Fielding was much sought after as a drawing-master, although this kind of employment allied to his own facility as an artist resulted in an enormous number of landscapes that are below his best. By 1829 he had settled in Brighton. In 1831 he was elected President of the OWCS, a position he maintained until his death.

BIBLIOGRAPHY S. C. Kaines Smith, 'Anthony Vandyke Copley Fielding', *Old Water-Colour Society's Club*, III, 1925–6, pp. 8–30. T. Mullaly, 'Copley Fielding', *The Sussex County Magazine*, XXVI, 1952, pp. 574–8.

FRANCIS OLIVER FINCH 1802–1862

Born in London, he was brought up by relatives in Buckinghamshire, and *c.* 1814 took up a three-year apprenticeship under JOHN VARLEY, followed by two years as his pupil. Finch first exhibited at the Royal Academy in 1817 and at the OWCS in 1822, the year he was made an associate member; he became a full member five years later. His landscapes, the genre to which he devoted himself, are idealised scenes, not dissimilar to some by GEORGE BARRET JNR, and his poetic approach to art was further encouraged by The Ancients, the circle of Blake enthusiasts that included SAMUEL PALMER, in which he became involved. Finch occasionally took pupils in order to augment his income; these he taught in London, a place he rarely left except for the occasional sketching tour and his one trip abroad, to Paris in 1852.

BIBLIOGRAPHY E. Finch, *Memorials of the late F. O. Finch, with Selections from his Writings*, London 1865. A. Bury, 'Francis Oliver Finch', *The Connoisseur*, CIII, 1939, pp. 254–7, 290. R. Lister, *Edward Calvert*, London 1962, Appx III.

MYLES BIRKET FOSTER 1825–1899

Born in North Shields on the River Tyne, he was brought up in London and apprenticed to a wood engraver. During the 1840s he worked as an illustrator for *The Illustrated London News* and other magazines, but after a tour in the Rhineland in 1852–3 he committed himself to learning to paint in watercolour, of which he became a skilful and hugely popular exponent. He was made an associate of the OWCS in 1860 and a full member two years later, and regularly sent works to its annual exhibitions. In 1863 he settled at Witley, Surrey, and many of his most typical works done over the next 30 years – sentimental rustic scenes of playing children or pensive wives outside pictures-que tile-hung cottages, which he painted in stipple – were inspired by the locality's quiet rural life and countryside. Foster regularly toured in Britain and on the Continent, and the results include some excellent finished watercolours based on his Vene-tian sketches.

BIBLIOGRAPHY F. Lewis, *Myles Birket Foster (1825–99)*, Leigh-on-Sea 1973. J. Reynolds, *Birket Foster*, London 1984.

THOMAS GAINSBOROUGH 1727–1788

He was born in Sudbury, Suffolk, trained in London and then set himself up in East Anglia as a portrait painter in oils, although he claimed to prefer to paint landscapes, which he produced throughout his career. In 1759 he moved to Bath, captivating his high-society clientele with richly coloured full-lengths influenced by Rubens and van Dyck. A founder-member of the Royal Academy and the rival of Sir Joshua Reynolds, he settled in London in 1774. Gainsborough's surviving drawings and watercolours are in various media – pencil, chalk, charcoal, wash, bodycolour – and most are either preparatory studies for oil paintings or free sketches, usually of imaginary landscapes. He did, however, occasionally paint finished 'presentation' watercolours to which he added decorative gold-tooled borders and varnish; these, like his sketches, he gave away to friends.

BIBLIOGRAPHY J. Hayes, *The Drawings of Thomas Gainsborough*, 2 vols, London 1970. *Thomas Gainsborough*, exh. cat. by J. Hayes; London, Tate Gallery; Paris, Grand Palais; 1980–81. J. Hayes, *The Landscape Paintings of Thomas Gainsborough*, 2 vols, London 1982.

HENRY GASTINEAU 1791–1876

He began as an apprentice engraver, after which he studied at the Royal Academy Schools, showing his first works at the Academy in 1812. Gastineau was made an associate of the OWCS in 1821, becoming a full member two years later. In 1824 he was among the British artists who exhibited at the Paris Salon, and during the 1820s and after frequently toured in Britain and Ireland; he also made several trips to the Continent. Landscape was his preferred subject. Throughout his career Gastineau lived in London, where he maintained a flourishing business as a drawing-master.

BIBLIOGRAPHY T. Pepper, 'A Watercolourist's Centenary: Henry Gastineau', *Country Life*, CLX, 14 Oct 1976, pp. 1044–5.

WILLIAM GILPIN 1724–1804

Born at Scaleby Castle, Cumbria, he was ordained in 1746 and then took over running a school at Cheam in Surrey, where he remained for the next 30 years. By the late 1760s he was planning a series of books describing tours in Britain in search of Picturesque scenery, to be illustrated with etchings with aquatint made after his own sketches. Between 1782 and 1809 eight volumes appeared, and a whole generation of tourists and amateur sketchers learned to discriminate native scenery according to his precepts. Gilpin was not a consistent thinker, however, and it was left to others, notably Uvedale Price and Richard Payne Knight, to wrestle with the difficulties of defining the Picturesque as an aesthetic category.

BIBLIOGRAPHY W.D. Templeman, *The Life and Work of William Gilpin*, Urbana, IL, 1939. C.P. Barbier, *William Gilpin: His Drawings, Teaching and Theory of the Picturesque*, Oxford 1963.

THOMAS GIRTIN 1775–1802

He and J.M.W. TURNER, his friend and rival, led the revolution in watercolours of the 1790s, and by the time of his early death Girtin had a considerable reputation. Born in Southwark, London, from 1788 he worked for EDWARD DAYES and THOMAS MALTON JNR. He began exhibiting landscape watercolours at the Royal Academy in 1794, the same year he toured the Midlands for the first time and, with Turner, was taken on by Dr Thomas Monro to make copies of Monro's collection of watercolours by JOHN ROBERT COZENS and others. Over the next seven years Girtin customarily toured in Britain each summer, working up his landscape sketches into exhibition pieces during the winter months; increasingly for these he suppressed descriptive detail in favour of broad effects executed in a limited tonal range of pure watercolour. Several artists received lessons from him, and in 1799 he set up a significant, if short-lived, sketching club, 'The Brothers'. Girtin spent the winter of 1801–2 in poor health in Paris, and his ambitious panorama, the Eidometropolis, opened only months before his death in London the following November.

BIBLIOGRAPHY T. Girtin & D. Loshak, *The Art of Thomas Girtin*, London 1954. *Watercolours by Thomas Girtin*, exh. cat. by F. Hawcroft; Manchester, Whitworth Art Gallery; London, Victoria & Albert Museum; 1975. *Thomas Girtin, 1775–1802*, exh. cat. by S. Morris; New Haven, Yale Center for British Art, 1986.

JOHN GLOVER 1767–1849

The son of an impoverished Leicestershire farmer, in 1794 he set up as a drawing-master in Lichfield, Staffordshire. One of the founder-members of the OWCS in 1804, he was instrumental in its short-lived reconstruction as a society of watercolour and oil painters (and briefly its President), but withdrew in 1817, the year he made his unsuccessful bid for election to the Royal Academy. In 1820 he held the first of his one-man shows in London, and in 1824 helped set up the Society of British Artists. Glover undertook regular sketching trips in Britain, notably to North Wales and the Lake District, and from 1814 on the Continent. In 1831 he emigrated to Tasmania, using his substantial savings to set himself up as a sheep farmer.

BIBLIOGRAPHY B.S. Long, 'John Glover', *Walker's Quarterly*, XV, 1924, pp. 1–51. H. Smith, 'John Glover, OWCS: 1767–1849', *Old Water-Colour Society's Club*, LVII, 1982, pp. 7–21.

ALBERT GOODWIN 1845–1932

Born in Maidstone, where his father ran a building firm, he was taught in London by the Pre-Raphaelites Arthur Hughes and Ford Madox Brown. Elected an associate of the OWCS in 1871, he became a full member ten years later. Following a three-month trip to Italy in 1872 with JOHN RUSKIN, Goodwin made numerous trips abroad, voyaging as far afield as India and the South Seas.

He worked at, and exhibited, land- and townscapes throughout his long career, and after establishing a home in Arundel, Sussex, frequently went on sketching excursions in the surrounding counties. His work was heavily influenced by that of J.M.W. TURNER.

BIBLIOGRAPHY H. Smith, *Albert Goodwin, R.W.S., 1845–1932*, Leigh-on-Sea 1977.

JAMES DUFFIELD HARDING 1797–1863

The son of a drawing-master living in Deptford, London, who had trained under PAUL SANDBY, Harding was taught by SAMUEL PROUT c. 1811 before being apprenticed to the engraver John Pye. He abandoned engraving after one year to devote himself to painting in watercolour, teaching and lithography. He became an associate of the OWCS in 1820 and a full member the following year. In 1824 Harding made the first of his several trips to Italy, and followed Prout in specialising in the Continental picturesque, although RICHARD PARKES BONINGTON and J.M.W. TURNER were the chief influences on his style. He became the foremost drawing-master of his day (in the early 1840s JOHN RUSKIN was among his pupils), and well-known for his illustrations in the *Landscape Annual* as well as for the lithographs and (from 1841) lithotints he made for his own published portfolios, such as *Sketches at Home and Abroad* (1836), and his manuals, for example *Lessons on Trees* (1852). Harding also made prints after works by others, including Bonington, J.F. LEWIS and DAVID ROBERTS.

BIBLIOGRAPHY C. Skilton, 'James Duffield Harding: A Centenary Memoir', *Old Water-Colour Society's Club*, XXXVIII, 1963, pp. 37–53.

WILLIAM HAVELL 1782–1857

The son of a Reading drawing-master, Havell was a founder-member of the OWCS in 1804. He travelled in North Wales in 1802 and 1803, and in 1807 settled in the Lake District for a year. Havell was a regular contributor of illustrations to various publications, and a notable series of his watercolours was aquatinted and published in 1812 as *Picturesque Views of the River Thames*. Four years later he was included in Lord Amherst's embassy to China, but turned back at Macao and spent the next eight years in India painting portraits and some landscapes in watercolour. On returning to London he rejoined the OWCS in 1827, then spent 1828–9 in Italy in the company of Thomas Uwins, but from c. 1830 concentrated on painting in oils.

BIBLIOGRAPHY *William Havell, 1782–1857: Paintings, Watercolours, Drawings and Prints*, exh. cat. by F. Owen & E. Stanford; London, Spink & Son Ltd; Reading, Museum & Art Gallery; Kendal, Abbot Hall Art Gallery; 1981–2.

THOMAS HEAPHY 1775–1835

He trained in London as an engraver while taking lessons in portrait painting in the evenings, and

entered the Royal Academy Schools in 1796. He was appointed portrait painter to the Princess of Wales in 1803 and became an associate of the OWCS three years later, but resigned from the Society in 1812, holding his own one-man show the following year. Although he went to Spain towards the end of the Peninsular War to make portraits in watercolours of British officers there, by then Heaphy was concentrating on picturesque genre scenes, for which he charged high prices. He also painted in oils, and was instrumental in setting up the Society of British Artists in 1824 and, at the end of his life, the NWCS in 1832.

BIBLIOGRAPHY H. Hubbard, 'Thomas Heaphy', *Old Water-Colour Society's Club*, XXVI, 1948, pp. 19–30.

THOMAS HEARNE 1744–1817

He left Wiltshire in his teens to work as a pastry cook in London before taking up a six-year apprenticeship in 1765 under the engraver William Woollett. He then spent several years in the Leeward Islands as the Governor-General's official artist. On his return to London in 1775 Hearne rapidly established himself as the leading topographical draughtsman of the day. His tours with Sir George Beaumont to the Lake District (1777) and Scotland (1778) contributed to his stock of watercolours of abbeys, castles and other Picturesque subjects, a number of which William Byrne engraved for their major series, *The Antiquities of Great Britain*, issued in two volumes in 1786 and 1806. In the early 1780s he worked for Richard Payne Knight. In the following decade the young J.M.W. TURNER and THOMAS GIRTIN were set to copying works by Hearne in the possession of another of his admirers, Dr Thomas Monro.

BIBLIOGRAPHY *Thomas Hearne, 1744–1817: Watercolours and Drawings*, exh. cat. ed. D. Morris; Bolton, Museum & Art Gallery; Southampton, City Art Gallery; Bath, Victoria Art Gallery; 1985–6. D. Morris, *Thomas Hearne and his Landscape*, London 1989.

ROBERT HILLS 1769–1844

A founder-member of the OWCS, he trained under John Alexander Gresse before entering the Royal Academy Schools in 1788. Hills became best-known for his studies of animals, and added deer or cattle to the foregrounds of landscapes by other artists, notably GEORGE FENNEL ROBSON, William Andrews Nesfield and GEORGE BARRET JNR. From 1798 he issued an extensive series of *Etchings of Quadrupeds*, and became an accomplished student of anatomy. He frequently toured in Britain with his friend JAMES WARD, and in 1815 visited the Low Countries, including the site of the Battle of Waterloo only weeks after the event. In 1831 he went to Jersey in the Channel Islands, returning there two years later with Robson. Many of his landscapes were made in West Kent and Surrey.

BIBLIOGRAPHY L. Herrmann, 'Robert Hills at Waterloo', *The Connoisseur*, CL, 1962, pp. 174–7. M. Lambourne, 'A Watercolourist's Countryside: The Art of Robert Hills', *Country Life*, CXLIV, 25 July 1968, pp. 235–8.

HENRY GEORGE HINE 1811–1895

Born in Brighton, he taught himself to paint landscapes and coastal scenes in watercolour, in part by studying works by COPLEY FIELDING in the possession of a local clergyman. Following his apprenticeship to an engraver in London, Hine spent two years in Rouen before returning to the capital to take up employment in 1840 as an illustrator for various magazines. He first exhibited in 1830, but did not become an associate of the OWCS until 1863, although he was quickly elected a full member the following year and served as Vice-President 1888–95. For much of his career Hine continued to work in Fielding's vein, and his preferred landscapes were those of Sussex, particularly the wooded hills and vales of the South Downs.

BIBLIOGRAPHY Hardie, *II: The Romantic Period*, pp. 229–30. Newall, *Victorian Watercolours*.

JAMES HOLLAND 1799–1870

He began as a flower-painter on pottery in his native Staffordshire and then, from 1819, in London, but by the early 1820s he was making watercolours of coastal scenes and architectural subjects. Although after *c.* 1830 he mainly worked in oils, and regularly exhibited at the Royal Academy and elsewhere, he was an associate of the OWCS 1835–43 and a full member from 1857. Holland became a sought-after illustrator for annuals, and following his first Continental trip, to Paris in 1831, regularly went abroad in this capacity, which included a visit to Portugal in 1837. His views of European cities, and Venice in particular, a city he visited several times in the 1850s, are elaborately coloured works influenced by RICHARD PARKES BONINGTON, whose watercolours Holland had studied early in his career.

BIBLIOGRAPHY M. Tonkin, 'The Life of James Holland of the Old Society, 1799–1870', *Old Water-Colour Society's Club*, XLII, 1967, pp. 35–50.

ALFRED WILLIAM HUNT 1830–1896

The son of a Liverpool landscape painter acquainted with DAVID COX, Hunt first exhibited at the age of 12, and later joined the Liverpool Academy, showing there and in London. Prior to 1861 he pursued an academic career at Oxford, but that year he married a popular novelist, and in 1862 moved to London and became an associate of the OWCS. A follower of J.M.W. TURNER and a close friend of the Pre-Raphaelites, Hunt regularly worked out-of-doors on his tours in Scotland, the Lake District, North Wales and elsewhere, and his laboriously executed exhibition landscapes are brilliant in both technique and colouring. In 1869–70, five years after he became a full member of the OWCS, he made his most memorable Continental trip, to Italy, Sicily and Greece. He was elected Vice-President of the OWCS in 1888.

BIBLIOGRAPHY V. Hunt, 'Alfred William Hunt', *Old Water-Colour Society's Club*, II, 1924–5, pp. 29–47. Newall, *Victorian Watercolours*.

WILLIAM HENRY HUNT 1790–1864

An outstanding technician who specialised in still-life compositions and genre subjects, 'Bird's-nest' Hunt was the son of a London manufacturer. He studied under JOHN VARLEY in 1804–11, spending some of this period at the Royal Academy Schools and at Dr Thomas Monro's 'academy'. His early works include watercolour portraits in miniature and landscapes, but by the time he joined the OWCS in 1824 (he became a full member two years later) Hunt was narrowing his field. He exhibited his first bird's-nest study in 1830, and over the following decades his still-lifes of fruit, flowers, nests and eggs (their remarkable luminosity is the effect of water- and bodycolour painted on a hard ground of Chinese white and gum) became prized objects. During the 1830s and 1840s he also exhibited a number of genre scenes, chiefly of figures in domestic settings, some of which are candlelit. Hunt's admirers included JOHN RUSKIN, who took lessons from him in 1854 and 1861.

BIBLIOGRAPHY *William Henry Hunt, 1790–1864*, exh. cat. by T. Jones; Wolverhampton, Art Gallery, 1981. J. Witt, *William Henry Hunt (1790–1864): Life and Work, with a Catalogue*, London 1982.

WILLIAM HOLMAN HUNT 1827–1910

He spent several years of drudgery in a London office before entering the Royal Academy Schools in 1844, where he met JOHN EVERETT MILLAIS and Dante Gabriel Rossetti. Their dissatisfaction with current academic art resulted in the formation of the Pre-Raphaelite Brotherhood in 1848, the subject of Hunt's late reminiscences, *Pre-Raphaelitism and the Pre-Raphaelite Brotherhood* (1905). In 1854–6 he undertook the first of several trips to the Near East in search of archaeologically accurate settings for his studio works on biblical themes, and the painstakingly delineated landscapes in the oils he showed in London mostly derive from watercolours made on these expeditions. Hunt also exhibited watercolours of Near Eastern and British scenery, some of them with the OWCS, of which he became an associate in 1869 and a full member in 1887.

BIBLIOGRAPHY *William Holman Hunt*, exh. cat. by M. Bennett; Liverpool, Walker Art Gallery; London, Victoria & Albert Museum; 1969. *The Pre-Raphaelites*, exh. cat., 1984.

SAMUEL JACKSON 1794–1869

The son of a Bristol merchant, after some initial encouragement from FRANCIS DANBY he developed into a skilful landscape watercolourist, frequently sketching in and around Bristol and along the Avon Valley. He toured in Scotland and Ireland early in his career, later making frequent visits to Wales and Devon, and in 1827 spent some months in the West Indies. He joined the OWCS in 1823 (resigning in 1848), helped organise the first exhibition of works by local artists the following

year, and was instrumental in the formation of the Bristol School of Artists in 1832. He twice toured in Switzerland, in 1855 and again in 1858.

BIBLIOGRAPHY *The Bristol Landscape: The Watercolours of Samuel Jackson (1794–1869)*, exh. cat. by F. Greenacre & S. Stoddard; Bristol, City Art Gallery, 1986.

JAMES JOHNSON 1803–1834

One of the most talented members of the circle of artists at work in Bristol in the early 19th century, he was the son of an innkeeper. A co-organiser of the city's first exhibition of local artists in 1824, during the early 1820s Johnson spent some of his brief career in London, and then, nearer home, was active in Bath as a drawing-master. In addition to landscapes in watercolour and in oil, he executed a number of ecclesiastical interiors in a characteristically sharp, meticulous style.

BIBLIOGRAPHY *The Bristol School of Artists: Francis Danby and Painting in Bristol, 1810–1840*, exh. cat. 1973.

EDWARD LEAR 1812–1888

A self-taught artist from London who became celebrated for his humorous Nonsense verses, he began as an ornithological draughtsman for the Zoological Society and then, in 1832–6, for the Earl of Derby, who kept a menagerie at Knowlsey, Lancashire. By the time Lear set out for Italy in 1837 he was a committed topographical painter, and the wanderings he undertook in southern Europe, the Near East and elsewhere over the next 40 years were copiously recorded in thousands of distinctive colour-washed drawings. These provided the material for the saleable finished watercolours and oil paintings he exhibited back home. Apart from the period 1850–54 Lear rarely stayed long in London: he first visited Greece and Egypt in 1848–9, and as late as 1873–5 went the length and breadth of India and Sri Lanka. His travel books include *Journals of a Landscape Painter in Greece and Albania* (1851) and *Southern Calabria* (1852). Between trips Lear lived mostly in Italy, from 1871 on the Riviera at San Remo, where he died.

BIBLIOGRAPHY P. Hofer, *Edward Lear as a Landscape Draughtsman*, Cambridge, MA, 1967. *Edward Lear, 1812–1888*, exh. cat. by V. Noakes; London, Royal Academy of Arts, 1985.

GEORGE ROBERT LEWIS 1782–1871

Born into a family of artists in London, he studied under J. H. Fuseli at the Royal Academy Schools. Lewis worked in watercolour and in oil, and painted portraits as well as landscapes, the latter frequently georgic subjects, such as harvesting. In 1813 he toured in Wales with JOHN LINNELL, and five years later visited France and Germany as a professional draughtsman to the bibliophile Dr T. F. Dibdin, whose illustrated *Picturesque Tour* of their travels appeared in 1821. From 1820 Lewis published a number of illustrated books on subjects

ranging from phrenology to medieval English churches, and although not a frequent exhibitor he continued to show landscapes at the Royal Academy, the OWCS and elsewhere until c. 1860.

BIBLIOGRAPHY *Dictionary of National Biography. The Tate Gallery Illustrated Catalogue of Acquisitions, 1980–82*, London 1984, pp. 27–8. Mallalieu, *Dictionary*, 1, revd 1986.

JOHN FREDERICK LEWIS 1805–1876

The son of a London engraver, he began as a painter of animal subjects in the company of Edwin Landseer. Having been elected an associate of the OWCS in 1827 – the year he travelled through Switzerland to Venice – and a full member in 1830, Lewis abandoned oil and painted exclusively in water- and bodycolour until the late 1850s. Having spent 1830–2 at work in Spain and Morocco, the results of which were lithographed and published as *Lewis's Sketches and Drawings of the Alhambra* (1835) and *Lewis's Sketches of Spain and Spanish Character* (1836), in 1837 he set off abroad once more, eventually settling in Cairo in 1841, where he remained for the next ten years. None of the vivid orientalist works he made in the Near East were seen in London until 1850, when he sent *The Hhareem* (private collection) for exhibition at the OWCS; upon returning home the following year his works received huge critical acclaim, although by 1858 he was forced to abandon watercolour and the OWCS for oil painting and greater remuneration. He was elected ARA the following year and RA in 1865.

BIBLIOGRAPHY M. Lewis, *John Frederick Lewis, R.A., 1805–1876*, Leigh-on-Sea 1978. C. Newton & B. Llewellyn, 'The English Harem', *The Independent Magazine*, 4 Jan 1992.

JOHN LINNELL 1792–1882

The son of a London frame-maker and picture dealer, he studied in his teens under JOHN VARLEY and at the Royal Academy Schools. Linnell began exhibiting works in watercolour and oil in 1807, but in 1811–12 – in the latter year he became an associate of the OWCS – he experienced a spiritual crisis that resulted in his long adherence to the Baptist Church. This marked a change of direction in his work, which became charged with a new spiritual intensity. In 1813 he travelled in Wales with GEORGE ROBERT LEWIS, visiting Dovedale in Derbyshire the following year. He left the OWCS in 1820 because of its renewed commitment to exclude works in oil, by which date he was also painting portraits and giving lessons. Having met WILLIAM BLAKE in 1818, he became his supporter and patron, introducing him to SAMUEL PALMER and other artists who later formed The Ancients. In 1851 he moved to Redhill, Surrey, where he devoted himself to painting landscapes, notably of the North Downs and Kentish Weald.

BIBLIOGRAPHY *John Linnell: A Centennial Exhibition*, exh. cat. by K. Crouan; Cambridge, Fitzwilliam Museum; New Haven, Yale Center for British Art; 1982–3.

THOMAS MALTON JNR 1748–1804

The son of an architectural draughtsman living in London, he was taught by his father and, from 1773, at the Royal Academy Schools. He subsequently exhibited architectural subjects at the Royal Academy, but in 1795 was refused ARA on the grounds that he was not a practising architect. Malton earned part of his income as a scene-painter at Covent Garden, but he also taught perspective, and both J.M.W. TURNER and THOMAS GIRTIN seem to have worked in his office. Throughout his career he remained wedded to architectural subjects, and between 1792 and 1801 published *A Picturesque Tour through the Cities of London and Westminster*, a series of 100 aquatints after his drawings. At his death he was still at work on a similar treatment of Oxford, some aquatints having been published in 1802.

BIBLIOGRAPHY Colvin, *Biographical Dictionary*, revd 1978.

JOHN MARTIN 1789–1854

Born at Haydon Bridge, Northumberland, he was apprenticed to a coach-painter in Newcastle upon Tyne but ran off to London in 1805, where for a while he earned his living painting china- and glassware. His first exhibits, from 1812 at the Royal Academy and other institutions, were chiefly in oil, but he later made numerous watercolours on his tours in the Home Counties and elsewhere. After 1821, the year he showed his oil painting of *Belshazzar's Feast*, Martin enjoyed an international reputation as a painter of apocalyptic themes, though some thought his work sensationalist and poorly coloured. In 1836 he became a member of the NWCS, but this connection was short-lived. His millenarian preoccupations extended to various technical schemes for urban renewal, although the pyromantic inclinations of his fanatical brother Jonathan, also an artist, who burnt down part of York Minster in 1829, seem closer in spirit to the awesome vision encountered in so many of Martin's finished works.

BIBLIOGRAPHY T. Balston, *John Martin*, London 1947. W. Feaver, *The Art of John Martin*, Oxford 1975.

JOHN MIDDLETON 1827–1856

The son of a Norwich painter and decorator, he was one of the city's rising generation of artists in the 1840s, having been the pupil of two local painters before taking lessons from Henry Bright. In 1847 Middleton moved to London, the year he also toured in Kent with Bright and produced a number of his best free watercolour landscapes. The following year the death of his father obliged him to return to Norwich, although he continued to exhibit works in watercolour and oil at the Royal Academy and British Institution as well as in Norwich. His tours in Britain included Wales and Scotland, the latter in 1853. He was also a keen photographer.

JOHN EVERETT MILLAIS 1829–1896

Born into a wealthy Jersey family, he entered the Royal Academy Schools, where his precocious talent allowed him to carry off all the prizes. Millais first exhibited at the Academy in 1846, becoming an ARA seven years later; he was made RA in 1863. He was among the founders of the Pre-Raphaelite Brotherhood in 1848, and his subsequent works, particularly those in oil, which are frequently of subjects from Italian and English history, Shakespeare and the Bible, are appropriately vivid in their colouring and scrupulously delineated. In addition, he painted a number of landscapes, including watercolours of the Scottish Highlands, and he also designed book illustrations. In 1855 he married Effie Grey, the ex-wife of JOHN RUSKIN, his former friend and supporter. A hugely successful artist who devoted himself increasingly to portraiture and sentimental subject pictures, Millais was made a baronet in 1885, and, in the year of his death, elected President of the Academy.

BIBLIOGRAPHY *Millais*, exh. cat. by M. Bennett; London, Royal Academy of Arts, 1967. *The Pre-Raphaelites*, exh. cat., 1984.

ALBERT JOSEPH MOORE 1841–1893

The son of a portrait painter from Birmingham who had settled in York, following the death of his father in 1851 Moore was taught by one of his own brothers. In 1855 he moved to London, entering the Royal Academy Schools three years later. At first preoccupied with bird studies and then for a while with biblical subjects, after spending some months in Rome in 1862–3 he gradually established himself as one of the High Victorian 'Olympians', painting Roman and Hellenic themes, and for many years exhibited at the Royal Academy.

BIBLIOGRAPHY *Art Journal*, 1881, 1893 & 1903. Mallalieu, *Dictionary*, 1, revd 1986.

WILLIAM JAMES MÜLLER 1812–1845

His father had been forced by the Napoleonic War to move from Danzig to Bristol, where he became Curator of the city's Museum. There Müller made his first drawings, following which he was apprenticed to J. B. Pyne, although he abandoned his master after only two years. During the early 1830s Müller toured in East Anglia and Wales, began exhibiting oils and watercolours in London and helped set up the Bristol School of Artists, but after his trip to Italy via Germany and Switzerland in 1834–5 he spent much of his short career abroad. In 1839–40 he travelled in Greece and Egypt, and in 1840 spent some months in northern France working on illustrations afterwards lithographed for *Sketches Illustrative of the Age of Francis I of France*

(1841). Three years later, at his own expense, he joined Sir Charles Fellows's expedition to Lycia in south-west Turkey. He returned the following year with sheaves of landscape sketches and studies of antiquities, but his health by then was in rapid decline.

BIBLIOGRAPHY *W. J. Müller, 1812–1845*, exh. cat. by F. Greenacre & S. Stoddard; Bristol, City Art Gallery, 1991.

FREDERICK NASH 1782–1856

His father was a London builder, and Nash studied perspective drawing under THOMAS MALTON JNR and then at the Royal Academy Schools. His skill as an architectural draughtsman – J.M.W. TURNER thought him unsurpassed in his day – led to his employment by John Britton on various illustrated books of British antiquities, and in 1807 he was taken on by the Society of Antiquaries. He became involved in the OWCS in 1810, and frequently exhibited with the Society. Nash first travelled on the Continent in 1816, and during the 1820s frequently visited Paris in order to make provisional sketches for the watercolours and oils of the capital and its surrounding chateaux that he afterwards exhibited. In 1834 he settled in Brighton and went on to make a number of landscapes of Sussex scenery; during this decade and in the 1840s he also made several tours to the Low Countries and the Rhineland.

BIBLIOGRAPHY *Dictionary of National Biography*.

PATRICK NASMYTH 1787–1831

His father, a successful portrait painter in Edinburgh, gave Nasmyth his first lessons, and from 1808 to 1814 he showed works at the exhibitions organised by the capital's Society of Associated Artists, a number of which were of Scottish scenery. Following his move to London in 1808 Nasmyth initially exhibited his works in oil and watercolour at the Royal Academy, but from the mid-1820s preferred to show with the Society of British Artists and the British Institution. He frequently went on sketching trips to the North and South Downs and elsewhere in the Home Counties, and in addition to his many landscapes inspired by the Dutch masters painted a number of careful nature studies.

BIBLIOGRAPHY P. Johnson & E. Money, *The Nasmyth Family of Painters*, Leigh-on-Sea 1977.

JOHN WILLIAM NORTH 1842–1924

He first trained as a wood engraver in London in the late 1850s under Josiah Wood Whymper, in whose workshop he met Frederick Walker, the artist-illustrator who became one of North's closest friends and his co-traveller to Algeria in the winter of 1873–4. In the early 1860s he was employed by the Dalziel Brothers, a leading firm of wood engravers who supplied the world of publishing with every kind of illustration. North moved to Somerset in 1868, where he found abundant

material for his landscapes and genre scenes of rustic life. He was elected an associate of the OWCS in 1871, becoming a full member 12 years later. In 1893 he was made an ARA, by which time he had embarked on his long-term preoccupation with the manufacture and marketing of high-quality paper for watercolour painting.

BIBLIOGRAPHY H. Alexander, 'John William North', *Old Water-Colour Society's Club*, v, 1927–8, pp. 35–59.

SAMUEL PALMER 1805–1881

Born in London, he showed his first landscapes at the Royal Academy at the age of 14. Three years later he met JOHN LINNELL, who directed Palmer towards the art of Albrecht Dürer and his age, and in 1824 introduced him to WILLIAM BLAKE. Palmer's admiration for Blake, which was shared by GEORGE RICHMOND, Edward Calvert and F. O. FINCH among others, led to the formation of The Ancients soon after. In 1826 Palmer moved to Shoreham, a village on the edge of the Kentish North Downs, where he remained until 1834. Much fine work was stimulated by the religious feeling of his Shoreham years, notably a sequence of mystical pastoral landscapes – moonlit harvesters, umbrageous vales, quiet streams – that offer a vision of parish England untarnished by want or unrest. Three years after his return to London, Palmer married Linnell's daughter; a two-year honeymoon in Italy followed. From 1839 to 1861 he taught drawing in London, was an active exhibitor with the OWCS, and painted Claudean landscapes. He then moved to Redhill, Surrey, to where Linnell had retired; there he continued to paint and etch.

BIBLIOGRAPHY *Samuel Palmer, 1805–1881: A Loan Exhibition from the Ashmolean Museum, Oxford*, exh. cat. by D. B. Brown; London, Hazlitt, Gooden & Fox; Edinburgh, National Gallery of Scotland; 1982. *Samuel Palmer and 'The Ancients'*, exh. cat. by R. Lister; Cambridge, Fitzwilliam Museum, 1984. R. Lister, *Catalogue Raisonné of the Works of Samuel Palmer*, Cambridge 1988.

WILLIAM PARS 1742–1782

During his youth in London he studied to become a landscape and history painter, but until 1764 earned his living as a portrait painter. That year he was engaged by the Society of Dilettanti to accompany the antiquary Richard Chandler and the architect Nicholas Revett on their expedition to record little-known Greek antiquities in Asia Minor. This trip lasted two years, and included a visit to Greece in the course of the journey home. Pars's drawings of the sites in Asia Minor were engraved and published in the two-volume *Antiquities of Ionia* (1769, 1797), while a number of those he made in Greece served to illustrate the second and third volumes of *The Antiquities of Athens* begun earlier by Revett and 'ATHENIAN' STUART. In 1770 Pars was elected ARA, the year he accompanied his patron Lord Palmerston on a Grand Tour through the Alps. The works Pars exhibited at the Royal Academy the following year were among the first Alpine views

BIBLIOGRAPHY F. W. Hawcroft, 'John Middleton: A Sketch of his Life and Work', *The Saturday Book*, no. 16, London 1956. Moore, *The Norwich School of Artists*, pp. 132, 142–5.

ever shown in London. He and Palmerston made trips to Ireland and the Lake District soon after, but in 1775 Pars set out alone for Italy. There he worked at his views of Rome, the Campagna and Naples in company with Thomas Jones and others until his death.

BIBLIOGRAPHY A. Wilton, 'William Pars and his Work in Asia Minor', *Richard Chandler: Travels in Asia Minor, 1764–1765* [1825], ed. & abridged by E. Clay, London 1971, pp. xix-xlv. A. Wilton, *William Pars: Journey through the Alps*, Zurich 1979. *Travels in Italy, 1776–1783: Based on the 'Memoirs' of Thomas Jones*, exh. cat. 1988.

SAMUEL PROUT 1783–1852

In 1801 in his home city of Plymouth Prout met the antiquary John Britton, who persuaded him to move to London the following year and work as a draughtsman on Britton's serial *Beauties of England and Wales* (1803–13). Prout soon began exhibiting coast scenes and other works at various venues in the capital, gradually became known as a drawing-master, and in due course published several instruction manuals. In 1817 he became an associate of the OWCS, the year he first visited the Continent in search of picturesque topographical subjects. Despite indifferent health, between 1820 and 1846 he regularly scoured Normandy, the Low Countries, the Rhine Valley, Switzerland, Venice and elsewhere; the warmly coloured drawings of old buildings and towns that he exhibited and easily sold reached a wider audience in the form of engravings and lithographs. Prout was based in Hastings for several years before moving to Denmark Hill in south London in 1844, where his new neighbour was JOHN RUSKIN, a fervent admirer.

BIBLIOGRAPHY R. Lockett, *Samuel Prout (1783–1852)*, London 1985.

ALLAN RAMSAY 1713–1784

One of the leading portrait painters in London in the mid-18th century, he was born in Edinburgh. He travelled to London in the early 1730s, where he received some studio training in portraiture, but spent 1736–8 studying with Imperiali in Rome, and then in Naples with the aged Solimena. Over the next 30 years in London Ramsay built up an enviable network of aristocratic patronage, and from 1761 was Principal Painter to George III. In addition to his commissioned oils he frequently drew head-and-shoulders portraits in pastels, and he also produced some landscapes, notably during his second stay in Italy in 1754–7. In 1773 he abandoned art altogether, probably because of an accident he received to his arm. He made two further visits to Italy in his quest to locate the site of the villa of the Roman poet Horace, dying at Dover on his return.

BIBLIOGRAPHY A. Smart, *Allan Ramsay: Painter, Essayist and Man of the Enlightenment*, London 1992. *Allan Ramsay, 1713–1784*, exh. cat. by A. Smart; Edinburgh, Scottish National Portrait Gallery; London, National Portrait Gallery; 1992–3.

GEORGE RICHMOND 1809–1896

Born into a family of painters in miniature in London, he also trained at the Royal Academy Schools, which he entered in 1824. There he met SAMUEL PALMER, who along with Richmond and several others went on to form The Ancients, a circle of admirers of the aged WILLIAM BLAKE, to whom Richmond was first introduced in 1825. He frequently visited Palmer at Shoreham in Kent in the late 1820s and after, but spent the year 1828 in Paris in order to continue his training as a painter; later, in 1837, he travelled to Italy with Palmer, remaining there for two years. In the 1840s Richmond took up painting portraits in oil as well as in watercolour, and by the time of his election as ARA in the late 1850s (RA from 1866) he had a flourishing practice, although the oils that resulted are mostly routine. He also did a number of landscapes in watercolour, and occasionally practised etching.

BIBLIOGRAPHY R. Lister, *George Richmond: A Critical Biography*, London 1981.

DAVID ROBERTS 1796–1864

He began as a theatre scene-painter in Edinburgh, moving to London in 1822, where for a while he was similarly employed. Despite having received no formal training as an artist, Roberts was exhibiting architectural subjects at the Royal Academy and elsewhere from 1825. His first lengthy tour abroad was in 1832–3 to Spain, and he returned with bundles of sketches on which to base his finished watercolours and oils. Many were then reproduced as prints, and collected as *Picturesque Sketches in Spain* (1837); their success put him much in demand as a topographical illustrator. Although Roberts frequently travelled on the Continent over the next few years, his most important undertaking was the arduous expedition he made through Egypt, the Holy Land and Syria in 1838–9, in the course of which he sketched almost all the classic sites. The 250 superb chromolithographs after his finished watercolours that subsequently appeared in six separate volumes as *Views of the Holy Land, Syria, Idumea, Arabia, Egypt* and *Nubia* (1842–9) earned him an international reputation. Having been made ARA in the year he set out for the Near East, he was elected RA in 1841. A decade later he served as a commissioner for the Great Exhibition held in London.

BIBLIOGRAPHY *David Roberts*, exh. cat. by H. Guiterman & B. Llewellyn; London, Barbican Art Gallery, 1987.

GEORGE FENNEL ROBSON 1788–1833

Having received a few lessons from a local drawing-master in Durham, he moved to London c. 1804, where he worked as a salesman in a workshop-cum-gallery. He soon became acquainted with the circle headed by JOHN VARLEY, whose work was to have a long-term influence on Robson, and he first exhibited at the Royal Academy in 1807. In 1810 he made a tour of Scotland, which resulted in a set of etchings published as *Scenery of the Grampian Mountains* four years later, and also fostered Robson's enduring enthusiasm for the wild scenery of Celtic Britain. He made a number of tours in the Highlands and Wales, and also visited Ireland. Most of the landscapes he exhibited at the OWCS, which he joined in 1813, serving as President in 1820, are of dramatic mountain scenery, often painted in deep purples and browns. The animals to be seen in these works are often by ROBERT HILLS.

BIBLIOGRAPHY T. Uwins, 'George Fennel Robson (1788–1833)', *Old Water-Colour Society's Club*, XVI, 1938, pp. 37–49 [reprinted from *Lo Studio*, 1833].

MICHAEL 'ANGELO' ROOKER 1746–1801

He learned engraving from his father, a part-time actor on the London stage, and in the 1760s Rooker was taught by PAUL SANDBY, who nicknamed him. He began exhibiting oil paintings in the same decade, entered the newly established Royal Academy Schools in 1769, and was among the first artists to be elected ARA the following year. In the 1770s he worked as a draughtsman and engraver while nourishing an ambition to become a professional oil painter, but by 1780 he had turned to drawing and watercolour, and to employment as a theatre scene-painter. A topographical draughtsman in the Sandby tradition, Rooker began making regular walking tours across the counties of England and Wales in 1788. The style of his meticulously drawn and coloured scenes of picturesque antiquities and other subjects was to change little over the years.

BIBLIOGRAPHY P. Conner, *Michael Angelo Rooker (1746–1801)*, London 1984.

THOMAS ROWLANDSON 1756–1827

A celebrated social satirist and caricaturist, he was the son of a bankrupt London merchant, and briefly studied in Paris in his teens before attending the Royal Academy Schools from 1772. In 1775 he began exhibiting his works, but did not keep this up for more than a few years. During the 1780s Rowlandson etched a number of political satires, although he was also producing some of his best pen and watercolour drawings, including landscapes, in the same period. From c. 1800 his enormous output was mostly handled by the print publisher Rudolph Ackermann. Rowlandson was a keen tourist – on the Continent as well as in Britain – and spas, gardens, city squares and other well-known places of attraction frequently figure as settings for his own grotesquely comic incidents.

BIBLIOGRAPHY J. Hayes, *Rowlandson: Watercolours and Drawings*, London 1972.

JOHN RUSKIN 1819–1900

The foremost art critic writing in English in the 19th century, he was the son of a wealthy sherry merchant who was also a keen collector of paint-

ings. The family frequently toured abroad, and Ruskin's first experience of the Continent was in 1833 when, eager to see the places he had gazed on in works by SAMUEL PROUT, he was taken to the Low Countries and the Rhineland. Two years later he travelled via the Alps to Venice, a city he revisited several times. He first met J.M.W. TURNER in 1840, and became his most earnest and articulate admirer. Ruskin was a practising artist all his life, having received his first lessons when quite young from COPLEY FIELDING, and his watercolour studies of rock formations, plants and other fragments of the natural world are particularly fine. He also painted many impressive Alpine landscapes in the 1840s and 1850s, originally intended for a history of Switzerland that in the end was never written. After 1860 social questions rather than art criticism preoccupied him, and for most of the last decade of his life, which he spent in retirement in the Lake District, Ruskin's mind was unhinged.

BIBLIOGRAPHY P.H. Walton, *The Drawings of John Ruskin*, Oxford 1972. N. Penny, *Ruskin's Drawings in the Ashmolean Museum*, Oxford 1988. *Ruskin and the English Watercolour from Turner to the Pre-Raphaelites*, exh. cat. by A. Sumner; Manchester, Whitworth Art Gallery; Bath, Holburne Museum and Craft Centre; London, Bankside Gallery; 1989.

PAUL SANDBY 1731–1809

The son of a Nottingham textile artisan and the younger brother of THOMAS SANDBY, in 1747 he was appointed as a draughtsman to the Military Survey in the Highlands, and spent the next five years in Scotland making pen and wash topographical drawings. In 1753 he and Thomas were giving lessons in London, and for many years after Sandby derived part of his income teaching amateurs and, occasionally, professionals too. He was one of the founder-members of the Royal Academy in 1768, the year of his appointment as drawing-master to the Royal Military Academy at Woolwich near London. Sandby was a versatile artist both in his use of media and in the variety of subjects and genres he attempted, and throughout his career he exhibited works in oil, watercolour and bodycolour that range from histories to country house views. The ramble he undertook in North Wales in 1771 with his patron Sir Watkin Williams Wynn was one of the first Picturesque tours of that part of the country, while his *XII Views in South Wales* (1775) are among the first aquatints made in Britain. *The Virtuosi's Museum* (1778–81) is an important early collection of 108 engravings made after his drawings of country houses and other places of interest.

BIBLIOGRAPHY *The Art of Paul Sandby*, exh. cat. by B. Robertson; New Haven, Yale Center for British Art, 1985. L. Herrmann, *Paul and Thomas Sandby*, London 1986.

THOMAS SANDBY 1721–1798

The elder brother of PAUL SANDBY, in 1742 he obtained a position as draughtsman at the Tower of London, but soon after was taken on as a mapmaker and topographer by the Duke of Cumberland, serving under him in campaigns on the Continent, and in North Britain against the Jacobites. From 1765 he lived at Windsor, Berkshire, the Duke being Ranger of the Great Park there, while Sandby served as Deputy Ranger. For many years he designed and executed various architectural and landscaping schemes at Windsor, which included lodges, bridges and the ornamental lake at Virginia Water. He was a founder-member of the Royal Academy in 1768, and its first Professor of Architecture. Unlike the numerous elevations, plans and other types of architectural drawings he made, his topographical watercolours are on occasion hard to distinguish from those by his brother, with whom he often collaborated.

BIBLIOGRAPHY Colvin, *Biographical Dictionary*, revd 1978. L. Herrmann, *Paul and Thomas Sandby*, London 1986.

WILLIAM BELL SCOTT 1811–1890

The son of an Edinburgh engraver, he was a decorative history painter and poet as well as a watercolourist. After receiving lessons from his father he spent several months in London in 1836 making drawings in the British Museum. He then worked under his father for six years before settling in London, where he began exhibiting his works within a couple of years. At this time Scott became acquainted with another painter-poet, Dante Gabriel Rossetti. From 1843 to 1864 he ran the School of Design at Newcastle upon Tyne, making many landscapes and coastal views as well as industrial subjects in his free time, and also touring occasionally on the Continent. Scott's final professional post was back in London, where he worked for the South Kensington Museums. His writings include a study of British landscape painters (1872), while the *Autobiographical Notes* he compiled appeared two years after his death.

BIBLIOGRAPHY *Dictionary of National Biography*. M.D.E. Clayton-Stamm, 'William Bell Scott: Observer of the Industrial Revolution', *Apollo*, LXXXIX, 1969, pp. 386–90. *The Discovery of Scotland*, exh. cat., 1978.

WILLIAM SIMPSON 1823–1899

He worked in a Glasgow architecture office prior to his apprenticeship as a lithographer, after which he moved to London in 1851. With the onset of the Crimean War three years later, Simpson was sent to the Crimea by Colnaghi & Son in order to make sketches of the campaign against the Russians that would be suitable for mass-market lithography. While there he also finished some less sensational landscapes in pencil and watercolour. Having thus established himself as a war-artist, Simpson was taken on by *The Illustrated London News* shortly after as a foreign reporter, and for 20 years he covered a series of colonial wars and diplomatic events, from Egypt and Abyssinia to China and India. He was elected an associate of the NWCS in 1874, becoming a full member five years later.

BIBLIOGRAPHY *Mr William Simpson of 'The Illustrated London News': Pioneer War Artist, 1823–1899*, exh. brochure; London, Fine Art Society, 1987.

JONATHAN SKELTON
c. 1735–1759

He arrived in Rome at the end of 1757, the funds for his stay in Italy having been provided by William Herring, a cousin to the Archbishop of Canterbury. Although there are extant landscapes made by him in Greenwich, Surrey and Kent that date back to 1754, virtually nothing is known about Skelton himself before he reached Rome. Paradoxically, the letters he then began sending home to his patron provide the kind of detailed day-to-day account of work and excursions that is rarely to be met with in connection with this period. In Italy Skelton was among the first English artists to follow the Welshman Richard Wilson in painting landscapes out of doors. He soon began working in a classicising manner influenced by the 17th-century Ideal landscape painters Claude Lorrain and Gaspard Dughet, and spent much of April and the summer months of 1758 sketching the scenery and antiquities near Tivoli in the Alban Hills.

BIBLIOGRAPHY B. Ford, ed., 'The Letters of Jonathan Skelton Written from Rome and Tivoli in 1758'. *The Walpole Society*, XXXVI, 1960, pp. 23–82. S.R. Pierce, 'Jonathan Skelton and his Watercolours – A Checklist', *The Walpole Society*, XXXVI, 1960, pp. 10–22. *Travels in Italy, 1776–1783: Based on the 'Memoirs' of Thomas Jones*, exh. cat. 1988.

JOHN 'WARWICK' SMITH
1749–1831

The son of a Cumberland gardener, he studied under Sawrey Gilpin, who in turn introduced his pupil to the Earl of Warwick. As a result Warwick sent Smith to Italy in 1776, and liberally supported him there for the following five years, hence Smith's sobriquet. During his time in Italy Smith sketched and travelled a good deal with WILLIAM PARS, Thomas Jones and FRANCIS TOWNE. He and Towne returned to Britain together through the Swiss Alps in 1781. Over the next few years Smith was active in working up his Italian sketches into exhibition pieces, and he also undertook frequent tours in Wales and the Lake District. Among the sets of engravings made after his works are *Select Views in Great Britain* (1784–5) and *Select Views in Italy* (1792–9), while a series of aquatints appeared in W. Sotheby's *Tour through Parts of Wales* (1794). Smith joined the OWCS in 1805 and was elected full member the following year, although by then the broader handling and stronger colours borne in by the revolution in watercolours of the 1790s had made his carefully tinted drawings appear decidedly old-fashioned to some.

BIBLIOGRAPHY I.A. Williams, 'John "Warwick" Smith', *Old Water-Colour Society's Club*, XXIX, 1946, pp. 9–18. *Travels in Italy, 1776–1783: Based on the 'Memoirs' of Thomas Jones*, exh. cat. 1988.

JAMES 'ATHENIAN' STUART
1713–1788

A fan-painter in London in his teens, Stuart spent 1751–3 in Greece with Nicholas Revett making the first accurate measured drawings of Athens's classical architectural remains. He also painted numerous highly coloured topographical watercolours of local scenes, which he later exhibited in London at the Society of Artists. The first volume of his and Revett's *The Antiquities of Athens* appeared in 1762, by which time Stuart seemed poised to become the leading exponent among the first wave of Greek Revival architects and decorators, but his fatal indolence rapidly undermined the confidence of patrons, and he built little.

BIBLIOGRAPHY D. Watkin, *Athenian Stuart: Pioneer of the Greek Revival*, London 1982. *Great Drawings from the Collection of the Royal Institute of British Architects*, exh. cat. by J. Lever & M. Richardson; New York, The Drawing Center, 1983, pp. 58–9.

FRANCIS TOWNE 1740–1816

He was probably born in Exeter, Devon, and for much of his life divided his time between there and London. In the mid-1750s Towne studied at Shipley's School in the capital, and first exhibited at the Society of Artists in 1761. Over the next few years he regularly showed landscapes in oil, since it was as an oil painter that, without much success, he then sought recognition. Between 1775 and 1810 he sent many works to the Royal Academy exhibitions; during the same period he was frequently refused election as ARA. Towne spent 1780–81 in Italy sketching with Thomas Jones and his circle. He returned home via the Alps with JOHN 'WARWICK' SMITH. Towne's Italian and Alpine landscapes show his idiosyncratic style at its best; these bold pen-and-ink drawings with their flat washes of colour are the poetic high-point of the 18th-century tradition of tinted drawing. In the 1780s and 1790s he travelled often in England and Wales, and continued to teach drawing in Exeter to JOHN WHITE ABBOTT and other keen pupils, two of whom accompanied Towne on his tour of the Lake District in 1786. Soon after 1800 he settled for good in London, where, in 1805, he held a one-man show of his Italian, Alpine and Lakeland watercolours.

BIBLIOGRAPHY A. Bury, *Francis Towne: Lone Star of Watercolour Painting*, London 1962. *Travels in Italy, 1776–1783: Based on the 'Memoirs' of Thomas Jones*, exh. cat., 1988.

JOSEPH MALLORD WILLIAM
TURNER 1775–1851

The foremost British painter of the first half of the 19th century, he and THOMAS GIRTIN led the revolution that transformed the art of watercolour painting in the 1790s. Turner was born in London, entered the Royal Academy Schools in 1789 and exhibited his first watercolour the following year. Although his earliest works are firmly in the topographical tradition, the Welsh tours of the 1790s,

his work (1794–6) for Dr Thomas Monro, and his experience of painting in oil taught him how – in combination with the virtuoso technical processes he was devising – to realise powerful, atmospheric landscapes in watercolour. Over the next few years he often toured in England and Scotland, and once Europe's roads were open again after 1815 he frequently went abroad, visiting Italy for the first time in 1819. A large number of watercolours of Venice are connected with his visits to the city in 1833 and 1840, while the great Swiss watercolours of the early 1840s are the result of annual visits to Lake Lucerne and elsewhere. His prolific output in pure watercolour and in bodycolour (Turner did not usually mix these media) is of two kinds: many thousands of spontaneous sketches, some of which relate to engraved serial publications, for example the *Picturesque Views in England and Wales* (1827–38), and the elaborately wrought works, which more often were intended for sale than for exhibition. Turner remained committed to the Royal Academy throughout his career, and exhibited there until 1850. He never joined a watercolour society. Having been elected ARA in 1799 and RA three years later, he went on to serve as the Academy's Professor of Perspective (1807–37) and Deputy President (from 1845). At his death Turner bequeathed *c.* 100 of his finished pictures to the nation; the Turner Bequest today includes his sketchbooks and preliminary drawings and watercolours. It is housed in the Clore Gallery at the Tate Gallery, and at the National Gallery.

BIBLIOGRAPHY M. Butlin & E. Joll, *The Paintings of J. M. W. Turner*, 2 vols, London 1977, revd 1984. A. Wilton, *The Life and Work of J. M. W. Turner*, 1979. *Turner in Yorkshire*, exh. cat. by D. Hill et al.; York, City Art Gallery, 1980. *Turner and the Sublime*, exh. cat. by A. Wilton; Toronto, Art Gallery of Ontario; New Haven, Yale Center for British Art; London, British Museum; 1980–1. *Turner in Scotland*, exh. cat. by F. Irwin et al.; Aberdeen, Art Gallery, 1982. *Turner in Wales*, exh. cat. by A. Wilton; Llandudno, Mostyn Art Gallery; Swansea, Glynn Vivian Art Gallery & Museum; 1984. L. Stainton, *Turner's Venice*, London 1985. J. Gage, *J. M. W. Turner, 'A Wonderful Range of Mind'*, London 1987. A. Wilton, *Turner in his Time*, London 1987. E. Shanes, *Turner's England, 1810–38*, London 1990. *Turner's Papers: A Study of the Manufacture, Selection and Use of his Drawing Papers, 1787–1820*, exh. cat. by P. Bower; London, Tate Gallery, 1990.

WILLIAM TURNER OF OXFORD
1789–1862

He left his native Oxfordshire for London in 1804, where he studied for several years under JOHN VARLEY. He first exhibited at the Royal Academy in 1807, but after being made an associate and then a full member of the OWCS the following year, thereafter showed his works at the Society's exhibitions. During the next few years Turner painted numerous landscape watercolours of the Oxfordshire countryside, in particular the meadows along the River Cherwell, but he also ventured further afield: his first sketching tours were made in the Avon and Thames valleys, but from 1814 he travel-

led to the Lake District, Wales, Derbyshire and elsewhere. Throughout this period Turner was also building up his practice in Oxford as a drawing-master, for he was a teacher all his life. He began visiting the New Forest in Hampshire in the late 1820s, while many of his panoramic views of the Sussex Downs beneath open skies date from the following decade. In 1838 he made his only visit to Scotland. Turner was never abroad, although he did produce some Italian and Swiss scenes after works by others.

BIBLIOGRAPHY *William Turner of Oxford (1789–1862)*, exh. cat. by C. Titterington & T. Wilcox; Woodstock, Oxfordshire County Museum; London, Bankside Gallery; Bolton, Museum & Art Gallery; 1984–5.

CORNELIUS VARLEY 1781–1873

The brother of JOHN VARLEY, following the death in 1791 of their father he was brought up by an uncle, an instrument maker, who encouraged Varley's precocious interest in science. He attended classes at Dr Thomas Monro's academy *c* 1800, and in 1802 was sketching in Norfolk with his brother. The same year the brothers toured in North Wales, and Varley returned there the following year with JOSHUA CRISTALL and WILLIAM HAVELL, and in 1805 on his own. In 1808 he visited Ireland. He was a founder-member of the OWCS in 1804, and began as a regular exhibitor of Welsh and East Anglia landscapes as well as scenes of London. Despite his talent, however, he sold little, and after 1810 contributed less. In 1820 he resigned from the OWCS, although for some years he continued to make watercolour sketches out of doors. Throughout his artistic career Varley was equally absorbed in making improvements to various drawing instruments, and in 1811 patented his Graphic Telescope, a refined *camera obscura*, afterwards used by JOHN SELL COTMAN. Varley's *Treatise on Optical Drawing Instruments* appeared in 1845.

BIBLIOGRAPHY M. Pidgley, 'Cornelius Varley, Cotman and the Graphic Telescope', *The Burlington Magazine*, CXIV, 1972, pp. 781–6. *Exhibition of Drawings and Watercolours by Cornelius Varley*, exh. cat. by S. Somerville, introd by M. Pidgley; London, Colnaghi & Son, 1973.

JOHN VARLEY 1778–1842

The elder brother of CORNELIUS VARLEY, in 1791 he was apprenticed to a silversmith, taking lessons in drawing in his free time. He made several sketching tours in Wales 1798–1802, studied at Dr Thomas Monro's 'academy' from *c.* 1800, joined the Sketching Club in 1802 and was a founder-member of the OWCS two years later. By then – and at a time when his work was strongly influenced by that of THOMAS GIRTIN – Varley was emerging as a popular drawing-master, one to whom a large number of the next generation of landscape watercolourists were to be indebted. During the summer months he rented a house at Twickenham, from where he and his pupils sallied forth to sketch by the banks of the River Thames. He also toured, including visits to Yorkshire in 1803

and to Northumberland five years later. Varley was a prolific exhibitor until *c.* 1812, after which he was almost overwhelmed by his teaching commitments, a large family, perpetual insolvency and the issuing of manuals, notably his *Treatise on the Principles of Landscape Design* (1816–18). In 1825 his studio was burnt down. At the end of his life he recovered something of his former powers, exhibiting a number of Claudean scenes that were enthusiastically received.

BIBLIOGRAPHY A. Bury, *John Varley of the 'Old Society'*, Leigh-on-Sea 1946. C.M. Kauffmann, *John Varley (1778–1842)*, London 1984.

JAMES WARD 1769–1859

Born in London, he was trained as a mezzotinter, first by his brother and then under J.R. Smith. Although he was appointed painter and mezzotinter to the Prince of Wales in 1794, during the 1790s Ward drifted away from printmaking in order to concentrate on painting, and initially produced a number of rustic genre works, both in oil and in watercolour, in the style of George Morland, his brother-in-law. By degrees he made landscapes and animals his subject, and became well-known for his monumental presentations of prize cattle and other beasts, for which he made careful studies, many in watercolour. He was elected ARA in 1807, and RA four years later. By then he was working on ambitious large-scale landscapes aspiring to the Sublime, and influenced by Rubens. Around 1830 he retired to Buckinghamshire.

BIBLIOGRAPHY *James Ward, R.A., 1769–1859*, exh. cat. by J. Munro; Cambridge, Fitzwilliam Museum, 1991–2.

JAMES ABBOTT MCNEILL WHISTLER 1834–1903

An American expatriate who spent most of his career in Britain, he was born in Lowell, Massachusetts. After expulsion from West Point, followed by work with the U.S. Coast Survey, he moved to Paris. There, while training as a painter, he became fascinated by imported Japanese prints, silks and furnishings. In 1863 Whistler settled in London. Over the next 30 years he became a celebrated etcher and portrait painter in oils, as well as a dandy and controversialist. In 1878 he successfully sued JOHN RUSKIN for libel, Ruskin having castigated one of Whistler's Nocturnes – tone poems in oil paint after pastel sketches of the River Thames, in which Whistler sought to harmonise colour, line and form in a way analogous to music. Awarded only a farthing by the court, and no costs, the bankrupt Whistler left for a stay in Venice, where he made a number of etchings and watercolours. His first substantial showing of watercolours was in London in 1884, and throughout the 1880s he worked on marines, coast scenes and other subjects in this medium. In 1884–6 he served as President of the British Society of Artists. His aesthetic pronouncements, and his views on art and society, he published in 1890 as *The Gentle Art of Making Enemies*.

BIBLIOGRAPHY D. Sutton, *Nocturne: The Art of James McNeill Whistler*, 1964. D. Sutton, *James McNeill Whistler: Paintings, Etchings, Pastels and Watercolours*, London 1966. H. Taylor, *James McNeill Whistler*, London 1978.

HUGH WILLIAM 'GRECIAN' WILLIAMS 1773–1829

The orphan son of a Welsh sea-captain, he was brought up in Edinburgh, where, in the late 1780s, he studied under the portrait painter David Allan. Williams, however, inclined towards topography. He regularly travelled in Scotland in search of subjects, and in 1811–12 published a small group of engravings of Highland scenery. He was a founder-member of the short-lived Associated Artists (1808–12). After the end of the Napoleonic War made foreign travel possible again, he set off in 1816 across the Continent for Greece, returning two years later by sea. Once back in Edinburgh Williams exhibited his sketches of Greece in 1819, published the illustrated *Travels in Italy, Greece and the Ionian Islands* in 1820, held a one-man show of his finished works in 1822 and, finally, published some of these as engravings in *Select Views in Greece* (1827–9). During the 1820s he also continued to paint Scottish landscapes and to make finished works after the sketches he had done in Rome and elsewhere in 1816.

BIBLIOGRAPHY Halsby, *Scottish Watercolours*, pp. 40–45.

THE ARTISTS		CONTEMPORARY EVENTS

1727–1760: **Reign of George II**

PAUL SANDBY appointed draughtsman to the Military Survey in Scotland, part of the Hanoverian campaign to subdue the Highlands following the failed Jacobite rebellion of 1745–6.	**1747**	
	1748	Treaty of Aix-la-Chapelle ends the pan-European War of the Austrian Succession, but although this includes France's recognition of the Hanoverian Succession in Britain, numerous unresolved issues soon lead to further conflict between the two powers.
ALEXANDER COZENS returns from 3 years of study in Rome, and sets up as a drawing-master in London.	**1749**	Henry Fielding's *Tom Jones* published.
Richard Wilson travels to Venice, then lives in Rome for five years before returning to Britain.	**1750**	
JAMES 'ATHENIAN' STUART and Nicholas Revett in Athens; they return in 1755.	**1751**	Death of Frederick, Prince of Wales, a notable patron of the arts.
An academy for British artists is set up in Rome, privately patronised by Lord Charlement and other nobles and gentlemen.	**1752**	
PAUL and THOMAS SANDBY begin holding sketching classes at Poultney Street, London.	**1753**	
William Shipley opens his drawing school in the Strand, London, which evolves into the Society of Arts four years later. ROBERT ADAM in Italy and Dalmatia until 1758.	**1754**	French troops from Canada seize the Ohio Valley, and open conflict with the British breaks out.
	1756	The Seven Years War begins, into which Britain is dragged in its continuing struggle with France for supremacy in North America, India and the Caribbean.
Edmund Burke publishes his influential treatise on aesthetics, *A Philosophical Enquiry into the Origin of our Ideas of the Sublime and Beautiful*. JONATHAN SKELTON reaches Rome in December, where he remains until his death in January 1759.	**1757**	With the recapture of Calcutta and Robert Clive's victory at the Battle of Plassey, the way is open for British rule in India.
Society for the Promotion of Arts & Manufactures ('Society of Arts') founded (the Royal Society of Arts from 1847).	**1758**	
THOMAS GAINSBOROUGH moves from Ipswich to Bath, where he establishes himself as a society portrait painter.	**1759**	A French invasion fleet is destroyed by Admiral Hawke in Quiberon Bay. British forces under General Wolfe defeat the French at Quebec and end France's presence in Canada.

1760–1820: **Reign of George III**

In London the Society of Arts holds its first exhibition.	**1760**	
A split in the Society of Arts leads to the foundation of the Society of Artists of Great Britain (the 'Incorporated Society' from 1765), which continues in operation until 1791; the Free Society of Artists is set up the following year, and continues until 1783.	**1761**	The Bridgwater Canal is opened, the start of a major transportation network of waterways that continues to expand until it is throttled by the railway boom of the 1840s.
	1763	After an unprecedented series of military successes against the French in the Seven Years War, with the Treaty of Paris Britain is established as the world's leading colonial power.

Death in London of William Hogarth. WILLIAM PARS sets out for Greece and Asia Minor, returning in 1766.	**1764**	
THOMAS SANDBY is appointed Deputy Ranger of Windsor Great Park; PAUL SANDBY shows his first Windsor subjects at the Incorporated Society of Artists exhibition in London. In the late 1760s RICHARD COOPER JNR trains in Paris as an engraver, and *c.* 1770 travels to Italy, returning to Britain in 1778.	**1765**	The Stamp Act is imposed on the American colonies in order to finance the cost of their defence. Agitation leads to its repeal the following year, but unrest and suppression continues.
Royal Academy of Arts founded by senior artists ejected from the Incorporated Society of Artists of Great Britain; its first exhibition is held in London's Pall Mall the following year.	**1768**	
PAUL SANDBY's first recorded visit to North Wales, which he tours the following year with Sir Watkin Williams Wynn. During the 1770s WILLIAM GILPIN undertakes numerous tours in Britain in search of the Picturesque.	**1770**	Outrage follows the shooting of five Americans – the Boston Massacre – by British troops guarding the city's Customs House.
	1773	Cargoes of tea shipped to America by the East India Company are hurled overboard in the tax protest known as the Boston Tea Party.
GAINSBOROUGH moves to London. JOHN DOWNMAN travels through France to Rome, from where he goes on sketching trips in the Campagna with Joseph Wright of Derby.	**1774**	
PAUL SANDBY publishes *XII Views in Aquatinta made in South Wales*, using the novel printmaking technique developed the previous decade by J.B. Le Prince. Aquatint is able to imitate closely the visual effects of a watercolour wash, and SANDBY was the first to popularise its use in Britain. THOMAS HEARNE returns from the Leeward Islands.	**1775**	Civil war (the War for Independence) begins in earnest in America. Opinion concerning the conflict is sharply divided: in Britain many strongly support the colonists, while *c.* 80,000 American Loyalists choose to leave for British Canada.
JOHN ROBERT COZENS and his patron Richard Payne Knight travel through the Alps to Rome, where Cozens remains for the next two years. Thomas Jones reaches Rome in November, and stays until 1783. His circle of friends there includes WILLIAM PARS, JOHN 'WARWICK' SMITH and FRANCIS TOWNE, all of whom feature in Jones's *Memoirs*.	**1776**	Independence is formally declared in Philadelphia by the Thirteen Colonies. That autumn George Washington's army is driven from New York City by British troops under General Howe.
HEARNE and Sir George Beaumont touring in Scotland.	**1778**	The French Government enters into a formal alliance with the Americans (later joined by Dutch and Spanish powers).
The Royal Academy moves to Somerset House in the Strand, where it remains until 1837. In the 1780s James Whatman perfects his 'wove' paper for watercolour painting, and William and Thomas Reeve set up in London as colourmen, supplying ready-made watercolour paints.	**1780**	Despite protests in Britain, military successes in the continuing War in America convince George III and his Government they can still win.
TOWNE and SMITH travel back to Britain from Rome.	**1781**	A powerful French naval presence is established off the American coast while a Franco-American coalition army lays siege to Yorktown, Virginia, forcing its British army of occupation into a disastrous surrender and the London Government into peace negotiations.
GILPIN's *Observations on the River Wye* published, the first of his Picturesque tours. J.R. COZENS and his patron William Beckford travel through the Alps to Naples.	**1782**	
GAINSBOROUGH visits the Lake District.	**1783**	Britain recognises an independent USA at the Treaty of Versailles.
WILLIAM DANIELL sails for India with his uncle Thomas.	**1785**	
TOWNE touring in the Lake District.	**1786**	

WILLIAM BLAKE makes his first hand-coloured relief etchings; over the next few years he prints a number of his Prophetic Books using this method, and, in 1795, some colour-printed monotypes.	**1788**	George III becomes mentally unstable.
In London EDWARD DAYES gives THOMAS GIRTIN lessons; during the same period THOMAS MALTON JNR is teaching J.M.W. TURNER.	**1789**	The French Revolution breaks out in July, thus ending Louis XVI's absolute rule. The event alarms both despotic and benign rulers and governments throughout Europe.
TURNER exhibits his first painting – a watercolour – at the Royal Academy (he shows his first oil there in 1796). The French artist Louis Francia arrives in London and begins teaching at a school in Hampstead.	**1790**	
TOWNE undertakes another tour in the Lake District.	**1791**	Tom Paine's *The Rights of Man* published. A Constitutional Act divides the province of Quebec into Upper and Lower Canada.
WILLIAM ALEXANDER voyages to China. TURNER makes his first extensive trip to South and Mid Wales.	**1792**	The French Revolutionary War begins, with the Republicans throwing back the Prussian counter-revolutionary invasion at Valmy. The London Corresponding Society is set up to campaign for political reform, and is quickly forced underground by the Government. WILLIAM BLAKE and Tom Paine are among those who lend active support to its members.
	1793	Louis XVI is executed, soon after which French armies invade the Austrian Netherlands and war against Britain is declared. Despite subsequent British successes at sea, the threat of invasion continues until 1802.
JOHN GLOVER sets up as a drawing-master in Lichfield. WILLIAM DANIELL returns from India, and begins on the serial publication of *Oriental Scenery* (1795–1810). TURNER travels in North Wales. J. R. COZENS is taken into care by Dr Thomas Monro, who sets up his informal 'academy' in London about this time. Among the young artists who attend Monro's during the next few years are TURNER, GIRTIN, Francia/ JOSHUA CRISTALL, JOHN VARLEY, HENRY EDRIDGE and PETER DE WINT.	**1794**	
Death in London of J. R. COZENS. TURNER makes his first visit to Yorkshire.	**1797**	
TURNER undertakes a seven-week tour of Wales.	**1798**	Wordsworth and Coleridge publish *Lyrical Ballads*. In Ireland a republican rising led by the United Irishmen against British rule is swiftly put down. French armies invade Egypt in July, but destruction of the French fleet by Lord Nelson at the Battle of the Nile in August ruins Napoleon's ambitions in the Near East: French rule in Egypt ends in 1802 (although its influence continues), the year that Mohammed Ali, the Ottoman Sultan's nominal viceroy, founds a dynasty that lasts till 1952. By 1821 the Sudan has fallen under Egyptian rule, and the Holy Land during the 1830s.
'The Brothers', or the 'Sketching Club', is initiated in London by GIRTIN; its members include Francia and Robert Ker (the club's minutes record meetings to 1801). JOHN CONSTABLE enters the Royal Academy Schools. TURNER travels in North Wales.	**1799**	Wordsworth settles at Grasmere in the Lake District. Napoleon seizes power in France.
BLAKE moves to Felpham in Sussex, where he lives for the next three years. GIRTIN at work on his panorama of London, the Eidometropolis. Having invented lithography in Munich two years earlier, Alois Senefelder arrives in London to patent his process. By the 1820s lithography, which is cheaper and more convenient as a reproductive medium than etching or aquatint, is displacing these older techniques in book illustration.	**1800**	
TURNER spends the whole of July and August travelling in Scotland.	**1801**	Union of Great Britain and Ireland.

Death of GIRTIN. JOHN SELL COTMAN sets up a sketching society in London, the successor to Girtin's 'Brothers'; among its members is JOHN VARLEY. DE WINT moves to London from Staffordshire. TURNER travels through the Swiss Alps, returning to London via Paris, one of many British artists to take advantage of the Treaty of Amiens to visit the Continent.

1802

Treaty of Amiens signed, and with it the end of the French Revolutionary War. Access to the Continent is brief, however, for hostilities are renewed the next year.

Norwich's School of Artists is founded by John Crome. COTMAN spends the summer in North Yorkshire, returning there in 1804 and 1805.

1803

The Napoleonic War begins following French aggression on the Continent. The British coastline is further fortified against invasion, a continuing threat despite Nelson's victory at Trafalgar in 1805.

DAVID COX moves to London from Birmingham.
Sixteen artists, among them ROBERT HILLS, CORNELIUS and JOHN VARLEY, GEORGE BARRET JNR, JOSHUA CRISTALL, JOHN GLOVER and WILLIAM HAVELL, set up the Society of Painters in Water-Colours, the first organisation of its kind. Its first annual exhibition opens in London in April 1805. That year 16 'Fellow Exhibitors' join the original 24 members. From 1813 to 1820 it is known as the Society of Painters in Oil and Water-Colours. In 1821 reverts back to its original title, but from 1832 is popularly known as the 'Old Water-Colour Society' (OWCS) in order to distinguish it from the New Society of Painters in Water-Colours (NWCS) founded that year. In 1881 it becomes the Royal Society of Painters in Water-Colours, afterwards changed to its present title, the Royal Watercolour Society. It is housed today at the Bankside Gallery, London.

1804

British Institution for Promoting the Fine Arts in the United Kingdom set up; it gives premiums until 1842, and ceases to function in 1867.

1805

Admiral, Lord Nelson gains a notable sea victory in the Napoleonic War by destroying a combined French and Spanish fleet off Cape Trafalgar, southern Spain.

COTMAN leaves London for Norwich and works as a drawing-master.

1806

In January the Sketching Society, or the Society for the Study of Epic and Pastoral Design, is set up in London by A. E. and J. J. Chalon and Francis Stevens. It survives until 1851.
The New Society of Painters in Miniature and Water-Colours is also founded, the first rival to the OWCS. In this year it changes its title to the Associated Artists in Water-Colours, and holds its first exhibition. In 1810 it again changes its title, becoming the Associated Painters in Water-Colours, but disbands in 1812.
Turner pays his first visit to Farnley Hall, Yorkshire, the home of Walter Fawkes, a keen patron of his work, returning there almost every year until Fawkes's death in 1825.

1808

The Peninsular War begins, as British forces under Arthur Wellesley, later Duke of Wellington, seek to oust the French from Spain and Portugal.

Death of PAUL SANDBY. BLAKE holds his own exhibition in London (which runs until 1810), but with limited success. Anne Frances Burne (1775–1837) is elected to full membership of the OWCS, the first woman to be so.

1809

GEORGE FENNEL ROBSON touring in Scotland.

1810

George III becomes incurably insane.

CORNELIUS VARLEY patents his Graphic Telescope.

1811

Luddite riots involving machine-wrecking break out in Nottingham and spread to other textiles areas; disturbances continue over the next few years.

THOMAS HEAPHY is in Spain, where he makes portraits of British officers fighting in the Peninsular War. COTMAN moves to Yarmouth.

1812

While Napoleon is preparing his calamitous attempt to invade Russia, the War of 1812 between Britain and the USA erupts, following the seizure of American ships attempting to force the blockade imposed by Britain on French ports during the Napoleonic War. American forces burn York (Toronto); the British burn Washington D.C.
In Britain the Prince Regent, later George IV, assumes executive power.

	1814	The Napoleonic War ends with the Emperor's abdication and retirement to Elba. Stalemate in the British-American War of 1812 leads to the Treaty of Ghent. Wordsworth publishes *The Excursion*.
COX sets up as a drawing-master in Hereford, remaining there until 1827. HILLS visits the battlefield of Waterloo.	**1815**	Napoleon escapes from Elba and war begins again. The French are defeated at Waterloo; Napoleon is exiled to St Helena.
WILLIAM HAVELL joins Lord Amherst's embassy to China, after which Havell spends eight years in India painting watercolour portraits. 'GRECIAN' WILLIAMS sets off across the Continent.	**1816**	The architect John Nash remodels the Prince Regent's pavilion in Brighton, turning it into Europe's greatest oriental fantasy palace.
Francia returns to France. TURNER tours the Low Countries and the Rhineland. COTMAN makes his first visit to Normandy, returning there in 1818 and 1820. SAMUEL PROUT makes his first trip to the Continent.	**1817**	
BLAKE meets JOHN LINNELL, who introduces him to JOHN VARLEY and CONSTABLE, as well as SAMUEL PALMER, who later forms The Ancients, a circle of Blake devotees. TURNER tours in Scotland for the purpose of illustrating Walter Scott's *Provincial Antiquities and Picturesque Scenery of Scotland* (1819–26). C.J. Hullmandel sets up the first lithographic press in London.	**1818**	
TURNER's first visit to Italy: Venice, Rome, Naples. Walter Fawkes opens his London house (repeated the following year) to show his collection of watercolours by contemporary British artists, many by Turner.	**1819**	Peterloo: the Manchester Yeomanry kill a number of persons attending a peaceful political meeting. The East India Company buys Singapore.

1820–30: Reign of George IV

RICHARD PARKES BONINGTON continues working in Paris until 1828, with occasional visits to London.	**1820**	
Death of HENRY EDRIDGE.	**1821**	The Greek War of Independence begins. In 1822 Turks massacre Greeks on the island of Chios, inspiring Delacroix's *Les Massacres de Chios* and murals in a villa in Bath by Thomas Barker. The eventual success (1829) of the Greeks marks the beginning of the erosion of Ottoman power in Europe.
TURNER in Scotland.	**1822**	
The Society of British Artists sets up in premises in Suffolk Street and opens its first exhibition; known as the Royal Society of British Artists from 1877. Bonington, Constable and Copley Fielding win medals at the Paris Salon.	**1824**	Death of Lord Byron at Missolonghi while giving active support to the Greek War of Independence.
BLAKE meets GEORGE RICHMOND, Edward Calvert, FRANCIS OLIVER FINCH and other artists who form The Ancients. BONINGTON visits London, and is accompanied by Delacroix on sketching expeditions. TURNER begins his illustrations for the *Picturesque Views in England and Wales* (1827–38), his most ambitious series.	**1825**	The Stockton-Darlington Railway opens, the world's first passenger system. By 1850 there are 6621 miles of track in Britain, and 17,900 by 1880.
PALMER settles at Shoreham in West Kent. COX tours Flanders and Belgium, the first of three tours he makes on the Continent in the late 1820s.	**1826**	
Death of BLAKE in London. First exhibition held in Manchester that is exclusively of watercolours.	**1827**	

DE WINT visits Normandy, his only visit to the Continent. TURNER makes his second trip to Italy, spending most of his time in Rome. Death of BONINGTON in London.	**1828**	
COPLEY FIELDING settles in Brighton. FRANCIS DANBY moves to Switzerlind for 12 years.	**1829**	George Stevenson's steam engine, 'The Rocket', succeeds at the Rainhill trials.

1830–37: Reign of William IV

J. F. LEWIS in Spain and Morocco for the next two years.	**1830**	The Liverpool & Manchester Railway opens. Canal and coaching networks go into rapid decline with the railway boom that follows in the 1840s. The 'Swing' riots, involving agricultural machine-wrecking, break out in Kent and spread across south-east England. CONSTABLE and PALMER are among those who have no sympathy for those involved in rural unrest. French armies occupy Algeria.
The Northern Society of Painters in Water-Colours founded in Newcastle upon Tyne. TURNER visits Scott at Abbotsford, then tours the Western Highlands and Isles. THOMAS SHOTTER BOYS and WILLIAM CALLOW share a studio in Paris. GLOVER emigrates to Tasmania. In the 1830s Winsor & Newton begin marketing colours in small pans for portable sketching boxes.	**1831**	Charles Darwin begins his 5-year voyage around the world in *The Beagle*. Michael Faraday begins his research on electricity.
New Society of Painters in Water-Colours (known as the 'New Water-Colour Society', or NWCS) founded, the second rival to the original 1804 society. In 1863 it becomes the Institute of Painters in Water-Colours, and in 1884, two years after special premises had been built for it in London at 195 Piccadilly, the Royal Institute of Painters in Water-Colours. It is housed today in Carlton House Terrace, London. The Society of Bristol Artists is set up; its members include SAMUEL JACKSON and W. J. MÜLLER. J. F. LEWIS spends the next two years in Spain and Morocco. DAVID ROBERTS in Spain 1832–3.	**1832**	First Reform Act: the male franchise is extended by 50% to include the prosperous middle-classes.
RUSKIN makes his first tour on the Continent, inspired, in part, to do so by SAMUEL PROUT's engravings; he visits the Low Countries and the Rhineland. TURNER in Venice this year.	**1833**	W. H. Fox Talbot begins his photographic experiments at Lacock Abbey, Wiltshire, which he publicises in 1839. Slavery is abolished throughout the British Empire.
COTMAN takes up the post of drawing-master at King's College, London. TURNER visits Scotland.	**1834**	Houses of Parliament burnt down. Death in London of Samuel Taylor Coleridge. The Tolpuddle Martyrs, 6 Dorset agricultural labourers, are transported to Australia, having held 'seditious' union meetings; public outrage secures their return.
RUSKIN travels through France and, for the first time, over the Alps to Milan, Verona and Venice.	**1835**	

1837–1901: Reign of Victoria

	1836	Serial publication begins of Charles Dickens's *The Pickwick Papers*, his first novel. Construction of new Houses of Parliament begins; completed 1847.

Death of CONSTABLE. PALMER leaves Shoreham. THOMAS SHOTTER BOYS returns to London from Paris to work on the Continental chromolithographs he publishes two years later. J. F. LEWIS sets out for Italy, Greece and the Levant.

1837

PALMER travels to Italy, where he spends the next 2 years. Late in the year W. J. MÜLLER reaches Egypt and travels up the Nile to Luxor; he then goes on a sketching expedition to Turkey and Lycia, spending 3 months sketching the ruins of Xanthus and other sites, returning to London in 1839. DAVID ROBERTS travels up the Nile, sketching numerous monuments en route. WILLIAM TURNER OF OXFORD tours in Scotland.

1838

For the next 10 years the Chartist movement for political reform dominates public debate.

1839

The Opium War begins, which followed from China's attempts to halt illicit drug traffic. It ends in 1842 with the decisive defeat of Chinese forces by the British, the weakening of the Manchu government and the gradual opening of the Chinese market to European trade.

RUSKIN and TURNER meet for the first time. Later in the year Turner is in Venice; during the 1840s he frequently spends his summers around the Swiss Lakes. In 1840–1 Ruskin travels through France to Nice, Naples, Rome, Florence and Venice.
During this decade and the 1850s COX spends his summers at Betws-y-coed in North Wales.

1840

Victoria marries Prince Albert of Saxe-Coburg-Gotha.

J. F. LEWIS settles in Cairo, remaining there for the next ten years. David Wilkie dies at sea off Gibralter on his return voyage from a six-month tour of the Near East, undertaken so that he could paint biblical subjects in authentic settings.

1841

Deaths of COTMAN and JOHN VARLEY in London.

1842

The Rebecca Riots in West Wales against tollpike trusts continue until 1844.

RUSKIN publishes the first volume of *Modern Painters*, a defence of Turner's art and contemporary landscape painting.

1843

Friedrich Engels in Manchester writing *The Condition of the Working Class in England*.

RUSKIN in Geneva, Lucca and Venice. MÜLLER returns from Lycia.

1845

RUSKIN in Venice. About this year Winsor & Newton introduce metal tubes containing moist watercolour paint.

1846

Following the failure of the potato crop in Ireland, chronic famine lasts for several years. Almost one million starve to death, and during the next decade a further million emigrate, most to the USA.

1847

Emily Bronte's *Wuthering Heights* and Charlotte Bronte's *Jane Eyre* are published.

JOHN EVERETT MILLAIS and WILLIAM HOLMAN HUNT are among the group of young artists that form the Pre-Raphaelite Brotherhood in London.

1848

Paris Revolution, bringing to an end the Orléans monarchy. Karl Marx travels to London, where he settles.

HOLMAN HUNT tours the Continent with Dante Gabriel Rossetti, a fellow Pre-Raphaelite.

1849

Charles Dickens's *David Copperfield* is published.

1850

During the 1850s nearly half a million Britons emigrate to the USA.

Death of TURNER in London. RUSKIN publishes the first volume of *The Stones of Venice*, and defends Millais and Holman Hunt in letters to *The Times*. J. F. LEWIS returns to Britain and exhibits his Orientalist watercolours to great critical acclaim. LINNELL moves to Surrey.

1851

The Great Exhibition opens in London's Hyde Park, the world's first international exposition of arts and manufactures.

1852

Louis Napoleon establishes the Second Empire in France, and sets out to make Paris the cultural capital of Europe.

THE ARTISTS		CONTEMPORARY EVENTS
RUSKIN and his wife, Effie, visit the Highlands with Millais. The Ruskins' marriage is annulled in 1854, and Effie and Millais marry the following year.	**1853**	First railway through the Alps (Vienna-Trieste) opens, speeding the journey for tourists heading south to Italy.
HOLMAN HUNT visits the Holy Land and Egypt. THOMAS COLLIER moves to Betws-y-coed, North Wales.	**1854**	Following Russia's seizure of the Black Sea, France and Britain invade the Crimea.
WILLIAM SIMPSON travels to the Crimea to record the conflict, as does the photographer Roger Fenton. WILLIAM CALLOW settles in Buckinghamshire. SAMUEL JACKSON visits Switzerland.	**1855**	The Australian colonies become self-governing, as does New Zealand the following year. Exposition Universelle held in Paris, with British contributions.
	1856	Russia's humiliating defeats in the Crimean War lead to the Peace of Paris. The Arrow War begins, in which the British and French invade Peking and force further trading concessions from the Chinese in the Treaty of 1860.
	1857	The Indian Mutiny, a rebellion against British rule by native regiments of the East India Company, is ruthlessly crushed following massacres of Europeans.
EDWARD LEAR travels to the Holy Land and Lebanon. JACKSON returns to Switzerland.	**1858**	The British state absorbs the East India Company's powers and possessions and runs India by direct rule until 1947.
LEAR's first trip to Egypt (the fifth, and final, one occurs in 1872). J.A.M. WHISTLER begins his visits to London, having spent the last four years in Paris; he settles in London in 1863.	**1859**	Alfred, Lord Tennyson's first set of *Idylls of the King*, Charles Darwin's *The Origin of Species*, J.S. Mill's *On Liberty* and George Eliot's *Adam Bede* are published.
	1860	Garibaldi declares Victor Emmanuel King of Italy (crowned 1861). Abraham Lincoln elected President of the USA.
PALMER settles in Surrey near LINNELL.	**1861**	Death of Prince Albert. The American Civil War begins, with the final defeat of the breakaway Confederate states by the Union's armies in 1865. One effect of the War is a chronic cotton famine in Britain, with 500,000 textile workers dependent on poor relief and charity.
Deaths of ROBERTS, WILLIAM DYCE and WILLIAM HENRY HUNT.	**1864**	
	1867	Second Reform Act extends the male franchise to 2 million. Karl Marx publishes the first volume of *Capital*. Exposition International held in Paris.
The Royal Academy moves into Burlington House, Piccadilly, its present home.	**1868**	Robert Browning publishes *The Ring and the Book*. Last public hanging in Britain takes place.
Death of SAMUEL JACKSON. A.W. HUNT travels in Italy, Sicily and Greece, returning in 1870.	**1869**	Suez Canal opens (begun 1859). Thomas Cook & Co granted exclusive control of all passenger steamers on the Nile and give their first tour of Egypt and the Holy Land. Egypt becomes a winter resort for well-off Europeans. Meanwhile, Stanley and Livingstone meet at Lake Tanganyika.
	1870	Franco-Prussian War begins. In the 1870s massive importations of cheap foodstuffs begin to ruin farming and property values in Britain; serious depopulation of the countryside follows.
RUSKIN buys Brantwood, the house in the Lake District that becomes his final home.	**1871**	

ALBERT GOODWIN in Italy with RUSKIN.	**1872**	National Agricultural Labourers Union is set up: within a year it has 100,000 members.
LEAR returns to the Riviera, having spent two years in India.	**1875**	Britain buys 176,602 shares in the Suez Canal from the Khedive Ismael of Egypt, giving it a 40% stake.
Deaths of J. F. LEWIS and HENRY GASTINEAU.	**1876**	The British and French become involved in Egypt, and establish an Anglo-French condominium over that country soon after.
RUSKIN denounces WHISTLER's *Nocturne*; the libel action that follows bankrupts Whistler.	**1877**	Victoria is proclaimed Empress of India.
Scottish Water-Colour Society founded.	**1878**	The Zulu War in southern Africa begins; the following year the Zulu army is destroyed by British troops. Thomas Hardy's *The Return of the Native* is published. Another Exposition Universelle is held in Paris.
Royal Society of Painter-Printmakers founded; this provides an annual exhibition for painters who make original etchings and engravings, as opposed to reproductive prints. Now based at the Bankside Gallery, London.	**1880**	The First South African War by the Boers against the British breaks out.
Deaths of PALMER and G. R. LEWIS.	**1881**	The Mahdi's rebellion in the Sudan against Egyptian rule begins; British armies become involved. Completion of the St Gothard tunnel (begun 1872) through the Alps.
Death of LINNELL.	**1882**	The British occupy Egypt, and maintain control into the 20th century.

SELECT BIBLIOGRAPHY

Note: for bibliographical items on individual artists, see the Artists' Biographies (pp. 312–323). Exhibition catalogues are listed by title, not author(s).

D.G.C. Allan, *William Shipley: Founder of the Royal Society of Arts*, London 1968

M. Andrews, *The Search for the Picturesque: Landscape Aesthetics and Tourism in Britain, 1760–1800*, Aldershot 1989

The Arrogant Connoisseur: Richard Payne Knight, 1751–1824, exh. cat. by M. Clarke & N. Penny; Manchester, Whitworth Art Gallery, 1982

Art for Newcastle: Thomas Miles Richardson and the Newcastle Exhibitions, 1822–1843, exh. cat. by P. Usherwood; Newcastle upon Tyne, Laing Art Gallery, 1984

J. Barrell, *The Dark Side of the Landscape: The Rural Poor in English Painting, 1730–1840*, Cambridge 1981

Beauty, Horror and Immensity: Picturesque Landscape in Britain, 1750–1850, exh. cat. by P. Bicknell; Cambridge, Fitzwilliam Museum, 1981

A. Bermingham, *Landscape and Ideology: The English Rustic Tradition, 1740–1860*, London 1987

P. Bicknell, *The Picturesque Scenery of the Lake District, 1752–1855: A Bibliographical Study*, Winchester 1990

D. Bindman, ed., *The Thames and Hudson Encyclopaedia of British Art*, London 1985

L. Binyon, *Catalogue of Drawings by British Artists and Artists of Foreign Origin working in Great Britain preserved in the Department of Prints and Drawings in the British Museum*, 4 vols, London 1898–1907

——, *English Watercolours*, London 1933, revd 1944, reprd New York 1969

T.S.R. Boase, *English Art, 1800–1870*, Oxford History of English Art x, Oxford 1959

The Bristol School of Artists: Francis Danby and Painting in Bristol, 1810–1840, exh. cat. by F. Greenacre; Bristol, City Art Gallery, 1973

British Artists in Rome, 1700–1800, exh. cat. by L. Stainton; London, The Iveagh Bequest, Kenwood, 1974

British Landscape Watercolours, 1600–1860, exh. cat. by L. Stainton; London, British Museum, 1985; revd as *Nature in to Art: British Landscape Watercolors*; Cleveland, OH, Museum of Art; Raleigh, NC, Museum of Art; 1991

British Watercolours: A Golden Age, 1750–1850, exh. cat. by S. Somerville; Louisville, KY, J.B. Speed Art Museum, 1977

British Watercolors, 1750–1850: A Loan Exhibition from the Victoria & Albert Museum, exh. cat. by

G. Reynolds and J. Mayne; USA touring exhibition organised by the International Exhibitions Foundation; Washington, D.C. 1966

British Watercolours, 1760–1930, from the Birmingham Museum and Art Gallery, exh. cat. by R. Lockett; Arts Council touring exhibition [1980]

British Watercolours and Drawings from Rowlandson to Riley, exh. cat. organised by the British Council and the Edinburgh International Festival; Edinburgh, Royal Scottish Academy, 1982

British Watercolors: Drawings of the 18th and 19th Centuries from the Yale Center of British Art, exh. cat. by S. Wilcox; New Haven, Yale Center for British Art, 1985

British Watercolours from Birmingham, exh. cat. by S. Wildman; London, Bankside Gallery; Birmingham, City Art Gallery; 1992

D.B. Brown, *Catalogue of the Collection of Drawings in the Ashmolean Museum, Oxford, IV: The Earlier British Drawings, British Artists and Foreigners working in Britain born before c. 1775*, Oxford 1982

——, & F. Owen, *Collector of Genius: A Life of Sir George Beaumont*, London 1988

Brush to Paper: Three Centuries of British Watercolours from Aberdeen Art Gallery, exh. cat. by F. Irwin; Aberdeen, Art Gallery, 1991

J. Burke, *English Art, 1714–1800*, Oxford History of English Art IX, Oxford 1976

P. Butler, *Three Hundred Years of Irish Watercolours and Drawings*, London 1990

C. Chard, 'Rising and Sinking in the Alps and Mt Etna: The Topography of the Sublime in 18th-century England', *Journal of Philosophy and the Visual Arts*, I, 1989, pp. 60–69

M. Clarke, *The Tempting Prospect: A Social History of English Watercolours*, London 1981

Clarkson Stanfield, 1793–1867, exh. cat. by P. van der Merwe; Gateshead, Tyne & Wear Museums, 1979

Classic Ground: British Artists in Italy, 1740–1830, exh. cat. ed. D. Bull; New Haven, Yale Center for British Art, 1981

D. Clifford, *Watercolours of the Norwich School*, London 1965

——, *Collecting English Watercolours*, London 1970

R. Cohen, ed., *Studies in Eighteenth-century British Art and Aesthetics*, London 1985

Color Printing in England, 1486–1870, exh. cat. by J.M. Friedman; New Haven, Yale Center for British Art, 1978

H.M. Colvin, *A Biographical Dictionary of English Architects, 1660–1840*, London 1954, revd as *A Biographical Dictionary of British Architects, 1600–1840*, 1978

Concise Catalogue of British Watercolours and Drawings, Manchester City Art Gallery, 2 vols, 1985, 1986

P. Conisbee, 'Pre-Romantic "Plein-air" Painting', *Art History*, II, 1979, pp. 413–28

D. Cosgrove & S. Daniels, eds, *The Iconography of Landscape*, Cambridge 1988

M.C. Cowling, 'The Artist as Anthropologist in Mid Victorian Britain', *Art History*, VI, 1983, pp. 461–77

H.M. Cundall, *A History of British Watercolour Painting*, London 1908, revd 1929

L. Cust & S. Colvin, *The History of the Society of Dilettanti*, London 1898

H.A.E. Day, *East Anglian Painters*, 3 vols, Eastbourne 1968–9

A Decade of English Naturalism, 1810–1820, exh. cat. by J. Gage; Norwich, Castle Museum; London, Victoria & Albert Museum; 1969–70

The Discovery of the Lake District: A Northern Arcadia and its Uses, exh. cat., prefaced by John Murdoch; London, Victoria & Albert Museum, 1984

The Discovery of Scotland: The Appreciation of Scottish Scenery through Two Centuries of Painting, exh. cat. by J. Holloway & L. Errington; Edinburgh, National Gallery of Scotland, 1978

Dr Thomas Monro (1759–1833) and the Monro Academy, exh. brochure by J. Mayne; London, Victoria & Albert Museum, 1976

Drawing: Technique and Purpose, exh. cat. by S. Lambert; London, Victoria & Albert Museum, 1981, revd London 1984

J. Egerton, *British Watercolours*, London 1986

——, *English Watercolour Painting*, Oxford 1979

R.K. Engen, *Dictionary of Victorian Engravers, Print Publishers and their Works*, Cambridge 1979

English Artists Paper: Renaissance to Regency, exh. cat. by J. Krill; London, Victoria & Albert Museum, 1987

English Drawings and Watercolours, 1550–1850, in the Collection of Mr and Mrs Paul Mellon, exh. cat. by J. Baskett and D. Snelgrove, with a foreword by C. Ryskamp & introdn by G. Reynolds; New York, Pierpont Morgan Library; London, Royal Academy of Arts; 1972

English Landscape, 1630–1850: Drawings, Prints and Books from the Paul Mellon Collection, exh. cat. by C. White; New Haven, Yale Center for British Art, 1977

English Watercolours and other Drawings: The Helen Barlow Bequest, exh. cat.; Edinburgh, National Gallery of Scotland, 1979

J. Farington, *The Diary*, 16 vols, ed. K. Garlick, A. Macintyre & K. Cave, London 1978–84

T. W. Fawcett, *The Rise of English Provincial Art*, Oxford 1974

S. Fisher, *A Dictionary of Watercolour Painters, 1750–1900*, London 1972

The Fitch Collection: A Record of the Major English Watercolours and Drawings Collected by Dr Marc Fitch, exh. cat., introd by A. Wilton; London, Leger Galleries, 1988

Forty-two British Watercolours from the Victoria and Albert Museum, exh. cat. by J. Murdoch; USA & Canada touring exhibition; London, 1977

D. Foskett, *A Dictionary of British Miniature Painters*, 2 vols, London 1972

R. Gard, ed., *The Observant Traveller: Diaries of Travel in England, Wales and Scotland in the County Record Offices of England and Wales*, London 1989

Gilpin to Ruskin: Drawing Masters and their Manuals, 1800–1860, exh. cat. by P. Bicknell & J. Munro; Cambridge, Fitzwilliam Museum; Grasmere, Dove Cottage and Wordsworth Museum; 1987–8

P. Goldman, *Looking at Prints, Drawings and Watercolours: A Guide to Technical Terms*, London 1988

R. T. Godfrey, *Printmaking in Britain: A General History from its Beginnings to the Present Day*, Oxford 1978

M. H. Grant, *A Dictionary of British Landscape Painters*, Leigh-on-Sea 1952

——, *A Chronological History of the Old English Landscape Painters*, 8 vols, 2nd edn, Leigh-on-Sea 1957–61

A. Graves, *The British Institution, 1806–1867: A Complete Dictionary of Contributors and their Work from the Foundation of the Institution*, London 1908, reprd 1969

——, *The Royal Academy of Arts: A Complete Dictionary of Contributors and their Work from its Foundation in 1769 to 1904*, 8 vols, London 1905–6

——, *The Society of Artists of Great Britain, 1760–1791; The Free Society of Artists, 1761–1783: A Complete Dictionary of Contributors and their Work from the Foundation of the Societies to 1791*, London 1907, reprd 1969

A. Griffiths, *Prints and Printmaking: An Introduction to the History and Techniques*, London 1980

G. Grigson, *Britain Observed: The Landscape through Artists' Eyes*, Oxford 1975

J. Halsby, *Scottish Watercolours, 1740–1940*, London 1986

M. Hardie, *English Coloured Books*, London 1906, reprd 1990

——, *Watercolour Painting in Britain*, 3 vols, ed. D. Snelgrove with J. Mayne and B. Taylor: *I: The Eighteenth Century*, London 1966, revd 1967; *II: The Romantic Period*, 1967; *III: The Victorian Period*, 1968

R. D. Harley, *Artists' Pigments, c. 1600–1835: A Study of English Documentary Sources*, London 1970

J. Harris, *The Artist and the Country House: A History of Country House and Garden View Painting in Britain, 1540–1870*, London 1979, revd 1985

A. Hemingway, 'Cultural Anthropology and the Invention of the Norwich School', *Oxford Art Journal*, 11/2, 1988, pp. 17–39

——, *The Norwich School of Painters, 1803–1833*, Oxford 1979

——, 'The "Sociology" of Taste in the Scottish Enlightenment', *Oxford Art Journal*, XII, 1989, pp. 3–35

——, *Landscape Images and Urban Culture in Early Nineteenth-century Britain*, Cambridge 1992

C. Hemming, *British Landscape Painters: A History and Gazetteer*, London 1989

——, *British Painters of the Coast and Sea: A History and Gazetteer*, London 1988

L. Herrmann, *British Landscape Painting of the Eighteenth Century*, London 1973

W. Hipple, *The Beautiful, the Sublime and the Picturesque in Eighteenth-century British Aesthetic Theory*, Carbondale, IL, 1957

S. Houfe, *The Dictionary of British Book Illustrators and Caricaturists, 1800–1914*, Woodbridge 1978

C. E. Hughes, *Early English Watercolours*, London 1913, revd (by J. Mayne) 1950

J. D. Hunt, *The Figure in the Landscape: Poetry, Painting and Gardening in the Eighteenth Century*, London 1976

——, 'Picturesque Mirrors and the Ruins of the Past', *Art History*, IV, 1981, pp. 254–70

C. Hussey, *The Picturesque: Studies in a Point of View*, London 1927

S. C. Hutchison, *The History of the Royal Academy, 1768–1968*, London 1968, revd 1986

In the Shadow of Vesuvius: Views of Naples from Baroque to Romanticism, 1631–1830, exh. cat., with essays by G. Briganti, N. Spinosa & L. Stainton; London, Accademia Italiana delle Arti e delle Arti Applicate, 1990

D. Irwin & F. Irwin, *Scottish Painters at Home and Abroad, 1700–1900*, London 1975

R. Joppien & B. Smith, *The Art of Captain Cook's Voyages*, 3 vols, London 1985–8

F. D. Klingender, *Art and the Industrial Revolution*, London 1947, revd edn by A. Elton, 1968

R. P. Knight, *Expedition into Sicily*, ed. & introd by C. Stumpf, London 1986

R. Kuhns, 'The Beautiful and the Sublime', *New Literary History*, XIII, 1982, pp. 287–307

L. Lambourne & J. Hamilton, *British Watercolours in the Victoria & Albert Museum: An Illustrated Summary Catalogue of the National Collection*, London 1980

Landscape in Britain, c. 1750–1850, exh. cat. by L. Parris; London, Tate Gallery, 1974

Landscape in Britain, 1850–1950, exh. cat. ed. J. Collins & N. Bennett; London, Hayward Gallery; Bristol, City Art Gallery; Stoke-on-Trent, City Museum & Art Gallery; Sheffield, Mappin Art Gallery; 1983

H. Lemaitre, *Le paysage anglais a l'aquarelle, 1760–1851*, Paris 1955

R. Lister, *British Romantic Art*, London 1973

London – World City, 1800–1840, exh. cat. ed. C. Fox; Essen, Villa Hugel, 1992

Louis Francia, 1772–1839, exh. cat. by P. le Nouëne & A. Haudiquet; Calais, Musée des Beaux-Arts et de la Dentelle de Calais, 1988

S. T. Lucas, *Bibliography of Water Colour Painting and Painters*, London 1976

H. L. Mallalieu, *The Norwich School: Crome, Cotman and their Followers*, London 1974

——, *Understanding Watercolours*, Woodbridge 1985

——, *British Watercolour Artists up to 1920*, 2 vols, Woodbridge 1976, revd 1986; vol. 3, Woodbridge 1990

Masters of the Sea: British Marine Watercolours, exh. cat. by R. Quarm & S. Wilcox; New Haven, Yale Center for British Art; London, National Maritime Museum; 1987

E. Moir, *The Discovery of Britain: The English Tourists, 1540 to 1840*, London 1964

S. H. Monk, *The Sublime: A Study of Critical Theories in Eighteenth-century England*, New York 1935, reprd 1960

W. C. Monkhouse, *The Earlier English Watercolour Painters*, London 1890, revd 1897

A. W. Moore, *The Norwich School of Artists*, Norwich 1985

The Most Beautiful Art of England: Fifty Watercolours, 1750–1850, exh. cat. by F. W. Hawcroft; Manchester, Whitworth Art Gallery, 1983

C. Newall, *Victorian Watercolours*, Oxford 1987

The Northern Landscape: Flemish, Dutch and British Drawings from the Courtauld Collection, exh. cat. by D. Farr & W. Bradford; New York, The Drawing Center, 1986

The Old Water-Colour Society and its Founder-Members, exh. cat. by B. Taylor; London, Spink & Son, 1973

A. P. Oppé, *English Drawings: Stuart and Georgian Periods in the Collection of H. M. the King at Windsor Castle*, London 1950

The Orient Observed: Images of the Middle East from the Searight Collection, exh. cat. by B. Llewellyn; London, Victoria & Albert Museum, 1989

The Orientalists, Delacroix to Matisse: European Painters in North Africa and the Near East, exh. cat. ed. M. A. Stevens; London, Royal Academy of Arts, 1984

Original Eyes: Progressive Vision in British Watercolour, 1750–1850, exh. cat. by D. B. Brown; Liverpool, Tate Gallery, 1991

I. Ousby, *The Englishman's England: Taste, Travel and the Rise of Tourism*, Cambridge 1990

F. Owen, 'Sir George Beaumont and the Old Watercolour Society', *The Old Water-Colour Society's Club*, LXII, 1991, pp. 23–9

Painters and Engraving: The Reproductive Print from Hogarth to Wilkie, exh. cat. by D. Alexander & R. T. Godfrey; New Haven, Yale Center for British Art, 1980

Painting from Nature, exh. cat. by P. Conisbee & L. Gowing; Cambridge, Fitzwilliam Museum; London, Royal Academy of Arts; 1980–1

Painting in Scotland: The Golden Age, exh. cat. by D. Macmillan; Edinburgh, Talbot Rice Art Centre; London, Tate Gallery; 1986–7

M. Paley, *The Apocalyptic Sublime*, London 1986

A. Payne, *Views of the Past: Topographical Drawings in the British Library*, London 1987

I. Pears, *The Discovery of Painting: The Growth of Interest in the Arts in England, 1680–1768*, London 1988

The Picturesque Tour in Northumberland and Durham, c. 1720–1830, exh. cat. by G. Hedley; Newcastle upon Tyne, Laing Art Gallery, 1982

M. Pointon, *The Bonington Circle: English Watercolour and Anglo-French Landscape, 1790–1855*, Brighton 1985

Preferred Places: A Selection of British Landscape Watercolours from the Collection of the Art Gallery of Ontario, exh. cat. by K. Sloan; Toronto, Glendon Gallery; Kitchener-Waterloo Art Gallery; Sarnia, Public Library & Art Gallery; 1987

The Pre-Raphaelites, exh. cat., introd by A. Bowness; London, Tate Gallery, 1984

Presences of Nature: British Landscape 1780–1830, exh. cat. by L. Hawes; New Haven, Yale Center for British Art, 1982–3

M. Rajnai, *The Norwich Society of Artists, 1803–1833: A Dictionary of Contributors and their Work*, Norwich 1976

R. Redgrave & S. Redgrave, *A Century of Painters of the English School*, 2 vols, London 1866, revd 1890, reprd 1947

S. Redgrave, *A Dictionary of Artists of the English School*, 1874, revd 1878, reprd Bath 1970

R. Reilly, *British Watercolours*, London 1974, revd 1982

G. Reynolds, *A Concise History of Watercolours*, London 1971

——, *English Watercolours: An Introduction*, 1950, revd London 1988

Richard Wilson: The Landscape of Reaction, exh. cat. by D. H. Solkin; London, Tate Gallery; Cardiff, National Museum of Wales; New Haven, Yale Center for British Art; 1982–3

S. K. Robinson, *Inquiry into the Picturesque*, Chicago 1991

J. L. Roget, *A History of the 'Old Water-Colour Society', now the Royal Society of Painters in Watercolours*, 2 vols, London, 1891, reprd Woodbridge 1972

Romantic Art in Britain: Paintings and Drawings, 1760–1860, exh. cat.; Detroit, Institute of Art; Philadelphia, Museum of Art; 1968

M. Rosenthal, *British Landscape Painting*, Oxford 1982

S. Ross, 'The Picturesque: An Eighteenth-century Debate', *Journal of Aesthetics and Art Criticism*, XLVI, 1987, pp. 271–9

The Royal Watercolour Society: The First Fifty Years, 1805–1855, Antique Collectors' Club Research Project, Woodbridge 1992

Ruins in British Romantic Art from Wilson to Turner, exh. cat., introd by L. Hawes; Nottingham, Castle Museum, 1988

Scenery of Great Britain and Ireland in Aquatint and Lithography, 1770–1850, from the Library of J. R. Abbey: A Bibliographical Catalogue, Folkestone and London 1972

Sketching at Home and Abroad: British Landscape Drawings, 1750–1850, exh. cat. by E. J. Phimister, S. Wiles & C. Denison; New York, Pierpont Morgan Library, 1992

The Sketching Society, 1799–1851, exh. cat. by J. Hamilton; London, Victoria & Albert Museum, 1971

K. Sloan, 'Drawing – A "Polite Recreation" in Eighteenth-century England', *Studies in Eighteenth-century Culture*, 11, 1982, pp. 217–39

M. Spender, *The Glory of Watercolour: The Royal Watercolour Society's Diploma Collection*, London 1987

A. Staley, *The Pre-Raphaelite Landscape*, Oxford 1973

Town, Country, Shore and Sea: British Drawings and Watercolours from Antony van Dyck to Paul Nash, exh. cat. by D. Robinson; Cambridge, Fitzwilliam Museum, 1982

Travels in Italy, 1776–1783: Based on the 'Memoirs' of Thomas Jones, exh. cat. by F. Hawcroft; Manchester, Whitworth Art Gallery, 1988

M. L. Twyman, *Lithography, 1800–1850: The Techniques of Drawing on Stone in England and France and their Application in Works of Topography*, London 1970

Victorian Landscape Watercolours, exh. cat. by S. Wilcox & C. Newall; New Haven, Yale Center for British Art; Cleveland, OH, Museum of Art; Birmingham, Museum & Art Gallery; 1992

Visions of Venice: Watercolours and Drawings from Turner to Ruskin, exh. cat. by T. Wilcox; London, Bankside Gallery, 1990

Wash and Gouache: A Study of the Developments of the Materials of Watercolor, exh. cat. by M. B. Cohn & R. Rosenfeld; Cambridge, MA, Fogg Art Museum, 1977

E. K. Waterhouse, *The Dictionary of British Eighteenth-century Painters in Oils and Crayons*, Dictionary of British Art II, Woodbridge 1981

——, *Painting in Britain, 1530 to 1790*, Pelican History of Art, Harmondsworth 1953, 4th revd edn 1978

D. Watkin, *The English Vision: The Picturesque in Architecture, Landscape and Garden Design*, London 1982

W. T. Whitley, *Artists and their Friends in England, 1700–1799*, 2 vols, London 1928

I. A. Williams, *Early English Watercolours, and Some Cognate Drawings by Artists born not later than 1785*, London 1952

A. Wilton, *British Watercolours, 1750–1850*, Oxford 1977

C. Wood, *Victorian Painters*, Dictionary of British Art IV, Woodbridge 1971, revd 1978

H. T. Wood, *The History of the Royal Society of Arts*, London 1913

N. Wood, 'The Aesthetic Dimension of Burke's Political Thought', *Journal of British Studies*, IV, 1964, pp. 41–64

William Wordsworth and the Age of English Romanticism, exh. cat. by J. Wordsworth, M. C. Jaye & R. Woof; New York, Public Library; Bloomington, Indiana University Art Museum; Chicago, Historical Society; 1987

Works of Splendor and Imagination: The Exhibition Watercolor, 1770–1870, exh. cat. by J. Bayard; New Haven, Yale Center for British Art, 1981

PHOTOGRAPHIC ACKNOWLEDGEMENTS

Aberdeen, City Art Gallery and Museums Collections, fig. 24

Amsterdam, Rijksmuseum, cat. 229, 246

Birmingham Museums and Art Gallery, cat. 7, 54, 57, 63, 66, 67, 68, 76, 135, 141, 232, 275, 315, 322

Bolton, Manor, Ray and Foley Photographers, fig. 37

Bristol, Andy Cotton, cat. 101, 102, 103, 104, 186, 187, 188, 189, 190, 191

Cambridge, Fitzwilliam Museum, cat. 1, 17, 20, 23, 24, 74, 112, 113, 119, 136, 139, 164, 165, 168, 199, 202, 203, 207, 220, 221, 236, 263, 264, 320, 321, 323, 324

Cambridge, Neville Taylor, cat. 133, 146

Cardiff, National Museum of Wales, cat. 75, 105, 243, 279

Chicago, Art Institute of Chicago, cat. 73

Dunscore, Susannah Jackson, fig. 39

Edinburgh, National Galleries of Scotland (Antonia Reeve Photography) cat. 50, 97, 98, 111, 142, 235, 249, 261, 288, 308, 309; fig. 48

H.M. The Queen, cat. 5, 251, 252, 254, 259, 260

Hereford, Hammonds Photography, cat. 96, 99, 100, 316

Leeds, City Art Galleries, cat. 8, 36, 42, 51, 53, 87, 92, 137, 138, 145, 150, 273, 274, 276, 286

Liverpool, John Mills (Photography), cat. 59; fig. 7

Liverpool, University Art Gallery and Collections, cat. 71, 77, 116, 237

London, Agnew's, cat. 65, 81, 310

London, Albany Gallery, cat. 172, 262

London, Chris Beetles, cat. 157

London, © British Library, fig. 17, 18, 19

London, © British Museum, cat. 13, 28, 29, 31, 32, 38, 40, 43, 44, 48, 82, 85, 95, 114, 140, 148, 149, 152, 160, 173, 218, 231, 240, 247, 250, 257, 265, 268, 269, 311; fig. 1, 2, 4, 13, 14, 15, 20, 21, 23, 25, 26, 33, 34, 40, 41, 52

London, Christie's, fig. 5

London, Courtauld Institute Galleries, cat. 55; fig. 3

London, Prudence Cuming Associates Ltd., cat. 3, 6, 12, 15, 19, 25, 37, 39, 61, 62, 64, 72, 91, 107, 109, 115, 117, 118, 120, 121, 122, 123, 124, 126, 151, 155, 156, 162, 169, 170, 174, 175, 176, 177, 184, 197, 216, 217, 230, 248, 270, 272, 281, 283, 287, 292, 293, 297, 301, 312

London, Martyn Gregory Gallery, cat. 49, 128, 204, 205, 206

London, Hazlitt, Gooden & Fox, cat. 79, 80, 210

London, Leger Galleries, cat. 134, 194

London, Paul Mellon Centre for Studies in British Art, fig. 30, 32, 49

London, Peter Nahum, cat. 132, 183

London, Trustees of the National Gallery, fig. 10, 43

London, P-inc Photography, cat. 158, 234

London, Royal Academy of Arts, cat. 241

London, Royal Institute of British Architects, cat. 266, 267

London, Sir John Soane's Museum, fig. 51

London, Sotheby's, cat. 153, 212

London, © Tate Gallery, cat. 11, 18, 52, 69, 70, 143, 163, 193, 195, 225, 242, 277, 280, 285, 289, 290, 291, 294, 298, 299, 300, 302, 306, 313, 319; fig. 8, 12, 22, 28, 29, 31, 45, 50

London, © The Board of Trustees of the Victoria and Albert Museum, cat. 26, 27, 30, 33, 34, 35, 47, 56, 60, 78, 86, 147, 171, 182, 200, 219, 222, 238, 244, 271, 307; fig. 35, 44, 46, 54, 55

Manchester, City Art Galleries, cat. 58

Manchester, Whitworth Art Gallery, cat. 41, 83, 144, 198, 209, 214, 314

National Trust Photographic Library/Derrick E. Witty, cat. 10

Newcastle upon Tyne, Laing Art Gallery, cat. 22, 154, 256, 305; fig. 11

New Haven, Richard Caspole, Yale Center for British Art, cat. 45, 106, 108, 127, 129, 130, 166, 196, 223, 228, 239, 282, 317, 326

New York, © The Pierpont Morgan Library, 1992, cat. 9

Northumberland, Fiona Lees-Millais, cat. 318

Nottingham, Layland Ross Ltd, cat. 16, 21, 181, 255, 258; fig. 16

Oxford, © Ashmolean Museum, cat. 90, 125, 131, 179, 215, 233; fig. 6, 27, 36

Pittsburgh, PA, Mellon Bank Corporation, cat. 46

Preston, Norwyn Photographics, cat. 180, 295

Reading, Jonathan Farmer, cat. 159, 161

Sheffield, City Art Galleries, cat. 14, 296

Southport, Alan R. Jones Photography, cat. 4, 88, 89, 167, 211, 227

Surrey, Nick Nicholson, cat. 110, 178, 185, 201, 284; fig. 47

Washington, DC, © National Gallery of Art, cat. 2, 84, 94, 208, 224, 245, 253, 266, 304, 325

Wolverhampton, Eardley Lewis Photographers, cat. 278

INDEX